THE IRON BUTTERFLY

a trip through the twentieth century

Doris Colmes

PublishAmerica
Baltimore

ISBN: 1-59129-472-X
PUBLISHED BY PUBLISHAMERICA BOOK PUBLISHERS
www.publishamerica.com
Baltimore

Printed in the United States of America

For Elaine Skoler

ACKNOWLEDGMENTS

Most of all, to my children, whose innate strength, humor and endurance surmounted formidable challenges, making them adults of power, faith and integrity.

To John Roger, for his wisdom, common sense and powerful teaching—and without whose presence in my life this story would have had a different ending.

To Elie Wiesel, a true hero: A role model of quiet strength and integrity whose little note to me in 1998 inspired the writing of this book. Thank you, Reb Wiesel, for all you have done to teach the world true grace by your shining example.

To Dr. William Glasser for teaching me that the concepts of Reality Therapy and Control Theory can be successfully implented not only with others, but with myself—bringing a plethora of choices I never knew existed in satisfying those four basic needs.

Many names have been changed in order to respect and honor the privacy of participants.

Table of Contents

Prologue The Odd Couple..7

Chapter 1 Nursery Rhymes..11

Chapter 2 Heil Hitler..19

Chapter 3 Speed and Danger..29

Chapter 4 Harlem Nocturne...39

Chapter 5 Death and the Maiden......................................49

Chapter 6 Teen Dreams..59

Chapter 7 Co-Ed's Guide to Higher Ed.............................75

Chapter 8 Love and Marriage...91

Chapter 9 The Stepford Wife..119

Chapter 10 The Mad Housewife.......................................135

Chapter 11 Transitions...147

Chapter 12 California Dreamin'..165

Chapter 13 Sex, Drugs, Rock 'n' Roll, Part I:
 "Chain of Fools"..171

Chapter 14 Sex, Drugs, Rock 'n' Roll, Part II:
 "Mama Tol' Me Not To Come"........................187

Chapter 15 The Sorcerer's Apprentice..............................201

Chapter 16 Leaving Your Heart In San Francisco...............221

Chapter 17 Disco Madness..243

Chapter 18 Beginnings..257

Chapter 19 The Trip is Still a Trip.......................................267

Epilogue 271

PROLOGUE

The Odd Couple

Max

The Weimar Republic, nestled uncomfortably between two wars, occupied a dangerously slippery spot in twentieth century history. It sent most Germans hurtling into the dark, rocky chasm of a severe national depression in which lurked all the intense and terrifying shadows of economic deprival. There, they huddled together in the dark, wretchedly nursing their social, economic and political grievances, their eyes glowing like beasts caught in the headlamps of retribution. They dreamed of revenge but could not yet identify the enemy.

Meanwhile, in the verdant hills of social privilege, the sun shone on plump burghers who became rich, bought nursemaids, built villas and cheated on their wives. Their trees grew, their Daimlers glistened, their children were brought up to curtsey. Theirs was a time of satiated peace.

The Jew who thought he was a German lived there. He brought home a fancy American wife, a pianist, who was slightly overweight and rather asexual. When he arrived with the virgin bride, his mother hung herself in the attic. It was said she had thyroid trouble. After the funeral, the bridegroom changed from "Max" to "Lang," in honor of his mother's maiden name, and a new life began. He was the capitalist. He played chess and tennis with equal ardor. His dogs were purebred, his children beautiful and the nursemaid's breasts high and mighty. He liked to pat them all.

As the Weimar Republic economy disintegrated, he bought the foreclosed real estate of the newly impoverished and became even richer. He built a twenty-four-room villa, his loyal chauffeur washed the Daimler every Sunday, his wife gave recitals of Schumann and chamber music.

The oldest daughter showed artistic talent and so he claimed her for his very special own. His wife looked away. The second daughter resembled his late mother and was loved most carefully, most purely. The third daughter was a toy.

A dream time in the Weimar Republic. The Jew who thought he was a German laid his dark, balding head back on the deck chair in his Japanese Garden. He smoked cigars and entertained Russian Chess Masters. His wife

practiced her scales on the black Bechstein concert grand with the carved legs. She practiced all day to ready herself for concerts. When the concerts were over, she inevitably had screaming nervous breakdowns. When she screamed too much, the loyal chauffeur drove her in the Daimler to a sanitarium. There she would stay for awhile and receive visits from the Jew and the children. The children curtsied and said, "How do you do" in English in order to make her happy. The nursemaid adjusted her starched white uniform and smiled.

Isabelle

At the turn of the century, America lay waiting, paving her streets with gold and offering everyone a chance at it. And so they all came, clutching their rags, their *Torahs*, their children and each other, seeking the promised land and living on Delancey Street while they figured out the map. Under the horse manure they found only cobblestones. Maybe someone else found the gold. They shrugged. It was better than Russia.

The matriarch, Elizabeth, had no golden illusions at all. She was a socialist and ready to make war. She hung around the Union Hall where she smoked cigarettes and played wild games of chess with the comrades. Her games got so wild that her husband stopped playing. He drifted off to the Old Wild West seeking tamer frontiers than hers. And there he died, leaving Elizabeth with her cigarettes, her socialist ideology and five children to feed. She spewed her outrage at the world, angry and bitter. She was so fierce, they were all afraid of her and followed her directions well.

Jewish child prodigies were known to get their families out of debt and so they all became musicians, except for two of the girls who were tone deaf. Barney became the prodigy, much in demand at public performances and with a future date at Carnegie Hall. But when he returned from World War I, Barney sat without speaking for three years and then threw his violin away. That left Bella and Sonia to provide a future and they worked hard. Sonia sang *Lieder* and taught music. Bella got a scholarship to Juilliard (the first ever given to a woman), accompanied Sonia at song recitals and quietly grabbed the prize away from under Sonia's nose. Bella married the millionaire and became Isabelle. Sonia married a merchant and became fat. The rest stayed poor. Isabelle did not share. She smiled at her mother, laughed at her sisters and went off with her new husband to discover Germany.

When she got there, her mother-in-law examined the bride carefully and

then took to the attic. The other relatives found her behavior eccentric and her accent gauche. Tutors were immediately found to teach her proper German, but the Yiddish bled through. She made social errors and could not control the servants. Only her repertoire saved her.

The Marriage

The newlyweds had in common a love of chess, music, well-bred dogs and luxury. They both believed themselves to be the owners of their children, who were part of their property, born with the obligation of good performance.

He brought to the marriage a belief that love was sex, but if you enjoyed it with your wife it was like messing with your mother. He believed his wife to be a gifted, spiritual person who would give him a musical salon and talented children. He secretly wished her to be sexually responsive but understood that this was why God had created mistresses.

She brought to the marriage a belief that love was dangerous, altogether. It caused rage, betrayal and desertion. Sex was a mysterious, frightening, slightly repulsive marital act that had to do with a part of the body she referred to with alarm as "down there." She secretly wished to be kissed, but understood that this might be a perversion on her part.

She gloried in her new station and in her assets, which included major connections to the world of traveling artists. She promptly instituted a successful musical salon. Stray bass-baritones wandering the European circuit headed straight for a rest stop at the Villa in Meiningen where they were sure to get excellent food, good room service and a perfectly tuned piano.

Their union was a welter of miscommunication from the start, and along with the first child came a procession of nursemaids, divorced noblewomen, slender educators, dance instructors and female business associates that wound sinuously through the long marriage. Not even World War II and the Holocaust slowed down the parade.

CHAPTER 1

Nursery Rhymes

First memories are hard to catch. Some rise silently into the night like embers from a dying gypsy camp fire. Others flap wildly past like bat-swarms suddenly terrified out of their dark cave. Yet there are those which perch upon my shoulders, meadowlarks and vultures both, fluffing their feathers and calling for recognition.

The villa on *Helenenstrasse* number 7 in Meiningen was invisible. To get there, one had to open a great iron gate nestled into a monstrous gray stone retaining wall and then start climbing. The wide stone stairs went on and on, interrupted by a landing of ornate stone balustrade that held an apple tree and a bench, allowing the visitor both nourishment and breath enough to continue his journey.

For that matter, the *Helenenstrasse* was invisible, too. I knew it was out there, because Koch drove Daddy to business on it, drove Mother when she went out to tea, and my sisters down its hill to school. There was no need for me to go. Everything came in: The grocer, the beautician, the gardener, even the seamstress who took our measurements every six months and then provided velvet dresses with white lace collars: Burgundy for Marion, age ten; dark green for Elinor, age eight; and bright blue for me, the four-year-old, queen of her hidden universe.

Peeking down at *Helenenstrasse* meant poking my head through the balustrade on the landing because I was too short to look over the top. I could see tree tops and a bit of cobblestone. Nothing worth exploring. I had other things to do.

"Flying Dutchman" was a four-wheeled cart propelled by doing oar strokes with its handle. The harder I pumped, the faster it went. First, a quick skirmish on the gravel path around the giant fir tree centering the lawn, then a race through the kitchen yard, which had a cement path conducive to record-breaking speed and then a lurching, bumping reconnoiter in the Japanese garden in which split-second judgment was required in order to navigate the curved bridge over the goldfish pond without falling in and drowning. I careened around those garden paths like an Olympian getting

ready for the sculling medal, working hard to go faster than the dog, although that never happened. Audi was always faster.

After the races, it was kitchen time. The dark, red-tiled service hallway had great acoustics for American Indian war-whoops and led directly to Hannah who—with unfailing intuition—knew she was dealing with a starving person and always had emergency rations on hand. Cookie in pocket, we then patrolled the upper grounds: Behind an immense fence, this territory abutted the hilltop road across from which were a convent and a little cottage for the convent groundskeeper who was also Brunhilde and Eckerhardt's Daddy.

Near the fence were the kennels, where Daddy's German Shepherd show dogs were bred and trained. There, we had to sneak. We weren't allowed in because Audi picked fights with his brethren and I had a tendency not to relinquish puppies. Chased from the kennels, we looked for the gardener to see if we could annoy him. The dislike was mutual, and I'm sure he used all forbearance not to hit us with his rake.

Sometimes, red in the face, he chased us with it, but that just provided excitement. Eventually, we ended up in our own little forest, where there was a tree so big that it hid us from daylight and even had a bench built all around it, just right for catching your breath and sharing a cookie with your dog.

We like to be under the piano while Mother practices. It makes a cave in which we're surrounded by sound. If we are quiet and don't mess with the pedals, we can stay. We curl up around each other. We like each other's smell. Mother repeats her scales and four-note exercises forever. She calls it "practicing her touch." Quite often, the cave-dwellers doze off, and usually all's well unless Mother relaxes and starts playing Chopin. *Waltz Number 3 in A minor* is Audi's favorite, and with its melancholy opening phrases—the end of his tail quivering gently against the Chinese carpet—Audi lifts his head like a primal wolf, closes his eyes in passionate bliss and begins, softly, to sing along. *Ach Du Lieber*, that's when the screaming starts, we get rudely evicted and trundle off to the comfort of my family: Hannah-the-cook (my pretend "*Mutti*"), and Koch-the-chauffeur (my pretend "*Pappi*").

Hannah, at bathtime, leans over the end of the tub and pretends she's a Catholic priest: "Anno Domini, Anno Domino, Pox Vobiscum, Pater Schmahter, Ave Schmahveh," she chants. Hannah is at war with the nuns on the hill. Is she jealous? Mother sends us to Mass there because two nuns speak English and are willing to converse. Bath time is a wonder of soap and laughter with Hannah's arms flailing the air as she scatters imaginary incense

over us. The dog watches carefully, torn between his distrust of bathtubs and his uncontrollable urge to protect me.

Hannah's arms are like limbs cut from some primal forest: Huge and strong. Hannah could vanquish the Pope himself with those arms. At the balustrade, Hannah lets me straddle an arm to play "pony." She lifts me high in the air while I holler and ride in a crown of apple blossoms. Until Mother sees.

Mother is angry. How I rock and ride is indecent. It must stop at once. Hannah becomes a violent, rigid red. She drops me from her arm and from her life. She marches away holding high the topknot on her proud Lutheran head. "*Mutti*" is gone.

Somehow, there was always a steady succession of servants. Cooks, ma'amselles, cooks, ma'amselles. Mother did not understand class hierarchy. She became at once too friendly, crossing those boundaries which made the system work. The servants were insulted by her intimacy. They thought her crazy and finally, invariably, ignored all her instructions. Thank goodness, Koch belonged to Daddy.

Koch shows me the caterpillar that will become a butterfly someday. The little green creature with its hairy belly and prickly back who is munching the leaves right off our rose bush is about to spin itself a cocoon, a little safe cradle, says Koch, and stay asleep in it for a long time. "And when she wakes up, she will arise in glory just like the princess from a fairy tale. *Denk mal* (just think)! When she gets out of bed, she will be a butterfly. She will fly away into the sunshine and never even remember she used to be a stupid green rose-bush crawler. This is so magic—true magic, *Kindchen* —that you can never handle one, because their wings are made of angel-dust and the only way they can live is to remain untouched. " I think Koch is magic, too. Our eyes meet. I want to ask him why he can't be my Daddy, want to say, "I love you," but in that brief moment, no sound comes. I feel tears approaching, but don't know why. So I run, as fast as possible. Toward nothing. Away from my own heart. I will love butterflies forever, and always remember to honor their dusted wings.

Eckerhardt and I are playing horsie. Eckerhardt wears brown leather shorts with suspenders and sports a shaved head. We are hitched in tandem to an imaginary cart being driven by Eckerhardt's older sister, Brunhilde. We trot down the garden pathway, tossing our manes and snorting agreeably. Suddenly, there appears in the front of Eckerhardt's shorts a tiny, miniature

horse thing and Eckerhardt proceeds to make water in transit just like a real horse.

A stream of urine arcs to the ground in front of us, shimmering in the sunshine. I am amazed and whinny excitedly. How did he do that? Eckerhardt trots serenely on, completely oblivious to the magnitude of his accomplishment. I stare in admiration at a few stray drops drying on his shorts. My hero!

Clean dresses. Inspections for dirty hands, snarled hair, untied shoes. Last-minute admonitions to remain silent unless addressed by a parent. It's Sunday dinner time, our weekly formal appearance in the adult world. Fear, excitement and excellent cuisine vie for our emotions. Perhaps one of us will receive praise. Probably one of us will receive a scolding. We march in, remain standing until the parents are seated, then unfurl our napkins from their silver rings and prepare to exhibit Ma'amselle's latest instruction in acceptable table manners.

But tonight, there's a salad, and the salad has radishes in it, and cucumbers. Marion takes a big mouthful and—alas—crunches. She has broken the first rule of table: "Thou shalt not make noise while chewing."

Daddy's eyes become round holes of terror, blazing with flames of hellish retribution.

"Away! How dare you, you miserable beast, make such disgusting noises. Away!"

Marion looks at him, petrified. She still has some salad in her mouth, afraid to chew, afraid to spit it out. She is frozen. Daddy stands up and throws his napkin to the floor.

"Away, I said, away!"

Marion disappears quickly, to the kitchen. I am amazed and then angry. Radishes crunch. Cucumbers crunch. How does he expect us to eat them without crunching? Anger makes me brave. "Crunch Salad," I mutter into my napkin. Now it's my turn to be immolated by the fires of outraged manners.

"What did you say?" He stands, eyes blazing.

"Nothing, Daddy."

"Be quiet, then, and eat."

I give in, lower my head, look at the napkin in my lap. And listen to the extraordinarily loud crunching noises coming from Daddy's mouth. After that, when salad is served at Sunday dinner, our eyes meet in secret derision. Even Mother is in on the joke. She winks at us and tells Daddy, "My dear, the crunch salad is excellent." We, of course, are all careful to eat only the softer ingredients while Daddy chews like a regiment of hobnailed boots

tromping through an icy tunnel. Ka-runch.

A garter snake is making a bracelet around my arm, and Koch carefully explains that only snakes with triangular heads have poisonous bites. Garter snakes have safe oval heads but prefer not to be pets because they need a quiet, private place to shed their skin. The idea of removing one's outer layer in order to grow is fascinating, but I am glad that people don't need to do this and carefully give the snake back her privacy in the warm pine needles where I found her.

Under the nursery light fixture flew a giant pink textile kite. It trembled just below the ceiling, gently shaking the dark rose tassels of its three points. In a breeze it swooped. It hovered there, waiting to dive, waiting to engulf me, rake me with its tassel claws, devour me whole. And I was tied there, helpless, unable to escape, able only to scream. All of us were tied there, staked out like bait for whatever nocturnal predator chose to drift in the window. We were captives, victims of *Manschetten*.

Manschetten were cardboard tubes placed over our elbows and then fastened with string to the sides of our beds. So our elbows wouldn't bend, so we couldn't suck our thumbs.

Me (yelping): "Waaaaah!"

Marion (hissing): "Fight, *Dussel*, don't cry, fight."

Elinor (muttering): "I'm telling."

And Marion fought. She was the chief thumb-sucker, and *Manschetten* were meant to break her of sucking her thumb with one hand while rubbing the edges of her blanket with the other. But no matter how intricately the *Manschetten* were tied, she fought a way out of them. Defiant and furious, she had the last word—the last suck—in the end. Elinor and I learned to lie passive, falling asleep in weirdly uncomfortable positions while the strings snarled and our arms became sticks. Marion squirmed and wriggled, bit at strings, won battles and—eventually—the war. Mother finally gave up and Marion, victorious, now put thumb to mouth even in the daytime. She never did stop and became a thumb-sucking adolescent. Victories won bitterly are worth celebrating forever.

Daddy apparently had decided long ago that religious expression did not fit his life-style and thought of himself as a German "free-thinker." Despite descent from a long line of Rabbis and Jewish merchants, he enjoyed observing Christmas, which—for him—meant giving everyone generous presents and decorating a very large tree. On Christmas Eve, the salon was

illuminated only by tree candles. In this warm, slightly mysterious light, the servants, dressed in their best, lined up to receive gifts formally handed out by Daddy, the good German *burgher*. All curtsied or bowed except for Koch, who shook hands. Children each received one present which could be found somewhere in the darker regions of the room. In the dim candlelight, bicycles gleamed warmly and stuffed horsies assumed life. And St. Nicholas always left chocolate in our shoes, not straw which was for bad kids only.

Mother, with her Russian Socialist background, also placed no great significance on identifying a particular religion as her own. For her, it was much more important that her children spoke English. As a result, religion, to me, meant wonderful Gregorian chants, services chanted in Latin and (Hannah's Lutheran biases notwithstanding) the scent of incense.

Mother did not believe in sharing her music with the children any more than Father allowed them on the tennis court or the chess board. The two eldest were each given tennis racquets but no instruction. The youngest was occasionally permitted to shag balls at Father's matches. Each child was rather harshly taught the principles of musical notation and one piano piece (the two eldest got the *Moonlight Sonata* and I got *Für Elise*), and then banished from the Bechstein. Chess moves were picked up via careful observation, but no invitations to play were proffered.

Animals were the family bond—apparently the only safe common frame of reference—and parental love of the beautiful dogs was shared and encouraged. Daddy said Audi and I had the same birthdate. I hugged him, my brother—my brother who could pull the sled, fetch the ball, lick the face, make himself into a pillow, chase the cat and always be there: Audi.

A ladybug has landed on Koch's finger and is now exploring one knuckle. Koch extends his hand to me. "Look," he says, "this is a good-luck bug. Beautiful, but very foolish and silly. When a ladybug lands on you, it must always be reminded to fly away home to take care of its children. Otherwise its house will burn down."

The young couple poses, he earnestly bespectacled and balding, she quite beautiful, seated at the piano against which he leans. One of her hands rests tentatively on the keys. He holds a book. They gaze at the cameras, he devoid of expression, she smiling serenely, a calculating glint visible in her slightly narrowed eyes. And so they begin the documentation of their marriage.

Mother photographs everything and sends multiple copies to America. All have lengthy comments written on the back, describing the activity and identifying the servants. She seeks to document the splendor of her existence

so the folks at home won't miss a single luxurious thrill.

They give costume parties, costume balls. He is a Gaucho; she is Marie Antoinette. He is a pirate; she is a tea rose. Their friends are harem girls, generals, ancient Greeks. They face the camera. He smiles shyly, she enigmatically. They keep a careful distance apart.

Everything is beautifully posed. The Teutonic governess smiles voluptuously amid perfect shrubbery. Children, guests and servants surround the Birthday Girl who sits dutifully on her new tricycle in front of a gift-laden table. All face the camera. All smile or gaze soulfully off into the distance. No one looks at anyone. Except for infants who are held carefully by adults, no one touches.

Two little girls, in turn, are each posed with their doll perambulators into which has been stuffed a live infant. A nursemaid hovers nearby to be sure the baby does not fall out. The little girls do not look at their passenger; the new toy does not appear to rouse their interest. Dutifully, they face the camera.

Whenever possible, there are costumes: Adults wear bathing costumes at the seashore, Tyrolean costumes at the mountain resorts, American Indian costumes, fancy hats, clown-faces and elaborate dresses. Little schoolgirls all in a row carefully extend their skirts with fingertips. A four-year-old holds a butterfly, squinting down at it quite sadly.

There are no photos of spontaneous motion. No wild lunges into spraying garden hoses or oceans. No sudden grimaces or impromptu hugs. The smiles have been held for too long.

Mother holds the firstborn but does not look at her. Rather, the infant is exhibited. In another photo, a nursemaid holds the baby to her face. Their cheeks touch. The baby almost smiles.

Two children stand in the snow, identical scarves hanging neatly over each right shoulder. No one throws snowballs. Mother and children pose carefully on a sled, Mother's galoshes barely powdered. As usual, they gaze in toward the camera. The weather must be cold. The smiles, again, are frozen.

Koch is the only one in the family entourage who never poses for Mother's relentless camera. Photos show him in action only: Stomping across a meadow on a family outing, two Shepherds wagging at his side, he smiles over one shoulder at the photographer. At the launching of a small rowboat into an Alpine lake, he laughs and throws fishing gear into the air. In full chauffeur regalia, his boots glittering in the sunshine, he opens the Daimler door, doing his best to look solemn, but his ocean eyes twinkle.

Mother and I are walking on the cement path behind the kitchen doorway. She has her camera out, stalking a photo opportunity. And there, on a rose bush, sitting motionless in the morning light, is a large monarch butterfly. I have never seen a live thing so intricately beautiful and so quiet. The butterfly moves its wings once, changing the colors delicately. I am entranced. Mother says, "Pick it up and I'll take a photo of you holding it."

I am indignant. "*Verboten*," I say. "If you touch a butterfly the dust gets rubbed off its wings and it won't be able to fly. It will die. Koch says."

"Well, Koch is wrong. Pick it up. You won't hurt it, I promise."

"But Koch SAYS!"

"Koch is not your mother. I am your mother. Now pick up the butterfly and I promise you with all my heart that picking up a butterfly will not hurt it. It will fly away, I promise."

I pick up the butterfly, holding it gingerly at the tip of one wing, hoping not to rub away the magic dust. Mother snaps the picture. Relieved, I release the butterfly. It falls heavily to the ground, smashing my innocence. The photograph survives.

Then, suddenly, something's wrong, something's different, something's scary because no one will tell. Eckerhardt and Brunhilde no longer come to play. We no longer go to the convent to practice English. Mother and Father scream at each other, at us, Mother kicks the dog out of her way and stops practicing. One day, Elinor and Marion stay home from school and never go back. The pretty blonde nursemaids disappear, leaving me in the care of a grumpy new cook who won't even talk to me. And there's a new man always with Daddy. His name is *Herr Deipser* and he's been sent to observe the factory by some people called *Nazi*. I learn this by eavesdropping outside the kitchen, but none of it makes sense. Then, I hear them say the factory now belongs to these *Nazis, Herr Deipser's* family will be living in the villa and we're going someplace called Berlin. At once, everything happens very fast, and, quite abruptly, we're on our way to a new world.

Chapter 2

Heil Hitler

.

I remember how we drove across half the country to Berlin. Everyone was quiet in the car and Koch, for once, drove slowly. One lone goldfish from the Japanese garden wobbled in a bowl on Marion's lap and Audi somehow managed to make room for himself under our feet. Lucky for him, the Daimler was a limousine.

As the family moved into its new life, the picture-taking ended. There was one last little photographic gasp of three children costumed as a Scotsman, a Hungarian peasant and a Chinese coolie. But the new villa on Krohnprinzen Allee in Berlin, although in the poshest suburb, was hardly worth documenting.

I remember rhododendron bushes all around the new house and a great spiked iron fence protecting the property, but the Japanese garden with its resident carp, the terraced rose garden and the kennels had disappeared. Instead, there was a large, untamed forest right across the road, called *Grünewald*, where little girls could play with their dogs and still be within earshot of the Nanny. Koch came along with us and so my family remained intact. I felt content. Yet, deep underneath, there was a tiny unease. Something was shaky but I didn't know what.

Every Sunday promptly at noon, a miniature parade of SS troopers, complete with marching band and banners, clanked its way past. This was the weekly tribute to Chancellor Herman Goering, who lived on our same street. But instead of being allowed to jump and wave, we children were locked up at 11:45 AM and not again released until 12:30. This was because Herr Goering—a very dangerous person—might harm us if we made our presence known in any way. But what bad thing could happen with Koch as protector? Besides, that summer, just after my fifth birthday, I began a life-long love affair with the sea:

"We're going to the ocean," she says, "so you'll need these," and hands me a small pail and shovel. "Also, try this on," and stuffs me into a brand new bathing suit. Dark blue, with red and white sailboats. I like how it feels and

how the boats dance on my belly.

"What's the ocean?"

"It's a lot of water. Wait, you'll like it. We're leaving tomorrow and no, Audi can't come; there's no room in the car and the *Pension* doesn't allow dogs."

Torn between no Audi and lots of water, my face screws up, unsure of whether to cry or just whimper.

"And stop whining. You'll see Audi when we get back. That's final."

The sand is big and hot. There are people all over it, playing or just sitting. We walk on the sand and just when I hear it, I see it, too. It is big, bigger than the whole world and it makes music, it sings. It sings, "Raaaahhhrrr" very loud and it sings "Sshhhhhh" very soft and it is alive, it is alive water that sings and is big.

I run to it soon as they let me loose, and it reaches into my toes. First it's very cold and then it's not. It tickles my feet and says "sshhhhhh" and runs away, back to itself. It wants to play. Oh my goodness. I stand there with the pail and shovel and let it play with my feet and then I see the others playing catch with it. I can do that, too.

You run in as fast as you can, into the white foam which sings the softer song and then, all of a sudden, it picks you up and throws you upside down and all over and then it bounces you back out like a ball. It plays catch and you're the ball. *Ach Du Lieber*, I love you.

The pail and shovel go flying. I am the ball, I am playing catch with the big water, the big water goes everywhere and bounces me and I can fly like a fish or a water bird. I run in and get tossed out, run in and get tossed out and the water goes everywhere. It goes in the eyes and in the ears where it makes a whooshy sound and inside the bathing suit and in the wee-wee. But you can't let it in your nose because that makes you choke and spit and someone has to pick you up and slap you on the back to get it out, so you have to hold your breath when it picks you up. And you can't drink it either, because if you do it comes out the other end and makes awful watery poop in your new bathing suit and you cry and get taken into the dark house for washing and another suit.

But you can come back and it's still there, it's always there, making its music and ready to play. And you can fly flat if you want and sail onto the sand like a real little boat. Till they tell you, "You're turning blue, Doris, come out this minute" and dry you off with a big white towel which also feels very good and warm and they give you a cookie.

I want to stay here forever. Koch says there are seven of these and wherever you go in the world, you can find one. That night, drowsy and

slightly salty, I perch on the *Pension* bed and look out into the summer night. From afar, the ocean sighs and murmurs. "It's singing the stars," I tell my pillow, not knowing what I mean but believing it, nevertheless.

Mother's relentless pursuit of the English language now catapulted us into the Presbyterian Sunday School established for American expatriates who worked for such corporations as Woolworth's or Shell Oil and sent their offspring to a small American school which we also attended. Religion changed to the slightly tiring experience of long-winded sermons and boring hymns, but some kids from school came and cookies were served afterwards.

No one told me I was Jewish, and if anyone had, I would not have known what that meant. For that matter, no one said we were of any particular religion and no fealty was expected. Certainly, our parents neither discussed nor clarified either Judaism or any other spiritual pursuit. And Daddy's Christmas Eve was still spectacular. That first—and last—Christmas celebration in Berlin got me a pair of live parakeets in a cage (I named them "*Papa*" and "*Gei*" because *Papagei* was the German word for "parrot" and this delightful couple were half the size). Koch got a pair of rubber hip boots to make washing the Daimler easier on his feet; Marion and Elinor, new bikes. The tree was bigger than ever and the candles glowed more mysteriously.

So "Jewish" crept upon us quietly, dangerously and insidiously like the terminal disease it turned out to be. Somehow, I found out about this condition by eavesdropping on the servants and listening carefully to the propaganda from the loudspeakers at many Berlin street corners. "Jewish" was apparently an arbitrary designation which condemned the recipients to sub-human inferiority. According to the posters prominently displayed at the transit stop, it meant having a very large nose, a pot belly and extremely protruding ears. But no one I knew looked like that. Ignoring my increasing unease became impossible. No one spoke, but the tension was high.

Somehow, Daddy decided I was going to be the writer. Marion was the artist, alone at her easel. Elinor, the designated dancer. After school she disappeared to Ballet school where she practiced pliés with M'sieu Gessovski, Ballet Master of the Ballets Rousses. That left me.

I don't know when Flossie got started. I had just learned to write in English, and perhaps the first grade teacher at American School sent home some report stating I was doing well. Or perhaps I wrote something at school that pleased me and made the mistake of showing it to Daddy. What probably happened was that he read whatever little gem I brought home and decided

right then and there to start my literary career. Besides, I was too clumsy to dance, he said.

It was very quick. One minute I was minding my own business, playing with the dog and tagging after Koch and the next thing I knew, Daddy sat me down and started reading *King Lear* to me. I do not know what other six-year-old got sudden doses of *King Lear* twice a day and at bedtime. (Talk about wild bedtime stories: There's this old guy staggering around on the heath, crazy, muttering to himself while Cordelia suffers because she doesn't protest too much.) Not only was it entertaining, but I loved Daddy's undivided paternal attention. The price, however, was steep. It meant being locked into Daddy's study twice a week till I wrote something. I didn't feel like "writing something," it only got me angry. Nameless feelings rose up and choked me. I despised him, despised the process. I just sat there and hated Daddy, but in order to get out, I had to write.

So I did. I became both Goneril and Regan, writing whatever I knew would please the king. Thus, Flossie the Fish was hatched. I do not remember the story of Flossie's fishy adventures, but she swam into paternal approval. Flossie was conceived of scheming hypocrisy, and Daddy thought I was a literary prodigy. The shame of being praised for this disgusting contrivance was even worse than having to write it. Shame gave way to cynicism. I knew exactly what to say, how to please, in order to escape. Eventually, Daddy lost interest. His business had been taken over by the Nazis and he, too, was having to please someone, somewhere, in order to survive. As for me, I vowed never to write again, and kept that promise for over sixty years.

I am seven years old, home from school with a cold, sitting disconsolately in my bed because there is nothing to read and the dog is outside. Suddenly, my sister Marion appears at the foot of my bed. She is waving a piece of white cardboard. "I can eat cardboard," she says. "Of course, *you* can't," and then, sure enough, takes a big bite, sneers arrogantly down at my messy bed and turns to go.

"I wanna eat cardboard too, stinker, gimme some, dammit, gimme some!" Nose runs, eyes run, grown-ups run in alarm.

"Marion, give her some *Matzoh*, for heaven's sake," shouts my mother, and marches back to her piano. I'm transfixed. "*Matzoh*" is a new word, a new thing. Is it a new kind of cardboard? This stuff looks more like papier-mâché gone wrong: Thin and flaky. "*Juden futter*. It's Jew feed. Jews eat it. You're a Jew, eat it." Marion tosses a piece disdainfully over her shoulder onto my bed and exits. No further explanation is forthcoming. Peace having been restored, I take a bite. Hmmmm, not bad. Does taste a bit on the

cardboard side, kind of like a large, petrified cracker.

As soon as possible afterwards, I find Koch: "Koch, what's a Jew?"

But Koch stiffens slightly and, for the first time in our life together, avoids eye contact. "Well," he says, "You're Jewish, you know, but I'm really busy right now, so run along." He clears his throat, adjusts his cap and vanishes into the garage.

I shout after him, "But Koch, are you Jewish too?" and receive silence. Koch has always, before, answered every question clearly and understandably. His failure, now, is slightly alarming and so I put *Matzoh* out of my life. I never do find out where Marion got it. It must have been Passover time, somewhere.

Berlin has its advantages. After all, it is a Capital City and both parents jump delightedly into the cultural playground. There is no need for fancy costumes to give their parties some éclat. Now the guests are authentically glamorous and exotic dress is their natural adjunct.

Musicians from the Berlin Philharmonic have brought their instruments and the *Archduke Trio* wafts me dreamily to sleep. Later I wake up, startled and delighted, to the sounds of another kind of music altogether. Audi and I creep to the banister. The members of the Ballets Rousses have downed their vodka. Shirts are off, "AI HAH!" they shout. M'sieu Gessovski and his lover, Niki, are doing the *Gezzatski* on a tabletop. Niki's torso gleams with sweat in the lamplight; his muscles are doing a ballet of their very own. He ripples and shines. Maestro Auber's cello lies abandoned like a fat widow in a corner. Everyone stomps feet and claps hands to supply the beat. I have never seen anyone so beautiful as Niki, and I want the dance to go on forever. The colors of that night remain infinitely warm, dark red and gold, a permanent illumination.

In between their parties, their salons, those soirees filled with glittering sounds—with successful-in-exile American Negro bass-baritones belting out à capella arias from "Faust," with dancers, toe-cymbals and vegetarian gurus, chess masters, wearers of rouge and wigs, castanets clicking, heels clacking, Carmen-in-drag, fat cellos lying in the corner, Russians dancing—in between, they fight. His eyes bulge terror, she shrieks and weeps. Children try to keep out of the way, hidden under beds, peeping around corners. No one says why. Our silence is expected. Marion takes me in. "You don't cry. You never cry. Don't talk. Don't cry. That's it. No matter what, that is it. No one can make you." I listen carefully, with all of me. Marion is Goddess. Marion is Mozart.

At age five, I drew stick figures with legs coming directly out of heads. When Marion was five, she made watercolors that came alive with style and perspective, which were preserved for me to wonder at, to delicately touch and marvel over. She drew scenes of fevered imagination in which little girls sat up frightened in their midnight beds watching phallic monster worms wearing crowns and lascivious smiles waft in through the open windows. Her art must have been twenty years ahead of her physical and emotional development.

Intertwined with Marion's incessant schooling and artistic development was Mother's absence due to her incessant pianistic endeavors and the apparent emotional instability which periodically sent her screaming to the nearest sanitarium after she fought too long and too loud at home. What she felt, what horrified her so much that she went on intermittent binges of craziness went unspoken. There were no answers to what her screams were protesting—or hiding. Anyway, no one dared ask.

Daddy's obsessive control of Marion's life went unchallenged. No one saw her much. The older she got, the more she was isolated from the rest of the family. As she grew toward puberty, she seemed to disappear altogether, easiest to find after school when Daddy was at business and Elinor was at ballet school. Her artistic prowess grew to genius and her subject matter became more intense. Phallic apparitions still lurked and strong, dark angels pulled resistant girls into darkness. I adored her. If she said, "Don't cry," then I would not.

Mother is plump, bordering on corpulent, and I know that this is not at all a proper condition. All noteworthy females—ranging from Marlene Dietrich to Mrs. Ziemer at American School—are thin. And all of them have long red fingernails. Mother lectures sternly about these: "Women with long red fingernails are superficial, conniving and untalented," she says, looking proudly at her own hands whose nails are trimmed to the quick in order to facilitate her pianistic touch.

Now it is Sunday afternoon and Mother is getting herself ready for dinner guests. We bump into one another quite unexpectedly as she emerges from her bath at the same time that I am heading for the toilet. The sight of Mother naked leaves me flabbergasted, unsure whether to be amused or amazed.

Mother has immense, round, pendulous breasts whose giant pale aureoles point resolutely downward. Their wobbling bounty rests atop a high, generous belly which seems to support them like a soft, round architectural device. Mother, in fact, is a series of concentric circles, intricately

24

intertwined and interdependent, all gently undulating in unison. My gaze stops abruptly, I turn and run before my eyes commit the ultimate sin of landing on the forbidden territory of "down there."

Except for my sisters, I have never seen a naked person before, but I know, in my heart, that Marlene and Mrs. Ziemer would not look like this.

That evening, our dinner guests are Frau Von Müller and her daughter Wiese. Frau Von Müller is a special and particular friend of Daddy's. How these two tied up—he, the most despicable of all, a Jew, and she the respected and official Aryan—is uncertain. Perhaps they find one another exotic. In any case, she is one of those women (the servants call them "mistresses") who come to dinner on occasion, sit close to Daddy and cause Mother to become so taciturn that she refuses to play the obligatory after-dinner Chopin, pleading mysterious headaches and disappearing forthwith. None of these guests has brought a daughter before, and I am intrigued with her name: *Wiese*, in German, means "meadow."

The first thing I note is Frau Von Müller's slenderness. She is almost angular and her long, red nails seem to accentuate her bones. Wiese turns out to be a tall, skinny, mousy girl Elinor's age who speaks not and keeps her gaze on the carpet as she curtsies.

As the meal progresses, however, a social disaster looms. Wiese and Elinor, each perhaps emboldened by the presence of another twelve-year-old, suddenly begin to giggle. Daddy shoots a silent glare, but they keep right on. Immediately, before anyone can intervene, Frau Von Müller turns to the culprits and says sternly, "You are behaving improperly at the dinner table. This is not permitted. Get out of your chairs, young ladies, and sit under the table for the rest of the meal. Now, do as I say. At once." Wiese silently slides out of her chair and disappears. No one in our history has ever given such a command. Elinor looks to Mother for guidance, but Mother's eyes are fixed so sorrowfully on her plate, she seems to be giving liturgical last rites to her veal cutlette. No one speaks. Elinor looks to Daddy, who sits glaring silently into middle distance. Only Frau Von Müller is in charge. "What are you waiting for?" she asks. And Elinor slips out of her chair to exile, to shame, under the table. Frau Von Müller turns to Daddy, smiles and says, "Now what is it you were saying about the connection between Nietzsche and Wagner?" Daddy clears his throat and the conversation—now only between him and his guest—resumes.

I sit still, learning some very important lessons: Tall, thin, aristocratic women with long, red fingernails have more—much more, infinitely more—power than short, corpulent ones who are round all over. And, apparently, if you bring your mistresses to dinner, she gets to run the show.

I have found a package of cigarettes and gone to the downstairs bathroom to experiment. First, I am Marlene Dietrich straddling the toilet, hands cupping chin, the cigarette dangling disdainfully from fingers. I look into space, eyes half-closed, "From head to foot I am made for love, *Schatzi*." Marlene is hoarse and bittersweet. Then I become James Cagney. This time, the cigarette protrudes from the corner of my mouth like a little glowing weapon. "All right, you're all gonna die." Very tough, you bet. And, finally, I become Miss Minge, the young, blond, pie-faced teacher at American School. I bat my Betty Boop eyes, re-arrange my blouse so that no matter how I move a little underwear is visible, wave my cigarette around in the air and giggle. "Tee-hee," I say, "Ooooh my." Despite a certain nausea, I feel smugly, smokily triumphant. Maybe I will grow up to be Mata Hari.

After dinner, I wander down to the servants' kitchen to get some attention. Ma'mselle, Marion and Koch look up as I stand in the doorway. Koch moves his head in my direction. His eyes are cold, his voice freezing. He throws his words like icicles that pierce my heart and remain to melt later into puddles of shame. "This kitchen is for nonsmokers only," he says, and turns back to the others. I want to crawl off somewhere and die of chagrin. Oh God, will I ever be in his good graces again? "I will never smoke again, or lie, or steal, I promise, just, *Köchle*, forgive me."

The very next day Koch teaches me to ride a two-wheeler. In that twilit winter afternoon, I want so much to please him, to earn his ready smile that learning to balance on two wheels is stronger than the fear of falling. As long as Koch is with me, I will fear no evil. Even Audi, who wags his tail for only a select few, comes dashing and prancing when Koch signals.

Arno Koch, in his young thirties: Hairline threatened eventual recession; his unremarkable features hinted at their true strength only upon closer inspection. And his gray eyes could produce gale-force intimidation just like the ocean. Seldom seen in chauffeur uniform, he preferred most of the time an ill-fitting tweed sports jacket and a dilapidated cap worn slightly askew.

Koch found time to answer questions, administer discipline and make jokes. One rule was inviolate: No one but Koch himself was allowed to touch a car. No one. Even attempting to help wash or polish was forbidden. When it came to cars, Koch made no concessions and sternly chased dogs and kids away when absorbed in his work. Even Father kept a respectful distance when the hood was up.

And behind the wheel Koch was a devil. He knew the route to Mother's favorite sanitarium by heart, and on visiting days the kids cheered and Father

cussed as we avoided pot-holes on the narrow, rutted road by becoming airborne and careened, squealing, around corners. "*Ai Yai, Du verflüchter Esel* (you damn donkey)," yelled Father, clutching the safety strap by the window. But he was having trouble concealing a smile. And when they arrived back from Father's business trips, both were generally laughing, although there was visible sweat on Father's brow and his armpits were soaked.

What was it like for Koch, provincial son of peasants, suddenly given the gift of a glittering Berlin? Did he indulge himself in the cabarets, the excitement—licit and illicit—available only in a Capital City? Did the stomping music of intoxicated Russians wake him from peaceful sleep and cause him to peer at the dancers from a carefully-chosen vantage point? Did he, too, find Niki beautiful?

A year after we moved to Berlin, a decree was handed down that no German National under the age of sixty could be employed by Jews, nor could Jews any longer own real estate. And so the entire menâge moved to a large duplex on *Freiherr Von Stein Strasse*. Now, the current ma'amselle was a toothless crone who fought Mother constantly. (She usually won and cooked as she pleased.) Koch, who found a clean little basement apartment nearby, risked his life by continuing to work for us.

No sooner had the move taken place than Koch on his daily errands met up with Anna, daughter of the local butcher. Discreetly hand-in-hand, Koch and his fiancée often promenaded to our house on Koch's day off to smile amiably with us in the sunshine. I found them to be a much more sensible combination than the various oddities which fluttered at one another in Mother's Salon. They radiated comfort which—while not exciting—felt warm and safe. Eventually, working for us became too dangerous. Both he and his employers risked being shot on the spot were he discovered. And so, after his wedding (Why were we not invited? Was it too dangerous? Did the butcher disapprove? Did Koch not love us after all?), Koch disappeared. There was no good-bye, no explanation. He just, one day, did not come back.

When Koch returned from the war to his bombed-out cellar and to the formerly plump, apple-cheeked Anna, had he changed? What did he believe when he saw those first newsreels of Auschwitz, Dachau? Did he think of us?

Later, in 1949, a year married and temporarily in Michigan on one of my husband's lengthy business trips, I received a letter from my father, who had somehow gotten hold of Koch's address in Berlin. I wrote at once, a passionate outpouring of family news and dammed-up affection. A reply

came fast.

In his letter, Koch enclosed a picture of himself and Anna in front of the rubble cave that was now their apartment. Anna, thin and fragile, hugging herself against the cold, bore no resemblance to the pre-war sensuous Valkyrie. Her face seemed to have gotten longer, and her hair was no longer blonde. Koch, himself, had become a bit stoop-shouldered, and his hairline—destined to recede since my early childhood—had finally done so. The smile was smaller but still thrown at the camera somewhat diffidently. For once he was not caught in action. He was posing.

The letter was short. "Dear Doris," it said, "Anna and I want desperately to emigrate, preferably to South America. But in order to do so, we require a posted bond of $5000.00. Can you find it in your heart to do this for us? We must find another life. You are our only hope."

How could he have known we were no longer rich? That I was a girl bride with a husband living on the largesse of his wealthy but wildly penurious father? He could just as well have asked for five million. In 1949, $5000.00 was an unattainable sum.

Somehow, I felt both ashamed and angry. Was it at my own helplessness? At Koch for not knowing my age and circumstances, for perhaps believing I was still wealthy? For seeing me as a source of money rather than as his long-lost little girl, re-united at last? Was I angry at him for choosing life instead of the certain death that awaited him had he not disappeared when he did?

I carefully preserved the photograph and threw the letter away. Was it Koch's own integrity that kept him from writing again? Or did he, too, feel betrayed, angry, disappointed by the people to whom he had given so much and for whom he had taken such risks? As for me, I think of him at times, with a little twinge of sadness and more than a drop of unresolved guilt.

Chapter 3

Speed and Danger

Somewhere in the distance a sound resonates faintly, barely discernible, inexorable as a heartbeat. It can only be heard in the silence of night, behind the rustling of featherbeds, of leaves. It is the relentless march of history, treading ever closer in its jack-boots. Those with keen hearing pack up and leave. They head for Oslo, for Rio de Janeiro, for Johannesburg or London. Later, all those who turned a deaf ear will learn that this parade stops for no one, never has.

Life became strained at American School. The headmaster, Gregor Ziemer, was a transplant from the Midwest who ran this thriving little enterprise which catered mainly to upper-class Americans in town on business. His daughter, Patsy, was my age and a perfect little specimen: Blonde, blue-eyed and graceful, her hair never disheveled nor her clothing stained. I admired Patsy greatly and wished I were as perfectly groomed and poised. Sometimes she deigned to invite me to stay after school and these occasions were always pleasant for me as I seldom had human playmates. But this year the invitations stopped and Patsy silently avoided me.

For the past year, the school had seen an influx of wealthy German Jewish kids whose families wanted to give them a jump start on their imminent future as American immigrants. But now, at the end of the 1938 school year, we received a notice that in September, when school resumed, no Jews would be allowed to attend. As usual, I learned this by eavesdropping on the servants. This condition of Jewishness was becoming increasingly worrisome to me, and there was nowhere to turn for clarification. Even Marion was uninformed, or so she said.

Here on *Freiherr Von Stein Strasse*, "Jewish" took on a stronger dimension. Koch was gone. Nothing was said, he was not discussed. I understood his disappearance to be somehow connected to our Jewishness. I made a space inside me, saved for Koch's return: A cold space, dry and unforgiving, a barren Antarctic tundra. The atmosphere there was so pure and crystal one could see everything and it was much too cold for tears. I could live in that place. There, betrayal, rejection, fear—even the sadness of

abandonment and lost love—simply froze away into nothing. It was fine.

Meanwhile, I became an omnivorous reader. I gulped down *Gone With the Wind* in German and developed a crush on Rhett. I regularly devoured Daddy's American *Esquire* magazine, wherein I learned about the Spanish Civil War and gangsters. Best of all, I discovered that in the ornate Louis XIV book cabinet there were books behind the books. That second row yielded Radclyffe Hall's *Well of Loneliness* which clarified some of the nuances behind those various liaisons in Mother's Salon.

In Mother's Salon, persons were discussed in terms of their artistic merit only. Sex, race and origin were inconsequentials. As a result, sexual information drifted down to me in mixed, fragmented messages.

On one hand, it was: "This is M'sieu Gessovski's lover, Niki. He does the most incredible *grande jêtes*. You will see him in Swan Lake. Watch the leaps. He is marvelous." Or (in answer to my question): "Madame Franck dresses that way because she thinks she is a man. Ma'amselle Brown is her girlfriend. Madame is a terrible, awful vocal coach. She uses ineffective and outdated methods which give her and all her pupils a distinct nasal quality. She is ridiculous."

On the other hand, Mother referred with distinct dismay to that terrifying part of the anatomy called, "Down There." This place was not to be mentioned, nor was anything having to do with it. As a result, I grew up quite comfortable with others' differing sexualities, but knew nothing about my own. And the lovers who twittered through our rococo music room in their various combinations were perceived by me more as embodiments of romance than of lust. For such a sophisticated little kid, I understood very little.

Eventually, when the Facts of Life mystery really needs clarification, I turn to Marion, who always has a store of miscellaneous esoteric information. She makes fun of adult female breasts by straightening her arm and pulling down a triangle of flesh from the outside of her elbow. "Look, kid," she says, "teats." She illustrates the mechanics of sexual intercourse by making the two first fingers of each hand into legs, explains to me what is in each set of crotches and then slams both hands together quite violently. Ouch. My hands fly protectively to "Down There." No wonder it's off limits.

Our downstairs neighbors in the duplex were also Jewish. Their son, Stefan, my age, was a wildly argumentative kid with whom I fought enthusiastically. There was not a reality in our universe upon which we agreed, and on one shameful August evening I even sicced my dog on him. Audi, to his credit,

looked at me in canine astonishment, then simply put his front paws on Stefan's shoulders and made significant eye contact. He then dropped to all fours and walked haughtily away from me. I had, apparently, insulted them both.

Our constant squabbling prevented me from asking Stefan about being Jewish, so I began to lurk outside the Brandt ground floor windows, peeking in at the family to discover their difference.

This family sat down to meals together, which we didn't (except on Sundays), and held animated conversation (forbidden to us due to the "Children should be seen, not heard" edict). Mother did the dishes, Stefan swept the floor. All these were unheard of customs in my world. Instead of being taught about "Jewish," I was learning about familial love, which was just as alien to me. This was a difference I could never have even imagined. I was fascinated.

Now, I became an enthusiastic Peeping Tom. I watched the Brandts every evening, gorging myself on their warmth. The father tousled Stefan's hair. The parents hugged, they yelled at each other, they made up. Stefan was loud, yet went unpunished. I was hooked on the Brandts. They became my 1938 equivalent of TV, my *Donna Reed Show. Father Knows Best* at the Brandt's.

Even their food looked enticing. One evening I stole a jar of pickled herring from the Brandt windowsill and gobbled it down. "Very good," I said to myself, "but not as exotic as *Matzoh*." For this theft I was caught, and *Frau* Brandt complained to Mother that my incessant lurking must stop. I was ashamed, chagrined to find that they had known of my spying all along, and swore off the Brandt show. Shadowing my oldest sister and her boyfriend became the substitute for stalking happiness. And I was no further along the road to understanding "Jewish."

In that year, the year we left for America, Marion had her first true love crush. Going on sixteen, silent, she explicitly avoided our middle sister, Elinor, preferring to socialize in the servants' kitchen. I followed her around whenever she let me, hoping she would speak. When she did, she called me "kid" and tousled my hair. Those moments were so few and so precious that they became stellar events, carried in my heart as a personal holy grail.

When, Marion fell in love, inexplicably, completely out of character, she shared it with me. For her, this meant showing me the many pencil sketches she drew of Walter. She introduced me to him, and once even allowed me to stay in the room while they chatted. Maybe she had no one else to trust. I didn't ask. I was proud beyond belief and kept her confidences sacred. After

they had a spat, Marion sat down on the marble steps of our foyer, put her head in my lap and cried. In our brief lifetime together, I saw Marion cry only twice. (The other time was when she fell out of a tree while we were vacationing in Italy and hurt herself too badly to keep it in.) The honor of being allowed to cradle her head was beyond anything I had ever experienced. My admiration for her became worship and stayed that way. Now I loved the boyfriend, too. After all, he had the power to make an icon shed tears.

Walter Stortz was a sixteen-year-old Swiss National whose father was in Berlin on business. And Walter was beautiful. He had a shock of curly black hair, a creamy complexion and the grace of an Olympian. When he came calling, I hid behind the drapes and adored him.

I followed them when they strolled outdoors, keeping very carefully out of sight in good distance. Once, I trailed them to the movies and waited patiently for two hours till the film was over and they emerged so that I could watch them walk back home. I was a spy in the house of love. Mainly, I wanted to be with Walter. I wanted to find out what a boyfriend was really all about. I stalked him. I waited.

And then, one late afternoon, I got lucky. Walter came wandering down the street on some errand and I followed him home. When he got to his front door, I popped into view and asked if I could come in. My heart, my breath, my entire being stopped. I looked into his face. Goodness knows what Walter saw there, but he let me enter. No one else was home. Once inside, there was nothing to do but follow him around the house. After circling through the downstairs rooms once or twice, Walter finally settled on the kitchen. I wanted him to kiss me, sweep me up the stairs like Rhett Butler. Instead, he peeled some carrots for me and sat there while I ate them. Then he told me that it had been a pleasure to have me as a guest, that I could come back some other time and escorted me out. I trotted home in ecstasy. Walter's black curls, his movie-star smile, the unearthly grace with which he scraped those carrots were treasures beyond recall. I skipped and sang my way home. Stalking paid off.

I want to be included in Walter and Marion's magic twosome, so I pull out my best accomplishment as entry ticket. I find them, one winter twilight, in our living room and begin: "Hey," I brag in my extravagant English, "I'm a tear-jerker. I have jerked them. No one can make me cry, not even if you hurt me a lot. Go ahead, hurt me. Go on, hurt me a lot. If I don't cry I get to go to the movies with you. Come on, Walter, do it. Do it." This tirade continues long enough for Walter to finally get up from the couch, sigh patiently and

32

take my arm to twist behind my back. Marion watches silently. I am proud and excited. This is the big pay-off. Here's where I get to become an adult. "OK, GO," I shout, and Walter begins to twist.

At first, it's easy. Then, not so easy. I grit my teeth, grimace, but remain victorious. Then, quite unexpectedly, there is a slight movement—a tiny crunch—inside my elbow, and a pain so sharp that it takes breath away suddenly shoots up my arm and into my head. And I scream. Once started, I can't stop. The scream becomes the howl of wild, windborne savages in the Antarctic wilderness and causes me to run. I screech out of the room, desperate, beaten, humiliated. Somehow, I have betrayed Walter; somehow, I have betrayed Marion. I have even betrayed myself. I can't stand the shame, can't bear what I have done. I will never achieve grown-up status. I am a failure and a traitor and— worst of all—a crybaby. Not only that, I'm nothing but a humiliated, disgraceful mess. Unworthy.

Adults come running. The cook, my mother, all are screaming right along with me. "What is it? What's happened? Are you hurt?" My debacle is now public. I run wildly to my room, leaving Marion to explain the inexplicable, leaving Walter to a quick, silent exit.

There is no stopping the tears. They become a torrent, washing into my carefully tended empty space, melting the ice, soaking the tundra into a swampy morass. I cling desperately to my fragile childhood expectations, but these crumple damply into the bottomless sucking mud. I gasp and choke, knowing I will die there, drown there, be lost forever. And so I do. I drown and die. The Antarctic wilderness has swallowed me. The arm, quite miraculously, recovers quickly.

Traveling by public transportation instead of limousine, my sisters and I explored the city and saw the signs (*No Jews or Dogs allowed*), the lettering on store-fronts ("*Israel*" in white letters in front of the owner's name). Most major streetcorners boasted loudspeakers over which intermittent propaganda speeches were broadcast. Any citizen who did not stop to listen was subject to arrest. Adrenaline surged through the populace, producing such palpable tension that it prepared some to fight and others to flee.

We discovered a bench in the park, tagged in yellow: *Jews Only.* The catch was that if you sat and turned out to be a real Jew, you got hauled off never to be seen again. I would sit there and wait for the policeman to come along and shoo me off: "What's the matter with you? Get out of there. Shame on you, pretending to be a Jew!"

There was an intoxicating combination of speed and danger involved in these escapades. All participants involved understood quite clearly that this

game of cops and robbers was real, that there would be no second chances. It was important to assume exactly the right combination of facial expressions: A slight impudence, colored by a shared, complicit humor did the trick. "Ha Ha, it's a joke, after all" must be understood by both. Being blue-eyed and freckle-faced was almost an unfair advantage.

Same with the Olympic Pool, turned over to the public after the 1936 Olympics. My sisters and I ignored the "*Judenfrei*" sign and went swimming anyhow. The rules were that if you got caught, you disappeared forever, and age was not a consideration. If you went, you went. We kept one another within proximity, just in case. (Elinor, of the dark eyes and complexion, was especially alert.) If someone should show up who knew us, we had a signal, prepared for a wild dash in our bathing suits. No one ever caught us, or perhaps we were simply spared.

But the woman concierge across the street was not fooled one bit. She began chasing me with her broom and yelling, "*Raus, Judenvieh!*" should I dare to walk there.

I am almost ten years old, standing in the bakery to purchase day-old bread. Jews may no longer purchase it fresh. And there, behind the counter is a large new poster. It depicts an ugly, fat, sloppy-looking *Hausfrau* being led off between two storm troopers while she grimaces weepily. The large white caption reads: "SHE VOTED **NO**." I stand transfixed. Fascinated. I have just learned about voting in school and understand clearly that the whole point of voting is to be able to say either "Yes" or "No" with equanimity. Not only that, but it's secret. That's the whole point. I store the image carefully. Why do I have to wait a day to buy bread? Why can't she vote "NO"? The illogic of all this scares me. Fear? Discomfort? Resentment? What ought I feel?

The parental fights became louder, stronger. At those times, Daddy's terror eyes became even scarier —round and distended like those of a frightened horse. There was no Koch to hide behind. I was on my own, but soon found a good spot under the bed. With enough warning (I learned to recognize dangerous vocal nuance), I could even take the dog along for comfort. Now I overheard talk about America: "Everything into a 'Lift' and tickets to New York." It made no sense. What was a "Lift" and would even we kids be crammed into it? Were we traveling to New York in a giant elevator? If I asked "stupid questions" I got slapped across the face. Nevermind.

They hung a giant American flag from the balcony and stuck big rhinestone American flags into our coat lapels. These became our passports. We hopped on the trolleys, buses and elevated trains from which we were

supposed to be excluded. We wandered downtown, through department stores, explored Berlin from one end to the other. No one tracked us. We spoke loudly, assuming our atrociously German-accented English validated the rhinestone flags. The concierge across the street blocked my way so I couldn't escape and said, "*Och*, why didn't you tell me you are an American? I only chase Jews."

When things were calm, I spent afternoons teaching *Papa* and *Gei* to say, "Hello." They were slow learners, but my endless mouthings must have amused them because they cheerfully replied in "Parakeet-eeze."

That spring, there was a new neighbor boy across the street. Hans Joachim, the scion of proud Nazi parents, became my favorite playmate. The Blums were friendly folk who invited me to their cottage at the *Wannsee* to play with "Hajo" on occasional weekends. (Why my parents permitted this remained a mystery. Were they afraid to refuse? Or did Daddy still believe that because he was a non-practicing Jew, he was a German?)

Those weekends were just fine with me. As spring turned to summer, there was swimming and a motorboat. All I had to do was listen politely to Hajo's made-up stories about how the *Führer* bent down and scooped him onto his white stallion and pretend I believed him. The rest of the time I went swimming or played with Hajo's extensive collection of miniature race cars. The cars were great fun, and letting Hajo win our races provided unlimited access to them.

There was, nevertheless, an admission price for the weekend fun, payable at those times when the Blums had adult company along. Then, I was trotted out to perform.

Seated on the sunny terrace at cocktail hour with the lake shining blue in the background and her skirt charmingly arranged to show off her long, pale legs, Mrs. Blum would say, "All right, Doris, tell us what you are." This was my cue to stand up, curtsey politely and say, "I am a Jew." At this point, there was invariable mass hilarity. People slapped their knees, roared with laughter and begged me to do it again. I never did figure out what was so funny and the whole thing made me quite uncomfortable. I can only assume that my fair Teutonic beauty caused the company to believe I was at least a mildly eccentric or possibly emotionally disturbed child, pretending to be a Jew for everyone's amusement. Perhaps they found me exotic, like a giraffe suddenly dropped from the clouds onto their picnic. As for me, being a sudden exotic Jew was most distressing. I would rather have been the giraffe.

In September, the Lift—a crate the size of a small building—arrived at our

door, and all our belongings were packed in, except for the grand carved Bechstein, replaced by a puny Steinway.

Our ancient goldfish, lone survivor of the Japanese Garden in Meiningen, got dumped rather unceremoniously into the duckpond at the park. I was sad, the ducks were pleased. My parakeets were sent flying into the rainy September sky while I stood by, stone-faced, hoping perhaps some kind Nazi would rescue them before winter and give them to his little girl. She could teach them to say, "*Heil Hitler.*"

Stefan and I pummeled each another one last time, I said a polite good-bye to the Blums. Marion and Walter stood together, watching the furniture disappear into the bottomless maw of the Lift. When the Lift was full, Walter walked away. He was never mentioned again, but remained with us as a series of sketches in the margin of Marion's schoolbooks. Even in pale pencil, decades later, Walter was beautiful.

Thank goodness, there was no question about Audi. He received various inoculations, a new muzzle and accommodated himself with surprising docility to the baggage car at the train station.

Daddy apparently decided that this would be no ordinary refugee saga. If we must make an involuntary tour of various European capitals, his children might as well absorb culture, and length of stay would depend on degree of culture. Brussels was slated as our first stop, but first we had to get out of Germany.

My sisters and I are in our nightgowns with the jewelry pinned inside the hems, kneeling on the seats, shivering in the dark, our breath steaming the glass. It is the middle of the night. At a grim little station on the Belgian border, two elderly border guards and a young SS lieutenant, chest bulging out of his uniform like an oak slab, have just taken Daddy and some others off the train. Mother sits quietly, looking at her lap.

I watch Daddy standing with the guards and the SS. They are taking turns looking at his papers. Daddy's hands make gestures while his face alternately smiles or becomes earnest. Like a dog awaiting orders, he intently watches the SS lieutenant's every movement. The train makes a sudden grunting noise, jerks slightly forward, then stops again. Daddy is now out of sight. I hold my breath. Then we see him walking quickly toward the train, his head held forward rigidly, as if heading into a strong wind. I hear myself exhale. He appears in our compartment, breathing heavily, just as the train begins to move. As the train picks up speed, I watch the less fortunate recede. A few still figures, huddled with the guards. "Why," I wonder, "is my life worth more than theirs? What are the rules?" But there is no one to ask.

And so began our Odyssey. Packing, stopping, starting, trains, berths, underwear forgotten in hotel rooms or the dog in trouble with the concierge. In order to fulfill Daddy's cultural-enrichment itinerary, we dared fate and the local gendarmerie. Thus, Paris merited an exceptional three weeks (Versailles, the Louvre, just for starters), Brussels only a long weekend (there was apparently little to celebrate beyond "Mannequin Pis"), Amsterdam seven days (where, at the Reijksmusem, I had to be dragged bodily away from Rembrandt's "Night Watch" because one of the figures in its eerie light was beckoning me, reaching out for me to jump in and I twitched like a dreaming dog because I wanted to so much). London got two weeks (the Tower and Buckingham Palace). We never made it to Rome because the Italians wouldn't let us in. All this at erratic levels of intensity: One minute Daddy was our pleasant, leisurely tour guide, the next he hustled us angrily away as if the whole family was only one jump ahead of annihilation due to the bad behavior of his children.

Border guards became routine, their grim lack of humor about Daddy's Jewish lack of documentation quickly assuaged by his easily accessible Jewish cash and Mother's American Passport. We apparently left a long and sordid trail of bribery getting from one place to another. And I became quite brazenly blasé. Watching beads of "border sweat" accumulate on Daddy's brow, I smiled sardonically: "Serves you right, *Schweinhund.*"

Chapter 4

Harlem Nocturne

We made it. Others did not. 1940 was just around the corner and history had caught up. Hitler had annexed Austria, marched into Poland and activated his final solution to the Jewish problem. With wildly dissonant fanfare, with crash of bloody cymbal, with terrifying drum-roll echoing through the entire planet, the Holocaust had begun and nobody cared. When the cattle cars slowed through the countryside near Auschwitz, Polish farmers stood in the fields at track-side, drew their fingers across their throats, laughed and waved good-bye. In the shining sea of New York harbor, masses of tired Jewish refugees huddled under the Statue of Liberty's torch, yearning to breathe free. But their ships were turned away and they, their children, their forlorn hopes, sailed back to death. A slight national shrug of shoulder, a tiny hidden grin. None of America's heroes, not Lindbergh, not even FDR, wanted Jews. America the Beautiful, with her calculated indifference, validated their extermination. History had caught up and the world would never be the same.

"Land of the free," hisses Marion, "Everyone welcome: Melt in a pot!" She is standing directly behind me at the rail and her sudden voice startles. Everything is black. The sky, the deck, the water. Down on the dock, though, there is a myriad of colors. Bright lights on tall poles illuminate a flurry of seamen shouting, scurrying, hawsers flying as the giant SS Normandie allows herself to be tethered to America. There, far below, drifting back and forth like the detritus of some suddenly defunct circus, are pieces of trash. Papers, pieces of things, unidentifiable but lightweight objects all flashing bright against the dark blow around aimlessly. A monumental stench holds the whole scene together, sharp and acrid, as if everyone in New York had *aufgeworfen* their dinner in unison to welcome us to our new home. "*Ganz verdammt,*" I say to myself in my usual bilingual gibberish, "Hot dammit." I want to cry but know it would be of no use. Well, never mind, so this city smells of vomit and is buried under a moving trash heap. I am both scared and disappointed. In all my ten years I have never seen—or smelled—anything so dismal.

No place was like this new mess. Berlin was always clean—well, "*Judenrein*" meant "clean of Jews," didn't it? Even the departure port of LeHavre was busy and tidy with fussy but polite longshoremen who laughed a lot and held out their hands for "*bourire*." No place smelled like this. "They must be crazy," I think. "But it's too late. *Ganz verdammt.*"

The dog, standing guard beside me, whines. He is fresh from storage in the kennel on upper A deck, released to us like baggage. I hold onto his leash tightly. He is the only family member left who appears even remotely sane. I bend down so that his nose can touch mine. "It's OK, Audi, it's OK," I say and pat his head. But I am lying.

By the time we got to a hotel, the smell was only a memory. Now, instead, we had bedbugs. The next morning there were gigantic red welts on Daddy's back. He was furious. It was best to keep out of his way. No one spoke. Daddy glared at Mother. Maybe it was all her fault. After all, she was born here. A native New Yorker ought to know.

The bedbugs were a motivation. Within three days we found an apartment. Up in Harlem, at the corner of West 157th Street and Riverside Drive in Washington Heights where tribes of Jewish refugees huddled together abjectly with their cousins in misery, the Coloreds. We all shared the same cockroaches, the poverty and P.S. 151, the local elementary school.

Like the rest of New York's Upper West Side once inhabited by the richly comfortable, 800 Riverside Drive was an ancient bastion of former elegance, slipping genteely through the cracks of the Great Depression. The apartments were spacious, each boasting from eight to ten rooms, several still occupied by remnants of the building's former glory. The rest were crowded by extended families with nowhere left to go or by folks new to poverty who rented out most of their rooms to strangers. Languages other than English were shouted in the hallways, armies of cockroaches had taken over kitchens and the expensive mosaic tiles in the bathrooms had long ago cracked.

There was still a doorman, an ancient former vaudevillian named Ralph, who sported an orange toupee and ran the elevator. And there was a handyman. His name was Jimmy, but everyone simply called him "Handyman." Handyman was darkly dour, in permanent need of a shave, and he never spoke. His grimy presence lurked suddenly around corners, his black, angry eyes glaring from under his pulled-down knitted stocking cap. He was at all costs to be avoided.

Our apartment was spacious and reeked faintly of bygone luxury. Apparently, Daddy had forgotten he was currently penniless and thus wound up—like many other tenants in the building— renting out rooms. Therefore,

in our dining room lived two Jewish refugee doctors who were studying for their U.S. exams.

I slept on a cot in the hall, the dog at my feet. Elinor, in the parlor. Marion lived alone, isolated as usual, in a little cubicle off the kitchen that must have once been the maid's room. There, she painted an almost life-sized Renaissance maiden on the inside panel of her door. Richly attired in glowing blue and red velvet, the maiden turns away from the room, her outstretched arm reaching toward a freedom that waits just beyond the doorsill.

We had never lived so closely together before, and it was impossible to avoid one another. We stumbled into each other's bathroom habits, provided annoying bedtime noises, quarreled over nothing. Without a sanitarium at hand, Mother miraculously managed to contain her violent, wildly shrieking rages when Daddy or the refugee doctors were home. Random slaps in the face, smashed dishes, beatings with arbitrarily snatched household appliances somehow waited till they were absent.

In these close quarters, Marion's habitual icy avoidance of Elinor was impossible. She could not be kept out of hearing, out of sight. Marion circled Elinor warily, sending the hair on the back of my neck stiff, the atmospheric pressure making breathing difficult. Each curl of Marion's lip, each muttered imprecation frightened me more. Something bad was going to happen, I knew it, and I didn't want to be here when it did. There was nowhere to hide; the place was too small.

I do not know why Marion despised her sister so. Was it because Daddy loved Elinor differently, stroked her cheek, called her his *kleine Hasekuh*—"little female rabbit"—and never beat her? (Even Mother refrained from beating Elinor when she came after us. Was she afraid of Daddy's wrath, should Elinor tattle?) Secrets can be kept more easily in a villa than in this cramped space. What was it that demanded Marion's isolation from everyone but Daddy? Had it anything to do with her hatred of Elinor? There was no one to ask. There were no answers. There was no one to assuage my fear or relieve the tension.

Elinor seemed oblivious to the terrible quiet rumblings which precede earthquake. She stepped blithely into the forbidden, sang off key, made demands recklessly on enemy territory. Was she so unaware, or did the little female rabbit believe herself forever protected and secure in Daddy's pure and tender circle of love?

It is Sunday afternoon; the parents and the boarders are off somewhere. Elinor has spent her allowance on the Sunday paper and has spread it around

the living room. Marion enters and heads for the piano where she finds the sports section draped on the keyboard. She makes a noise somewhere between a sigh and a grunt, folds the paper away and flexes her fingers. It's going to be her only piece, the "Moonlight Sonata." Elinor gets up and walks over. Her eyes are narrowed. Her lips curl into a slight smile—almost seductive, almost a sneer. Her hands are on her hips. Quite conversationally, she says, "Hey, I was saving that. I had the paper there to save my turn. Get off. And give me my sports section, while you're at it." She walks up to the piano and slams the lid shut, barely missing Marion's fingers. Her eyes remain slits; her mouth stays in its cruel smile. Nonchalant in expected triumph she sits down at the bench, pushing over to nudge Marion off.

Something has suddenly become too intense. Only Marion's breath is audible. I am frozen into place, can't breathe, can't watch, but must do both. Like an entire Gestapo troop cornering the last Jew at the Berlin Olympic pool, she slowly turns toward her prey. Elinor does not seem to understand. Like the Jew in the pool, she keeps on splashing.

And then Marion grabs. She grabs and slams, making crashing chords from hell. Wordless, silent as the end of the world, she bashes her sister into the keyboard, composing music of shattering glass, of sudden flames bursting, of screaming terror in the night, of death. This force, this shrieking anthem is the retribution of some bitter god. And when the song is over, when she is done, when Elinor is a shivering mess in the corner, Marion quietly gathers up the Sunday paper, takes it to the window and—page by orderly page—sends it flying from the eighth floor. I watch the comics slowly undulating in the fall breeze. Dick Tracy and Little Orphan Annie flap in the sunlight. Moon Mullins and Krazy Kat wave away. And when the last page of the sports section has fluttered past, Marion goes to the piano, sits down, flexes her fingers and begins to play. The "Moonlight Sonata," with syncopated overtones.

No word is spoken. I am the witness, swearing myself to silence. Eventually, Elinor's whimpers silence. This time, she will not tattle. When parents and boarders return, they come back to quiet. Marion is sitting on the piano bench, I on the floor with Audi. Elinor is on my cot in the hall, asleep. Later, she somehow explains away the bruises. Nothing more is said.

The tension has broken, the aftermath, calm. Everything is the same; everything is different. Marion seems more open, Elinor, more closed. I am afraid of them both, but there is no further warfare. I can breathe again, the boundaries are clear, the air clean.

One day, I am at the piano teaching myself to play "Chopsticks" with both hands when Marion sits down next to me. She puts her arm around me and

draws me close to her in a genuine hug, letting my head rest on her shoulder. "You're OK, kid," she says, tenderly kisses my face, strokes my hair and leaves.

No one has ever kissed me so sweetly. I touch the spot on my face. I touch my hair. I sit, knowing with all my soul that this moment will be with me always, this gentle kiss cherished forever. My sister Marion loves me. I am loved. I stay seated for a long time, till Audi nudges at my knees and I move at last. Marion loves me. I am loved.

And so the family drifted into a period of respite. Elinor went off to a local high school. Marion entered one of the prestigious magnet high schools and was accepted as a pupil by William Meyerowitz. "Billy" Meyerowitz was a kindly, unpretentious man whose paintings hung at the Met. He took her there often, and for hours on end they studied the Masters. Under his tutelage, Marion began to realize her artistic potential. Her work grew increasingly imaginative, powerful and well-rendered.

But Marion's growing sense of independence was causing problems. She was, after all, a teen-ager and wanted to hang out with the kids at "the wall." "The wall" was a decorative stone balustrade that abutted the sidewalk of the street across from ours. After school, every neighborhood high school kid that mattered was seen draped over, leaning against, or sitting on the wall. And, on her few free afternoons, Marion claimed her right to do so, even though this meant being beaten viciously and regularly by Daddy when he realized boys were involved. With the same strokes that made him a tennis champ, his backhand would send Marion flying like a fresh Dunlop tennis ball. But Marion kept her mask of silent defiance firmly in place and didn't cry. Her only concession to the beatings was to raise her arms to protect her face and when Daddy was done hitting and calling her "whore," she turned silently and left the house. He never did chase after her, but—for the rest of the day—it was best to keep out of his way. Through the lens of my terror, I observed carefully. Learning how she triumphed would be of good use when it became my turn.

Marion's grades remained excellent, her art work did not suffer and she found solace with her friend Rose who lived on the sixth floor. Rose Chapman was a delicate blonde girl of quiet, kindly disposition whose family took Marion quickly into its warm heart. When she was with Rose, Marion was able to giggle, share teen secrets and just be a girlfriend. She and Rose danced the "Big Apple," "Trucked" to the Dorsey Brothers all over the Chapman apartment, ate a lot and discussed boys. Mrs. Chapman provided food, Coca-Cola and spontaneous hugs. On the sixth floor, Marion was on

vacation. On the sixth floor, she learned how loving and nurturing a family can be. But most of all, she learned Catholicism.

Rose's devout religious practice appeared to be the source of her serenity, and Marion was in need. Soon, she was taking informal instruction from Mrs. Chapman and went off to Mass with the family whenever possible. She even fashioned a make-shift rosary from a coral necklace, the beads of which served quite well. She whispered Hail Marys and hung this rosary-from-the-sea on her headboard every night. Perhaps it protected her.

I was on vacation, too. Everyone was too distracted to keep track of me, and I took full advantage. For the first time in my life, I was on my own. No more "American School of Berlin" where we all curtsied to the adults, ate serene lunches served on flowered china and were expected to play quietly using proper English.

By comparison, P.S. 151 was a carnival. It was so crowded that we shared desks during music appreciation class, achieving instant intimacy while the teacher played "In a Country Garden" on the rickety upright and we chanted, "Percy Granger, Percy Granger" in time to the music. Everyone was a different shade of brown, skin colors rich and warm against pastel clothing. I wished I could gleam like that. We girls hung out. Boys were not allowed. My new friends were fascinated by how I talked: "Say somethin', Dahress, c'mon, say somethin'. Just say *some*thing." They loved my speech, I loved their songs. (My favorite was "Slime an' Goo," which I sang enthusiastically for years before I found it was actually "Sly Mongoose.") We admired each other's hair. Mine was to touch, theirs to view as sculpture. In short, we found one another entertaining and exotic. And their mothers rolled their eyes heavenward ("MMH, mmh, mmh"), when I curtsied.

Being exotic at P.S. 151 was far more rewarding than being exotic at the Blums'. For one thing, it was mutual. We really enjoyed those things about us that were new and unexpected. I didn't mind "saying somethin'" for my girlfriends, didn't mind being pale. They, in turn, were generous with their stories, their songs, their food and their affectionate, sloe-eyed mothers who were usually home on Thursday afternoons, which was maid's day off.

I forgave my parents for that initial shock on the New York docks, almost forgave them for the cockroaches in our bathroom. This place was safe, after all, just as they had promised. Not only safe, but it was made to order for a little girl who was intoxicated with freedom and wild to explore.

At school, I swapped my soggy, meat-laden sandwiches of dark, heavy bread for peanut butter and jelly on Wonder Bread, which I thought was cake. We all wrote each other notes in class and paid no attention to our

teacher, Mrs. Hess. Everyone sang. They laughed at my determined quaver. In return, I taught them German swearwords which they could not pronounce.

My special friend was Adelaide. Adelaide (never "Addie," always Adelaide) was chubby, taller, bigger and of paper bag complexion. "Paper bag" was the exact correct designation, as Adelaide, my guide into the land of many colors, was quick to point out. "Paper bag," said Adelaide, was almost as good as "bright," which was several shades lighter and had freckles like her mother. "If you're bright, you're right," she chanted, "If you're black, step back."

Adelaide carefully explained the rules: "Only a Nigger can call a Nigger a Nigger, Dahress, so don't you even ever try." I understood perfectly. It was probably akin to Uncle Harry calling himself a "Yid" in the safety of my mother's large family circle. As for me, Adelaide said, I could allow persons to call me "Ofay," because, after all, that is what I was. But "White Trash" needed immediate retaliation or folks would think me a "Foo'." "Foo'" was "fool," said in capital letters and with extreme derision. It sounded awful and I did not want to be one.

For practice, we stood nose-to-nose in the cement yard that passed for a school playground and swapped identities so that Adelaide could teach me how to fight: She called me "Nappy-Headed Negro" and I, of course, hollered, "You're a white trash FOO'." Initially, I was so woefully inept at this new skill, I'm surprised I didn't curtsy first. Eventually, I caught on and—if we hadn't constantly broken down from laughing too hard—Mrs. Hess would have had to separate us as she did other fighters who were serious. When Adelaide and I could no longer control our laughter and were in serious danger of pants-wetting, we declared ourselves mutual winners and raised our arms in traditional championship salute while the rest of grade 5B stood around and cheered, having been well entertained.

I loved Thursday afternoons at Adelaide's house. At first, Mrs. Perry was very quiet, her eyes so cold they froze me into an embarrassed statue. Gradually, she allowed herself to ask family questions, eventually she smiled, finally she thawed and ultimately she accepted. And I became so welcome, I was allowed to be the towel person when Adelaide had her hair konked. This was important. Konking involved a lethal concoction made with potato lye, and providing fresh towels to protect Adelaid's eyes was an awesome responsibility. I stood at the ready, in proud silence.

"Hold *still*, Adelaide, I ain't got to the kitchen yet," Mrs. Perry would scold when Adelaide squirmed too much. "*The Kitchen*," I found out, was that spot at the nape of Adelaide's neck where her hair grew thick, wiry and stubborn. Adelaide squirmed anyhow. I would have, too. Konking took

forever and when it was over, hair was straight, all right, but also stiff as a board. Personally, I thought it was prettier just "natural," but would never have been so impolite as to say so.

Adelaide's mother sometimes reached Adelaide's face with such a gentle touch, the look in her eyes so filled with love, that the feeling brimmed over and the love spilled out to nurture the whole universe. "Is you my Nigger?" she would whisper. "Is you?" I had no memory of anyone ever giving me such tenderness. No one had ever looked at me like that. I was mesmerized, voraciously inhaling second-hand love and learning with my lonesome, barren heart the many meanings of this mysterious, powerful word. And yearned for the unknown.

The high point of our friendship occurred the day Adelaide turned to me annoyed, impatient about something and snapped, "Nigger, is you crazy?" My heart almost stopped with delight. I had just been ordained as family and was petrified with honor. I did not reply in kind. Only a Nigger can call a Nigger a Nigger.

We all had roller skates and house keys on strings around our necks. I was not allowed a spare house key—there was no need; Mother was always there—so I strung up a stolen closet key which was carefully tucked out of sight when I got home.

Sometimes, after school, we skated down the subway stairs, onto the IRT to 42nd street and right to the ticket office of the Roxy where we adored Lena Horne and cheered for Shirley Temple. (I stole the admission money from Dad's bureau.)

My new world was intoxicated with wild music. I loved Jelly-Roll, the Duke, Billie, Bessie and Cab Calloway with equal ardor. Lester Young made me cry as sincerely as when Aïda got locked up alive in a tomb or Mimi expired in Paris during the last acts of their respective operas. When Ella Fitzgerald sang, her voice danced directly into heart and soul. She made my spine limber and my arms fly. Mozart, Puccini and Charlie Parker were all one to me. Artie Shaw and Benny Goodman, Chopin etudes, it didn't matter.

In Berlin, dance was watching *Swan Lake* and knowing the difference between a grande jête and a plié. Now, with my new friends, we jumped up together, our shoulders shook, and our hips. We jitterbugged endlessly, taking turns being the guy. Smiles flew out from our faces and our eyes drifted shut. We danced. And nobody said, "Clumsy." Life was rich.

Best of all, we had Riverside Park. It ran along the Hudson River, all the way to under the George Washington Bridge where cars rumbled like the flow of some airborne ocean. There were swings, jungle gyms and wide swathes of grass. Everyone came. After school, I ran home, grabbed the dog,

strapped on those roller skates and bellered down to the park. Nobody at home seemed to care where I was, as long as I got home before dark. It was heaven.

We played tag on skates, we jumped rope ("Down the Mississippi where the boats go PUSH"), played ball ("A my name is Alice, I live in Australia and I eat APPLES"), we played intricate hand-slap games which I never got right. And when hunger struck, we took time off to skate up the hill to Amsterdam Avenue to steal fruit from the stand outside the grocery store. There was such excitement in those swift criminal expeditions. I loved the speed and danger. Not as lethally exciting as the cops and robbers game we played at the Berlin Olympic pool or the park "Jew Bench," but still fun. Here, we dodged the store clerk in his white apron who was pretty scary, too, in his own way.

And then, one day, in the park, I went to the water fountain for a drink. And looked. And froze. Just below the water basin in the stone lip that connected the metal bubbler to its base, someone had scratched, "NIGGERS GO HOME." The stone must have been too hard to accommodate curves; and so, the letters were angular, sharply triangular, looking for all the world like some ancient cuneiform descended from an archeological pillar. I was looking at hieroglyphs from hell.

In an instant I was back in Berlin, anxiously wading through a sidewalk ankle-deep in broken glass. Where there had been a plate-glass department store front window there was now only a black, jagged hole and blood-bright red paint all over what was left of the building. "*JUDEN RAUS*," screamed the paint: "JEWS OUT." Marion was pulling relentlessly at my arm. "Come on, *Dussel*," she hissed fiercely, "come ON."

I was ten years old. For months I had been free, allowed to experience joy. My heart suddenly cramped itself into a tiny, painful lump. I felt an agony far too intense for my years. "My God," I said, "they do it here, too. There is no safe place. Safe is all a lie."

After that, I looked at my playmates differently. I listened to their mothers more carefully and perceived bitterness under their banter. I began to see, began to read again. Now, I paid attention to Mrs. Hess and found the library. Mrs. Hess somehow recognized what I was after and gave me the gifts of Langston Hughes and Richard Wright. Bigger Thomas became my mentor. I read *Gone with the Wind* again, in English, and this time post-war Atlanta stood out more than Rhett's sexy cynicism. I asked Mrs. Hess relentless questions about Reconstruction, Carpetbaggers and the Ku Klux Klan. To her credit, she answered honestly. Now, when I heard Billie Holiday sing "Strange Fruit," I understood what was hanging from those Southern trees

and the crystal pain of her voice lacerated my heart. Sadly, I realized why I would be forever "Ofay" which was, after all, just pig-latin for "Foe."

The more I read, the more I understood how it really was, the more distant the girls and I became. Nothing was ever said. It was as if some shameful family secret had been discovered, one that no one could discuss because it was too horrible, too frightening. The roller skates rolled under the cot in the hall. The closet key string broke and it got lost. My vacation was over.

Chapter 5

Death and the Maiden

British PM Neville Chamberlain was busily appeasing Hitler by being more "umble" than Uriah Heep and giving historical meaning to the word "obsequiousness." Meanwhile, in Amsterdam, little Anne Frank—a year my junior—was merrily sassing her mom, sharing candy with her school-mates and giggling about boys with her friend Lies.

Daddy stopped beating Marion after Mr. Peshko. Mr. Peshko was a pal of Daddy's from Berlin who showed up in New York one day and renewed their friendship. We remembered him from Berlin: A natty, unctuous little man who emanated such an aura of sleaze that the three of us—for once united—nicknamed him "Mr. Pest-o" and made sure that we were never alone in a room with him.

Now, in Washington Heights, Daddy decided that since Marion was wanting to "date," he would fix her up with Mr. Peshko. And so he announced to her that Mr. Peshko would be taking her to the movies next Saturday. Marion, of course, refused. There, in the sunlight of our living room, Daddy took off his very large, brown, wing-tipped shoe and began to use it as a battering device that landed with excruciating thudding sounds on her head and shoulders. Marion landed hunched on her knees, arms wrapped protectively around her head, and the blows kept coming. This was no ordinary beating. I began to fear for Marion's life, silently begging her to cry so that it would stop. Mother, as usual at those times, was nowhere to be found. It was too much. And then, suddenly, he threw the shoe in a corner and walked away. Marion slowly picked herself up, managed, somehow, to stagger to her room.

From that day Marion was free. She never went out with Mr. Peshko and she never received another beating. When "Mr. Pest-o" came visiting, the three of us made sure at least two of us were present. Mr. Peshko eventually disappeared, Marion hung out at the wall; I turned eleven, entered sixth grade and discovered Iris Zommick.

The Zommicks lived on the first floor of our building. Their daddy was a retired physician with gray hair and the broad, benevolent smile of a

patriarch saint, secure and comfortable in his position. His wife quietly served as his acolyte, distributing orderly emotional largesse to their two daughters. Anita, the older, was a teen-ager who had some kind of undefined problems which kept her at home, where she was schooled by her parents. Iris, my age, attended a private day school, which explained why we had not previously met. But when we did meet, we were an immediate match. Most especially, Iris radiated comfort, a commodity of which I was in desperate need. In return, I supplied fun with as much speed and danger as Iris's law-abiding limits could accommodate.

Iris was short, plump, with a mane of long dark hair. Beauty emanated from her open smile and from her infinitely deep brown eyes. Those eyes were ageless, sparking centuries of Jewish wisdom and humor. It took little effort to imagine Iris, dressed in Biblical garb, flirting demurely in ancient Aramaic at some desert village spring while she filled her Bronze Age water jug.

Everything in the Zommick household was orderly. Dr. Zommick beamed from his study, the dining room table shone with polish, Anita smiled quietly and Mrs. Zommick made requests rather than demands:

"Would you please clear the dining room table, Iris?"

"Oh Mom, do I have to?"

But the dishes went kitchenward accompanied by a maternal, "Thank you."

I loved it when Dr. Zommick helped Iris with her math. I stood by, gaping, hoping to absorb some information. Math was easier when no one was yelling at you for being stupid, and I had long ago stopped asking for help at home. I never even did any homework at all, but no one noticed.

Actually, I hardly even attended school. I found that in order to get days, sometimes weeks, off, all I had to do was say I wasn't feeling well. Of course, this meant having to stay in bed, which was fine: I could read, make entries into my little red leather diary with the tiny lock on it and torment Audi.

Best of all, I could spend untold hours restoring my little internal Antarctic hiding place which had flooded so badly in Berlin. Meticulously, I dried it out and found peace again. In that place there was no need to think. There was just the crystal cold. No color, no air, no texture, no feeling, no being. Lying in bed with my pretend malaise, I could disappear completely, even from myself.

Finally, two things happened that jolted me back to PS 151 and the temperate zone. First, our two resident physicians emerged briefly from the dining room to diagnose me—without even so much as a cursory

examination or an interview—as having kidney disorder, which meant I had to drink a lot of water every day I was sick. They told Mother, "At least a quart," which she misunderstood as, "At least a gallon." Pretty soon, I was swamped, bloated, at the mercy of my bladder and constantly hauled out of Antarctica for yet another drink. Anything was better than this, even school. And then, the family received a letter from the school itself which stated that if I missed so much as one more day, I would not be promoted. My invalid days were over. I became interminably healthy the very next morning. It wasn't so bad. Iris was there in the afternoons, and we had fun.

We were emerging into a particular awareness which neither of our mothers was willing to clarify. We noticed that both women brought home packages of something called "Modess" every month, and that these bundles disappeared into their bedroom closets with quick secrecy. Ah, but we were observant detectives and—on comparing notes—deduced that "Modess" seemed to be bandages to prevent the blood stains which often caused their underpants to wind up soaking in the sink. (Even the panties of Anita and Marion were sometimes suspect, but we had no proof.) So we re-named these things "Moses," because, after all, he parted the Red Sea, and giggled our heads off. Old women bled every month, we decided, but it seemed to do them no harm and was certainly worth a laugh.

With Iris, Hand Jive games gave way to Jacks, but the rhyming ball games remained. We were still "Alice from Australia who ate apples." And the music, now, came mainly from the radio.

Every Saturday night, the Zommicks went out, leaving Anita to prevent incipient mayhem. Anita, however, locked herself into her bedroom as soon as her parents were out of earshot, leaving Iris and me to our own Saturday bacchanalia. And we sure had an end-of-the-week ritual as good as any.

First, we took our weekly dimes (Iris got an allowance and I stole mine from Daddy's bureau-top) to the grocery store. There, we each bought a half-sour pickle—the two best ones in the whole pickle barrel, which took a great deal of astute comparison shopping—and a chocolate-covered ice cream on a stick. We brought these treasures home and carefully began eating (pickles first, then the ice cream for dessert) at the very beginning of our very own beloved radio show, the *Saturday Night Lucky Strike Hit Parade*. Timing was of the essence. The pickle and ice cream had to be finished and the sticks in the trash just exactly before the top three songs came on the air.

The announcer beginning the big countdown was our signal to stand waiting at the Zommick dining room table. At the precise moment the music started, we began our dance around the table, shedding pieces of clothing as we went. It was important to be both extremely accurate regarding the rate

of clothing disposal and extremely wild in our dancing. This took both a lot of joy and a lot of concentration. Around and around we went, waving undershirts and socks, sending shoes and jerseys flying, till the number-one hit was announced, at the precise beginning of which it was absolutely necessary to have achieved complete nakedness. And, as the *Lucky Strike Hit Parade* went into its grand finale, so did we. We jumped, we flew, and—even if it was a lugubrious love song—we kept that rhythm going, we trucked, we pranced, we gave it our all. After which we sedately picked up our clothes, got dressed quickly and were seated in ladylike repose by the time the Zommicks returned, which they did promptly at 11:00. While not as exciting as roller-skating under the IRT turnstile, it was exhilarating nonetheless.

Sometime late that spring, we discovered Coney Island. This place had a beach and a roller coaster. Can you imagine? An ocean, speed-and-danger, and frozen-malted ice cream all in one place. Depending on which grown-up was in charge, one could have unlimited amounts of all three. Peace reigned. Aah, it was good.

Summer vacation came. Next September meant Stitt Junior High School—a place suitable for grown persons, I was sure. Meanwhile, Coney Island beckoned and Marion had found romance.

Big sister was almost seventeen, a well-developed young adult, anatomically far removed from "teats made of elbow skin." She was beautiful and bound to attract attention. The lucky fellow was Johnny Graham, the delivery boy from the A&P grocery store. In those days, groceries were delivered by handcart, pulled rickshaw-style by some enterprising youth in a white apron actively beating hard times with a steady job. Johnny came from an entire tribe of grocery people. His older brother, George, managed the store and Dad helped out as a spare clerk.

Johnny was nineteen, blond, polite, shy and pleasant: A gentleman through and through. When Johnny emerged from the grocery store with his cart, Marion might just happen to be passing by and off they would go, chatting amiably while he stopped at apartment house basements and put stuff on dumbwaiters. Whenever possible, I was nearby also, once again the invisible stalker watching from a distance.

Then, later that summer, just after her seventeenth birthday, Marion complained of muscle and abdominal pain. She became lethargic and quite unable to move. Daddy turned her over to the doctors in the dining room who diagnosed "*la grippe*" and recommended fluids.

Within a week it became obvious that her condition was critical and Marion was bundled off to Bellevue Hospital. There, she was diagnosed as

having an acute case of trichinosis, a disease in which parasites from undercooked pork congregate in the human diaphragm and eat it away. Few died from this disease as the symptoms were easily recognizable and—even in the days before antibiotics—curable. With Daddy's choice of medical care, however, the diagnosis had come too late. The worms ate through her diaphragm, and Marion, holding tight onto her rosary, died in great pain.

When Marion went to the hospital, I was bundled off to my Aunt Sonia's. No one told me anything about what was happening, but I knew it was perilous and bad. People tiptoed around me wearing strange, unreadable faces. Then one night, Aunt Sonia called from the hospital and started to tell me some stupid story about Marion being with the angels. I was completely disgusted, insulted and outraged. My tone was icy. "If you are saying that Marion is dead, thank you for the information," I said and hung up. How dare she patronize me with idiot stories about angels! I never forgave her for that disrespect, for attempting to treat me like a child. I was eleven years old and had not been a child for some time. I turned away from the phone. Death had no meaning. Neither did life.

At the funeral home, Daddy leaned over the open coffin at Mother who was standing on the other side. He screamed at her. "YOU!" His voice was so loud that it cracked. "This is YOUR fault. You did this. YOU!" Mother stood silent. "I molded her," he muttered, "I molded her," and turned away.

Later, when others had dispersed, I reached into the coffin and tried to move the fingers of her clasped hands, but they were stiff, cold, for once without paint around the nails, and would not budge. I cupped Marion's breast, her left breast. I had never had the opportunity to touch a breast before. It was almost resilient but—even under the taffeta gown—very cold.

During the funeral, I lost all control and cried. I sobbed. My entire body contorted in grief. I apologized to myself and to Marion for this lapse and just let go. I was quite surprised at this onslaught of tears; I had not the slightest idea where all this emotion was coming from. I only knew that letting go felt good. Perhaps I was crying for Marion, perhaps I was crying for me.

Afterwards, there was no further discussion. Marion's death was dead. There was no one left in my life who could love me, except the dog. But Daddy said keeping Audi was too much trouble and quite abruptly gave him away to a chicken farmer in New Jersey. Without explanation, Mother turned away from the piano and never played again. Elinor and I approached one another tentatively. We became playmates, making giant forts out of featherbeds, being cowboys and Indians. It never occurred to me to wonder why a fifteen-year-old would want to play kid games with a kid. Perhaps she,

too, was lonesome. But after a few weeks, we drifted apart again, neither one of us pursuing the other's attention.

The Zommicks did their best. Doctor hugged me to him, tears trickling, and whispered, "He could have called me, I wouldn't have charged him a penny. *Oi Gott*, I am so sorry." But the Zommicks' compassion did not penetrate the cold and I retreated silently. The *Lucky Strike Hit Parade* lost its magic. Instead of dancing, Iris and I played desultory games of Jacks. Eventually, I stayed home on Saturday nights, climbed into my bed and got lost.

Then, one day, I bumped into Johnny Graham. He stopped his cart, smiled, looked into my eyes and said, "Hey, kid, good to see ya. How're you doin'?" I saw no pity, no fake compassion, just simple interest. He did not demand my sadness, did not need to embarrass me by expressing grief. All he gave was simple acceptance, which was exactly what I needed.

I took a breath. The day felt sunny, I felt warm. Marion had liked this man, so he was safe. He would be my love. I took another breath. Life could go on.

I already knew the grocery routine by heart. Now, I spent every available moment of the summer days waiting for Johnny to emerge from the A&P with his red grocery cart and his white apron. Perhaps he felt true compassion, perhaps he missed Marion, perhaps he was just a nice man. In any case, he not only allowed me to tag along, he actually made conversation with me. He smiled when he saw me and I was grateful. Walking along his delivery route, listening to him extol the virtues of the New York Yankees made me feel happy and important.

In the New York summer heat, we trundled along Riverside Drive delivering groceries. The apartment houses all had cavernous basements, huge dark caves made of wire storage areas in which tenants kept spare belongings. Through this maze of wire cages and blackness we threaded our way, Johnny with a large bundle of groceries on his shoulder and I tagging after. We marched along walls of dumbwaiters where Johnny unloaded his burden, rang the right bell and sent the dumbwaiter up. Sometimes he let me ring.

Walking into those cellars from the bright outside made us blind, but Johnny knew every basement by heart. For him it was routine; for me each foray into the dungeons was an adventure. I expected rats, demons, ghouls and goblins. Johnny was my knight-protector and only his presence prevented some evil, dripping cellar monster from jumping out of the shadows and gobbling me up. The shivers up and down my spine were delicious, and as our steps echoed with dangerous clanks on the damp cement

54

floors, I stayed close.

Delivering at my house was especially fearsome. I was afraid of Handyman. This guy was no mythical monster; this guy was real. I would never go into our cellar without Johnny, just in case of Handyman.

Our basement was particularly labyrinthine. The easiest approach to the dumbwaiter banks skirted a row of wired storage bins and made a sharp right past a bare alcove with one tiny, barred basement window. One day, this window provided just enough natural light to illuminate the sharp silhouette of Handyman—in profile—relieving himself against the alcove wall. Before I could point, or even giggle, Johnny placed himself between me and the view, made a sharp turn between some storage bins and got to the dumbwaiters from another direction. Nothing was said, but Johnny hustled us out into the daylight at double time. When we got to the street, Johnny said, "See you later, alligator," waited for me to reply, "After awhile, crocodile," and, thus having completed our ritual farewell, we trundled off to our separate daily destinies.

The next day, I came home from the library to a tableau from hell. When the elevator door opened, Ralph and I were transfixed. There, on one side of the hallway, was Johnny in his white apron and his rolled-up sleeves, standing with his older brother. On the other side stood Handyman, overalls streaked with tarry grease, black stubble on his face, a lank string of dirty ebon hair falling from under the knitted cap, his eyes sending out dark danger, my father beside him. Johnny was yelling at Handyman, who stood silent, and Dad was yelling at Johnny. Johnny's older brother, George, seemed to be acting as Greek Chorus, yelling at the ceiling. When the elevator door revealed me, all of them, in unison turned to me and hollered, "There she is!" I turned to hide behind Ralph, but he pushed me out hard, closed the elevator door and left me all alone.

Something very bad was happening and—judging by the degree of anger—it was all my fault. Daddy's eyes were bulging with outrage. His voice thundered at me like an Asian tsunami, borne by an earthquake: "Do you know what rape is? Do you?" And as these words sliced into the air, into my life, Johnny suddenly lunged at Handyman, and then there were shouts and bodies, older brother George and Daddy all somehow engaged in a frightful furor that threatened to engulf me as well. Apartment doors cracked open and heads peeked out.

I dashed away, up the EXIT staircase to the roof and there, amid the pigeon droppings and flapping laundry, I sat down. "Oh my God," I thought, "What is rape? Is it watching someone pee in the cellar?" I didn't think so. I had seen little boys making water before and no one seemed to care. Well,

if it hasn't got to do with peeing, it must have something else to do with that thing Handyman had held, the thing of his crotch itself. The one Marion had so explicitly and repeatedly jammed into her other hand in Berlin: Sex. "Whatever it is, it is awful and disgusting and evil and rotten and dirty, Handyman triumphant after all and Johnny no longer my protector. Not only that, but it's my fault." Somehow I had betrayed a friend and was not to be forgiven.

And neither was my father. Disgust and loathing of Daddy flooded me. How dare he, how dare he speak those words to me—and to Johnny? How evil, slimy loathsome, for him to be allied with the Handyman. I groaned, "First he gives Audi to a chicken farmer in New Jersey and now this." I wrapped my arms around myself and rocked.

"How can he think Johnny and I do rape-sex? That's so disgusting. *Pfui!*" I spat. "*Pfui Teufel*, the hell with them all." Of course, I avoided the A&P assiduously and never again waited for Johnny's pushcart. I could not bear to see my guilt in his blue eyes.

For a time, it was hard to get lost in Antarctica. Contaminated with shame and hatred, it was no longer safe. The shame was easiest to bury and it soon disappeared below the ice. But the hatred, the anger, now flicked at me unexpectedly with a hard-edged flame that shot up the middle of me, disturbed the frozen silence like sudden lethal lightning and spewed me back into reality. The only thing to do was make peace with rage, keep hatred as an ally, learn to rely on them for strength, learn to love them both. Eventually they became part of the scenery, looming on the horizon like distant icebergs, keeping me safe, keeping intruders out. It would be almost fifty years before I realized just how much I counted on lethal, frigid rage to keep most other feelings at bay.

One thing was certain: The source of so much shame and power, "Down There" was much more important than I could ever imagine.

The two German doctors moved out of the dining room, which became a bedroom for Elinor and me. Into Marion's little cubicle moved a dour Dutch woman and her two solemn children who never spoke. They were waiting for their father to escape from Holland. Marion's Renaissance maiden stayed on their door, beckoning them toward the Great American Dream.

In September came Stitt Junior High, a marvel of disorder placed squarely in a large trash field on upper Columbus Avenue. Stitt produced the Ur-ancestors of modern gangs. I already knew the rules: Keep your mouth shut and don't mess with the gangsters.

Way back then there were turf wars, boys had shivs and everyone knew who was who. The boys we avoided in grade school were all there, ready to

rumble. (That's what we called gang war then: "rumble.") My old girlfriends from P.S. 151 were there, also, but we had all changed too much for more than an occasional chat. I stayed apart, didn't need to socialize because I was tough, too.

Stitt didn't even pretend to have a playground. The rubble-field did just fine. It was easy to hide there, easy to keep out of the way. At Stitt, kids were so rowdy, we were all locked out of the building at recess. No one wanted to have terrorizing marauders slipping into unexpected places making mayhem. If you wanted to use the bathroom during recess, you had to knock at the door and a frightened hall monitor got a teacher to let you in. But it had to be an emergency. I fell once, into a rubble pile of broken glass, but couldn't get anyone to open the door because the hall monitor took one look at my bloodiness and ran away. I wound up limping painfully home, dragging my right leg. It was twenty blocks of blood squishing in one sock and a pretty clear view of some strange white, stringy stuff that appeared to be part of my internal anatomy.

Someone eventually made a movie about Stitt, *The Blackboard Jungle*, a hit in the 1950's, but in the movie, all the kids were white. *TIME* magazine later identified Stitt as the single worst school in the continental United States. As for me, I still carry some scars on that leg.

But Stitt only lasted the school year. The Great American Dream was, apparently, beckoning for Daddy, too, and family fortunes changed abruptly. He formed a new business and with typical unexplained abruptness moved the family to Boston. Our belongings disappeared into boxes, the door panel with the Renaissance maiden on it carefully packed. I secretly wished for Audi back, but knew better than to suggest it. Anyway, he would be an old dog by now and—whether in New Jersey or Boston—probably soon dead. The Dutch family quickly found another place to wait for their father, I said good-bye to the Zommicks, stopped for a brief moment at the Chapmans', and off we went to a new adventure.

Chapter 6

Teen Dreams

*World War II: Air raid sirens shrilled during night-time drills. Black-outs.
War Bonds. Rationing, Bob Hope everywhere, entertaining the boys. And
boys they were: Boy heroes who literally gave their all. We cheered, we
worried, we watched John Wayne save the world—while eagerly awaiting
Ernie Pyle's dispatches from the real front. Women enlisted as army WAACS
or navy WAVES, while "Rosie the Riveter" did her bit at the ship yards.
"God Bless America, My Home Sweet Home."*

When I walk into the seventh grade classroom at Driscoll School in
Brookline, it's a shock for everyone. There's not a familiar-looking face in
the crowd. Not an Adelaide in sight, not even an Iris. Everyone here looks
alike: I'm wading into a sea of silk blouses, pleated skirts and matching
socks. Even the boys look neat with their perfectly parted hair and carefully
creased trousers. Blank faces, cold eyes, tight mouths threaten to drown me
in waves of contempt. No one speaks, but everyone is staring. I hear one
stifled giggle.

This is Brookline, after all, where those Boston Brahmins of Chestnut Hill
who choose not to send their children to private school allow them, uneasily,
to mix with the offspring of prosperous Jewish and other immigrants in the
public system. And into this bastion of Balenciaga, this citadel of Chanel,
shamble I, wearing my sister's old coat, the tweed one, whose torn belt
Mother haphazardly re-connected to its seam, albeit at an extraordinary
angle. My stomach's bulging out of the front, and one big toe, in obstinate
refusal to stop growth, is working an inquisitive little peep-hole into the
exhausted tip of my right shoe. I sit down quickly. Something's not right and
I'm scared.

I'm the immediate class pariah. Clothing's inevitably too small, faded,
often stained, sometimes torn. I even speak wrong—some strange
combination of ghetto slang and multi-syllabic intellectual jargon all offered
in clipped accents of meticulous enunciation. I'm the last one chosen for
Phys Ed teams, to the audible groans emerging from those who finally have
to take me. Finally, I'm found to be near-sighted, which results in glasses.

The large-framed child entering adolescence, broad-shouldered like a football player, with her stomping walk and increasing girth, now has ill-fitting spectacles to top off the image. "Clumsy" has come home to roost.

When I attempt chats, kids turn away sharply, but not before a swift and disdainful inspection of whatever bizarre, mismatched hand-me-down I'm sporting that day causes them to roll their eyes and snicker.

I wish I could be like Barbara Feldberg—slender, fair-haired, poised as a mannequin in one of her father's *Lerner Shops* clothing stores. Her brown-and-white saddle shoes gleam spotlessly in the morning sun, and her pale blue blouse is ironed so well its sleeves don't bend at the elbow. (How does she bite into a ripe pear without juice running down her chin?) But Barbara eludes me. Lofty and unattainable as Mt. Everest, she looks past me, through me. How can I learn if I don't exist?

Not only that, but homework assignments are expected to actually be turned in, and math is from some alien dimension, taught in a foreign language that everyone understands but me.

Solo, I create my own diversions. Roller skates are replaced by an old bike on which my greatest pleasure is caroming down those steep, cement stair-paths which connect several of the hilly Brookline streets. These long, narrow short-cuts are best attacked from the street above, by simply biking down them without killing myself. For me, this maneuver is effortless: I hurtle, fly, bounce, somehow avoid crashing into cars at the bottom, and grin. Ah, speed and danger, my lovers, my delight. (Last time I visited Brookline, I looked up at one of those paths and shook my head in wonder. Either I had been crazy or a budding, well-coordinated athlete. Probably some of each.)

Then, while exploring the Louis XIV book cabinet in a fruitless search for illicit sexual information, I find Voltaire instead and get hooked right away. This beats math by a mile, so instead of homework, I devour *Deism*. Since religion, to me, has never signified more than music, *Deism* answers all my spiritual needs. God had sure enough created the universe, is the "Author of nature's wonders" which keeps everything spinning in an orderly manner. But He doesn't sit around on a large cloud in the ceiling of the Sistine Chapel dictating, hollering, punishing and burning bushes. God, says Voltaire, is willing for us all to make our own way toward Him, and some of us do, and some of us don't, causing heaven and hell to exist right here on earth. That makes sense, and sure beats fire and brimstone. (Only it takes fifty more years before I "get it" and understand that we all quite literally create our own reality. Oh well...)

When it's time to graduate and start high school, math almost brings the whole process to a screeching halt. I wring my brain to no avail, wishing

desperately I had paid more attention to Dr. Zommick's tutoring sessions. But Mr. Meyers, our eighth grade teacher, sighs sympathetically; somehow either I fake it, or he decides to let me squeak by. Oh the relief! I don't get left back after all and enter Brookline High just in time for menstruation. No one's warned me that periods cause cramps. My armpits grow hair and my body emits peculiar odors from unexpected places. With both chagrin and awe I touch at my chest, which is tight and painful with budding breastlings. I'm definitely not ready for all this and—despite my sneaky peeking—have very little information.

It was 1942, World War II was raging, and the high school senior boys were preparing for the army. I immediately fell in love with the football captain, the class hero, destined for certain fame and glory. Other girls giggled about their crushes. I was dead serious. Johnny had a shock of curly black hair like Walter Stortz and a similar physical grace. I began to shadow him steadily. If it had worked with Walter, it could work with Johnny.

I figured out Johnny's school schedule and managed to be there when his classroom door opened. Often, I just happened to be strolling past his house after football practice, hoping he would speak. Of course, he did not. He didn't even see me.

I thought of no one, nothing else. Memorized his phone number, called regularly and hung up when he answered. I knew his father's workplace and what the family name was before they came to America. When Johnny went into the army, I saved up my allowance, stole from Daddy's bureau-top and bought a War Bond in his name, which I mailed to him anonymously. When I confided this to the first girl to smile at me in the school bathroom, my fate at Brookline High was sealed. Class pariah, once again, at least till the end of sophomore year.

That summer, the family rented a place near the beach. And there, like an ugly little caterpillar in a cocoon, I began my metamorphosis toward the land of butterflies. I found myself able to survive on a daily ration of two lambchops and several grapefruit. This, coupled with a three-miles-each-way trot to the beach every day, whittled away all the adolescent blubber and sculpted a high-breasted, small waisted tiger who could swim hard, listen attentively and—best of all—lie supine in the skimpiest bathing suit available, attracting male attention.

In the fall, my parents allowed visits to the family physician who cheerfully prescribed a magic little pill which kept me right on track. The butterfly now had wings of Dexedrine and would fly high. *Frau* Von Müller smiled proudly from afar.

Junior year: Progress. I learned how to shop for suitable clothes, how to walk, how to make eye contact with an expressionless stare that promised much and revealed little. The boys suddenly paid attention, and I was both delighted and disgusted. Billy Hacker liked to walk me home, chattering inconsequential drivel while furtively eyeing my nipples. I looked into his eyes and thought, "You jerk. I'm exactly the same person I was when I was fat, only now I'm suddenly OK because I look different and you want to be my friend. Yeah, Billy, that's rich, that's so great." And batted my eyes at him and laughed in all the right places. How easy, keeping him interested. I called it the "Scheherezade syndrome."

Meanwhile, as the war drew to a close, the Holocaust was revealed. Photos and stories crept in, horrifying beyond understanding. Only dumb luck had prevented our inclusion. I looked at survivors holding onto barbed wire fences for support, looked at piles of dead waiting to be burnt. True refugees began trickling in, with their numbered tattoos and their haunted eyes.

I pondered the significance of genocide, committed with the same careful technological expertise that produced Mercedes Benz. Had we lost a Shakespeare, an Einstein? Was the little boy marching to death with his hands in the air the discoverer of atomic fusion? The baby, her head bashed in at birth, who would she have been? What precious gift to humanity was lost in a puddle of infant brains on damp cement? Where was Stefan? What happened to Stefan?

Pride flowered in my heart along with sorrow. Six million Jews were looking over my shoulder to be honored, to be remembered. I could be both a *Deist* and a Jew, didn't have to be a woman in the balcony of a synagogue to qualify. Now I knew that rich, poor, observant or not, Jews were an entity, united by some unspoken bond and we all needed one another. Only a Jew, I decided, could possibly understand what being Jewish was really all about. Everyone else could only assume or speculate.

In the past, I'd let anti-Semitism around me just happen. I felt shame—both at myself for allowing this and also for being Jewish in the first place. I knew I was lucky to be alive and Jewish at the same time, knew myself to be the logical candidate for ostracism and harm. So, when kids told me nasty Jew jokes, I was grateful that nothing worse happened.

Now, I began to confront anti-Semitic remarks, but they kept coming. I looked so "Gentile," people simply made their racist statements freely, thinking I was one of them. It wasn't just "Niggers" that America despised, it was "Kikes," too: I had been rescued from the fire, but was expected to live cheerfully in the frying pan.

At home, Mother's becoming crazier, her rages more intense and dangerous. Elinor's off at nursing school and Daddy's away during the week on business. When he's home, Mother's behavior immediately calms. We're both afraid of him. But in his absence, she's gotten scary. Mother opens fire as soon as I walk in the door, with a tirade of non-stop senseless screaming, hitting, chasing, throwing. If I sit down, I'm a lazy idiot. If I stand up, I'm impertinent. If I try to study, I'm avoiding chores. And if I do chores, I'm too stupid to study. There is no relief, there is no stopping, there's no one to tell. The volume alone is intolerable, and the content maddening. She keeps it up, on and off, till bedtime, but by then, I'm as enraged as she and can't sleep.

Finally, one day I simply lock myself into my bedroom, assume fetal position on the bed with a pillow over my head and wait for it to stop. My bedroom fronts on the back porch and I've locked the screen door, just to be assured of refuge. But there she comes, rattling at the porch doorway. When I don't open it, she runs off and comes back brandishing our largest butcher knife. As I watch, paralyzed, she simply saws through the screen, puts her hand through the hole, opens the door and barges in. There she stands, over me, over the bed, the butcher knife waving in her hand as she makes slashing motions through the air. I do not move. Perhaps that is what saves me.

She turns, suddenly, and runs off, screaming wordlessly. The sounds do not stop but after awhile, when it seems safe, I tiptoe to use the bathroom and there she is: Stark naked, sitting in the waterless bathtub, butcher knife still in hand, screaming, screaming, screaming.

I have had enough. That night, at bedtime, I swallow thirty-six aspirin. I would have swallowed more, but that is all there are in the bottle. I leave no note, tell no one. I simply go to bed, certain I will not wake up the next morning and am content. The only emotion I can discern within myself is disgust.

The next morning, I wake up anyhow. There is a distinct ringing in my ears which doesn't go away for three days. Other than that, there is no apparent damage. I shrug my shoulders. All that aspirin must have burned out the disgust. Now even that is gone. Oh well....

Billy Meyerowitz and his wife Theresa remained family friends through the years, and on Memorial Day they invited us all to their summer cottage in East Gloucester. Gloucester, a fishing town on Massachusetts' Cape Ann, exuded peace, magic and the distinct odor of the Gorton Pew fish factory. Especially at low tide, the smell of brine was intoxicating. It smelled of life. The air at the beach was so salty, after a few hours I could taste it just by

licking my arms.

The water was so purely cold, the choice was either to take a deep breath, run like crazy and dive into the first breaker. Or—second choice—stand in the shallows until your ankles lost all feeling and then just start walking in.

Good Harbor beach, early in the morning, was my haven, my sanctuary. Silver, silent of human voice; only the shore birds, sea gulls, the gray ocean singing to me, singing love songs so ancient, so compelling they embraced and healed my tattered heart. I felt like David in the twenty-third Psalm, having my soul restored beside the still waters, except that the Atlantic was more playful than the Dead Sea.

East Gloucester was a little capelet of its very own surrounded by beaches and rocky promontories upon which the Atlantic could bash itself delirious. Just being there, being alone, hiking to the beach or climbing around Bass Rocks where the Atlantic did its exuberant best to batter its way into Massachusetts, gave me peace. Gloucester and I were lovers and neither one of us would ever hurt the other and every moment apart was a bit sad.

My parents liked this place as well. They particularly enjoyed being with the Meyerowitzes. Hooray, we came every weekend and even rented rooms in a little *Pension* at Rocky Neck, which was East Gloucester's accommodation to the tourist season. At least for these summer months, I could relax. No one would hurt me here.

There, that very summer, I met Reba. The butterfly was practicing a few new twirls, making social overtures to the poised, self-contained Jewish girls who shared their sand and suntan lotion so graciously.

Reba happened by one day, plopped herself down with casual familiarity on someone's blanket, turned to me and said, "Hi, I'm Reba." Her smile was not the polite charade with which I was so familiar. Instead it was warm, sunny as the day itself.

"I'm Doris," I said, and leaned forward for a closer look. This girl was tiny, and her face was homely as a monkey's. All her features were scrunched up in a little round moon face. Her dirty blonde hair was short when everyone else's was long, her fingernails were grimy, and her barely five-foot body was spectacularly proportioned.

Reba asked questions and did not laugh at my answers unless they were meant to be funny. This girl radiated acceptance and I was enthralled. No one had paid me such warm attention since Koch. Reba was at the beach just for the weekend but, as it turned out, lived in Brookline not far from me. We made plans to get back together at the end of the summer.

In September, beginning senior year, I hesitated to call. What if her warmth

had just been generated by boredom? What if she had seen me just as a novelty to be quickly forgotten? I turned her phone number over and over in my head and stalled, caught between wanting a friend and avoiding further pain and embarrassment. And while I was debating the proper course of action, she phoned. "Come on over," she said, "and keep me company while I have dinner."

Dinner, it turned out, was in a booth at the local delicatessen where Reba's father had a charge account. Reba's mother had died two years ago, and this was the arrangement Mr. Cohen had made to keep his daughter properly fed. Reba picked desultorily at a piece of chicken with her grimy fingernails.

"So, how's Brookline High?" she asked. "I almost miss it." Reba went to a private school, she explained, in order to bring her grades up. There, she was able to get passing grades without doing a lick of homework. I understood completely. Sounded just like my own approach to education.

After dinner, Reba invited me to her house. Home was a cavernous, ancient building on University Road, a lesser street amongst the wealthy Brookline scenery. The place smelled a bit musty, the furnishings were minimal. There appeared no obvious creature comforts, and my inspection of the fridge (de rigeur process in a new place) showed only a few wrinkled pieces of fruit and an ancient, disintegrating hot dog. The huge, mostly empty living room contained a couch, an easy chair and a rickety record player. Everything looked gray.

Reba, however, jumped quite comfortably onto the couch, patted a spot near her for me and started talking. She said her real name was Rebecca, that she had been adopted and that her adoptive mother, the only real mother she ever knew, died of cancer. Her daddy, she said, owned a liquor store, and his hours were long. She leaned back, lit a cigarette and went on to tell me about her current boyfriend, Julius.

"He's an orphan, so we really understand each other. Are you a virgin?"

"Well, yeah, are you?"

"Nope. Julius. Want a smoke?"

"Yeah, thanks."

I inhaled, sputtered, we both laughed and Reba showed me how to hold a cigarette, how to inhale without gagging. And so was born the Chesterfield Queen, the sophisticate who could imitate several styles of smoking, including the Bette Davis jab and the Bogart flick.

In no time, we were best friends. It turned out she, too, was lonesome. Mr. Cohen, who was quite elderly and walked with a marked stoop, was seldom at home. When he came in late in the evening, he would stop for a brief

moment at Reba's door. "Rebecca," he would say, "it's all right by you?" If all was well, he would ask if she needed money and tell her good night. And she left for school long before he got up.

It became routine to stop at Reba's on the way home from school. If I missed her, then she would show up at my place after her deli dinner. I became her surrogate family and she became my teacher.

With Julius away at college in Washington, DC., Reba, who was extremely popular with boys in his absence, fixed me up on a million blind dates, all of which turned into disasters because I had no social skills. A curtsey didn't cut it with the Coast Guard.

But, somehow, the flow of candidates kept coming. After all, it was 1945, the war was over, and Boston was full of returning young servicemen just emerging from their years of lost youth, from their years of horror. They celebrated their survival, took one look at Reba, and got all excited. Bringing along someone for her weird girlfriend was a small fee to pay for a date, and probably only meant calling in some favor from a pal.

We dressed at the outer edge of acceptability, the teen rebels of the 1940's. We drew signs on our boxy raincoats: On the backs, we printed "SLOW DOWN CURVES AHEAD" with arrows pointing over the shoulders. Above the rear were arrows pointing downward saying: DEAD END. We even bought blue jeans. These were not made for girls at the time, so we bought men's jeans, which were much too big in the waist, and cinched them in with clothesline.

And we were adventurers, indeed. We wore our regalia self-consciously, heading "intown," hoping some young serviceman would start a conversation by remarking on our sartorial originality. We even visited that hotbed of venality, Washington Street, known as the "Combat Zone," where we somehow got into a burlesque theater matinee, where we watched Sally Rand do her famous fandance to our admiring, speechless, open-mouthed fascination. On the way home on the "MTA," we did our best to scandalize all those proper, middle-aged ladies returning from their afternoon shopping at Filene's, by describing the whole thing in glorious detail. Loudly.

That winter, Julius is in Florida, visiting cousins during school break. Thus, Reba's popularity notwithstanding, when New Year's Eve came around, she is—and therefore I am—dateless. We hold earnest conferences and then comes inspiration: There, in the dining room cabinet, are lots of almost empty liquor bottles, refugees from Mr. Cohen's store. Stuff that's been accumulating for years, which—had Mrs. Cohen been alive—would surely have been tossed out a long time ago. There they sit, all those bottles,

winking at us, who had never been drunk. No words needed. I already have permission to sleep over. What's there to lose? Besides, it's New Year's Eve.

And so, in a rather orderly manner, we empty all the dregs into a pitcher. Scotch joins Manischevitz, gin with claret, vodka blended with bourbon. A little dib of this, a little dab of that, all of it well shaken and we're ready to party.

"You first."

"No, you first."

"Oh what the heck, Happy New Year," I say and tip the jug. My eyes water, my throat closes, my esophagus catches fire, but down it goes. "Hey, not bad. Tastes almost sweet. Your turn."

She swallows, rolls her eyes and only chokes slightly. We alternate till the jug is empty.

What joy, what liberation, what happiness. The rickety record player produces the music and we dance. We go "Racing with the Moon" to "Tuxedo Junction" and catch the "A Train." We whirl, we twirl, we sink, we rise again. We spin, the furniture spins. Time becomes a blur and so do the walls.

"Ooooh," groans Reba, "Happy New Year!" and staggers to the bedroom.

"Ooooh, Happy New Year t'you too, you old fart," and try to lurch along behind her.

By the time I get there, Reba is lying on her back, her bottom half covered by the bedspread, her top half naked. I'm a little embarrassed, very groggy and beginning to feel a trifle queasy. "Reba, where's your P.J.s?" Did I say that, I wonder, or did I just think I said that? "P.J.s," I say, "Pee Pee Pee Jays." That is funny. I giggle. But Reba isn't listening.

"Julius," she whispers, "Julius, oh Julius, touch me. Touch me, Julius. Doris, where's Julius, Doris, Doris, touch me, touch my breasts. Touch my breasts, Doris." Her head tosses on the pillow, her eyes closed. She whispers now, "Doris, please, just a little, just, please, a little touch, my breasts."

I look down at her. And, somehow, there is a sudden ray of clarity in my muddled mind. In that tiny moment, I know exactly what she is asking and where it would lead, where it would take me. And this destination is not mine.

I look down at Reba tossing on her pillow, her nipples puckering with desire and the midnight chill. I know I will never mention this to her, because if I did, she would deny it. And then the room begins to spin.

"Oh my God, I'm gonna heave. Oh shit. Oh shit, never make it to the bathroom!" And I don't. From the side of the bed and onto the shabby carpet flys a torrent, the spewing, the uncontrollable retching. Everything spins till

the retches become dry and, on the floor next to my vomit, I pass out.

Next morning, Reba is furious. "You pig," she shrieks. "You pig!" Ashamed and embarrassed, I get busy with the pail and scrub brush and don't stop till all is clean again. "That," declares Miss Cohen, "was disgusting." I agree. Disgusting.

Mr. Cohen, who had come in late and made his usual way to the bedroom door, had smelled the vomit, and he, too, is angry. "Shame on you!" he scolds. "Shame!"

The whipped puppy was contrite enough, and in a few days forgiven. So we continued our adventure through adolescence. We did a lot of giggling, and Reba became a steady visitor at my house. Mother seemed to yell less when she was there.

And then, one day, Reba came running into my bedroom from the den where she had been chatting with my father at his desk. Her little monkey face was red and even more scrunched up than usual. There were tears in her eyes. She sat down heavily on my bed and put her head in her lap. "That bastard," she whispered, "that son of a bitch." My heart stopped. Without even asking, I knew she was talking about Daddy, wished I was not so sure how he had offended. I had seen his eyes on her.

"What happened, what happened?" I asked, fearing the answer.

"Son of a bitch grabbed me! Just reached up, grabbed my breast. Ooh, I hate him, hate, I'm going home, I'm telling. I'm outta here." And she was gone.

Next day there was a call from Mr. Cohen. He wanted a meeting with Daddy and one was arranged. I was worried sick. Mr. Cohen was no adversary for Dad. I did not know what would take place, knew only that Mr. Cohen would be creamed.

The following afternoon, Mr. Cohen's stooped, shuffling gait propelled him into our living room. He looked older than ever. Reba held his hand. Everyone remained standing.

Daddy asked, "Well, Mr. Cohen, what can I do for you?"

"Mr. Goldsmith," said Mr. Cohen, "Rebecca has told me that you touched her improperly. You touched her in her bosom." His voice was too soft, almost apologetic, as if he knew he would lose.

Sure enough, Daddy's eyes bulged with their trademark "kill-the-enemy" fury.

"How dare you! How dare you make such a statement? Your daughter is a liar and you are a fool. Now get out of here before I lose control. You and your daughter are not welcome here. Get out and get out now!" His voice had

risen above a shout, bordering on a scream. He took a step toward Mr. Cohen. Reba began to cry. Mr. Cohen silently put his arm around her and they turned, together, toward the door.

But Daddy was not done. After the door closed, he turned on me.

"I know what the two of you do together, what you have been together, you lesbian slut. You keep your filthy lesbian self away from her, is that clear? Yes, I know your tricks, I know what you do. Now get out of my sight before I hurt you." I turned to Mother. She was looking down. She refused to meet my eyes, although I was certain she knew I was looking toward her for defense, for reassurance.

I went to my room. "Never let them see you cry," I heard Marion's voice in my ears and it gave me strength. "We'll see," I said to myself, and smiled.

Now all that childhood shadowing and stalking bore fruit. I knew how to navigate. In order to visit with Reba, I regularly set my alarm for 5:00 AM, was out of the house by 6:00, and at Reba's delicatessen by 6:30 while she had breakfast. I invented after-school activities, making sure they were logical ones. Last period study hall was optional for those with passing grades, so I could leave school early, hightail it to Reba's house and do my homework while I waited for her. It worked just fine. Those childhood skills were as reliable as a city bus. Not only that, but my tried and true old buddies, *speed* and *danger*, were there to cheer me on. Daddy could kill me, but couldn't stop me; and definitely could not make me cry. I was winning.

Mr. Cohen gave gentle acceptance. After witnessing what took place in my home, perhaps he felt compassion. Perhaps he was just wise. The friendship simply continued.

And then, on one of those blind dates, I met a young cadet in the Merchant Marine program and was captivated. I knew about southern gentlemen from Ashley Wilkes in *Gone with the Wind,* but I had never met one: A gentle man. Carpenter Jordan was his name, from McLean, Virginia, where his daddy worked for the government and also raised horses. I could tell from Carpenter's conversation that he felt the same deep love for animals as I, and I understood completely the sadness he felt at not being home when his favorite mare foaled. Blond, blue-eyed, he spoke quietly, rose when females entered the room, held doors open. Even his jokes were loving, their punchlines silly and mild.

On the weekends, we would meet at Reba's and go dancing at the USO, where Carpenter carefully watched the clock in order to get me home at the proper hour in his 1938 Plymouth coupe. He kissed me gently on the cheek and sent me up the front stairs, watching carefully till I got safely in the door. During the week, he sent me letters from his post, letters with little cartoons

in them, with funny faces and hearts, all about missing me and looking forward to our next date. For the first time in my life, I felt like a real girl, like a lady.

Carpenter was about to be sent to the Great Lakes Merchant Marine Station and would be in Boston for only another day or two. He promised he would write, would keep in touch always and wanted us to spend some very special time together before he left. And so, on Saturday night, I dressed in my finest and we went to dinner. Neither one of us had an appetite and we didn't talk much. Finally, when the 1938 Plymouth pulled up at my house, Carpenter put his arm around me and held me close. We sat together for awhile, my head on his shoulder, looking out the front windshield at nothing in particular till it was time to go. And when Carpenter walked me to the front door, his kiss did not land on my cheek. Soft, sweet, loving kisses were on my mouth, my eyes, my neck, my ears. I wanted him never, never to stop. The sweetness was unendurable. Intense, needed to continue forever. I felt myself melting into him and turned my face to his. "Once more," I whispered. "Once more." And Carpenter kissed me one last time. His lips were velvet, his touch was love. And then he quite abruptly pushed away. "Doris," he said, "we need to stop," and opened the front door for me. I floated up the stairs. I had been kissed, I had been loved, I was loved, I was desirable, I was a woman, I was beautiful, I was everything there was to be and Carpenter was his name.

And there, at the top of the stairs, was my father. "Get in this house, you slut, you whore. Get in this house, now." His eyes, of course, were bulging. And in I went, to his den, where he sat down at his desk and looked at me, standing before him with my smeared lipstick, disheveled hair and probably a run in my nylons. And there he kept me standing for two hours while he hurled invective at me, non-stop.

"I know your whore tricks." (That appeared to be his standard opening, no matter what I did.) "I know what you do. Yes, you know what to do, don't you? No, you don't have to go all the way, do you, you know what to do, you know how to please, you know all the ways to please, don't you, you filthy slut." And on and on he went, till I lost track of the tricks, lost track of the names, lost track of the time and became aware only of the fact that I was wearing high heels and that my feet were beginning to hurt beyond toleration. "Bastard," I said inside. "Keep on, bastard, I won't crack." Finally, when he had worked himself up to full rage, he began to hurl things at me from the top of his desk. And there I stood, the paperweight ricocheting off my hip, the telephone deflected by an elbow. When there was nothing left to throw, he stopped and I turned around and went to bed. I was terribly tired. Winning

70

took too much.

The next day, I decided to run away. I went to Reba's in the morning and did not come home for dinner. It was Carpenter's last day in Boston, and he was expected there early in the evening to say good-bye. Unfortunately, my parents decided I was probably at Reba's, and Mother came marching in directly after Carpenter. I could hear her voice in the entryway, asking for me.

"Oh boy," I said, "I gotta go," and went dashing upstairs to Mr. Cohen's bedroom, where I knew there was a large closet. Into the closet I jumped, hiding behind his various three-piece suits which all smelled vaguely of stale liquor and moth balls. I was prepared to stay hidden forever. But Carpenter came up and found me. "Oh," he said with his gentle drawl, "I don't believe I know what is wrong, what is troubling you, Doris, but I am certain that it will be resolved in time. You know," he went on, softly touching my shoulder, "that is your mamma down there, dear heart, and it is not fitting to disrespect her so. Come on now, you know what you must do." He knelt with me in the dark closet, put his hand on my face and looked into my eyes. And when I looked back into his, I saw pity. I saw disappointment. He was looking at me as if I were some little girl caught in traffic, who he was steering back onto the sidewalk and from whom he would walk away quickly, having done the right thing. He had surely used this very tone of voice before, perhaps in order to calm skittish horses. I wanted to die from shame. There was nothing to do but die. I would never survive, there was too much shame to survive. It no longer mattered to me what he said or did. I knew we were finished. His gentle life had held no preparation for this, this alien experience which would probably mystify him for years. He said, "You come on along downstairs and go home with your mamma now, you hear?" So I went down the stairs, catching the quick look of relief in his eyes as I turned on the landing. I walked home with my mother, silently. They had won, after all.

But I kept on seeing Reba. My parents must have known that no one needed to leave for school at six in the morning and that after-school activities ended well before six at night. But they said nothing.

Late that winter, Reba and I went to the movies one Sunday afternoon. It was a mystery movie starring William Powell. When I got back, no one was home but Daddy in his den, listening to the overture from *La Gaza Ladre* on the record player. One of my favorites. I was lighthearted and wandered off to the kitchen looking for a snack, humming along with Toscanini. Of course, that's when he began.

"Where were you, you slut? Hanging around with the U.S. Navy again?

Are you getting paid now? Get in here, whore, and tell me where you were."

I rolled my eyes at the ceiling. Oh well, here we go again. The tirades had become tiring and no longer scared me. This one was an annoyance, keeping me from the fridge. Oh, well. But I sensed a difference in myself this time, watched myself cross over a line.

I walked into the den. "Listen, " I said, "I was at the movies. So, if you're going to hit me, just do it now. You're not going to make me cry. You should know that by now. If you want me to move out, OK, I'll leave. But if I'm going to stay here, you better know right now, I don't care what you do to me. Just do it and get it over with."

I braced myself for the blow, and it certainly came. But this time, he grabbed me, which he had never done before. His hands were around my neck, he was choking me and suddenly he pushed me down onto the sofa. His hands slid from my neck down to my shoulders, pinning me to the couch and his body was on top of mine. His face was contorted into a strange, smiling grimace, head thrown back, eyes closed. Now he was straddling me, was beginning to lower his body down onto mine and that is when my knee flexed and I kicked upward as hard as I could. Every part of my being went into that kick, and it must have connected somewhere important because he suddenly flew up, flew away from me, all bent over like a flying comma, flew out of the room.

He never touched me again. I was free. For the rest of high school, I spent most of my time at Reba's house.

I am sitting in the bouldery cliff of Bass Rocks, just a spume or two above the fiercest breaker, high enough to see fishing boats wandering along the horizon and low enough so that only chance keeps me from being splattered with flying foam. I'm on my "soft rock," just concave enough to fit my bottom, where the sun writes messages on my salty face and a few fair weather clouds puff themselves around the sky. It's the summer before college and I have a lot of wondering to do. A lot.

A month ago, on high school graduation day, Daddy took me for a walk down to Beacon Street. After our physical confrontation we had avoided contact, silently circling each other around the apartment like prowling alley cats, and now I was suspicious, but curious. As we strolled, he put his arm around my shoulder, drawing me close. Then he began to speak, using a ponderous "I'm about to teach you something so listen carefully" tone. I perked up. Perhaps he was about to apologize for being so mean to me. "Doris," he said looking down at me kindly, "you have a very pretty face."

(I felt a sudden rush of warmth, of forgiveness, my eyes getting shiny. Maybe he loved me after all. I let myself snuggle into his side.) "But unfortunately, it is all you have. You have nothing else. Just a pretty face. And when that is gone, you will be nothing. Nothing at all." (I stopped breathing. My smile froze. What was he trying to tell me?) "So," Daddy continued, "as you age, your face will start to become ugly and wrinkled. By forty-five you will be ignored and when you are my age, you will have nothing left, because you have nothing else at all to offer anyone. Just your face." Daddy stopped and turned to me.

"Is that clear?"

"Yes."

"Good. You can go now." And turned and walked back to the house. I walked slowly back after him. I felt cold, chilled to the bone on this sunny day. I did not at all like this news. It felt awful, being only my face. He had said this to me before, in anger, but now he was making it official. It must be true, I decided, or he wouldn't have taken the time to explain so explicitly. What a strange graduation gift. In a way, I liked it. "I will be beautiful," I told myself. "That's not so bad."

Today, six weeks later, the family is attending a beach party given by the Meyerowitzes for the newlyweds, Dr. and Mrs. Briscoe. Dr. Briscoe is an elderly, retired physician. He is white-haired, white-faced, stooped, totters around leaning on an immense metal cane. Gossip has been flying so wildly that no one bothers to stop talking when I'm around. "He's eighty, she's in her forties, what a fool," they snicker. I am not impressed. In my world, the difference between eighty and forty is small, both are ancient. After all, thirty is the start of middle age, and after that, nothing matters. A cane at forty, a cane at eighty, what's the difference.

Mrs. Meyerowitz takes me to where Mrs. Briscoe is lying on a beach towel. The bottom of her two-piece bathing suit has been pulled down below her navel. As we are introduced, she takes off a pair of immense sunglasses, says, "Pleased to meet you," puts the glasses back on and resumes her sun bath.

I stand and stare, completely fascinated by Mrs. Briscoe's body. From her rib cage swoops a magnificent plane, awesome in its smooth elegance. There is not an ounce of flab, not a ripple of fat, the skin is taut as a sail in full wind. Like an escarpment, a soft cliff, a hint of ribs visible when she inhales, Mrs. Briscoe's front slopes to a tight belly, gleaming with suntan oil. I have never in all my life seen an old woman look like that. I had no idea it was possible to be so old and so perfect.

"Ah," I say to myself. "Yes, this is how I will be. This is how I will look. I will be Mrs. Briscoe." And I know in my entire being that this will be. All I have to do is help it to happen. I laugh into the sunshine and touch my little container of Dexedrine for good luck.

So here I sit, on my soft rock, knowing part of my future. Maybe being just a pretty face is not the end of the world. When I am over forty and am Mrs. Briscoe, I will be happy. I know. The tide is going out and has left a shimmery little pool just below. I climb down to see if I can find my reflection in it. I want to see Mrs. Briscoe.

Later that evening, Elinor arrives with her boyfriend. Elinor has graduated nursing school and is now a practicing RN who spends little time at home. She has been seeing Warren for some time now, and it is assumed that they will marry.

I like Warren. He is short, built compactly, has a ready smile and kindly eyes. He has a strong Philadelphia accent, a warm sense of humor and no room for pretense.

Warren's mother died early on, his father re-married and provided his sons with the proverbial wicked stepmother. So Warren left home early, joined the Navy and now is in the process of becoming a self-made man, following carefully all directions in the blue-print of the American Dream. He is good natured and determined, sure of his success. He has chosen Elinor to be his partner in that endeavor and is proud of his choice.

I like how Warren accepts me as a peer, how he laughs and—best of all—how little attention he pays to the machinations of my parents. He has come for Elinor, not for family drama. I like that. I believe I can trust Warren, that he is a friend.

Warren loves Gloucester, too. He has friends who summer here and knows all the nooks and crannies of Cape Ann. This will be a good summer, I do believe, but too short. College is waiting out there, scaring me.

Chapter 7

Co-Ed's Guide to Higher Ed

It's 1946, a year after the war. Glenn Miller never returned, but Benny Goodman and Artie Shaw are making up for his absence. Best of all, there's Frank Sinatra, teaching us how to swoon. The music's good, the sun is shining and all the collegians are raring to go: Besides the usual coeds and fraternity boys, there is a large, vocal and dominant contingent of former servicemen, ready to become educated via their G.I. Bill, which provides tuition.

With their usual arbitrary unpredictability, my parents decided where to send me to school. I was not asked my opinion and was given little notice. One day, they simply told me pack my belongings and get on with it. Their choice was a small Disciples of Christ liberal arts college in the West Virginia panhandle, where Wheeling is stuck tightly between Pittsburgh, Pennsylvania, on one side and Steubenville, Ohio, on the other. The school was in Wellsburg, a tiny little place, snug in the hollers outside of Wheeling. Climbing off the train just before dawn, I watched as the immense wooded hills turned from blacker than the sky, to darkest green. I was astounded by the beauty of these giant, soft hands which cupped the little town so closely. Maybe I would like it here.

I've unpacked my two suitcases. The dorm room is comfortable and I have a roommate. She is small, her blonde hair is thin and straggly, her features are those of a hungry cat, dominated by immense, green slanting eyes. Her eyes matter; when they speak, her scrawny body and sparse hair fade from view and only the hungry cat remains to devour all. She stops unpacking briefly, says, "Oh hi, roomie. My name is Caroline, you can call me Carrie," and before I have a chance to answer she grabs a pile of sweaters to dump into a drawer.

"I'm Doris," I say, she waves acknowledgment, I light a cigarette and sit down on the bed.

There is an endless parade of possessions toted by Carrie's parents from the car, which she sorts and stows. During a brief intermission, she introduces her parents, Dr. and Mrs. Moyer. I almost curtsy, stop myself, we

exchange soft "pleased to meet you's." The Moyers are from Morgantown and have the round beginnings of southern accents. Genteel, yes sir, yes ma'am, that they all are, indeed.

Carrie and I get acquainted at bedtime, exchange pertinent information. There is an older brother; Carrie is at Bethany because the family likes the music program here. Carrie is a lyric soprano, she says, and likes to sing Mozart arias. I like that. Carrie says the school informed the family that there would be a Jewish roommate, which almost caused her to withdraw from enrollment. "I had a Jewish roommate in prep school and she was awful. Loud, garish, Doris, garish. It was awful, but they said your family was musical, y'all were OK. Guess you are, at least you have manners, my folks and I figured, so I guess we'll get along." She smiles with her eyes as well as her mouth, so I guess she is OK, too.

"I've never had *any* kind of roommate before, not even a West Virginia lyric soprano," I reply, and we have one last cigarette, leaning out of the window together, watching the moon make glimmer paths on the round shoulders of those immense hills which, like brooding, overweight eunuchs, silently guard our harem.

Day two: I've taken my Dexedrine prescription to the Infirmary, and now I'm sitting in Freshman Assembly. The assembly hall is dark, with high ceilings. I look around at all of us, at the paneled walls, at the speaker's lectern up front, and feel such joy I'm barely able to sit still. This is my first day of college. College, where I will learn wisdom. Where true educators will transport me into realms of knowledge. I will become, I will become. It is a song, an anthem, a paean to my new status as serious student. I twitch in my seat, exultant, forgive my parents for everything at once because they have sent me here, to the place where everything I never knew will become mine forever. Someone speaks, welcoming us, and I applaud. No one else does and I am ashamed when eyes turn. Then we are told how to register. It's OK, I'm still here.

That night, back at the dorm, Carrie and our next door neighbor, Joan, are chattering. It's about boys, mainly, and I realize how singularly uninformed I am. I have excellent anatomical information, having greedily studied Elinor's illustrated texts, but still don't know what's being discussed.

I am so dumb, last year someone at Brookline High talked about rubbers, and—until Reba set me straight—I spent hours trying to figure out how a rubber (which to me meant the red eraser at the top of a pencil) could be birth control, unless someone jammed it into the little hole at the end of a penis, but how could that fit? Reba used a banana as part of her explanation and

laughed so hard she cried and squashed its middle. Then ate it through her tears.

Now Joan is talking about petting with someone whose penis didn't have a head. Carrie gasps and giggles, as do I, but what does she mean "head"? Elinor's anatomy book didn't say anything about a head. There's the shaft, there's the frenulum. But what's the head? Am I the designated Virgin of West Virginia? I am ashamed and grateful that elementary biology is a required course here.

I thought all the returning GIs were sexy and glamorous. I loved how they asserted themselves, how bravely they spoke out in class. Having celebrated V-J Day by dancing down Tremont Street and kissing every serviceman walking toward me, I held myself an expert. I expounded loudly to the girls as to my experience and preference.

Big mistake. Social acceptance at Bethany was sorority-based, and the girls—at least in public— were ladies, were discreet, clearly understood acceptable parameters. Bragging about running away from home, of smooching with a southern-style merchant marine, was death, and I was labeled "pariah" forthwith. September sorority "rushing" did not include me. Within three weeks of enrollment, I was back in the familiar territory of outcast, of misfit, of being barely tolerated in the cafeteria.

And then I met MacKinney. He put his tray down at my isolated table and asked if I wanted company. "Yessir," yodeled my heart. "Yessir, anytime, any place, anywhere at all, you bet." Out loud I said, "Yeah, sure," and he sat down in my life. Kerplop.

Name was John MacKinney, he said, from Tenafly, New Jersey, here in West Virginia to get his degree on the GI Bill and recover from a divorce. MacKinney was an older man, at least twenty-five, if not twenty-seven, and oozed sophistication. He was well over six feet, his black hair fell in a distinctive widow's peak, which heralded a receding hairline, his eyes were dark, his smile was cruel. Tennis was his game, he said. It took precedence over everything else, including academics, but he was sure he could manage both. I was sure he could manage anything at all, and said so. He looked down at me and allowed his eyes to add some warmth to his upturned lips. If a cobra could grin, it would have looked like MacKinney.

"Oh, if there is such a thing as love at first sight, it is happening to me, don't let it stop, I'm yours," I would have thought if my brain were still operational. But that organ had apparently ceased to function and, instead, there was a strange new sensation shooting all over my body, emanating distinctly from somewhere "Down There." Warm, tingly up my solar plexus

went this feeling, like internal electricity, it shot directly into my heart causing it to skip erratically, which in turn caused me to gulp for air and almost spill my coffee. "I need a cigarette," I decided, but was unable to move.

"You feel like watching me play tennis tomorrow? I've got a match at 3:00. See you then," and off he marched with his empty cafeteria tray and my full heart.

On the tennis court, he was like the ocean: Fluid and powerful, sometimes quiet, often wild, always in charge. Then he became a toreador, smiled, and demolished his opponent—all with great economy of movement and very little sweat.

Afterwards, he was happy. His eyes showed life, his smile was warm.

"So whatcha think, want to go celebrate?" He didn't wait for an answer. Just turned, tossed a towel over his shoulder, yelled, "Pick you up at 8:00," and disappeared down the hill.

The man of my dreams: Happily ever after, here I come. College, romance, the whole world, all mine, like a hillbilly lyric run amok.

"Thar wuz whiskey an' blood on the highway, but I didn't hear nobody pray. I didn't hear nobody pray, dear brother, I didn't hear nobody pray. Thar wuz whiskey an' blood on the highway, but I didn't hear nobody pray..." This was pretty funny. I loved the lyrics, but was it music? There was Roy Acuff and his Rocky Mountain Boys, Hank Williams and a score of others, each and every one of them willing to wake me up laughing when Carrie's radio went off in the morning. I trundled off to biology class chuckling to myself and humming, *"I got tears in my ears from lying on my back in my bed and crying over you."* I wasn't sure how one would dance to it, but it sure gave the day a good start.

My brief infatuation with the magic of higher learning disappeared with Elementary Biology 101, where, instead of learning arcane secrets having to do with how life begins, I wound up with just another dried-out pickled frog that stank of formaldehyde and looked frighteningly similar to his many brethren which I had so reluctantly butchered in high school.

As for the vaunted Music Appreciation Seminar, so strongly recommended by Carrie as the ultimate source of classical information, I found myself the instructor's peer. I was indignant and willing to argue with him if I had a diverging opinion regarding the structure of a Bach fugue, which provided some diversion but left me terribly disappointed. I had so wanted to learn something, to become excited.

But there was MacKinney. My life, my love, my reason for being, with

his tennis racquet and little silver flask of bourbon always at his side, MacKinney came courting. We went to the Student Union and then for a walk. Of course the moon was full, of course he put his arm around my waist, of course he talked, took a slug of bourbon, talked some more and allowed unlimited gazing upon his perfect countenance. Now I had a place on campus, just like the sorority girls. I had the saddle shoes, the sweater sets, the plaid skirt, and now I had a boyfriend. Yes, I was a coed, after all. And MacKinney was no ordinary beau. There was no one more handsome, no one more dangerous, no one more sexy. And everything was as it should be until he kissed me.

We stood on the front porch of the dorm, he smiled down at me with his cruel eyes and said, "Well, see ya," and then eviscerated me. His mouth landed on mine like an eagle on a rabbit— smooth, soft feathers hiding lethal talons. There was a sudden sharp connection from my lips, my tongue, through my belly to that spot below which suddenly exploded. Everything tore loose—head from shoulders, heart smashed through breasts, legs separated from knees. Like a starving infant, I twitched frantically toward the proffered nourishment, wanting only to be suckled back to life.

This was not Carpenter Jordan's gentle caress. No, indeed. This was sex. When we finally separated, MacKinney said, "Well, well, well" and wandered off into the moonlight. As for me, I couldn't wait to get to Carrie. For the first time, I had something real to share and was sure she would listen.

"Oh Carrie," I said, "I want him so. I want to lie down with him, I want to give me up."

But Carrie looked at me, expressionless, her green eyes cold. "You know, Doris, you are so public, it's a shame," she said, and turned off the light.

So we dated. He allowed me to watch his tennis matches, took me to the usual dance at the Student Union, and caused intense biological uproar to my entire being when he kissed me good night. He knew. It was only a matter of time, a matter of his convenience, of his choosing.

And I waited for it to happen. If kissing did all this to me, I could barely imagine what would happen when we actually made love. I waited, wanted nothing else. Even arguing with the Music Appreciation professor lost its cachet. I had become my body, only my body. My mind was gone and I didn't miss it.

I loved his power, his arrogance. He called the shots, decided what we would talk about, where we would go, how we would do what he had in mind. He did not flirt, did not desire my approval. He allowed me to be with him and I wanted that, wanted him to be in charge of me, wanted him to be

my ocean, to play with me, to drown me.

Looking at MacKinney made me dizzy. Add a mustache and there was Rhett Butler. Get some of that receding hair back on his head, and, voilà, here's Walter. Put him in a pair of dirty overalls, and maybe—dangerous as that might be—there's even a touch of Handyman. That such a sophisticated man chose to be with me was a constant wonder.

He showed up hours late for our dates, tapping on my dorm window after I had long given up. With enough bourbon, he would discuss his divorce. He couldn't figure out why his wife left him, it made no sense at all, she had given no particular reason. "Why would she do that?" he asked. "Why would she?" I had nothing to offer. I couldn't imagine why, either.

Brad, one of the GI Bill vets, walked from the library with me. He said, "You're a good kid, Doris, and you deserve better than this. MacKinney's got a real bad rep. He drinks too much, he talks too much. You hang around with him much longer, and you're gonna get a rep, too. This is a real small campus. I'm from Detroit; it took me awhile to figure out how it works down here. You're from Boston; you don't know what a small campus can do. A guy with a rep can make it. A girl with a rep is a goner. You're a good kid, Doris. I'm sorry." He did not wait for a response. His eyes held mine for an instant, and he was gone. "Hmmph," I thought. "Jealous."

The tennis courts were on a bluff overlooking the hills below with such wide visibility that approaching squalls wafted their dark, translucent veils of rain sinuously along the skyline like Salome dancing for the king. I loved to watch them coming in the warm gray fall afternoons, sometimes staying too long and letting them drench me while everyone else ran for cover. MacKinney said, "What's the matter with you?" And I had no answer. I loved the hills, loved the rain, loved MacKinney. I felt beauty that had no words; the only speech I knew was love.

MacKinney and I are returning from the movies. I am wearing my very best dating outfit: A white sweater set with a string of fake pearls around the neck, the white wool skirt with the pink and blue plaid lines on its accordion pleats. And, of course, saddle shoes. This is my favorite outfit, makes me feel like I fit in. He is wearing his usual green V-neck sweater, over grimy khakis and worn-out tennis shoes. After the movie, I parade my date and my wardrobe proudly for everyone at the Student Union, thinking, "Ha Ha, match *this,* peasants." Meanwhile, MacKinney has sipped liberally from his little silver flask and is tilting slightly to starboard as he walks.

We have reached a grove of trees just above the dorm and now

MacKinney leans me against an oak and kisses fiercely. I, of course, go limp with pleasure and, braced by the tree, am held up by the pressure of his body. I feel his hands on my underpants, let them slip down to my ankles. He lifts me up from the ground a bit, using the tree as leverage, my underpants are gone. I feel him on my genitals, he is rubbing himself against me. I think it must be his penis that is rubbing, it is hard, it is strong, it hurts. His hands are under my buttocks, lifting. Suddenly, something bad happens. There is a terrible, frightful, searing pain. I yelp into his mouth, "No, aah, no," but the pain keeps on. I believe he is rubbing himself too hard against my genitals, he is hurting me there, he is too rough and he won't stop. The pain becomes worse. I try to push him back but he is relentless. He is cutting me to pieces, shredding me with his terrible swift sword and then, suddenly he stops, steps back, turns away from me in the darkness. I am trying not to cry. The pain won't go away. I can't find my underpants. "MacKinney, that was awful, that hurt."

"Ok," he says, "Let's go."

We walk to the dorm. He is silent, he does not look at me, he lurches off into the night when we reach the front steps. We are late, everyone else is already in. I rush to the bathroom, want to look at myself and figure out where and how he hurt me so. I dash into a stall and when I lift my skirt I see the entire back of it is drenched in blood. There is blood trickling down my legs into my white bobby socks, onto my saddle shoes. "Oh my God," I whisper and sit down on the toilet. There is something terribly wrong, something weird and wet and floppy and ugly is hanging out of me. Has he torn loose part of my anatomy? Has he hurt me that badly? Will I die? I grope, I grab, I pull and with a dull sucking sound I suddenly am holding a bloody, red, limp, used condom. Now, finally, I know how a rubber is used.

I wash myself as best I can, use wads and wads of toilet paper to stanch the blood and wash the bloody skirt in the bathroom sink. I am terrified. What if someone comes in and sees? I will say that I just unexpectedly got my period. But maybe they won't believe me. Everyone will know what has happened, everyone will know what I have done. I will have a rep. I am too scared to cry. I wash the skirt, I mourn. My beautiful white wool with the pink and blue plaid, my favorite possession. It does not occur to me to grieve over anything else.

When I get to bed, I lie there, shivering, and wonder, "How did he do that? How did he get inside of me? How did he make that happen? Why didn't I feel him inside of me, why was there only pain? I wish Carrie didn't despise me every time I confided something. Why is it OK for her and Joan to chat about sex and not me? I wish Reba were here."

Next time I see him, I say, "MacKinney, there was blood all over the back of my skirt."

He replies, "Yeah? That used to happen to my wife a lot, too." His face remains expressionless and we walk on in silence.

We drifted into winter, which, in West Virginia, was endlessly gray. The sky, the hills, even the snow was the color of nothing. When I complained to Carrie, she said, "Yeah, but just you wait till spring, Doris, the Hollers are worth the wait." "Hollers," it turned out, was the local word for the little dells and curvy hollows snuggled into all those forbidding hillsides. It seemed a long wait.

Winter abated, spring emerged and nothing changed. MacKinney and I continued to collide, always in the dark, always outdoors. In the cow pastures, under the trees, behind the cafeteria. It was always the same: We kissed, I loved him passionately, he hurt me terribly. After a while, the bleeding each time stopped, but the pain continued. When he was done, there was only silence and a rapid walk back to the dorm. It seemed as if he were angry, somehow, but I was afraid to ask why. Perhaps it was something I was doing wrong, but the subject was off limits. I wondered what it looked like, if his penis was one with a head. I never saw. And I loved him, wanted to touch his face, wanted to hold his hands on my breast, wanted to kiss his eyes, wanted to be the next Mrs. MacKinney and do his laundry.

MacKinney was my world, and all I wanted. Little else made sense or mattered.

No one else talked to me, not even Brad. He looked at me one day and just shook his head. After that, he did his best to avoid me, although I noticed he and MacKinney were friendly and joked around a lot in the Student Union.

Carrie said, "Now's the time to explore the Hollers if you want to see them at their best." So I hitched a ride out of town and hiked up the hills and into the Hollers. Stripes of sunlight shone through the glades painting gold faces on purple flowers. Trees, prancing with blossoms, became gilded dancers. No spring, anywhere, was ever so delicate. Surely there were fairies hidden in these woods, Oberon popping out when least expected, satyrs making irresistible music on their pipes for the gods who frolicked, who made birdsong in the twilight. Re-birth of the world in these fluted cradles was gentle and quiet. The Hollers of peace, the Hollers of love. I was entranced, learned to hitch-hike like a hobo and wandered incessantly through these magic kingdoms of green lace. I could dream there, give myself stories of life that sparkled like teardrops in the sunshine.

It is June, a week or two weeks before school ends. MacKinney and I are sitting in the grass behind the tennis court. I can feel the wind change; a squall is coming. He kisses me more gently than usual and when he rolls on top of me, the rain blows warmly in. I feel it on my face, feel the soft wind, feel MacKinney move inside of me. There is no pain. There is movement, there is warmth. Is this love? Is he loving me at last? I want him to continue, want to be in his arms wrapped in him and in the rain. I feel my body arching toward him and then he is done. But he, too, seems to have noticed a difference. For once he is not angry. He holds me close to him as we walk home. "No damned rubber," he mutters and almost smiles.

It's the summer of 1947 and I am back from school, safe with Reba. I tell her all about the world of love, relieved to have a friend again, at last. She shakes her head, does not seem to understand what it is that makes MacKinney so desirable, but is willing to accept what she calls my "masochistic tendencies."

But discussing the possibilities of masochism has taken a back seat because my period has not come. We wait, we wonder, but there is no sign. I have read somewhere that turpentine fumes cause miscarriages, and now I sit for hours in Reba's dark living room inhaling from a bottle. We know that breasts change in pregnancy and so carefully examine my nipples. Are they becoming browner, are my breasts heavier? We give it until mid-July and then I panic. I know. I just know. Don't know how I know, but I know.

There are only two kinds of girls: Good and bad. Girls with a "reputation" are bad, used for sex by men who joke about them to everyone afterwards. They are stringently avoided by other girls who are afraid the dreaded "rep" will taint them as well. If a girl becomes pregnant, she might just as well be dead. Of course, no one would ever consider marrying such a person. In order to survive, girls who become pregnant are shipped out of town, into hiding, and the infant given up for adoption at birth. The entire family is shamed. The parents are held up to ridicule, their social standing ruined.

I cannot imagine telling my parents. I know I could not survive the cruelty of their punishment, which would last a lifetime. There is no one to turn to, nowhere to hide. Who is there who can help? Reba and I talk it over desperately and decide that the only person with any kind of resource at all is Elinor. She's a nurse, maybe she has an antidote.

Elinor becomes stiff and silent, but then she goes to Warren. And Warren comes through. No judgment, no scolding, no excess sympathy, no dirty jokes. Warren says, "It'll cost two hundred and fifty dollars, and I'll front

that for you. But you better call the guy and tell him to fork it over. I'll tell you where to go and when. So, meanwhile, don't do anything stupid, OK, kid?"

Warren won't accept more than a simple, "Thank you." "These things happen, " he says. "It don't mean a thing." But I know better. Warren is a friend, a true friend, and how he handles this matter is an indication of who he really is.

"John, I'm pregnant."

"Oh yeah? Who's the lucky father?"

"John, that's not funny. I'm getting an abortion and it will cost two hundred and fifty dollars, and you're going to have to pay your share, John. It's a loan from my future brother-in-law."

MacKinney says, "I'll be there next weekend," and hangs up.

Next weekend turns out to be the ideal time. Mother and Daddy are in Gloucester, Elinor is planning to be with Warren, I have the house to myself. MacKinney is in my father's bed. I watch him while he sleeps, study his body carefully. I have never seen him undressed before and even now, as he dozes on his back, his penis is safely tucked away in boxer shorts and I don't dare disturb him to take a peek. I content myself with his upper torso, wide-eyed with the wonder of his perfection. MacKinney's body hair is perfect: Enough to make him a predatory animal and not so much that it becomes fuzzy or sprouts out of unseemly places like back or shoulders. Just enough to cover that magnificent chest and taper gracefully to his concave abdomen. "Oh, so manly, so beautiful." I sigh, watch him for a long time, finally fall asleep still at worship.

MacKinney never mentions the money Warren has laid out, nor does he ask with whom or how the abortion has been arranged. "Well," he says, "let me know how it all comes out. Heh, heh." I get that he is making a pun, a little joke. Maybe he will pay Warren back after the abortion has been completed. I don't dare ask. I take MacKinney to the train station, and wait for Warren and Elinor to come back from their weekend in Canada.

When they return, Warren asks if MacKinney has taken responsibility for getting me pregnant and for funding the abortion. "I don't know, Warren, he didn't say anything. He said to let him know how it all comes out, heh heh. Maybe he'll pay you back after?"

I am more ashamed than scared. I am so ashamed of myself for being inept, ashamed for MacKinney, ashamed for becoming pregnant, for not having any money, for letting Warren down. I cannot speak. I just sit there. Warren says, "Sonofabitch backed out, huh. It's OK, kid, it's OK. It's only money," and gives me a hug.

Inside Beacon Hill, the streets wind dark and narrow, the houses are ancient. Some, behind ornate wrought-iron fences, sport priceless lavender glass window panes, installed before the American Revolution and cherished through generations of Boston Brahmin wealth. Some are ready to fall down upon themselves, and some appear to have already begun to do so. In the doorways of some lurk drunken sailors, in others there are baby-carriages.

The house to which Warren has directed Elinor and me is dark, anonymous, indistinguishable from its neighbors—neither run down nor upper-class, just another spot in a row of rows. We park, ring the bell. A small, dark, foreign-looking man in a business suit answers. "The one come in, the other come back in an hour," he says. Elinor walks away. I am terrified. "You wait here," says the man, and leaves me in a little room with a day-bed kind of couch, covered in dark corduroy and occupied by a very large gray cat. There is a saucer of milk on the window-sill for the cat, who pays no attention to me at all.

Then the man comes for me and we go to another room, painted in a dark cream color and outfitted minimally with an examination table, a cabinet and a sterilization tray complete with shiny, lethal-looking instruments. Waiting for me at the foot of the table is a short, squat, bald-headed man wearing surgical scrubs and mask. From behind the mask, he says, "OK, now, don't be scared. I'm Dr. A and this will be over for you very quickly. It will be painful, because I am not going to anesthetize you, that is not what we do in these situations. You will have to bear with me, follow all directions and remain quiet even when it hurts. Are you ready?"

I nod and turn to the fellow in the business suit. "Are you going to be here?"

"Yes," he says, "I will be at your side."

"Can I hold your hand? If I hold your hand and squeeze when it hurts, I won't make noise."

"Yes," he says, and I take off my pants, climb on the table and put my legs in the stirrups.

It hurts. It makes that first time with MacKinney feel like a love-pat. It hurts in a different way. MacKinney was sharp, this is blunt. It hurts all up inside of me, a terrible dull rending of my soul being torn out of my body. I grab the man's hand and squeeze as hard as I can. "Hey," he says. "Not so hard, let go, dammit," and shakes himself loose. I'm on my own. I wish I could cry, I want to die, and then it's over.

Dr. A says, "Good girl, that was good. You did that really well. Good. Everything is good. Now you go in the other room and rest for a bit and then

you go home and rest some more. You will bleed for a few days, don't worry about that, it is OK, it all went very well, you will be fine."

"What was it, was it a boy or a girl?"

"Don't know. Sorry."

He gives me some pads, I find a way to get off the table and am escorted back to the little room with the little couch. The cat is still there, lapping at the saucer. I visualize it full of blood, the cat licking a saucer full of blood with maybe a few chunks of fetal tissue added. I curl up on my side on the couch, trying to survive till it's time for Elinor to pick me up and wonder if I just had a boy or a girl. Oh well, too late for that. Gosh, that hurts!

Elinor appears, gets me into the car somehow, and when we get home I crawl into bed. I stay there for days, pleading a combination of menstrual cramps and stomach flu, which no one disputes. I feel sticky and dirty. No amount of washing removes the smell of cat, of blood, of fear, of pain. I have become unclean. I pass a piece of meat that looks for all the world like raw calf's liver. This strange lump does not cause pain, but frightens me terribly. I am afraid that it is left-over baby. Or perhaps a vital piece of me that has been scraped loose by mistake and I will die without it. I want never to get up and huddle desperately under the clammy sheets.

Elinor and Warren visit. Warren sits down on the bed and takes my hand.

"You're a brave one, kid, I am proud of you."

I smile at him gratefully. His eyes are honest, his smile friendly, as if we are cohorts about to share a joke.

"Now, you gotta get up and take a good long hot shower, and then get dressed because Ellie and I are on our way to Gloucester and we're taking you along. You're gonna be just fine. OK?"

"OK. You sure it's OK?"

"Yep. Sure."

So I soak in the shower, wash my hair, put on make-up, get into fresh clothes and limp off with my sister and her wonderful mate. I curl up comfortably in the back seat, and when we get to Gloucester, we sit on the sand eating fried clams from Bob's Clam Shack and bask in the sun at Good Harbor Beach. Maybe I will be OK after all. Maybe.

Life at home resumes its rhythm. Years ago, when Mother gave up the piano, she took up writing. Most mornings, instead of getting bathed and dressed, she sits at the dining room table in her grimy white terry-cloth bathrobe and writes. (On "writing" days, my playing the piano, listening to the radio or making any other intrusive sounds is life-threatening.) She writes all day until just before it's time for Daddy to come home, when she suddenly metamorphosizes into a housewife, complete with dress, shoes,

stockings.

Mother is still writing the book she began those years ago: A biography called *Isadora,* which appears to be a rendering of her life. Sometimes she reads me passages. Isadora is a living saint, a sanctimonious martyr who overcomes with flawless virtue all vile torments and adversities flung at her by such base and heartless protagonists as her husband and children. Everything I despise is glorified in *Isadora.* Her version of reality is so blatantly self-serving, contains such maundering spirituality, self-pity, inflated grandiosity and cheap sentimentality that when she reads, I can barely contain myself. Three paragraphs of *Isadora* are enough to send me raving to my room in unreasonable, uncontainable rage, the depth and source of which are unfathomable to me.

As for Daddy, his costume jewelry factory in Providence also employs his current mistress, a large woman named Rose who is the resident jewelry designer. Fortunately, he pays little attention to me and often stays in Providence during the week.

If I do my chores and don't argue with Mother, I am left alone. I can spend time with Reba and we have fun going to the movies and flirting with guys on the subway. There is even a beau. Name is Eddie, just back from the Navy and ready to start life. Eddie, thank goodness, is chaste and respectful. He is safe company and a bit boring. But it is good to be liked, to be respected, to be a decent girl without a rep.

Warren keeps an eye on me, as well. He says nothing, does nothing very differently, he just seems to be there more often. Perhaps this is because he and Elinor are now making serious commitment plans. In any case, I am grateful for how he includes me in their life, offers me friendship as an adult, often takes me along on their excursions. Elinor does not seem to mind. She must be thanking her lucky stars that her methods of birth control are working. Maybe sheer relief causes good humor.

Summer passed too quickly. I dreaded going back to school. My grades were barely average, I was facing a new roommate. Carrie had bowed out. She cited pledging to Delta as cause for leaving, wanted to room with a sorority sister. My new roomie would be Joan from next door.

MacKinney was going to room with Brad, and they were both thinking seriously of pledging to Sigma Phi. This frightened me. I prayed that MacKinney would keep his mouth shut about the abortion. I knew I was skittering at the edges of a "reputation" and that was scary.

September, 1947, and the situation at school was worse than I thought.

Billie's "Good Morning, Heartache, Sit Down," was the anthem, suicide the only reasonable outcome.

The sun shone, the campus was abuzz with all the new freshmen milling about, pursuing excellence, searching for love. And at least one of them found exactly what she was trolling for. She found MacKinney.

Her name was Mary Ann Jones, a righteous Catholic girl from Pittsburgh with a long, lithe body, lots of expensive clothes and—when it came to dealing with potential rivals—the disposition of an irritable tiger.

Mary Ann, in fact, was everything I wished to be that I knew was unattainable. Even her family was part of her success: Mother had been a Delta girl, Daddy—who owned a steel manufacturing business—a Sigma Phi. Everyone wanted to be her roomie, especially MacKinney, who promptly pledged to Sigma Phi when Mary Ann went Delta.

After meeting with me a couple of times in the Student Union, MacKinney simply disappeared from my life and popped up in Mary Ann's. Was I jealous? Was I insane? Did I pray for retribution, peer from the crack of my window-shade to watch them wander arm-in-arm? Did I scream silently when I saw how he looked at her? Yes!

The same moon-struck, mindless, goopy gaze with which I had worshipped him was now his. And his eyes so warm, his smile so loving as he escorted her to class, to lunch, to breakfast, to dinner, always with a protective arm around her long, supple waist to keep her from harm, to keep her from me. His face eternally turned to her, even his tennis game neglected.

I raved, but there was no one to hear. My new roommate, Joan, listened politely enough, but she seemed uncomfortable with me even when I was calm. By October, she let me know that by spring semester she would be moving in with someone else.

One evening, Brad comes calling. Says he wants to spend some time getting to know me. Brad is now a big man on campus. He started out as spokesman/advocate for the veteran students, from there became an important member of student council and is now liaison to the school administration. Brad oozes respectability and power. With any kind of luck, some of it might rub off on me.

We go to the Student Union (where—oh what a relief—folks greet us both), he buys me a Coke and then takes me for a walk to the cow pasture. I watch us as if from afar. Watch me wrestle ineffectually, hear me whispering, "No, please." Watch me wishing desperately to somehow stop him without knowing how. Watch me, inert, powerless, hopeless, a flaccid object submitting in silent outrage to great sorrow. I search for feeling and

find only shame. Afterwards, he says, "Yeah, well I heard you were easy," and walks away. It is official. I have a rep.

Somehow, the time passed. The campus was a Sane Asylum where I was the only crazy. I wrote to Eddie, wrote to Reba, pretended I was fine. But the shame, the shame burned with such a dark and searing flame. At the Student Union, girls giggled, guys leered. In the night, knocks on my dorm window woke me, caused frantic burrowing under the pillows and wrecked sleep entirely. I did the only thing I knew how to do, which was to dive back into my almost-forgotten, long-neglected Antarctic sanctuary where there was nothing, where there was cold and silent peace.

Warren and Elinor got married during Christmas vacation. The wedding was a crystal respite from insanity. For a brief moment I experienced love, even if it was vicarious. Elinor became "Ellie," Warren became my brother, they moved into a sweet apartment in Waltham and I had a family. Even in the middle of the wedding excitement, Warren took time to talk. We discussed my transfer to another school and he promised to explore this with Mom and Daddy. Warren, my brother, the excellent hugger. An official ray of sanity at last.

Sure enough, during spring break, I persuaded my parents to allow me a transfer to American University in Washington, DC, next fall, citing their top English Lit program as reason. I told them Bethany was too provincial and elaborated about having to argue with the music professor over fugue structure. Warren had prepared them well. They bought it, hallelujah, and American University somehow accepted my less-than-perfect grades. If I could just manage to survive till June, all would be well. At least no one knew me in Washington.

Chapter 8

Love and Marriage

1948: History was still marching along, but now it was a brass band parade with banners waving as Israel became a sovereign state. I was so proud of us and cheered from afar at every headline. Israel a nation! A Jewish homeland at last, a bastion of courageous survivors. What a blessing, what a glorious beginning.

That summer, I begged for time in Gloucester. With no more rhyme or reason than any of their other parental decisions, Mother and Daddy suddenly agreed. "Yes," they said, "that sounds like a good idea," and July first, right after my twentieth birthday, they cheerfully installed me in a room at the little guest house at Rocky Neck. What a gift!

There I sat, alone, un-monitored, given enough money to last till September and no instructions whatsoever. Was I in heaven? Did God have mercy after all even on his crawliest worm? I looked out the window, smelled the air and promptly called Reba.

Reba was delighted to come. As far as Mother and Daddy were concerned, I might just as well have fallen off the planet, and they never called or checked up on me. Not only did I have the ocean, peace, and sanity—at last I had a decent roommate!

Our summer was created by an artist who painted in pastels, used only the most beautiful scenery and ate good food. We had ritual, we had fun.

Every morning we hiked up to Good Harbor Beach with our portable radio, our blanket, suntan lotion and cigarettes. Each day had its rhythm, its predictable routine.

Early, while the skies were still misty, the surf whispered to the gulls and shorebirds who called back as they hopped and strutted. There we sat, sharing silence, watching the life-guards prepare to rake the beach. The noise of their strange contraption—a kind of Sand Zamboni—was the first human intrusion and a signal that phase two was about to commence.

Phase two came as the sun began to shimmer and the initial tourist surge claimed blanket space. The portable radio began to sing, toddlers began to wander, their little bellybuttons steering them through the sand. Suntan lotion

appeared, sweatshirts got lost, friends hollered.

By noon, the beach was a mass of bodies, locals, tourists, all ages, all sizes, sitting, lying, playing, running, losing-and-finding their offspring, eating, flirting, ogling, smearing each other with lotion and roaring into the water. Now, the sand was so hot everyone had to skip rather than walk, now the icy Atlantic beckoned. Running away from the heat, running toward salvation we plunged, we screamed, we threw ourselves away from potential heat-stroke into the mercies of that wild, wet lover who let us body-surf to our heart's content, until we were blue and chattering. Now, the life-guards checked their little boat, patrolled along the shallows and made us all feel safe and protected.

There were two of them, two lifeguards. There was chocolate and there was vanilla. Chocolate was Joe Paynotta, a Portuguese marvel of flashing white smile complete with elongated dimples, aquiline nose in sculpted brown face, eyes that shone like black diamonds and a body apparently created simply to astound: The dark brown shoulders were too wide for reality, the waist too small and the buttocks two round miniature beach balls that bobbed enticingly under his tight little trunks.

Vanilla was Gardie Gardener, who looked exactly like Joe, except that his tan was golden rather than dark brown, his hair blonde and his eyes borrowed from someone's sapphire collection.

They walked the beach together, wearing their little red trunks and beige pith helmets. One could track their path by the turning of necks along their route. Females of all ages seemed impelled to report lost wallets at least twice daily, ask endless questions and occasionally let their bathing suit tops fall perilously close to disaster when they bent to adjust them as the guards marched by.

Joe and Gardie were impervious to it all. They smiled, they answered the questions, looked for the lost wallets and modestly averted their gaze from runaway bosoms. Reba and I loved watching the show but were not contestants for the prize. Perhaps that was why they sometimes stopped at our blanket to chat a bit or bum a cigarette. We welcomed them, felt flattered, believed Joe and Gardie were simply part of the Good Harbor Beach magic, where only peace and beauty were allowed.

We stayed at the beach all day, Reba and I, not talking much, swimming when the heat prodded, rubbing lotion on each other's backs, watching the action. In late afternoon, we marched back down to Rocky Neck and headed straight for the tiny gift-shop-cum-restaurant whose specialty was lobster salad rolls. These were hot dog rolls filled to overflowing with large chunks of claw and tail all done up in a magic salad dressing. One of those with a

cup of tea was enough to last till next morning.

Evenings, we strolled along, window-shopping in great and serious detail whatever was being displayed. Perhaps there was a bed-time ice cream and that was the end. Sun-seared and exhausted, we fell asleep early. Nothing was more serene, nothing more restorative. Life had declared a truce. Some blessed Hand stroked my bowed head, dried the unshed tears, healed the deadly wounds. I peeked out from Antarctica, sniffed the briny Gloucester air and was content.

After awhile, Reba had to get back to her dad and I was on my own. Nothing changed. The beach days at Good Harbor, the lobster rolls, the evening walks continued. The sameness, even to the identical daily meal, was part of the cure.

Predictability was safety. If nothing changed, no harm could come.

Joe brought his girlfriend, Ginnie, over to my blanket. "You looked lonely," he said, "so Ginnie and I thought you'd like company." He was right, Ginnie was great fun. Blonde, pretty and sensible, she was a summertime waitress at one of the fancy Rocky Neck restaurants, and came to the beach on her days off.

Joe and Ginnie were a perfect match. She was the calm breeze to his hurricane. His voice was excited high tenor, hers, slow rich alto. He worked the fishing boats in off season, she, fresh out of high school, lived at home where she helped out. What they had in common was kindness, loyalty, a great love of fun, of the ocean and of each other. They were a message, a sign that love could happen, that people could truly care about one another. I sighed with contentment and let the days slip by, each one a jewel of great and unimaginable value, wisely spent.

Then came Warren and Ellie, bouncing into town ready to rumble. Warren's good friend, Charlie Stabile, was heading a dance-band at the Rocky Neck Inn and we were all going to be the designated cheering section. Warren said, "You come along, Doris, you get dressed up and you better come." He looked at me with such mischief, I gave in and got all dolled up—which I had promised myself never to do again, never, at least not here where the daily outfit was a bathing suit and a sweat shirt, with maybe jeans added on a cool day.

Warren inspected me more carefully than usual, looked at every detail—even my fingernails— and finally pronounced me suitable. "What's up?" I asked, but he only laughed.

"You'll see," he said, "now come on."

The place was so dark one could hardly distinguish faces, but the bandstand was brightly lit, the musicians shining in the spotlight. The music

was good, I was surprised. I had thought Charlie a dilettante. Children of an old Italian banking family, he and his sister, Ella, had never held jobs. They led honorable lives, occasionally making their presence known in the bank boardroom and pursuing their various hobbies. Charlie had an such an open, cheerful, laissez-faire personality, I didn't think he would provide the discipline needed to keep himself, four other musicians and a vocalist on track. Also hadn't realized Charlie was an excellent pianist with good musical taste.

This music was eminently danceable. The repertoire consisted of popular standards played in tight arrangements and with just the right beat. "Blue Moon" hovered "Somewhere, Beyond the Sea" and set my toes to tapping, my head bobbing.

Yes, this was a splendid idea. "Warren," I said, "For an old brother-in-law, you ain't too shabby."

Warren said, "Hey, you ain't seen nothin' yet," and asked me to dance.

I check out the musicians. There are two trumpets, a saxophone who doubles on clarinet and a drummer. The drummer. Dark hair receding from a widow's peak, expressionless black eyes. "Hmmmm." I feel Warren watching me and say, "Hey, who's the drummer?"

Warren looks bemused. "Wait," he says, "just wait."

At break, the guys come over to chat. Warren buys drinks for everyone, and they all introduce themselves, sit and chat. "What a nice bunch of people," I decide. "Wow, they're all so friendly." And they truly are.

First trumpet: Larry Murphy from Somerville, young, innocent, ebullient, looks like he's still in high school. Second trumpet: Tim Divine, dark, shy, intense. Serious Education major at Boston University.

Drummer: Bill Grant. Quietly charming, makes all the right pleasantries, sounds almost rehearsed. His eyes tell me he knows I have been watching him. He is sizing me up, too. "Hmmmm," I think, "glad Warren got me into these heels after all."

Vocalist: Tommy Furtado. Slender, delicious, brown eyes with lashes out to here. A wonder man, complete with the smile and the innate strong presence of a star in the making. His handshake firm, his attitude sincere, he radiates professional confidence. Tommy also knows how to sing. He wraps his silky baritone around the lyrics so smoothly, abandons himself to the music with such generosity, that the old standards spark and flame. "Good as Sinatra," I judge. "Exquisite phrasing. The real thing. We'll hear from this one on the radio someday, or maybe Broadway." I tell him, tell Charlie.

Charlie says, "Crazy, Man."

Tommy says, "Hey, this chick's a gas," and the voltage in his smile goes up two degrees.

Saxophone player: Nowhere to be seen. Warren keeps craning his neck and looking toward the doorway. Charlie looks at his watch, fingers drumming on table. I see their eyes meet, they smile at each other and shrug.

Next break, Charlie comes to the table with the saxophone man in hand. Warren stands up. "Have a seat for a minute, Gene. Let me buy you a drink." He and Charlie exchange looks again, smiling at each other. And Gene sits.

Everyone congregates. The waitress pushes two tables together. Larry tells "knock-knock" jokes, Tim sips his drink and smiles a bit, the drummer somehow gets shuffled to the farthest end of the two tables, Ella and Don laugh at Larry's "knock-knock" jokes, Warren and Charlie wind up on either side of the saxophone player and me, hemming us in, pushing us together.

"So, hi," says he.

"So, hi," say I.

"Cigarette?"

"Sure, thanks. So, what do you do when you're not playing music?"

"I'm in Gloucester for the summer, actually. I'm working in a jewelry store here in town all season, till school. How about you?"

I look into his eyes, decide to flirt, get the right combination of banter, interest and sincerity going, add sparkle so he'll know I'm gently teasing: "I'm in Gloucester for the summer, actually. I'm lying on the beach here in town all season, till school."

Gene's eyes are blue, thick hair tightly wavey blond, smile shy. He stirs his drink, takes a drag of his cigarette and says, "That beach you lie on, is it Good Harbor by any chance? My uncle has a house across from Bass Rocks, right by there. Good Harbor is great."

"Yeah, Good Harbor. Good Harbor is good." I allow my eyes to greet his soul. He clears his throat and—for a flicker—our hands brush as he dumps the cigarette butt.

Right then, break is over and they all disappear en masse, like migrating swallows suddenly vanishing from Capistrano. The music starts, Warren beams, Gene-the-saxophone-player has turned in my direction. "At Last," he plays it so fine, plays it just for me.

Of course, we're back tomorrow. At break, I seek the drummer, but he and Charlie have some business that keeps them away. Gene, however, is pleased to sit. "We never really got formally introduced," he says. "I'm Gene Colmes."

"Doris Goldsmith. Pleased to meet you, Gene."

We smile correctly, shake hands and then there's a pause. I have to think

of something quick to say.

"So, where do you go to school, Gene? What's your major?"

"Suffolk, business major. How about you?"

"English Lit, just transferring to American University in D.C."

"What do you like—as an English major, I mean—what do you like to read?"

"Oh, classics, mostly. Stuff I almost understand, know what I mean?"

He looks into middle distance, clears his throat and suddenly begins reciting Chaucer:

"When that Aprille with his shoures sote,
The droght of Marche hath perced to the rote,
And bathed every veyne in swich licour,
Of which vertu engendred is the flour;
Whan Zephirus eek with his swete breeth
Inspired hath in every holt and heeth
The tendre croppes, and the yonge sonne
Hath in the Ram his halfe-cours y-ronne
And small fowles maken melodye."

His delivery is flawless. He rolls the Old English "r" with just the right trill, clearly understands the rhyming pattern, knows how to pronounce the final "e" of words. He has given the *Canterbury Tales* the gift of his shy youth, of his music. "And small fowles maken melodye," indeed. I sit and stare, for once speechless.

He is watching me carefully. "Yes," I say, "yes, that's how Chaucer meant it. Where did you get that understanding, that accuracy of mood?"

"I dunno," he answers, "it just happened."

Right then, I regard young Mr. Colmes differently. He has just serenaded me as purely as any medieval swain under a maiden's balcony. He has sung Chaucer to me. No one has ever even come close to taking such a risk for my sake. Gene is suddenly a person of great interest.

At next break, we are friends.

"Want to see where the peasants live?"

"Well, yeah, sure, where?"

"Up in the attic. Can you stay till after the gig and I'll show you."

Warren, who somehow seems to be aware of every word, answers for me. "Sure," he says. "Haven't seen a peasant attic in some time. What say we go for breakfast after? My treat."

The peasant attic turned out to be a large, airy, former balcony now closed in and outfitted as a dorm. Personal belongings were strewn everywhere, beds were unmade and there was a large electric phonograph sitting on a stack of suitcases in the middle of the whole mess. Gene went directly to it and all of a sudden, there was Ella Fitzgerald at her best. "How High the Moon" was the tune, which she twisted, turned, challenged, made love to and finally brought home to Valhalla, to paradise. "Whoa," said I, "what is that? I need that. Where can I get that?" and jumped off the bed.

I hadn't been in touch with jazz for years, hadn't heard Ella since—"A Tisket, A Tasket"—she lost her yellow basket. Jazz had drifted away when we moved to Brookline, replaced by the usual pop stuff to which I paid little mind and by Arturo Toscanini who had my heart no matter what he conducted.

"Gene, that is the best thing I've heard in a long time. You just gave me a true gift. Got any more like that?"

Gene looked as pleased as if someone had just appointed him president. "You like that? Whoa. Yeah, I've got more. Ella is my Queen but Billie is Empress. You know her, Lady Day?"

Did I know Billie. What a question. I no longer had to make up topics of conversation with this guy, this guy was real and I wanted his music. Ella had just rattled all my molecules, rearranged them and brought them back down in a slightly altered pattern. Even Reba didn't know good music. I thought it was just me and the girls at P.S. 151. Much to my credit, I stayed calm.

"Yeah, you're right. Lady Day rules. But I haven't heard her in a long time."

"Well, my day off is Sunday. If you like, we can go to the beach and maybe stop at my Uncle Abe's house and then maybe come back here and listen to some stuff."

"Yeah, sounds great. Pick me up at the guest house?"

And so we began. Gene healed me like balm from heaven. He was gentle, he paid attention to everything I said, laughed at my jokes, hovered, protected, loved music, loved the ocean. No one had ever cared what I thought before, or been so kind.

Warren and Ellie went home, I went to the gig every night, was designated as "with the band" and didn't have to pay the cover charge. Reba came out for a weekend and placed her seal of approval on us. I re-discovered music. Be-bop had blossomed while my back was turned, and I had a lot of catching up to do.

Gene's record collection was limitless. Every once in a while, he drove

home to Brookline for a fresh batch. I fell in love with Dizzy Gillespie right away and talked endlessy with Larry about "flatting the fifths" in the band's arrangement of "The Peanut Vendor." (He said, "Never.") Then came Dexter Gordon and Illinois Jacquet, Gene's saxophone idols. I loved Jacquet's brashness. He played like he was giving the world "the finger" and was good enough to get away with it.

But above all, there were Lady Day and Ella Fitzgerald. All of us worshipped at their altars. Two such different views of the world: Ella had a vocal purity, a young girl's innocence incongruously delightful against the sophistication of her "scat." And Billie had been to hell, had burned, had been killed and resurrected. Yes, she had emerged from fire and brought back crystals transformed into diamonds. She sang for me, sang my life. We spent hours listening, the musicians learning, the rest of us grooving. Man, we were Hep Cats, every one.

Everyone was good company. Charlie—who seemed older than Warren, maybe even over thirty—functioned as parent, keeping order without even appearing to do so. His wife, Sylvia, came out for the rest of the season. Sylvia was Hispanic, wore her hair severely pulled back, had the looks and grace of a flamenco dancer. Her eyes flashed, her smile glistened and she took no sass from anyone. She was my age; I admired her greatly, wished I had her command of life. We got along splendidly.

Going out with Gene was a group activity. We were a pack of rowdy puppies, playing in the sand, having late-night picnics, singing along with Tommy-the-choir-master, making each other very, very happy. As soon as they met, the group absorbed Joe and Ginnie, who then showed up every night, the minute Ginnie got off from waitressing. Our "with the band" table was full and getting fuller.

This was my first unconditional group inclusion. Acceptance made this puppy's tail wag with wiggling excitement. Every day was sunny, every night a new adventure.

Where was the catch? Where was the string attached? I looked, examined, couldn't find anything wrong. There was no catch; Gene loved me. I could tell it was real because he looked at me like I looked at MacKinney. After each kiss, I recognized my eyes in his face.

The jewelry store where Gene worked turned out to be his dad's. Mr. Colmes was in the jewelry store liquidation business. He bought stores that wanted to go out of business and then ran the "Going Out of Business" sale. Gene explained: Mr. Colmes and his brothers had gotten their start working scams in traveling carnivals. There, they ran booths with "bargains," with fake auctions; you name it, they knew how to do it. Now they were

respectable and only did it in jewelry stores where they cheerfully marked up prices so that they could mark them down again during the sale and give everyone a good bargain. Sometimes they ran jewelry store auctions, but this depended on the city ordinances of a store in question. Everyone had a good time: The customers (all named "Mark"), the clerks and most of all the Colmes brothers who stayed in a town for the three months or so it took to liquidate a store skimmed daily profits "off the top," and celebrated every night in their hotel rooms.

Every once in awhile, Mr. Colmes became attached to a store and kept it. There were two other permanent stores: A small one in Portland, Maine, and a huge, high-class emporium—"A regular Tiffany's," said Gene—in Grand Rapids, Michigan. Gene was the family apprentice, and Gloucester seemed like a good place to break him in.

Gene picks me up for an after-the-gig beach bonfire picnic. But when he comes to the door he averts his eyes. When I open my arms and rush for a hug, he steps back leaving me standing on the sidewalk with arms outstretched, like Jesus. He slams himself into the car and drums his fingers on the steering wheel while I fiddle with the passenger door. I get in, say "Hi." He shoots me a withering sideways glance and remains silent. This is very scary; I am afraid of his anger. What is he mad at, what have I done, what about me is suddenly despicable?

At the bonfire, he goes quickly to help Joe Paynotta carry wood, then seats himself with Larry. Larry says, "Hey, have you read *Over the Cliff* by Oliver Sudden?" Gene looks away. Time drags. I don't know what to say, or to whom to say it, am stiff with shame.

Eventually, he comes to where I sit stricken and says, "You want to eat?"

Now's my chance. Maybe I can fix it: "Gene, I am so sorry. Can you forgive me?" I have no idea what I'm apologizing for, but the process seems to work.

There is a long pause, then Gene turns away from the fire and looks down at me bitterly. "You committed for us to come to this picnic and you didn't even bother to consult me. Don't ever do that again. That was really dumb. What am I, a nobody with no mind, with no opinion? What if I wanted to do something different? What if I hate bonfires?"

I resume the mea culpa, apologize abjectly for acting without him, and eventually he sits down next to me, grumpily offers me a hot dog. Larry hollers over, "Hey Gene, have you read *The Russian's Revenge* by Ivan Tortittsoff?" Gene, at long last, laughs. I release the breath I've been holding, sigh with relief. Boy, that was awful. But at least I've learned how to fix it.

And know what not to do again.

Gene tells me Colmes legends. The family immigrated from Russia early in the century, changed names from something akin to "Kolomeitz," and the "boys" scrambled hard for the American Dream. Isidore, Gene's dad, began by selling umbrellas from a pushcart before graduating to the carnival and never lost his edge, his contempt for "the sucker—the Mark" who was always also his good friend. All five brothers were in "the business," except the eldest, Uncle Abe, who became a doctor.

"They think he's God, but he's a jerk. Got an ego. You know, Jewish Royalty, 'the Doctor.' I'm surprised they don't all bow when he walks in. You'll see."

We are sitting on the stone wall of Eastern Point Road, having a cigarette. Behind us, the tame water of Niles Beach ripples sedately, carressed into gold by a full moon. We are a romance movie. Gene's arm is secure around my waist, his kisses are warm, passionate without being sloppy. When Gene kisses me, I feel so loved, cherished, safe as Ginger Rogers in Fred Astaire's arms. I float, I love the love, my soul purrs.

"Gene, say some more Chaucer for me, it's so good, y'know, how you do it."

"I said it already. That's all I know."

"What do you mean, 'That's all I know'?"

"Well, I was in prep school and I liked how the teacher said it, so I said it, too, those lines, and they just stuck. No reason, there wasn't a test or anything. Don't even know what it means. Came in handy, though, sure worked. Gotcha good, huh? Bless prep school, that's what I say."

For a moment, I stare at him. He is looking at me, holding his breath, waiting for the verdict. He's a little kid, braced for a spanking but his hand—still greedily foraging in the cookie jar—has just found the biggest chocolate chip. He can't decide whether to be a vulnerable orphan pleading for life, or a gleeful imp jumping out, waving the cookie. His eyes are sparking, he wants so badly to laugh but he's too worried.

Then I start laughing and can't stop. The joke's on me. I got hooked by nine lines of poetry and he doesn't even know what they mean. "Got me good, I'll say," laughing so hard I'm almost falling off the wall.

We can't stop laughing. We hold onto each other to keep from falling. "Gene, you're too much. That's the funniest thing that's happened to me in years."

He looks at me as if I'm the Statue of Liberty, suddenly directing all the marine traffic in New York Harbor with her torch while Fourth of July

fireworks erupt overhead. Then his eyes fill up; he whispers:

"I love you, I love you, I love you. I love you, Doris, I do."

He is cradling me now, saying it into my ears, my eyes, my mouth, my neck. "I love you" becomes his breathing, is purified by his tears. "I've never said that before, never, and I'll never say it to anyone else. Please, I love you, please, always, always, I love you."

Yes, I will be his. I am certain. I am his MacKinney; he will love me forever. I will stay with him gladly. Such love does not come often and it is to be cherished, nurtured, honored. I am terribly happy. And terribly sad. We walk back to the guest house, without a word, knowing more than we can speak. At the door, he bends to kiss and I whisper into his mouth, "Ah, the yonge sonne."

July is almost over; we still have August: A beach of Sundays for Gene to tell me of his family, of himself. He has an older sister, he says, his dad travels a lot. "And," he tells me shyly, "I used to be real fat. I was fat in high school and I was fat in prep school and I stopped being fat just a couple of years ago. I hated it. I hate fat, I really hate fat."

Yes, I know about that, understand how much courage it takes for him to tell me, but keep quiet. This is his story and I want to hear it.

"It's hard, with my dad, y'know? He got drunk the day of my Bar Mitzvah. He came to my room and he said I was nothing but a fat pig and I wasn't even worth having the party. He said I was a Mama's boy and a sissy and he was ashamed of having me around him. There was a baseball bat there, leaning up against my bed. I knew if I picked it up and hit him with it, I would be safe from him forever. I knew this was a test. 'Today I am a man,' you know? I had to hit him with the bat or fail, I wouldn't be a man. I knew that, and I almost picked it up, but I didn't, so he won, and he knew it and I knew it and he just sneered at me and turned around and walked out. But I'm a man now, I have you, with you I am a man, you make me know that."

He is lying on a beach towel, his head in my lap. Oh yes, I know, I know, and bend down to kiss his eyes. "Oh Gene, I love you."

I've been at the Meyerowitzes', sitting for a portrait, and Gene picks me up there for a cook-out at Uncle Abe's. That "house across from Bass Rocks," which I thought would be one of the countless small places scattered along the winding roads between the cemetery and Eastern Point Road, turns out to be one of the Bass Rocks mansions. These places face the ocean, hidden behind ornate fences with only the immense pillars of their front verandas visible. The small, two-lane road separating them from the Bass Rocks cliffs

sports large, red "No Parking" signs along its length and is often patrolled by private, unmarked security cars.

Uncle Abe has a mane of gray hair, a decided Yiddish accent and piercing, wintry eyes. He looks me up and down so intently that I almost drop a curtsy. He says, "You two are a bit tardy. Where have you been?"

Before Gene can answer, I take the blame. "My fault," I say, "I was sitting for the Meyerowitzes and I had to wait for them to quit."

Uncle Abe's eyes widen, lose their glare and become benevolent as a priest forgiving a sinner. "The Meyerowitzes? You mean William? You sit for William Meyerowitz? How is that, please?"

"They're kind of, you know, almost family, so I have to. I'm sorry we're late."

"Oh, no, it's fine, come in come in, have a seat. Gene, bring Dora a cold drink, come sit here, talk to me. You look just like a little *schiksa,* Dora, what a *punim*, no wonder Gene is so happy lately. So what is Meyerowitz painting this summer?"

It turns out Uncle Abe is an art buff and a Meyerowitz fan and Billy is my passport into the realm of Colmes, but I am much too intimidated to tell Uncle Abe my name isn't "Dora." If he's such an art buff, I grumble, he should know that Dora belonged to Picasso. I look around. Very fancy but singularly tasteless. Hmmm, *nouveau riche*? Calls for excessive politeness. Maybe I just should have curtsied, he'd have liked that. But I'm in; Uncle Abe has given his seal of approval. He smiles at Gene over my head. "Good boy," says the smile. "Good."

In August, my parents come to visit with the Meyerowitzes. There, I introduce Gene, upon whom they bestow approval while Warren stands by, grinning affably. Billy serves his usual treat— cantaloupe with the seeds still inside (because, he says, they're good for the digestive tract) and vodka. Everyone seems to get along just fine. But I have yet to meet Gene's parents and they sound formidable, especially Mister, who I hope will be sober. "Whew," Gene and I complain to Warren, "this can be scary."

Warren laughs. "Families are weird. It's OK."

We are sitting at the band's table, just before it's time for them to begin playing. Gene takes me aside. He is agitated. His eyes shift all around, looking every place but at me; he lights a cigarette, takes a drag and puts it out. He picks up Larry's drink and swallows it in one gulp. Is he angry? Have I done something wrong again? I'm afraid to ask. Then he says, "My, ahem, my brother's in town. He's coming here. He'll be here later," turns on his

heel and abruptly climbs to the bandstand. He fiddles with his saxophone, mouths a new reed, turns his back.

Brother? What brother? I've only heard about an older sister, Florence. Never heard about a brother. Hmmm, brother, eh? Maybe he's older, maybe he's dark-haired, maybe he's exciting. I could definitely go for an older, darker, slightly more urbane brother. So why is Gene so pissed about it? Beats me. I stir my drink and anticipate a new adventure in which older brother and I are seen in Paris, holding hands at a Left Bank bistro, chatting with Hemingway. Hemingway says, "Hey, you really know your Chaucer." Brother smiles modestly and sips his absinthe.

At break, Gene walks over to the table with a guy. The guy is tall, fat, homely. Greasy, thinning, brown hair slicked back. Face looks deformed, as if someone had delivered him from the womb by grabbing his head with an ice-tong because it was stuck. The whole head is elongated, kind of like a summer squash. Eyes are tiny, set close together and the lips are pendulous and loose, as if the ice tongs maybe hadn't worked and the mid-wife finally got the infant loose by grabbing its mouth and pulling hard. "Doris," says Gene, "I'd like you to meet my brother Bobbie. Bobbie, this is my friend Doris," and without another word, he is gone.

"Well, so much for Hemingway," I say to myself, and to Bobbie, I say, "Well, hi there. Pleased to meet you. Have a seat."

Bobbie, his lips a bit too wet, says, "Well, I am pleased to meet you, too," and sits down.

It is clear that Bobbie is slightly retarded, but it only takes a minute to get into his rhythm. He wants to know how we met, listens carefully and smokes a lot. He nurses his beer carefully, making it last. I am relieved. At least he won't be drunk. I ask him how he likes Gloucester, tell him about the very good beach. We are getting along well. Bobbie may be on the slow side, but he is a good guy. He squints through the cigarette smoke, wipes his lips enough to keep them mostly dry, and tells me his baby brother is a very nice boy. I tell him I believe the same, and so we become comfortable with one another. I listen to his stories, he talks, smiles. During breaks, Gene disappears with Charlie, does not come to our table. By eleven o'clock, Bobbie says, "Well, it's late, I gotta drive back to Boston. I really had a good time. Gene is lucky. I'm gonna tell Mom, Gene is lucky." And he is gone. I breathe a huge sigh. OK, so brother Bobbie is retarded. Now what.

When Gene finally shows up, it's almost closing time. He is fidgety, his eyes jerk around the room, he looks ready to either fight or flee but cannot decide which. I say, "So, your brother is a good guy, Gene. We got along good. Where were you, anyway? We missed you."

Gene sits down at the table, suddenly, heavily, looking at his shoes, at the ceiling, at his whiskey glass. "Yeah," he says. "Yeah."

On the walk home, he holds me tight. At the door, he takes my head in his hands, looks into my eyes at last and says, "Thank you. I'm glad you got along." Then he is gone.

I go to bed, musing. "Ashamed, he's so ashamed. Bobbie's not that bad. What's he so ashamed about? Gotta be a family thing, a family shame. Oh well.."

August self-righteously declares itself fall's messenger. Just for emphasis, it has produced a drizzly night, the wind a bit too harsh, the air too chilly. Gene has wrapped his band-jacket around my shoulders and we are huddled together, walking home from the gig. When we get to the guest house, Gene follows me upstairs. Not a word is said but I know what's coming. I don't want it, don't know how to stop it, there's no escape, it's going to happen and there's no one to help me. "Oh God, please," but God is busy elsewhere and there is only Gene standing in front of me, undoing his necktie.

His kisses are gentle, he's down to his shorts and undressing me. I don't know how to not let him. I think of MacKinney and his strange brutality. Gene is not like that. He touches my face, kisses my eyes, arranges us on the bed so that we can both be comfortable. I wish MacKinney could have been like that. Gene touches my breasts and I want him to be MacKinney.

Then, Gene moves himself, the shorts are off, he hovers over me, he is about to enter and as he descends I see a strange, horribly pendulous piece of belly hanging from him, wobbling, like a deflated inner tube, flapping in a breeze of its own making. Horrified, I realize I am looking at some kind of deformity and in that instant, Gene enters me and I break. MacKinney crowds in, with his pain and blood. Brad is standing in the shadows, laughing, calling me "slut." There's a huge gray cat sitting on the bed, watching, its whiskers stained red with fetal matter.

Gene enters me and there is no stopping the tears. I don't want to cry; I want to stop and there is no stopping. I am done. Hopeless, forever doomed to be a slut, to be a piece of meat, without MacKinney, without love, no one, nothing, I don't want to do this anymore, I don't want this without MacKinney.

Gene moves inside me, he is looking down at my face, I close my eyes so that he will not see my shame, but the tears keep coming. When he is done, Gene brings me into his arms. He holds me close, comforts me, "Hush, hush, there now, it's OK, my baby, my love, it's OK, it's your first time, it's your first time, I'm sorry, I'm sorry, it's the first time, poor baby, sweetheart,

baby, I love you, love you, hush." He croons it to me, over and over, holding me, loving me, till I am calm, till the tears stop. "Next time you won't cry, I promise," he says, and lights a cigarette. We lie in the dark, holding one another. I cling to him; he is the only comfort in my desolation. I want him never to leave me, never to go away.

Gene takes my hand and puts it on the fold of flab below his belly. My hand sinks into it. It feels kind of like a little warm, soft pillow. "I was so fat," he says, "I never got rid of all of it. This stayed. I'm so ashamed of it. I was so afraid you'd laugh."

"I love you, Gene."

He is lying on his back, my head is nestled safely on his chest, in the hollow of his shoulder. His arm is around my back, one of my legs thrown over both of his. I will never leave him, I know. We fall asleep, my hand resting comfortably just below his little shame cushion.

We're driving to Rockport for an art exhibition. Frank Sinatra is on the radio, "Racing With the Moon." We hum along, I'm about to say that Tommy Furtado's version is just as good, when there's a sudden curve in the road that slows us down abruptly, and in the curve is a very large sign, home-made black paint on white wood. The sign says, "PUPPIES," and without a word needing to be said, Gene turns into the driveway because we are going to have a dog. And there he sits. The homeliest excuse for a cocker spaniel ever conceived. He's blonde, has spaniel ears (almost), a little stubby tail and full certaintude that he is about to be adopted. He is completely confident that he is ours, and he is correct. He costs twenty-five dollars, which is a lot of money for a dog with no papers, but he is so completely fated to be ours that the money is of no consequence. We turn right around and head back to Gloucester. Our doggie needs us.

We name him "Bunzo" in honor of Bunzo Burns, a friend of Charlie's who has a wonderful sense of humor with a bottomless fount of excellent "one-liners." Unfortunately, this guy, Bunzo, thinks it's an insult to have a dog named after him and says he'll never talk to us again. Oh well, it's too late. Bunzo is Bunzo, the doggie "love-child" symbol of our perfect union.

Bunzo has a large wart on his head and is flea-ridden, but other than that, he's perfect. He will live in the peasant attic till the gig is up, but during the day, while Gene is working, he is with me. Perfect equal custody. He loves the beach, plays in the little wavelets at ocean's edge like a baby seal. He's housebroken quickly, knows his name right away and eats whatever we have to spare. Has a disposition straight from heaven, and neither Gene nor I have given a thought as to who will take care of him when I vanish to Washington,

DC, just next month.

The weather is changing, the perfect beach days are winding down a bit. It's an overcast Monday morning, and I'm debating whether to walk to the beach or hitch-hike to Rockport for the art galleries. Just then, the guest house proprietor knocks at my door with a phone call from Gene.

"Hey, are you going to Good Harbor?"

"Not sure yet, why?"

"Well, my dad's in town and wants to meet Bunzo. Can you come?"

"Sure, why not. We'll be down."

Oh, now what? Well, it's only 10:00 AM; he'll surely be sober. I shrug myself into a sweatshirt, pull on some jeans and get the leash so Bunzo and I can hitch-hike into town. We meander down to the store just in time for lunch and maybe a quick trip to Bob's Clam Shack, push the door open and there, watching intently, is Isidore.

He's average height, skinny, but wiry. Stands alert, light on his feet, like a boxer waiting for the next move. Same tightly waved hair as Gene, only his is brown and thinner. Eyes are blue, but not soft like Gene's. This guy has cold x-ray vision, camouflaged unsuccessfully by a wide and chilly smile. Looks at me, through me, makes some kind of life-altering, permanent judgment on what he has just evaluated and extends his hand. To the dog.

"Well, what have we got? It's a baby, a puppelleh, a good boy." And Bunzo, who knows a true friend when he smells one, responds with all the ardor of his puppiehood. He jumps, he wriggles, he licks, his tail goes into propellor mode. The leash gets tangled, dropped and he's landed on Isidore's polished loafers.

Isidore looks up from petting and says, "So, you must be Doris. Pleased to meet you." His voice is metallic, as if he's speaking through tin teeth and resonates with a toned-down version of Uncle Abe's accent.

"I'm happy to meet you, too, Mr. Colmes. Gene has told me such exciting things."

"Well, come in, come in, here, have a seat. Eugene is just around the corner, getting some cigarettes. He'll be back in a minute. What kind of things, exciting?" He directs me to a high stool behind the cash register and there I park.

Isidore switches to "charm mode": Courtly, pleasant, sincere, almost flirtatious. He asks me lots of questions about school, parents, how I'm spending the summer, and gets exactly the answers I presume he wants, delivered in dulcet tones, with my most enchanting smile and just the right amount of direct eye-contact. I know how to do "charm mode," too. Matter of fact, we're about even.

106

Pretty soon, Gene comes in. He's beaming, can tell at once that his dad and I have hit it off. Isidore says, "Dorrie, I hope you will come and visit us in Brookline before you go off to school? Meanwhile, Gene, why don't you take this young lady to lunch? Bunzo can stay here with me, can't you Bunzelleh, little puppy, where did you get such a name, Bunzelleh, come here, come here, good boy. Atta boy. Good dog. Get him a bowl of water before you leave."

Gene and I head for Bob's Clam Shack and order large fried clams, a celebratory meal indeed.

"Looks like Bunzo has a place to stay, huh?'

"Looks like it."

We raise our Coca-Colas triumphantly. As Isidore goeth, so goeth the family.

And soon the turtledoves descended to pay official visits to one another's families. Mine was easy. Apparently Mother and Daddy had done their homework—possibly aided by good old Warren—and discovered that the Colmes family had money and was of good repute, which meant no one was in jail and Florence had gone to college. More than that, they felt no need to know. Gene comported himself most respectfully with Daddy, wanting desperately to please. But Daddy displayed little interest and simply smiled agreeably at whatever Gene had to say. "Fatuous remarks, probably no great brain. Nice enough," was the verdict afterwards. Mother smiled at Gene silently, but with such a smirk, such a downright lurid, indecent leer, that it embarrassed me terribly. Whatever she was thinking, it was filthy and I hoped Gene didn't notice.

The Colmes family lives in an immense home on Clinton Road, where the houses have porticos and maids in uniform are seen shaking dust mops out of the windows. There are a foyer, an immense living room, a den and a solarium downstairs. I see no Louis XIV, Biedermeyer or even American Colonial, but the Persian rugs are excellent and the ambience harmonious. There is a great deal of silver stuff on display. Jewelry store pelf, perhaps?

Mrs. Colmes is "Lee," formerly "Leah," and of all the relatives, she displays the most genuine warmth. I fall in love with her at once. She is small, gray-haired, sports a diamond ring so huge it looks like a transparent lima bean and welcomes me as if we are favorite cousins, re-united at last. "So, come, let me look at you," she says, taking my arm and steering me into the den. "Bring Bunzelleh, he'll be fine." And for once, there is no inquisition about school, about my father's jewelry manufacturing business

or my mother's music. There are just some practical questions about Bunzo's diet, how often he needs to be walked and if he needs the rest of his shots after I leave for Washington. I can't help myself. Her eyes are so kind, they melt defenses like hot chicken soup melts the flu. There is nothing to do but relax. "So, *nu*, Gene has got himself a little *schiksa*. What is there to do, we'll have to manage." She is making a little joke. I laugh a little laugh. I am falling in love.

Then, without warning, comes a sudden apparition. Posing like a gray troll, magically errant from a fairy tale, there stands a woman, wearing the ugliest bathing suit ever seen anywhere. It looks like a caricature of those heavy woolen things women wore to the beach in the roaring twenties. Shapeless, gray wool, clinging in all the wrong places and hanging loose everywhere else. "Well, how do ya like it?" the woman shouts. "What do you think of it, I just got it at *Bests*." Is she kidding, is this a joke, a test, Oh-My-God this must be Florence, and now what? I look into her face, trying to determine what she wants to hear, but Florence has one slightly wandering eye, so I can't tell whether she is looking at me directly or past me. "Hmm," I say, "very interesting. You must be Florence. Interesting suit. Certainly. You'll enjoy, I'm sure. Comfortable. Well. I'm Doris."

I must have passed the test, because Florence smiles and says, "It's a designer original, glad you like it. Pleased to meet you. Gotta go." And sure enough, gone she is. I daren't look at anyone, afraid to find out if they all believe "designer original" automatically means "appropriate," or even "flattering."

I scan for possible escape routes—a sudden bathroom need, perhaps—and there, standing in the doorway, about to enter with a silver tea tray, is a woman in full gray and white maid's regalia, even to the little lace cap. This person is of "bright" complexion, perhaps in her late thirties—whose rich, long, "natural" hair, done in a luxurious bun, crowns her startling beauty. Her bearing is so gracious, so graceful, she looks like a cross between a movie star and a church deacon. She has been watching the scene intently, and when our eyes meet, she suddenly has such trouble keeping her laughter from erupting that only a coughing fit saves her.

"*Oy*, Elma, careful, here let me help you." Mrs. Colmes jumps to rescue the tray and pat Elma on the back. "Elma, this is Gene's friend, Doris." Between Elma's gasps, we manage our, "How do you do's," while simultaneously sharing the joke with our eyes. Elma takes the tray back from Mrs. Colmes and serves impeccably; and, through the years, we continue our eye-contact conversations. They're always pretty funny.

August became September, became Labor Day and the last bonfire roared, Oliver Sudden turned the last page of "*Over The Cliff*," Ginnie and Joe waved, "We'll see ya soon."

And, yes, Gene was right: I didn't cry the second time, or the third, or any other time with him. At best, I felt loved and comforted in his embrace; at worst, I felt nothing. But it was all right, I could live forever on the worship in his eyes. I knew about orgasms, knew they were out there somewhere, in the land of sexual intercourse, but no matter if Gene didn't provide them. I learned to give them to myself.

We hugged good-bye, Gene took me to the airport and cried in my arms. I cried, too. I was scared silly. There was no safety net, no way to prevent a new MacKinney from lurking in the halls of academe. There was only Gene to protect me, and Washington was too far away.

Washington was not just hot; it was so humid that everything stuck to everything else. Blouse stuck to bra, hair stuck to forehead, even toes stuck together inside shoes. Oh boy. The dorm, however, was a marvel. Somehow, I wound up on the top floor of an ante-bellum mansion in an immense, airy, high-ceilinged bedroom that must have once been at least the quarters for important visitors. This was more than luxurious. For a college dorm room, it was palatial. And there was no roommate. My spirits lifted considerably. Unpacking took no time and I was up and out to get registered in less than an hour.

"Pleased-to-meet-you's" were exchanged with my new housemates. They looked just like the girls of Bethany, had the same appraising eyes as they evaluated me from the make-up on my face to the shine of my new loafers. I knew enough to remain quiet. Volunteered nothing, asked nothing. Maybe I could do it this time. Maybe it would all be just fine. But I was worried.

Then, two days after arriving, the guillotine rumbled, its sharpened blade trembled, my neck stretched itself delicately onto the decapitation block. I was dead, the blade didn't even have to fall. My head was rolling into the basket all on its own. Julius called. I had forgotten he was in town, forgotten even his existence. Now, here he was and it was not good.

"Hi," he said, "I heard you were coming down here. How about that. How d'ya like it? Hot enough for you? Say, listen, we're gonna have to get together, y'know? The sooner the better. So, how about a welcome to Washington? Friday? Pick you up at eight? Can't wait. See ya."

He sounded like Brad, he sounded like every Brad in the world all rolled into one. His tone, his words, the way he made our date for us so casually inevitable. He was going to get me, he was going to get himself onto me, into

me in the slimiest, sleaziest way possible and when he was all done, he would probably take out a full page ad in the *Washington Post*, saying, "Doris Goldsmith, bimbo in town, go get her, knock her down, knock her up, it's a freebie." Everything in his voice told me what would happen. Everything in my entire being told me I would not be able to prevent it. And I had only been here two days. I might as well kill myself right now and be done with it. I was ruined. Never make it. And Reba would find out, my best friend betrayed. Dead by Thanksgiving. I knew it. There was nothing to be done. I sat on my bed in the fancy dorm room and wondered where to get some cyanide.

The next day, there was another call. This time it was long-distance. This time it was Gene. Gene said, "Come home. Come home on the next plane. We're getting married. I can't make it without you. Just come home."

"Gene, your parents, my parents, how can we? Can we? Is it OK?"

"Yes, yes, yes, they all say it's OK. Call your folks right away, oh, come home, come home, or I'll come down there and bring you back myself."

"Oh, yes, oh yes, oh yes, Gene, Genie, Genie-oh, yes, I will. I'll call you back soon as I make a plane reservation."

And I went, and I did, and I said, "Good-bye" to the girls on the dorm floor and got my tuition deposit back, packed in fifteen minutes and by the weekend I was home. Safe in Gene's arms, safe from the world, from all the drooling, evil Juliuses and Brads, safe forever. Gene, my lover, my savior, my true knight in shining armor, we were really and truly getting married and there would be two Mrs. Colmeses—me and my new mom.

What a flutter of a twitter. What shopping, what parties, what converging tribes of in-laws, well-wishers and floating musicians. Good grief!

We set the date for October 7th, only to find that's in the middle of the Jewish holidays between Rosh Hashanah and Yom Kippur, and the Colmeses' rabbi won't officiate. Scurry around till we find a brand-new Reformed Temple with a rabbi who's willing to give it a go. Whew!

We agree this will be a small but elegant affair: Immediate families only, with a reception dinner at a good restaurant and a weekend honeymoon in New York because Gene has school the next day. All participants agree. And now comes Reba.

I have never known such conflict: I will permit nothing, nothing to interfere with the smoothness of this wedding. Having Reba appear as "immediate family" will send my father into apoplexy, there will be a frightening scene, my new in-laws will withdraw their support, the marriage will not go as planned. This I know.

On the other hand, Reba is not only my best friend, she *is* my "immediate family." She has been confidante, mentor, guide and companion through an impenetrable jungle of social skills and teen-age *angst* strong enough to daunt even someone with a normal family. Without Reba in my life, without her patient tutoring, I never in a million years would have been considered a suitable bride— not by Gene, not by anyone. Reba has been more loyal, more caring than anyone and has never asked for anything in return.

But I cannot include her in the wedding party. I am Aaron Burr, I am Iago, I am Lady Macbeth, a scheming, double-crossing betrayer of the innocent. And I am about to go forth, Gene securely in hand, and spit in the face of my best friend. Between choosing Reba and choosing a wedding, there is no choice. This marriage is beginning with a betrayal. What kind of omen is *that*?

Reba, Gene and I meet at Reba's. The dark, cavernous monstrosity on University Road is history. We're all three reclined on Reba's big new bed in the Cohen's big, new, bright apartment near Coolidge Corner. Reba's room has cheerful, flowered wall-paper, a huge window with fluttery transparent curtains, the furniture matches, there's carpeting throughout and a little vase with a rose-bud sitting on her night-table.

She's happy. Holds both our hands, lets go of Gene's to light a cigarette, but doesn't lose her grip on mine. Can't stop grinning, can't stop asking questions: "Who, where, what, when, how, wow!" Suddenly, she senses my tension, stops bubbling, lets go of hand, draws back and then just waits. There is a long paragraph of silence. Gene becomes shifty-eyed under the stress and establishes contact with the ceiling, the floor, the rose-bud, the end of his cigarette, his shoelaces.

"Well," I say, "there isn't really going to be much of a wedding, you know? I mean, there aren't going to be any guests. There's no one, no guests, not any, you know? Just my parents and his, just my sister and her husband and Gene's. We're just gonna see the rabbi and be married, you know? I mean, no wedding party, nobody, Reba. Maybe we can have a party afterwards some time, I mean, have a celebration later? I mean, we can plan, you know, be in touch? You know?"

"Yes," says Reba finally, "I know. Well, I sure wish you the best of everything, you two, and we'll certainly be in touch, won't we."

She gets off the bed, finds herself another cigarette says, "Well, good to see you guys," and walks us out. She looks past my face, past my eyes into the stairwell, gives us just enough room to squeeze past and then disappears behind her slammed door.

Gene says, "You OK?"

I say, "Yeah, it's OK." Gene cannot know what Reba has been to me; there's no explaining what just happened. I've murdered my best friend without even changing the smirk on my face and it's over. Gene and I are OK, it's OK. Only a couple of weeks to October, it's OK.

Next, there's a financial meeting between the two sets of parents. This takes place in the den at my folks'. For once, the sliding doors are soundproof. Gene and I are shut out. Our future is being planned without our presence. Gene is placid; I'm annoyed.

"They're talking about us like we're some kind of property, Gene. Like, I mean, aren't we supposed to be in there? We're not kids, you know? What's up?"

"Oh, it's OK. It's OK. Come on, let's play a game of gin. Beat you in two hands. Come on."

So I find a deck of cards and mutter sullenly into my hand. Gene is unperturbed and wins. Eventually, the sliding doors creak open and the smiling adults emerge, shake hands, say good-bye to one another. One set leaves with their son, the other sits down for a cup of tea.

"So, what's up? Am I getting married? What?"

Daddy explains: "You are both still in school. Gene and you both have this year to go and next. They'll pay for his tuition, we pay for yours. You'll have to transfer to Boston University. That is what is expected. You will live, for the time being, at Clinton Road until an apartment opens in one of Isidore's properties. There is nothing to tell." And sips his tea. Conversation over.

The children have been parceled out, their fates decided. I do not know why I am so angry. Somehow, I expected not to be a child any longer; somehow I still am. One thing I know for sure, there is no way I am transferring to Boston University. School is over. Tough on their agreement. Tough, I say. Besides, I know in my deepest heart and soul that Daddy has no intention of paying a dime for anything further having to do with me. This I know without asking. This I know.

I find a dress. It's kind of a gray-green satin two-piece number with pink beads embroidered on its modest borders. There's a matching pink kind of veil thing whipped up by the boutique and a pair of high heels. There's even a bouquet, green and pink in nature. I dislike the outfit, but love the navy blue "going-away" suit, beautifully tailored, classy cut. It will stand me well in New York.

October 7, 1948. Afternoon, sunny day, Beth Israel Temple. I sit in the ladies' lounge, frozen to my chair. Any minute, someone is going to yank me

to my feet and send me upstairs to get married. There is a perfect clarity in my head. This is a mistake. I do not want this. This is a major error. This is a mistake. My thoughts are lucid and they are paralyzing me. My eyes are fixed on middle distance. I sit quietly. This is not good. This is a mistake. I sit.

Ellie and Florence come into the lounge, smiling beatifically. "Dah da-da-da, Dah da-da-da." Come on bridey, come on Mrs. Colmes, come on you beautiful thing, it is time. There is no escape. The deed is as good as done.

I get up, I go upstairs, I get married. Florence catches the bouquet. Oh boy!

Until that apartment becomes available, we move into Gene's room on Clinton Road. Gene goes to school, plays gigs on the weekend and, during Christmas break, goes out of town on a liquidation sale with his dad.

I spend my days playing with the dog and hanging around the kitchen. There, Elma makes masterful pineapple upside-down cakes and Lee produces brisket pot roasts, oozing fat and tantalizing juices. I eat. I gain visible weight. The entire Colmes clan is aghast. Even Bobbie looks at me with something akin to suspicion.

Gene comes back from his liquidation sale to find me in bed with a high fever and such a terrible pain in my neck that I can barely move. My body is on fire. The doctor has said the dreaded words, "Polio is a possibility," and everyone is tiptoeing. I even smell funny. Gene comes back from his liquidation sale and wants to make love. I turn to him with my rheumy, fevered eyes and beg off. Gene pulls away in terrible anger. "Who have you been fucking?" he screams and marches out of the room. When he returns, he is still angry. "You've gotten fat," he spits. I count on the fever to help me lose a few pounds and pray we get an apartment soon, so I can diet in earnest.

The newlyweds had in common a love of music, dogs and an urgent need to be taken care of. They both believed themselves to be somewhat inferior beings who must hide from themselves—and from one another—the degree to which they knew themselves to be damaged goods.

He brought to the marriage a belief that his wife was the only true example of all that love could be: If he could only possess her, devour her essence, somehow make her physically a part of him forever, he would become whole. "Spit into my mouth," he moaned as he lay under her, "spit into my mouth." He begged for her juices as if for life itself. His wife was not to be shared. Not with anyone. He pretended to want children because he knew this was his role, but shuddered at the idea of anyone other than

himself at her breast. He looked suspiciously into all corners for traces of interlopers, made certain that he knew at all times where she was and what she was doing. He trusted no one.

She brought to the marriage a belief that a good wife was, first of all, a good mistress. To her, this meant pleasing her husband in all ways. From bringing him breakfast in bed on a tray with a flowered bud vase, to remaining eternally slender and beautiful, she knew her duties. This meant going back, permanently, to one meal a day, laced with generous amounts of Dexedrine. It meant learning adeptly and joyfully every sexual nuance that would bring him pleasure. She held him close when they danced, laughed at his jokes and fell asleep every night with her hand resting gently on his spent penis, just the way he liked it. She kept her skills sharp by flirting with his friends when he wasn't looking: She needed to test her attractiveness just to be sure that her mistressing abilities remained honed to perfection. She wanted children, but had not the slightest idea what that entailed. Somehow, she would figure it out, she was sure.

They both enjoyed entertaining and were excellent hosts who complemented one another's ability to make guests happy. As soon as they had their own apartment, they began giving hugely successful parties, modern equivalents of "Salon."

We pay a visit to my parents, our very first appearance as husband and wife. I am now a grown woman, officially entitled to respect, to recognition as a peer, to a politely social reception just like any other guest. I take Gene's arm as we climb the stairs, smile confidently. I have a protector at last. No one will abuse me ever again. My husband, my ally, will stand between me and my parents. "No," he will shout. "You may not speak to my wife like that." And they will bow to his fierce admonition. We knock.

My mother opens the door, and as we enter begins to scream at the top of her voice: "Where were you, idiot? You're late. We said 3:00, not 3:15. You fool, you cretin, you idiot, who do you think you are? Idiot, idiot, that's what you are, idiot." Her voice reaches a crescendo, threatens to crack, recoups its strength, she takes in a fresh breath and continues on, her decibels and epithets increasing in volume and vulgarity.

I look to Gene. OK, Gene, it's your cue. Go get 'em, teach that lesson, protect your bride, go for it, Gene-io, give 'em hell. Gene stands silent. He just stands there. He says nothing. He stares into space. He is going to let me down. He has deserted his post, given up his honor. He just stands there. I am alone. Not only alone, but my mother has discovered that she can now embarrass me in front of anyone, even my chosen one, any time. It is worse

114

than before. At least, before, it wasn't in front of company.

I turn, walk back out the front door, climb back down the stairs. At the street, I notice Gene has followed me. I turn to face him, but say nothing. He has just lost all my trust. Whatever amount there was, whatever expectation I had of him as a strong and equal partner is gone forever. I will never respect him again and we have only been married a few weeks. It doesn't matter. I say nothing. He says nothing. We go home.

Our very own apartment, at last. On Commonwealth Avenue, where the MTA line ended at Chestnut Hill. The place belonged to Gene's Uncle Max, who occupied one of the units. Sister Florence lived upstairs with her new husband, Sylvan. And downstairs were my very favorite cousins-in-law, the Brilliants, who had just produced their first baby. There was much running up and down the stairs, cups of coffee, general gossip and a lot of laughter. Elma had been delegated to visit Florence once a week in order to clean her house. The rest of us made our own beds. All was as it should be.

Gene went to school, played weekend gigs, his musician friends stopped by. They brought gifts: Strange and wonderful little cigarettes rolled up all lumpy, which were inhaled hugely, smoke kept inside with held breath as long as possible. I loved those little buggers. "Reefers," they were called, smoked quietly, passed around like an Indian peace pipe. Everything slowed down. It took my arm a half-hour to descend from lip to lap. Everything was slow, everything easy. I loved that stuff, couldn't wait for the gigs to be over, the boys to show up, to get my share. Everyone got hungry.

"Make popcorn," Gene says. I get a pot, put in oil, put in the corn and wait. I have never made popcorn before, ever. I figure it will pop soon enough, and so it does, all over the place. I didn't put on a lid. Oh well, live and learn, we laugh and start over. Now I know how to make popcorn. The new bride learns to cook.

Gene's friend Jerry stops by. He knows I take Dexedrine. He is looking for speed. "Can I borrow just a couple? Can I have just a few?" He whines and begs.

I let him have a couple, but that's all. "Hey," I tell him, "that's a prescription. I only get it filled once a month, and I need those."

He thanks me profusely and leaves. "Bless you," he says. "Bless you."

Gene comes home from school and I tell him Jerry was here. Gene flips out. "Did you fuck him, did you? Goddamn it, can I leave you alone for even an hour without someone fucking you?" He stomps, he yells, he slams the bathroom door, he throws over a kitchen chair, he locks himself in the

bedroom. It takes forever to calm him, to convince him Jerry was after my Dexedrine, not my virtue. I even count out the remaining pills. Gene calms. I now understand what kind of information to withhold. Besides, why would I fuck Jerry? Redheads have never been my passion.

The newlyweds are in Maine, ostensibly working at the store but actually having a winter vacation. They are photographed horseback riding in the snow and playing with their doggie against the frozen blue sky. She manages to impart high-fashion panâche to a shapeless white parka.

Next summer, the camera follows them back to Gloucester where they live in a large, airy room on a converted pier. He, ostensibly working at the store, but actually having a summer vacation. Most of last year's crew has re-assembled: Charlie nestles his head on Sylvia's lap, Bunzo Burns (he has forgiven us) ogles the women, Uncle Abe provides his mansion, and the newlyweds kiss on their beach blanket. All summer long, we inhale brine and exhale passion. The converted pier rocks under the onslaught.

Ginnie and Joe are now Mr and Mrs. Paynotta. As newlyweds, they buy an ancient villa right at the edge of Niles Beach. This place is a landmark, elegant and appreciating in value by the minute. Joe has become an entrepreneur. Formed a security business in which he assures the "off season" safety of all those Bass Rocks mansions. His is one of those unmarked cars that patrol the road, watching everyone carefully.

There is wild talk about a Frenchman named Cousteau who is tinkering with some kind of gadget that allows underwater breathing. "If they sold stock in it, I'd buy it," hollers Joe. "Just you wait, just you wait, there's a whole new world out there, under there."

Gene graduated from Suffolk and for his perseverance received the gift of a trip to Europe from a smiling Isidore. What a graduation party! Bunzo went to live with his "grandparents" and we were off on the Queen Elizabeth to see what was left of the old world.

London had huge gaps where once were buildings, but Madame Toussaud's still waxed large. Scotland provided just the right amount of purple flowered moors and a windswept castle at Edinborough. Paris enchanted, exactly as always, and we missed nothing, no one, survived on croissants washed down with endless cups of café au lait.

In Germany, we united with my aunt and cousins, all of whom managed to survive the war. My steely hatred of the Germans was stronger than theirs. They were so grateful to be alive, they had no time for holding grudges. Instead, they talked about those folks who had sneaked them food at risk of

their own lives.

But I wanted revenge and took it on train conductors, service providers, anyone who looked healthy. I snarled, refused to show my ticket and took Gene to first class where I sneered and dared anyone to say we were in the wrong car. Everyone bowed to the American. I read somewhere that the Germans are either at your throat or at your feet. This made me even more disgusted.

In Venice, I fell in love. Had never been there before and allowed myself to be shamelessly seduced. Seduced by the way the city and the water were wed, by the pallazzos, by how the balcony of our hotel room absorbed the sound and sunlight of the canal that served as "Main Street."

We fed pigeons in the square, watched the masts of moored boats swaying black against the sunset, wandered through the cobbled streets and over the curved bridges, shyly touched the sculpture. I had found paradise and Venice was an Italian love song forever singing in my heart.

At Cannes, we gambled our very last fifty dollars on roulette. We put the whole thing on red and prayed. We wound up with enough to buy a Leica camera and get back to Paris, where we had to abandon the croissants but managed quite well on large loaves of bread which we laced with fromâge. By the time the Nieuw Amsterdam deposited us back in America, we had exactly enough money for a train to Boston and streetcar fare to the apartment.

Two months passed and we became happier, closer. Our honeymoon was forever. We discovered that our senses of humor matched exactly. We made each other laugh with just a raised eyebrow at the right moment. We played, giggled uncontrollably in public, held hands, made puns, our private jokes were in sign language. Our water fights started with a sprinkle and ended with Gene brandishing a full douche-bag. We danced, we pranced, we made love. I relaxed and my body began responding. I learned to have fun, just for the fun of it. I loved loving, loved spoiling my husband, loved pleasing and pleasure, loved being loved so intensely. I no longer minded the jealousy. It's because he loves me so much, I decided, and that was good.

I gave him Stravinsky, he presented Art Tatum. We discovered Brubeck together. We played with the dog, played with our friends; Lee gave us her old Chrysler and we cruised to Gloucester.

Living in a Jewish family was pure delight. I enjoyed the traditions, became an enthusiastic student of everything. The gift of an entire culture landed in my heart, with Channukah songs, real Seders, and Friday night candles. I loved the wonderfully eloquent, witty Yiddish which was easy to understand because so much of it was German-based. Best of all, I felt

safe—protected from anti-Semitism by this tight family circle and relishing all those jokes made at the expense of Gentiles: *"Goyim."*

Everyone was pregnant. Charlie and Sylvia, Elinor and Warren, Florence and Sylvan, our entire universe bulged with fecundity. The in-law aunties tapped me on the belly and said, *"So nu?"* Everyone was waiting, except us.

I confided in Lee. "We just want to have a year or so all to ourselves."

As usual, she let me know all was well. "Let them talk," she told me. *"Lass zein"*. I loved Lee. I was so grateful to finally have a real mother, a mom who took good care of me, hugged me a lot and loved me unconditionally. All I had to do in return was stay thin.

Chapter 9

The Stepford Wife

Mahatma Ghandi, that exemplary example of peace as power, killed so violently three years ago, left India and Pakistan still teetering warily on the threshold of viable co-existence. America entered year two of war in Korea, the Cold War was becoming hotter, but business was good and Gene wouldn't be drafted. Color TV came along, John Huston made The African Queen, *and Dr. Seuss coined the word "Nerd."*

We were expecting a baby, a child conceived with such attention to detail, with such fervor that it was bound to emerge a masterpiece. I was four months along, inspecting myself daily to determine the time for maternity clothes. Jeans with holes in the front, elastic skirts, overblouses and nursing bras—marvels of engineering guaranteed to support overloads of lactation—all transported to Youngstown, Ohio, where Gene was on some going-out-of-business business for which I was permitted to be the cashier. Each day, I sat triumphant on my cashier's stool, listening to Isidore do his carnival pitch and collecting from a crowd of Mr. and Mrs. Marks at least two months worth of their individual paychecks. Pregnancy caused an aversion to smoking, but no other symptoms. I drank skimmed milk, ate chicken breasts and lots of veggies. This baby would be born to a healthy, slender mommy. The obstetrician gave me a prescription for Dexedrine to make sure of that.

End of November, time for the Christmas bonanza. Business is accelerating so wildly, extra clerks have been hired and there are now two cashiers. I sit with professional aplomb, attired in a brown striped maternity business suit, collecting the life savings of the Marks when, suddenly, I feel the baby move. Just a tremble, a gesture, the flutter of a butterfly, a greeting from within. "Hi, Mommy, I'm here," the baby says and then goes back to sleep.

When we get home from work, I hug my husband. "Genie, baby, Gene-io, the baby moved today. Can you imagine? It moved. I wanted to yell it all the way down the store. Is this wild, or what?" Gene pulls back.

"You stink, you know it? Ever since you've got pregnant, you stink. It's

119

some kind of B.O. and it really stinks. When you get close, it's awful. I've been meaning to tell you. You need to be more careful. You smell like an animal."

"I do? Oh, wow, Gene, I'm so sorry. Why didn't you say something before? Geeze, Gene, next time tell me, huh? Yikes, you're supposed to tell me stuff like that, you're my husband."

Pregnancy B.O.? Never heard of it before, but I'm off to the shower. Henceforth, there will be two of these a day, with special attention to armpits and crotch. I won't put Gene's hand on my belly to feel the baby till I am safely clean and in bed, with fresh pajamas and new sheets.

Pregnancy made me a sexual predator. Without that damn rubber diaphragm in the way, without any interference between me and Mother Nature, sex became wonderful. I couldn't get enough. Orgasms happened in bunches. If I controlled my breathing to not let Gene know when the first one happened, three or four could be had in rapid succession and then I let loose and hollered. I cajoled, tickled, engaged in unnatural acts, did whatever necessary to get that thing going. Gene looked at me with some suspicion, called me a nymphomaniac but kept on. I loved him for that, more each day. I was content. Marriage was good.

It's December. We are still in Youngstown, cashing in on everyone's Christmas Club money and their various seasonal bank loans. I am getting rounder. The baby makes my stomach ripple with exploratory pokes. The tentative flutters have become tidal waves. Major drumbeats.

Late at night, I put Gene's hand on my belly while we whisper about names. Michelle if it's a girl, we decide, and Geoffrey, in honor of Geoffrey Chaucer, if it's a boy. "Oh, I love you so," I whisper, and allow my hand to sneak down to his crotch. Tonight is Saturday and we don't have to wake up early to go to work tomorrow. My hand, which has a mind of its own, begins to do its magic but nothing happens. I prepare to follow the hand with my mouth. I kiss my way down Gene's chest, lingering at each nipple. I am almost at his navel, when he suddenly pulls my head back up.

"No," says he, "you look like an animal. You look disgusting. Look at you. All fat and bulgy. Go look in the mirror. Leave me alone. If there was another bed in here, I'd move." He turns away.

I sit there, looking at myself. My nipples have become impertinent giants whose color is no longer an attraction. My stomach, to be sure, is the size of a beach ball. But there's nothing to be done about any of this. There's a baby in there. I look at Gene's back. He shows no sign of returning. Maybe this is

normal. Maybe this is part of the process. Maybe Mother Nature plans it this way, so people won't copulate right up till labor starts and maybe hurt something. I sigh. I know that after the baby, it will be back to the diaphragm. What a waste.

March 30, 1952. Gene and I are back in Boston. We have all survived childbirth. The hospital nurse has laid my newborn child upon my belly and life has taken a brand new turn into a land of music and rainbows, into a world where magic has ten perfect little toes and looks exactly like her Grandma Isabelle. I take off her hospital nightie and examine her every pore and crevice. She murmers in her sleep, stretches her little body like a miniature lioness and makes a sucking sound. This causes my breasts to tingle and I am tempted to offer her my nipple, but at the last second remember Gene's instructions: "No, you won't nurse. You'll spoil your breasts. Nursing, for God's sake, that's like an animal." It's OK, it's all OK. I just have to figure out how to be somebody's mother. This perfect little being lying in my arms needs me and I haven't a clue. Never even held one before for practice. Should have, I suppose, but it's too late now. Here we are together, Michelle and I, God's gift of perfection to such an imperfect being; we'll manage. I kiss her little toesies, her hand has clasped itself around my thumb, she sleeps on. My baby. She is my music, Shelli is. She is a Bach Cantata, a Liszt Rhapsody, she is Ella and King Pleasure, the Marriage of Figaro and the Rite of Spring. We sing together. We sing.

Thank goodnes, somebody gave me Dr. Spock in paperback. Thank God for Dr. Spock. Without Dr. Spock, we would both have died. While she sleeps, I memorize the pages. When she wakes, I do exactly what he says. He is always right on target. Kind of like following a recipe for some meal never before prepared, sniffing for the outcome and hoping the oven is set at the right temperature.

Immediately, I introduce her to Bunzo. She lies on my lap and Bunzo gets to sniff and lick her to his heart's content while I tell him what a good dog he is. We're not going to have sibling rivalry here. Bunzo at once assumes the role of benevolent uncle and general factotum. He watches her carefully, whines when she cries and quickly learns exactly where to position himself during her feeding times so that he can catch her formula on the fly when she barfs. Dr. Spock has alerted me to this. He calls it "projectile vomiting" but when I try to tell the pediatrician, he assumes I am a hysterical mother and ignores the whole thing. It's OK, it's all OK. At least Bunzo is there to clean it up and get bonded to the baby all at the same time.

Gene pays close attention. He, too, examines his little girl. He touches her, he holds her, he is afraid of her. He bends over her, kisses her belly,

kisses her face and puts her hand in his. His eyes are filled with love, with pride, with awe. He takes her in his arms, sits down with her in the easy chair, looks up at me in amazement. "We're a family," he says. "Even Bunzo. We're a whole family." Until she poops, at which point he hastily resigns from fatherhood and goes back to being a spectator. This is how it will be. "Poop-shy Daddy," I call him, but he won't change a diaper. Not his job. It's OK.

Thank goodness for all that skimmed milk and chicken breasts. I only gained eleven pounds and as soon as I got back home, I started with the sit-ups. Not a stretch mark to be seen, and all my clothes fit. When I went back for my post-natal check-up, the obstetrician laughed. "My God," he said, "when you walked in the door, all I could see was tits." Gene was pleased, I was proud. Life was beautiful and all OK.

Three months later, just as Shelli begins to display her very own personality, Gene begins to display his. He ignores the baby, won't look up from his paper even when she smiles and gurgles at him. He stops talking to me, turns away when approached, refuses sex. He has, it seems, gone into one of his sulks. I know for once I haven't done anything wrong: The baby is clean, the house in good order, meals served promptly and no one could have asked for a more compliant or inventive sex partner.

One night I pray for courage, hope I don't say anything that gets him even madder and ask him what's wrong. He stares at me for a long moment, seems unsure of how he wants to answer. Clears his throat, looks away.

"All you do is spend time with the baby, all you do is talk about the baby, that's all you do. You're no fun, you know it? Baby this, baby that, baby, baby baby. All I hear is baby."

I take a deep breath. He's jealous, for heaven's sake. Now what? This is scary. Don't remember reading anything in Dr. Spock about this, or do I? Well, too late now, here I go. I switch to mistress mode, pat the sofa seat next to me and invite him to sit.

"Gene, it sounds like maybe you're missing the way it used to be, you know, like breakfast in bed and like that. The baby does take time away from us together, I know that." I take his hand, look into his eyes like Bunzo looks into mine at mealtime. His shoulders relax, but he's still frowning. I rev it up a bit.

"She's ours, you know, she is from both of us and I only love you more for giving her to us. I thank you in my heart every moment for being her daddy. I miss the time alone with you, too, babe, I love you."

I reach out to his face, touch his cheek, keep my eyes soft. His shoulders

loosen a bit and he takes a swift inventory of me before looking away again. Progress.

"You're her daddy, I rely on you with all my heart and no one, nothing can come between. And you love her, I know you do. I see it in your eyes, I see it every time you pick her up, I see it all over you. You love her, you want her to have it good, I know you do."

Now he turns to me fully and lets me know he is paying attention by reaching for a cigarette and offering me one before lighting his. I accept, and we blow smoke at one another for a moment. But I'm not done.

"Oh, honey-babe, it's OK, it's hard becoming a daddy all at once. Kind of 'Oliver Sudden,' huh. I love you, Gene. It's different from loving the baby. It's your own special love, just for you, in its own special place and that can't be touched. Ever. Not by anyone or anything."

That's my best shot. It's over. I wait. Gene puts out his cigarette, stands up, stretches. Says, "Let's get a sitter for tonight, go to the movies."

I stand up, too, and step toward him. I feel like Scheherezade. I snicker inside. All I need is a magic carpet, I've already got the Genie. My gaze fondles his face, touches deeply into his eyes. He comes into my arms. "There, there, it's all right." I hug him and pat him gently on the back, just like I do Shelli when her stomach has gas and she has trouble getting the burp out. His head is buried in my shoulder.

"I love you," he says.

"I love you, too," and roll my eyeballs at the ceiling.

Protecting the baby, I figured out, was not just a matter of keeping her healthy. I was the lioness mother now, making sure the hungry sire didn't devour his cub. To this end it was necessary to keep those manipulation skills constantly honed. Scheherezade needed to be kept sharp. I got a list of reliable baby-sitters from Florence and began to use them. Gene was assured of dining out, going to the movies, even taking weekends away whenever I sensed a mood change. It worked. Gene made peace, invited his friends to visit and—although he drew the line at changing diapers or feeding bottles—Shelli had a place in his arms. I was delighted.

He, too, became protective of his baby. When I accepted a joint from one of his visiting musicians, Gene took it away. "You're a mother now," he told me. He was an old-fashioned school master, teaching a difficult lesson. His tone was kind, but there was no arguing. "Mothers don't smoke joints."

I was sad, but agreed. Mothers don't smoke joints.

"Well, neither do daddys."

He was sad, but agreed. *Au revoir*, pot, *Au revoir.* Oh well.

Shelli continued to be a wonder. A little person rested in my arms, reached for the doggie, became increasingly aware of herself, made a place for herself in the world and all exactly on Dr. Spock's schedule. I began to see myself as a good mother. After all, if I could ensure that Shelli was progressing just as Dr. Spock said she should, then I must be doing it right. It was on-the-job-training, not only in pediatric proficiency but also in love. Unconditional love was new to me. It nurtured maternal intuition, gave confidence to decisions, provided sappy humor. Shelli and I, we were successful partners and we were both flourishing.

Meanwhile, Isidore approved of his new grandchild and decided it was time for his son to settle in one spot, at least between sales. He bought a store in Springfield, Massachusetts, held a "Going-Out-Of-Business" sale that lasted three months and then turned the place over to Gene, who, after all, had a family to support. Gene found us a rental house, we packed ourselves up and settled down on Forest Street.

On one side lived the Corchorans. Elias was the scion of a local real estate magnate, Cyndee a former hooker. The family had been just about ready to disown him for this liaison when she gave birth to a daughter who was such a spitting image of Elias that the family relented, got them married and made them into our next door neighbors. He was a shapeless thirty-something, headed straight for a life of flab. She, taller and skinnier, seemed the stronger. Cyndee told stories about life in the club scene, about life in the sack with Elias. When we sat down on her front stoop and I said, "Oh, Cynthia, let us discuss the vagaries of life," she gave me explicit information about the uselessness of an early morning "pee hard-on." Another time, she explained that if you put left-over gravy on your husband's pecker, the dog would lick it off and, in the process, do your prep work for you. I learned a lot.

Across the street were the Levys. Eliott was handsome as a magazine ad. His hair stayed in place, his eyes shone with ambition, his muscles danced. He played golf, helped run her family's liquor store and spoke little. Sarah looked as if she had just arrived from some turn-of-the-century Lower East Side New York ghetto. She was overweight, her hair would have done fine on a sheep and refused any human compliance. Her nose was too big and her black eyes too close together. All she needed was a "*babushka.*" And Sarah was warm as fresh *challe*. Her smile invited me in, her arms welcomed. I was not alone anymore.

We were immediate best friends. Her store of information, while not as exotic as Cyndee's, was more valuable. Her kids, already in grade school, had apparently had strong infancies, and Sarah had accummulated a store of

tricks which ranged from how to assuage teething pains to which diaper service in town was the most reliable. She steered me toward a good pediatrician, loved to read, and knew which stores had the best bargains.

Gene did not grow roots. He went on Isidore's three-month "Going-Out-Of-Business" sales as often as possible, sometimes home only a few weeks in between. He left the store to a series of managers, even at Christmas and left me to my own devices through the lonesome seasons. Thank goodness for my little Shelli and for the good neighbors. We did fine. I honed my looks, exercised, dieted, got the hang of mothering.

Each time Gene came home was a celebration. The first thing he needed was time alone with his beloved. A nanny appeared, and off we went for our newest honeymoon. It was Miami Beach, the Catskills, New York City, or—best of all—Gloucester.

There the Paynottas were, ready to party. Their family was growing fast, as was Joe's new business of SCUBA diving for the fishing fleet. His job was to do keel-cleaning, propeller repair, anything and everything that could be done underwater, thereby saving the owner the expense of dry-docking. It was only a matter of time, said Joe, before everyone was SCUBA diving for fun.

Once back in Springfield, satiated and exhausted, I would watch Gene grudgingly play Daddy for awhile, tend to his store for a bit, and then the cycle repeated.

Warren and Elinor had already expanded their family and now had two boys. She was adamant in her belief that the best space for sibling bonding was a sixteen-month interval between babies. I watched carefully, and sure enough, Stanley and Andrew behaved like Damon and Pythias. They seemed never to swat at one another, shared toys and gave each other hugs. They smiled, they twinkled, they spewed love at one another. I was inspired.

The next time Gene came home, we talked about it. "Come on," I said, hitting well below the belt, "you want a son, you know it." Gene agreed, especially after a visit to the Kastner's where Stanley and Andrew—right on cue—displayed fraternal love behavior for their Uncle Gene. He was impressed and decided that a son, right about now, would be a good thing.

To this end, it became necessary to have intercourse when I was ovulating and to ensure this, I became a hussy, a hustler, a hooker, paraded around in sexy underwear bought especially for that purpose and licked his ear when I served him breakfast. I was having a good time, because sex *au naturel* ruled again. I sighed and stretched, turned to my lover in the middle of the night and bit him gently on the buttocks. When I didn't conceive during the first month, the script replayed and Gene became furious.

"You bitch," he yelled afterwards. "You don't give a shit about me. You're just using me for a stud. You are fucking me like a stud animal, damn you."

I didn't get that one.

"Gene, I thought we both wanted this baby. I thought we were planning."

Gene glared. "I'm just a piece of meat to you, that's all. You don't give a shit about me. Go to hell."

OK then, the deal was to become passive, not initiate sex, not let him know when I was ovulating and just sneak up on him at the right time, subtly, hiding my sexuality under a cloak of adulation. "Ha," I decided, "there's more than one way to make a baby." But that hurt. There wasn't much left in my trust bank and little icicles were beginning to form around my soul. They fit easily, like comfortable old friends.

Geoffrey arrived November 25, 1953, but the vaunted experience of loving sibling partnership did not. Still performing à la Dr. Spock, Shelli—proud graduate of potty training school—threw her diploma out the window and went back to panty-pooping. No matter how I tried the "Bunzo method of familiarization"—which meant allowing her to explore the new baby, touch him, pat him, while I held my breath and prayed she did it gently—no matter how much time I spent with her alone, making sure she did not feel neglected, she was not impressed. Finally, I told her that if she pooped in her pants one more time, I would spank her, and she reclaimed her status as a young person of appropriate sanitary habits. This did not mean, however, that she was through with the intruder. She was almost two and she knew her rights.

Jeff was a wonderful infant. He was at peace with the world, knew that night-time was for sleeping, smiled, looked around, ate well and flourished. He understood that whatever Dr. Spock ordained was his duty to fulfill. I, too, had grown. Having and holding a new baby was easy business. Having two little ones just meant becoming more organized. Everything was on a schedule, everyone marched right along.

Gene was eager to celebrate his son and heir. As soon as I was again operational, the live-in nanny arrived and off we went.

We're on vacation in Florida. Miami Beach, early fifties. Little old Jewish ladies airing their diamonds in the sun. Everybody in avid discussion regarding last night's dinner and tomorrow's lunch. World Boxing Champion Sugar Ray Robinson driving down Lincoln Boulevard in his pink Cadillac convertible—a real head-turner, that one: *"Oi Gottinyeh, giv nur a kick."*

I am bored. Idly undress the Puerto Rican busboys from behind my

sunglasses, swim endless laps in the pool and disdain the non-stop rapacious attacks by my peers on the various foods offered in such endless array. Instead, I sniff my disgust at such debauchery, lie back, adjust my bikini and pop another Dexedrine.

And then, everything changes. All at once, when Gene and I go dancing, my whole world goes on exuberant tilt. With the first beat, red lights flash, sirens wail: Soul Alert! Soul Alert! My spirit jumps out of my skin directly onto the bandstand, leaving a wide gap through which the music quickly takes possession of my bones, particularly those in my feet. My arms rise like wings. My hips are irrevocably and permanently fused to the sound. It's *¡La Musica Salsa!*: Cha Cha becomes my heartbeat, Mambo my destiny.

The trumpet player is looking at me. I look back at him over Gene's shoulder, see it is true love and make a lifetime commitment. Salsa and I elope that night and stay happily married ever after. Each time that music starts, my muscles twitch, my mouth emits strange grunts, head throws back, eyes close, hips go wild. The trumpet player on the bandstand carresses me fiendishly with his eyes and his instrument, and I say, "Aaah, this is good." Salsa, Salsa, dance with me, be my mate, hop onto my table, bare chest gleaming, and dance the *Gessatsky* anytime, forever.

Puerto Rico, I need to go. Cuba, I need to be. All the Carribean wants me for a daughter. Help me, help me, I am drowning in desire. Can't get enough of it. I learn the names as fast as possible: Tito Puente, Eddie Palmieri, Essie and Noro Morales, Chano Pozo. *Ai Ai* and book our next trip to Havana. There, we dance at the Tropicana where Salsa causes such an uproar in my heart that I jump up, grab my man and go crazy on the dance floor. "MAMBO," I shout, flirting dangerously over Gene's left shoulder with whoever is playing the trumpet. *¡Hola!* Gene catches the fever and, back in our hotel room, we conceive Megan in a wild tangle of Merengué and absinthe. *¡Hola!*

This time, it was not OK. Gene was not to be relied on. He would not help, would not stay home from sales, still would not even change a diaper. I knew I was on full capacity flying solo with two little ones. Without Gene's help, without his presence or support, I knew I couldn't parent three children all under three, with only eleven months between the two youngest. Triplets would have been easier, at least they'd all be at the same developmental stages. Dr. Spock had no answer for this. I was desperate.

"Gene, I can't do this alone. You're gonna have to help me. I can't do this by myself."

"It's OK, we'll get you help, don't worry, you'll do fine."

"No, you don't understand, I can't do it alone. I won't be able to parent

right. I will do harm. You don't get it. I can do two alone, I can't do three. I'll do harm."

He didn't get it. I went to the obstetrician and tried to get help from him.

"I need some help, Doctor Boater. I won't be able to do it right. I need help."

I wasn't even sure what kind of help I was seeking. Psychiatric help, perhaps, or some kind of assistance in convincing Gene that he needed to change, to become a real father: The kind that stayed home, helped with the feeding and the diapering, was there when colic erupted in the night, was available for emergencies. I didn't have the words. Glib as I usually was, I didn't have the words. I could only repeat, "I need help. I can't do this alone."

Dr. Boater pushed his spectacles down his nose and looked at me sternly. "I don't know what you're asking, but I don't do that here," he said, and ushered me out.

My poor babies, my poor little kids. I tried one last time.

"Gene, listen to me. I won't be able to do this alone. This time, you're going to have to help. Please, listen. I need you."

Gene listened. He brought me to his chest, held me in his arms till I quieted down. The next day, he contacted an employment agency and within a week, there at my door stood a large mahogany woman. We checked each other out in a glance; I asked her in.

"The agency sent me. I'm here to help. My name's Lucille. Lucille Richardson."

I noted a wedding band. "Well, come on in, Mrs. Richardson, let's see how we can make this work."

She wasn't Gene, she didn't love me, she disappeared at night and on weekends, but she was going to do her best. Her best would not be good enough, I knew that. Without Gene I would not be able to parent the kids right, but she would help. That I knew.

"Do you prefer to be called Mrs. Richardson or Miss Lucille?"

"Lucille is fine."

"I'll call you Lucille then, but you'll be 'Miss Lucille' to the kids. That's fitting."

"That's fine," said Lucille and moved right in to do it right. Without Lucille, the story would have had a different plot.

November 15, 1954 and along comes Megan. I am trying to figure out how to do this. I sit down in the old easy chair to feed this little marvel, and Jeff—who isn't even walking yet—crawls over to us on the floor. He is

clutching his bottle, he pulls himself up on the leg of my jeans and looks into my eyes, pleading for the impossible. Shelli stands outside the door and stares at them both. I need another set of arms, another body. A tsunami of guilt suddenly roars up from my toes, and there, feeding my new baby, looking down at my sad little son who wants only to be held, watching Shelli silent in the doorway, I drown.

Jeff is navigating the upstairs hall in his metal walker when Shelli suddenly pushes him and it down the stairs. There is an explosion of tears and panic. I dump Megan onto the floor and rescue my son. Nothing broken, thank God. Shelli stands for a moment at the top of the stairs and then quickly turns away. Oh my God! "What if" looms over my shoulder like a dark monster. I am becoming desperate.

Shelli develops a vocabulary. "Cudnits," she says, tugging at the curtains. I sweep her off her feet and dance around the living room with her. "Curtains, yes, curtains, oh good for you. Curtains!"

She laughs. "Cudnits."

It is Jeff's turn to be "Bunzo," and he has been placed in Megan's crib to explore. He is only a year old, but somehow he knows that this is a new, fragile, amazing little being he is touching. He puts his hand on her face as delicately as a butterfly settling on a rosebud and then looks up at me, smiling. The expression on his face is of such wonderment, he has discovered the stars, the sky, the ocean and the moon right there, lying in front of him. He understands the miraculous, puts his face to hers, rubs his nose on her cheek, touches his mouth to her forehead. Takes her little hand in his and compares fingers. He says things to her in his own language and smiles and smiles. Megan lies on her back, waving her arms and feet. She seems to be trying to reach him. She smiles and gurgles. My eyes are wet. I run, get the camera and immortalize the moment.

Megan is a wild woman from the very start. As a newborn, she was never held enough, cuddled enough, carressed enough. Now, at three months, when I try to hold her, cuddle her, rock her in my arms, she fights me like a tiger. She squirms, arches her back, makes angry noises, pushes the bottle away. We both flirt with exasperation; it's hard to tell which one of us is the most frustrated. Finally, I give up, no longer try to feed her in my arms. She winds up in something called a "baby feeder," which is a like a little car seat with straps. Dr. Spock looks over my shoulder in dismay, the ocean of guilt threatens another storm but that's how it's going to be. Now, while I feed Megan, I can also put Jeff on my lap and—if everyone cooperates—extend an arm to Shelli. No one ever cooperates, though, and these moments are rare.

Lucille was the rescuer, the companion. She cleaned Jeff's playpen after he discovered the artistic potential of smearing it with feces, fed the dog, entertained Shelli by putting her on a footstool and letting her help with the dishes. She knew how to give baths with lots of play and bubbles and, best of all, managed to keep the house tidy. Gene was a stickler for tidy.

Every noon, Lucille phoned her own young daughter, Shirley. These conversations were conducted in some kind of regional patois entirely devoid of consonants, the words of which I couldn't understand, the language of which was obviously "Universal Mom-ese."

Sometimes, Lucille and I chatted, but for the most part, she communicated mostly with the kids. She had a fine sense of right and wrong and knew how to get ideas into little heads. Somehow Shelli, under Lucille's care, figured out how not to murder her brother and got hugs in the process. I began to depend on her for more than housework. We all needed a good mom.

Meanwhile, I took stock. Most importantly, my body was fine. Through some genetic miracle there were no stretch marks; sit-ups and Dexedrine shaped me up fast. Whew! With that major worry under control, I could turn full attention to what I knew about raising kids. It wasn't much.

I made a list of child-rearing priorities and committed to religiously following those I knew I could do. Number One: I would protect them with my life. No matter what happened, no savage jungle predator would fight for them more fiercely than I. Number Two: I would never make a promise I couldn't keep. Number Three: They would be shown how to love the ocean. Number Four: They would be shown that animals were their best friends. That's all I knew. Everything else, I would simply have to trust Dr. Spock to provide.

The logistics of three kids and a house were fairly simple: I broke the daily schedule down into tasks and just made sure that each task was completed on time. If this meant rushing anyone or not accommodating a child's unscheduled need, so be it. When Gene came home, the babies were fed and ready for bed, the house was clean and I was in black velvet toreador pants and eye makeup while serving a pre-dinner cocktail to the working man.

To get the love of ocean started, I began with playful little face-dribbles while they were still tiny little infants in the bathinette. From there, we graduated to the bathtub, where we played games involving face-in-the-water and lots of splashes. Before they were out of diapers, they were fearless underwater swimmers, already firmly enamoured of the wet.

Bunzo, of course, was the tutor for how to love an animal. He provided

every kind of knowledge from how to give a good belly-rub to playing "fetch" or just cuddling up and ear-scratching. Uncle Bunzo, he was patient, forgiving and had an excellent sense of humor. He was with them on such an intimate level, they surely thought he was a relative.

Gene was more possessive every day. Instead of lavishing love on his children, he became increasingly obsessed with me. All his free time was to be spent with me alone, and every person in my life needed to pass his inspection. Sarah and Cyndee were OK, but males were off limits. When Dr. Boater laughed about his short stature and told Gene he had to stand on a step-stool to deliver Megan, Gene's face reddened and he clenched his fists. Once we were alone, he grabbed me by the shoulders and said, "I wanted to kill him, I wanted to kill him for looking at you and joking about it."

Being loved with such madness was rather flattering, but also increasingly demanding. I was the center of another's world, the sun around which his planet revolved, the adored, the exalted. I was also the reviled, the feared: I had too much power and he hated that. He screamed at me over imaginary trespasses and set ever-increasing standards for my looks. He began bringing home last-minute dinner guests, expecting a perfectly groomed hostess and a well-prepared meal. I delivered on schedule and as required. If it meant shuttling the kids off to bed early and neglecting bed-time stories and snuggly good-nights, oh well, that's the way it was. Being a goddess was better than being a beggar.

Socially, we made a good team. We both enjoyed entertaining, knew how to make guests feel at home and there was soon a circle of friends We played a game, Gene and I, which we called "the pencil and paper syndrome." The object of the game was to get a man to procure a pencil and paper somewhere in order to draw an explanatory diagram for me. I would finesse the guy into conversation, ask questions, appear interested to the very bones and—usually within ten minutes— there appeared a pencil and paper which the guy covered with great details. I usually hadn't the faintest idea what he was talking about, the point being that the quicker he hauled out the pencil and paper, the more points I got in the game. Of course, Gene had to be present while the game took place because it entailed a lot of close contact, complete with deep stares and absorbed smiles. Perhaps Gene believed it to be under his control, but it was flirting, plain and simple.

We both liked to water-ski and Gene was developing an interest in boating. We window-shopped regularly and it was only a matter of time before we bought a craft. Gene's other hobby was wood-working and he soon had a complete shop in the basement where he spent hours turning table legs on a lathe and mitering corners. The table legs never developed tables and the

mitered corners were the corners of nothing, but he seemed to enjoy the sawdust and the general noise. I loved it. It kept him out from underfoot and I got to catch up on my reading.

Jeff is screaming again. He is sitting on the floor, looking at his baby toys and screaming at them. Jeff has been screaming steadily since he turned two and I don't know what is wrong. He looks at his toys and screams. I pick him up, try to console him, check his diapers, but nothing helps, not even Bunzo. He just sits there and screams at his toys. Now, he is three and he is sitting in the living room and screaming at his peg board. Shelli and Jeff have been given identical peg boards. These are almost like little easels with a seat attached and come with trays full of pegs: Round, square, every shape and color. The object is to pick up a peg and put it in the board. Shelli likes to sit there and match round pegs to round holes, yellow ones to yellow holes, and smiles proudly when all her pegs have found their proper homes. Not so, Jeff. He sits there and screams at the easel, screams at the pegs, gets all red in the face till I pick him up and comfort him. Over my shoulder, he looks down at the peg board and sniffles. It has been going on too long; I am worried. We make a date with the pediatrician.

Dr. Fegel finds nothing physically wrong and refers us to a child psychologist. We visit the kiddie shrink, who begins by testing comprehension. Picture after picture is produced for Jeff's view and he is asked to explain what he sees. Jeff, who has been talking for a year, tells all. Then, he tries to draw a picture of his own. The kiddie shrink finally puts the materials away and says, "The problem, Mrs. Colmes, is that your son's mind is too far ahead of his physical coordination. I stopped testing Jeff when we reached nine-year-old level. He may be comprehending at more than at nine-year-old level, but nine years is enough to determine the problem. He sits at the peg board and his mind wants to make complex patterns and colors with the pegs but his little three-year-old hands don't have the coordination or the speed to make that happen for him. So, he gets terribly frustrated and yells and screams. Now, we have to figure out how to help him through till his coordination catches up with his ideas."

"OK, what do I do?"

"Recognize that you have a brilliant person sitting around in training pants. Be patient, help him, read to him, talk to him, the more he learns the happier he will be. Please arrange for your son to spend time alone with his father every night. It doesn't have to be long. Twenty minutes a night will make all the difference. From what you tell me, Jeff is surrounded by females. A sister on either end, a woman housekeeper and you. There are no

males in his life. He is ahead of himself; he needs to have time with his dad. Twenty minutes, you will be surprised what twenty minutes will do for him. And just be aware that you have a gifted child here. Gifted children have special needs. OK?"

He shakes my hand, pats Jeff on the rear end and sends us off. I am excited. Whoopee, we've got a genius. How about that? Can't wait for Gene to get home. Just lucky he is in town for a fairly long stretch. Genie, baby, have I got news for you!

That evening, as soon as the kids are in bed, I snag my husband and tell him the whole story. "Twenty minutes, hon, twenty minutes every evening that you are not on the road. Oh Gene-io, this is so exciting. Is this neat or what—you get to teach him stuff and he gets to admire you, and he's gifted and you're gifted, what a pair."

I'm babbling, my words are dancing out of my mouth like bubbles of champagne, it doesn't matter, it's a gift for Gene and for Jeff, too. Gene sits for a moment.

"Twenty minutes?"

"Yeah."

"Every night? Twenty minutes every night?"

"Yeah."

"No."

"What do you mean, 'No'?"

"I mean I'm not going to. I don't want to. Simple. No. End of conversation. Now leave me alone. I'm reading the paper."

For a while, I try again. Maybe he just doesn't get it. But he becomes angry, asks me what part of "No" I don't understand and goes down to the basement.

Goes down to the basement and loses his wife. It's over.

He does not know this, can't tell the difference: I continue to behave as expected. But I'm not there anymore, I am protected by ice, I have gone forever. I will never forgive him for this, I will never forgive. Jeff is on his own. He has no daddy to help him grow and his mommy is isolated by her bitter, frozen sea. Poor baby, poor all of them. The only functional parent they have is Bunzo.

Three weeks later, Gene calls me from the basement: "Come down here, I want you to see something."

"What? I'm busy."

"Come down. It won't take a minute. Come on. Something to show you."

Oh creeps, another lathed table leg, what the hell, so I put down my book and grumble to the stairs. He's standing there, his face tilted up toward me,

smiling.

"Look what I found in the Cracker Jack box. Come on, look."

I trudge down the stairs, wondering now what, when Gene digs around in his box of Cracker Jacks and comes up with the ring. It has two stones and they are so big, I do believe he is handing me the world's largest rhinestones. I am not impressed. He looks as if he's about to explode or wet his pants. He is dancing in place, his face is red, his smile is intense, his eyes are locked to my face. If this is a joke, it's not funny.

"Gene, what is this?"

"It's a ring, for heaven's sake. It's a ring. It's your engagement ring. It's yours. Put it on."

I take a closer look. Maybe it's not rhinestones. Lee's lima bean diamond comes to mind. Holy cats, this thing is diamonds. Two huge monsterous diamonds, held together by a curve of baguettes. Is he kidding? Is this real?

I put it on. It sure sparkles. "Gene, is this real? Wow, Gene, thank you. I mean, is this for me to keep? Is this mine? Wow." I rush over to him, almost knock him into the lathe with my hug. "Thank you, thank you, oh wow, thank you, Gene." My eyes meet his with their patented gaze of bottomless love. "Oh Gene, thank you. I don't even have words enough. Thank you."

Gene says, "Well, wear it in the best of health," and continues to watch me perform my gratitude dance. I give the performance an extra edge, do several encores before dragging him upstairs so that I can thank him with my whole person. The ring turns out to be five carats worth of diamonds. It is certainly worth much less than twenty minutes spent with Jeff. But it represents a lot of money, and both Cyndee and Sarah are duly impressed. Gene grumbles that I haven't thanked him enough. I don't know what he expected. Respect, maybe? Trust? Love?

Chapter 10

The Mad Housewife

It's the fifties and the cold war is boiling over. Supplies are being air-lifted to Berlin while American kids dive under desks during school A-Bomb drills, suburbanites build bomb shelters stocked with cans of Spam, adolescent girls wear poodle skirts at sock hops and I hate Elvis. He's a thief. Everyone's making a fuss over this jerk who steals Ma Rainey's songs, delivers them like a white boy pretending to be black and thinks he's got "moves." If we're going to have music for history on the march, let it be Chuck Berry. At least he knows how to dance and sings his own stuff.

In 1957, we found our dream house. It was in the poshest Springfield suburb—a town called Longmeadow, which sported a fancy country club for gentiles (wealthy Jews had to play golf across the Connecticut River, but their club was even fancier), and an excellent school system.

Our house was exactly right. We both knew it the moment we walked in and we bought it immediately. Across from some woods slightly reminiscent of Berlin's *Grünewald*, it sported a twenty-eight foot sunken living room, a modern kitchen, a giant master bedroom complete with dressing room for Gene, and enough bathrooms to float an armada. The place seemed to have more windows than walls: Every room was a room with a view.

The girls shared a bedroom. Two large, immaculately curtained windows dominated the air, lighting twin beds with matching spreads and dressers, toy boxes and pretty pictures on the pink walls. The view was of an immense, fenced yard with its badminton set, jungle gym, swings and a chestnut tree good for climbing. If one looked carefully to the right, one could even see parts of the yard next door.

There they stood every night, looking out of their windows into the summer evenings, pulling open the curtains, fidgeting, muttering softly to each other as they watched the kids next door playing in the long twilight. The world next door was an alien one, where kids their age cavorted with parents, played catch, ate hot dogs, sat on laps until it became too dark to see. They yearned for passports there, but could not apply.

Two little girls, living together amiably until they could grow up enough

to judge one another. For now, one starting kindergarten and the other almost ready for nursery school, they scratched only idly at the surfaces of envy, of outrage, for the most part content with an occasional squabble.

Their brother, in isolated splendor across the hall, had three windows, one of which faced the double driveway where he could have watched for his father's vintage Jaguar XK140 to pull in, but he did not look out. Instead, he sat on his bed, a silent four-year-old, content to draw incessant pictures. No stick figures with legs coming directly out of heads for him. Jeff's rabbits reclined, lop-eared, slyly contemplating giant carrots lying nearby in excellent perspective. His people were trailed by large dogs, whose faces actually showed emotions of patience and curiosity. He drew so completely in the style of James Thurber, the renowned artist for *The New Yorker* magazine, that when I attached one's sketches to the other, there was little difference.

Jeff's drawings kept him company when he wasn't reading. They and his imaginary playmate, Slonky, who had been with him since he was able to talk.

Shelli, Jeff and Megan—they dared not question. The law was absolute. At seven-thirty PM, children disappeared and it was grown-up time. There was no negotiation. If it was hot, the air-conditioner turned on. At seven-thirty, children were expected to go to sleep. At seven-thirty, Daddy arrived home, expecting nicely garnished old-fashioneds, a tray of hors d'ouevres and an attendant wife, coifed, dressed, waiting breathlessly for an account of his day. The house was to be quiet, with the exception, possibly, of Dave Brubeck or maybe Miles Davis, making soothing sounds on the stereo. That was the law.

This house, this dream house, was the master's quiet sanctuary, its living room graced by a Steinway on white wall-to-wall carpeting under a crystal prism chandelier, adjacent to the French doors leading out to a screened verandah. The never-lit fireplace was framed by black marble above which floated a cubist scene, all cold angles and muted color. On the white coffee table froze a single scarlet rose, silk, in a Chinese bud vase. The immense front windows, draped in blue the color of Arctic summer, afforded scenic views of the untamed park land across the street. There, from their nests of wild underbrush, birch, pine and elderly elms waved branches laden with migratory birds whose schizophrenic poetry cackled all summer. Sometimes, sharp-eyed advance scouts from a renegade raccoon platoon emerged to reconnoiter our garbage cans and the occasional skunk challenged wandering housecats, imbuing the entire neighborhood with the intense odor of its victories.

But Gene preferred the den on the other side of the tiled foyer, with its tweed couch, TV, leather easy chair and matching hassock in hand's reach of low oaken table. All three walls were windowed, the main bank facing across the side street where the entire Doherty clan splashed wildly in their new pool. When it got dark, they dried the kids and lit strings of Chinese lanterns which cast a warm carnival glow over everyone.

At seven-thirty, his back to the windows, there on his leather throne reigns Gene, drinking too many old-fashioneds, picking idly at the hors d'ouevres, becoming annoyed with life in general and his wife in particular in direct ratio to the ingested amount of liquor. His dinner is scheduled for eight, but will go untouched. Gene is taking after his dad with a vengeance: Drinking is better than eating and affords an excellent opportunity for dishing out verbal abuse.

I am Circe—smiling, my eyes promising exotic adventures, conversation nimble, applause elaborate. There I sit, posed prettily at his feet, calming his anger, entertaining his favorite fantasies, soothing any bruises he might have incurred during the business day. I stroke his knee, look up at him with obvious adoration, say whatever he wants to hear and freshen his drinks. As he becomes drunk, turning swiftly into a Circean swine, I can hear my heart thump, each beat hammering contempt more securely into place. My eyes, so clear, framed by their perfectly mascaraed lashes, are secret. Anyone searching those windows to my soul would find, perhaps, a flutter of disdain, nothing more. Circe, she is practiced, she is swift, she is smooth, she is loving and she is icily indifferent.

The den is his. The living room, mine.

It's Shelli's first day of Kindergarten and we watch a man hug and kiss the teacher while his little boy stands by. Afterwards, he turns to us and says, "Isn't this amazing? Mrs. Osgood was my Kindergarten teacher and now she's Eric's."

I am overcome with joy. Now I know I am giving my children a secure and stable setting in which to grow strong. No dragging them through night-time borders, no switching towns and countries at a moment's notice. My kids will have a solid footing. I'm almost in tears of gratitude for this blessing. At last I'm doing something right.

Longmeadow did not have many employed housewives. Most were home-makers whose husbands returned from work expecting clean houses, well-behaved children and compliant women. In return, the men supplied copious

material possessions and—probably more often than not—filial love and devotion. I, however, had a quite specific job description.

Every morning that Gene was home from one of his three-month business trips involved a job-skills assessment. This meant I climbed, naked, onto the bathroom scale and Gene guessed my weight. If I was more than 1/2 pound over the designated amount, I simply did not eat that day. Gene liked to see the knobs of my collarbones. He called it "that concentration camp look," a comment that resonated strangely in my consciousness, causing shivers every time he said it.

We both loved the ritual. Everything I knew about female power was contingent upon being seen as physically attractive. Anorexia (which hadn't even been invented yet) was a small price to pay for personal triumph. I was a cheerful starver. The resulting adulation was my salary. I loved my work. As for being seductive, when Gene was home I was Scheherezade. Every night there was a different story, a different song, a different dance.

Gene avoided his own kids. Their faces had no space in his wallet. Instead, it held photos of other people's children, those of employees and customers. In his downstairs office was a framed photo of a very young girl in formal riding apparel, profiled sitting on her show-horse. She was the daughter of a sale client in Texas. I pretended not to notice. He was obsessed with me. That was good enough.

Gene's interest in boating grew. Our boats kept getting bigger. We both loved water-skiing and took turns towing one another through every available stretch of water. The Atlantic, of course, was best and we spent a lot of time in Gloucester with the Paynottas, whose kids got along swimmingly with ours. Joe's SCUBA business was flourishing and his enthusiasm, contagious.

One weekend in Gloucester, Joe finds a spare wet suit and tank for Gene and Ginny lends me hers. After some basic instructions, Joe puts us on a "buddy line," and, securely leashed, we swim down the anchor-line of his SCUBA boat. I am almost out of my head with awe, wonderment, delight, fear, excitement—possessed, is what I am. I am a porpoise, I am a whale, I am a sea-mammal of my very own, I am home, I am hooked. And so is Gene.

First thing Monday, Gene contacts the Y for a schedule of SCUBA classes. But when I ask to come along, he becomes angry.

"Dammitt, why do you always have to do everything? You're so fucking competitive. You and your big glib mouth. 'The ocean's my mother,' what crap. The Mouth, that's what you are, the Mouth. I'm doing this, and you keep the fuck away from me. Now go diaper a kid, be a wife, for Chrissake."

So, I wait till his next business trip and take the course by myself.

Afterwards, I go to the Dive Shop and buy us both tanks, regulators, fins, wet suits, the works. I borrow the money from Lee. Tell her it's a special birthday surprise. And sure enough, when he comes home, Gene is so pleased with the equipment that he forgives me and allows me along. "I just don't like worrying about you," he says, and gives me a hug.

The Chriscraft gave way to a twenty-eight foot Grampion sloop, good for diving, sailing and superb as a weekend getaway. Gene took a sailing course with the Coast Guard and soon acquired a flotilla of boating friends. Gene was a careful, excellent sailor and I trusted him completely on the water. Time on the TIME OUT was surprisingly relaxed. Gene seemed less tense, less critical. Sometimes, he even let me take the tiller. I remained wary and alert, but nothing bad happened. The TIME OUT appeared to be a war-free zone. I even got to eat.

And, oh, the diving. For me, there was always an initial burst of terror: "Oh my God, I'm down here now, lost forever." I would have to deliberately pick up something and examine it carefully: A stone, a shell, anything at all while the panic subsided. And then there would come a joy so calm, so quietly peaceful, devoid of all human thought. Then there was only the ocean. To be in there, inside my very source, was more than a thought, because there were no thoughts. There was only extending a finger to a horseshoe crab, swimming alongside a flounder, coming face to face with a sea robin, undulating along with the algae.

Gene would catch lobsters. He had to sneak up on them and grab them from behind, carefully keeping their desperate claws facing out and away and then stash them in his "bug bag."

Afterwards, stripped of wet-suits, we would lie on the deck, exhausted, salty, happy. Later, we would cook the lobsters together and serve them to one another with drawn butter. And having feasted, would share a cigarette, watch the stars a bit, make the boat rock with our love-making and fall sound asleep.

It's almost 1960. Jeff has followed Shelli into public school where he is excelling in a third-grade foreign language immersion course for gifted kids. His French is fluent. Megan is in first grade, coping with teachers who expect her to be a model student like Shelli, or brilliant like Jeff.

Gene and his boating buddies are having a yacht club business meeting at our house. They've bought the land, they've got the permits, now they're planning the building and the swimming pool. I've got drinks and goodies on a tray ready to serve when Ernie walks in. I've never met Ernie before. He's

tall, dark, with a widow's peak hairline, and acutely observant hazel eyes. I take one look and almost drop the tray. "Oh my God," I mumble to myself, "this is the one."

Ernie seems to know what's on my mind. "Here," he says, "let me help you," and steps just a bit too close.

As I look up into his face, a searing flash screams from my crotch to my heart, electrocuting everything but passion. I haven't felt anything this fierce since MacKinney. "Yes," I reply, "please do."

The moment Gene leaves on his next business trip, Ernie and I connect. I take him to my bedroom, go into the bathroom where I take off all my clothes and stand shivering. Suddenly, I am shy. I am naked. I will have to walk out of Gene's dressing room into a stranger's vision with no clothes on. Shyness becomes fear. I can't do this. Yes, I can. Yes, I must. So, I fling a towel over one shoulder and parade out. I walk slowly. If I'm going to be on display, he might as well get a full look.

Ernie is transfixed, I pounce and we burst into full bloom. We are a perfect match, our bodies constructed meticulously for mutual gratification. Everything fits just right, our timing is perfection, I love bouncing around on his pelvis, I adore all parts of him, can't get enough, want more, get more, we sweat, we groan—thank goodness no children wake up—we lie supine, he staggers into his clothes, I walk him downstairs, walk into his life, I'm his forever.

Next day, he phones. "The sight of you walking through that dressing room has been permanently etched into my brain. If I live forever, then your image will live forever, too. I will take it with me to heaven or to hell, and no one else will ever have that." That's it for me. I am so wildly and passionately in love that when I think of him, my breath stops. I close my eyes and groan.

We were together incessantly. Even when Gene came home, we managed. This time, my stalking was welcomed warmly. The old tricks paid off: Got up early, got the kids off to car-pool, told Gene I was running errands and waited patiently at an intersection convenient to Ernie's street, where I could see his car leave the driveway and follow him into the park. We stole moments, stole kisses, I ran back to my car, he drove off to work.

When Gene was out of town, we raised afternoon hell in motel rooms. Ernie gave me money for the rooms and told me what to wear: "Black garter belt, black stockings with mink stole," or, "T-shirt with high heels," or, "Nothing. Be lying on your back with legs apart."

I would check in, phone him with the room number and get myself ready.

Neither of us was ever disappointed. If he had said, "Let's run off together," I would have run.

The longer we were together, the more obsessed I became, the more chances I took. Nothing mattered. I believed that, somehow, we would wind up together, that he would leave his wife, that our children would merge into one family, that we would live happily ever after. I stopped using birth control. The very idea of becoming pregnant with Ernie's child was Nirvana. I figured I could pass off a dark child with hazel eyes as simply taking after my father's side of the family. After all, there was my sister Elinor to reference with her dusky skin and Mediterranean eyes. But the years flew by and there was no baby. Ernie never guessed I wasn't using birth control.

Gene gifts me with a black leather trenchcoat which I put on one afternoon with absolutely nothing else underneath but a pair of black heels. Then, I climb into my car and drive downtown to the courthouse, where I know Ernie is presenting a case. I park in front, wait for an hour or two, smoking cigarettes and sipping at a jam jar full of vodka gimlet. When Ernie emerges from his hearing, I follow him in the car, tooting the horn gently as he drives his Chrysler out of the lot. I trail him to the park, get into his car, straddle his lap and open the coat. Manage to get home just in time to slide into jeans before the kids come home.

Ernie slips on the winter ice in his driveway and breaks his arm so badly, he's hospitalized. I try to join him. I figure if I break something too, I can be with him. I rig up one of Gene's filled weight-lifting bars onto his closet clothing bar with some clothesline and let it drop on my shin. But nothing happens, except a large lump and a black-and-blue mark. So I have to sneak in to see Ernie. I am persona-non-grata with his wife and have to be careful.

A year later, I miss my timing at Ernie's intersection, and his car plows into mine at the corner. My car ricochets off and hits a tree, sending the engine squarely onto the driver's seat and me under the dash. Wearing a seat belt would have killed me. As it is, I wind up in the hospital, paralyzed from the waist down for two days. Then, the paralysis lifts and I'm OK. Thank goodness, my husband is out of town, but he is distraught and returns home at once. Gene, who has been jealous of Ernie from the very start, is not amused. Neither is Ernie's wife. And I have a lot of explaining to do: "I was coming back from the dry-cleaners and I was in such a big hurry because I had to go potty and I just didn't look at the intersection. Really, it was my fault. Really." No one really believed me, but then, no one could prove otherwise.

Now, Gene's jealousy became as crazed as my obsession with Ernie. He checked the mileage on my car, came home from trips unexpectedly, burrowed through my bureau drawers: ("What this?" he demands, holding up my black garter belt. "It's to hold up stockings. Why, you wanna borrow it?") But, worst of all, he became impotent.

No ordinary impotence was this. Genie-baby was able to achieve erection and engage in the act, but, at the slightest indication that I was about to orgasm, he either climaxed or wilted. Even my proficient breathing control proved hopeless. He simply became more attuned to the anatomical changes inside my vagina and reacted with the precision of a Swiss watch. He made no attempt to help me out, and I was left to masturbate in the bathroom. Something had to give.

It's the morning after a particularly harsh episode of impotence which has left me aroused and frustrated to the point of madness. After the house empties, I go to the fridge and take an extraordinarily well-shaped cucumber up to the bedroom where I use it well. Afterwards, I keep it aside with all my juices still on it, and that evening when Gene comes home, I carefully slice it into his salad and—with an adoring smile on my face—watch him eat it.

The kids suffered the most. Exluded by their father, now their mother turned on them. They were getting older and harder to control. I could no longer simply send them to bed at seven-thirty. They had lives, they had needs, they needed me in a different way. I responded by abusing them. I didn't beat them. But they received lots of random slaps on arms, legs, heads, tushies, whatever parts of their anatomy was closest. I wasn't an irrational screamer like my mother. No, it was my father's style of anger that hit them broad-side and unexpectedly. All they had to do was disrupt my schedule or demand something I didn't have—like patience, spontaneous playfulness, or a willingness to step into their worlds and listen quietly.

I was irritable (probably due to hunger) and prone to unexpected flashes of rage. My eyes flashed Daddy's patented glare, guaranteed to melt asbestos at five paces. My voice was cutting, dripped with sarcasm and announced punishments like an executioner on speed. Well, I *was* on speed. Other housewives discovered Valium and wandered about in dopey states of tranquilization. But at our house, Dexedrine—still cheerfully prescribed by the family MD—continued to rule. I loved Dexedrine. Couldn't imagine life without it: Got me up at the crack of dawn to start the household going, helped me starve, gave me power.

I loved the children with a desperate intensity, but didn't know how to show it. Love popped out unexpectedly and, thank God, attuned me to them enough so that I was always there for them in any kind of emergency. I was able to love them through music, showering them with everything from Prokofiev to Puente, from Bach to Bikel, from Stravinski to Sinatra and Moussorgski to Makeba; they reveled in it all. Music was the good communicator, the love connection. Nothing bad ever happened when the music was on. And, somehow, those original tenets stayed in place: Loving animals, loving water, and keeping promises, but those were in no way enough. After all, their daddy didn't want them and their mommy was a narcissistic speed freak.

There was such a lack of consistency in the quality of my mothering that the emotional see-saw of my unpredictable, rageful moods began to take a toll. Shelli and Jeff managed to hide their pain and outrage and, on the surface, showed no ill effects. At least, none that were overtly visible. I can only imagine their inner torment and the desperate self-discipline it must have taken to appear "normal."

Megan showed the damage more overtly. This youngest, the one not cuddled, not held enough as an infant, was learning how to get attention any way possible: She became the Great Disrupter. She could disrupt almost anything—from birthday parties to family dinners to watching *Howdy Doody*—either via non-stop, arbitrary screaming, or by simply lying down wherever we happened to be and pretending to sleep. She wrecked winter skating excursions, trips to the zoo and dinner at Howard Johnson. Megan even intimidated the dentist.

Nowadays, it's called "Negative Attention-Seeking Behavior" and is a sure sign the child is feeling neglected and unloved. The cure is to simply show the child how to get attention in more positive ways and shower him/her with loving attention throughout. Back then, Dr. Fegel said, "Well, spank her." That didn't help, and besides, who knows if I would have had enough sense to attend to her emotional needs. Narcissists don't think that way... Thank goodness Lucille was still along for the ride. If the kids got any stability, it came from her.

Bunzo is dead! Our next door neighbor, Helen, backed out of her driveway and straight into his head. He didn't even have time to yelp. Boom. He's gone. I shiver, thinking she could just has easily have backed into one of the kids—hers or mine. The family mourns. "Uncle Bunzo" with his large vocabulary, sense of humor and loving patience will be hard to replace. We talk about him a lot. Then along comes Martha.

Gene is out of town. I'm bored, pick up the paper, and there on the front page is a magnificent, giant Saint Bernard. Apparently, this dog was picked up wandering the streets and no one's even called to claim her. She's gorgeous. Bunzo's gone. Hmmmm.

So, I go to the Humane Society and tell them this is not my dog.

"But it might belong to my brother-in-law. See, he just this week parked his van—with the dog inside—in front of our house on his way to California, and when he got up the next morning to be on his way, the van door was open and the dog was gone. And I don't even know the dog. Just that she's a Saint Bernard. And my brother-in-law must be in Colorado or someplace by now. What do you think?"

Works like a charm. I name her Martha after a former girlfriend of Ernie's and bring her home where she settles in like a long-lost cousin. Two weeks later, Gene calls to give me his arrival date and asks what's new. I tell him I've dyed my hair blue and there's a Saint Bernard in his bathtub. "Very funny," says he and hangs up.

The week he's due home, I have my hair streaked baby blue to match my new dress, and, just before leaving to pick Gene up at the airport, I lock Martha in his bathroom. At the airport, Gene takes one look and says, "So, what're you gonna put on your driver's licence? Blue?" Driving home, I feel his intermittent stare and see the corners of his mouth twitch. As soon as we hit the driveway, he jumps out of the car and explodes up the stairs. When he comes back down, Martha is at his side and he's laughing so hard he can't speak. "You," he gurgles. "You...."

We all love Martha. Jeff announces his engagement to her. She is excellent for sleeping upon and her only problem is drool, which she flings about with wild abandon as she plays. (When we bring her along skiing, she cadges lots of free food by hovering over outdoor picnic tables and slobbering lasciviously onto people's hamburgers.) She's not intuitive, she's not smart, she's just always loveable. Perfect.

But later, in her old age, Martha develops such severe arthritis in her shoulders that she can no longer stand, and I'm the designated executioner who takes her to that final vet appointment. Afterwards, I declare a hiatus on dogs. It doesn't last.

Before long, we're owned by a German Shepherd who decides which baby sitter to allow upstairs, which mailman is OK to deliver mail and whether or not the ocean's a safe place for children. Woof.

Meanwhile, the endless array of "vacation nannies" continued while Gene and I went to Miami or St. Croix to scuba-dive in the winter, or sailed to the

Newport Jazz festival in the summer. Kids did not go out to dinner or the movies with us. When they got older, they were allowed on scuba camping trips to Gloucester or the Cape, and on the sloop. Just not every weekend. If they came too often or stayed too long, Gene would become irritable. He would blame "business worries" and cut the outing short.

Chapter 11

Transitions

Astronauts zip past, Neil Armstrong leaps around on The Dark Side of the Moon and The Beatles enlist Sergeant Pepper; Stones roll and Who's behind blue eyes? Aretha and Motown and Nights in White Satin; Smokey and Gladys, Jimi and Janis and Marvin Gaye, Hey, Hey, JFK and where were you the day he died? But, Stop Children What's That Sound? It's Viet Nam and police dogs snarling in Selma and Martin Luther King and Bobby and Malcolm and Wow, man, that's some good weed and Jane goes to Hanoi, I want to go to Wounded Knee, and what's new pussycat and Laugh In, Far Out, it's all such a muddle. Everybody Must Get Stoned, the times they are achangin' much too fast, I need a little help from my friends, or at least a seatbelt. Oh Jim Morrison, open your Doors and take me away. To Woodstock. Flower Power. Groovy!

So there I was, in Longmeadow, doing whatever was right and proper to be a good wife and a good mistress. But it never did work right. I never managed to fit in with my peers. Those upper class Jewish housewives in my set who joined Hadassah, went to luncheons and kept a close eye on me whenever their husbands were around did not do it like me.

For fun, these ladies played golf in the summer and went skiing at Mt. Tom in the winter. At the country club, they clogged the fairways while they chattered along in their interminable foursomes. After nine holes, having given their all, they collapsed at poolside in puddles of suntan lotion and margaritas. When they got too hot, they put on giant shower caps to protect their bouffant hairdos and dog-paddled sedately in the shallow end.

At Mt. Tom, they donned their *Bain de Soleil*, their stretch pants (Spandex hadn't been invented yet) and went off to sit in the sun or flirt with the ski instructors from whom they took endless lessons, after which they fumbled their way helplessly down the bunny slope at least twice daily.

I never did it like that. I played 27 holes of golf and then swam laps in the pool. I taught my kids to swim before they could walk and had them jumping off the diving board as soon as they were out of diapers. The sunbathers watched me wait in the water under the diving board, grab my youngest by

her training pants after she jumped and steer her toward the pool edge. They talked, not sure whether to approve or reprimand. After golf season, I took martial arts lessons.

Yet, misfit or not, I insisted the kids attend Jewish Sunday School. I wanted them to have roots. I told them that when they grew up they could choose whatever spiritual expression they wanted, but that they would do this from a foundation of Judaism. At least they would know their spiritual origins more than I had.

So we join a Reformed Temple and every week I drive them to religious school and pick them up afterwards. I do my best to observe all the holidays correctly, but sometimes I goof. Like today. It's a lovely fall morning and the holiday of *Succoth* is upon us. It's a lovely little festival in which one builds a little trellis enclosure into which one hangs autumn fruits and other harvested things and I want to do it with the kids. But I don't know how. There's a name for the little trellis thing and a way to do it right. So, standing in the Temple parking lot with the kids, I stumble and stutter around, finally having to break down and ask them for directions. They look at me, big-eyed. Finally, Jeff, who is all of seven, takes me aside. "Mom," he says, looking up at me with his loving, compassionate Ancient Hebrew eyes, "It's OK. Even if you aren't even really Jewish. You aren't really Jewish, are you? But, you don't have to worry. It's OK." Well, it is OK. We'll stumble through together. Eventually, Jeff will be Bar Mitzvah. And at least know who he is, where he's from.

I wanted to be in the family of my lover. Like a Dickens orphan, I shivered in the cold dark with my nose pressed against Ernie's warm window. He did it right. His kids went everywhere with him. In his universe, everyone seemed to experience love and feel secure in his or her proper role. He loved his daughters and was gentle with his wife, even though he said she was frigid, was overweight and nagged a lot. I loved Ernie for being solid, conservative, stodgy and dependable. I wanted that, wanted some of that family feeling. Of course, he didn't share it. His wife looked at me askance, and, after that infamous auto accident, refused to speak to me, even though our families were charter members of the Yacht Club. I didn't understand her attitude: Where I was from, mistresses came to dinner.

That winter, Ernie's two daughters found Mt. Tom and soon he was up there every weekend, joining them in ski school to have some family fun. Well, if Mt. Tom offered a stalking opportunity, then that was where I was headed.

My neighbor, Helen, lent me her boots and skis for a week while she was away. I bought a lift ticket, went to the top of the intermediate hill and looked down. There, far below, were some hay bales piled up to protect a railing and that's where I pointed the skis. Over and over, that first day, I went flying down the hill and bashed myself straight into the hay bales. I bashed so hard that, each time, my feet flew out of the too-large borrowed boots, forcing me into incessant re-lacing. My old, trusted childhood chums, *speed* and *danger*, greeted me joyfully. They sat on my shoulder and shrieked into my ears. They laughed and cheered when I fell, applauding vigorously if this included involuntary somersaults. At the end of the day, my face was red and my hair was wild: *Après ski* was quite a bit like *après sex.* I marched into the ski shop and bought the works.

I kept right on with the hay bale bashing until some kindly elder took me under his wing and told me that one needed to make turns. He called it "skiing in control" and taught this by skiing next to me in a kind of crouch with his ski pole hovering under my bottom, hollering, "Weight on the downhill ski! Be a comma! Sit! Sit!" After I figured out how to do that, there was no stopping. Skiing took on a life of its own, took on my life, took me away and changed everything.

It was me and Mother Nature dancing together, a wild fandango which tired neither one of us. Daring the mountain on its own terms was like having a love affair with an alien who refused to play by earth rules. Exciting, eternally seductive, always a new trick: It meant pitting myself against gravity, extremes in weather and my own limits. Body and soul flew into space together and the challenge was in landing upright and asking for more.

Everything froze. Parka to chairlift, mucous from nose, fingertips inside mittens. Snow found its way into my ski boots. It didn't matter. For hours at a time I was free, powerful, having fun. And under the laughter there began a deep spiritual awakening. I could not stop myself: There, in this joy of snow and freedom, God so very quietly emerged and some first tiny glimmer of self-acceptance sputtered shyly to life.

A year later, I passed a rather grueling test and joined the National Ski Patrol. This took some doing. Gene was still seething from having me as his Scuba-diving buddy. He was angry at his own ambivalence. At one level, he enjoyed having me to himself with no interruptions from children and at another he was furious at my wild enthusiasm. He continued accusing me of being "competitive" and kept on making fun of me in front of his cronies about that business of believing the ocean was my mother.

Now, with skiing, his ground rules became stricter: 1. Every meal was to be served in the dining room rather than the kitchenette, with formal linen

and silver service. 2. Lift-tickets money was not to be had. 3. No cleaning lady was allowed during ski season. 4. Ski equipment for the children could be sexually negotiated but the price was steep.

It was all OK with me. I got up earlier, pre-cooked elaborate meals, got season tickets for the kids via the Patrol office and very proficiently acquired kid's ski boots along with increasing contempt for both the provider and the process. Gene's tantrums were a minor inconvenience. This boy was dealing with a pro: Arbitrary authority, senseless dicta and anger as manipulation were only tired re-runs, and quite easily managed.

That parka with the yellow cross gave me sudden social prestige. The ladies gathered 'round for pointers. Their husbands simply gathered 'round.

To ski every day, all day, with my cohort of patrollers became my true *raison d'être*. Camaraderie flashed in the glittery sunshine, laced with the sexual tension of good old speed and danger. We were a pile of monster snow-puppies. We spoke our own language, needed few words. Our dancing levitation spoke for us. We flew together on the edge of breath, down the narrowest trails, in the ice, through the sleet, flying, flying like handfuls of drunken butterflies. They cheered when I became airborne which was often completely unintentional. I was entirely free of fear. Falling caused me such paroxysms of laughter that I was more often in danger of wetting my pants from the inside than from the outside.

I learned that if I displayed a particularly somber, rather haughty demeanor while skiing out of control, most people seeing the Yellow-Cross Parka thought I was doing everything on purpose. One day I lost control on the ice while pulling an empty First Aid toboggan and wound up inadvertently racing through the parking lot. Thank goodness the toboggan and I hit nothing and everyone stepped aside respectfully after seeing that dedicated professional stare. ("Maybe she is on her way to rescue someone from an automobile?") Afterwards, I collapsed in laughter while the boss asked the ceiling what he had done to deserve me. When John Glenn, the astronaut, showed up to ski with a large entourage and a coterie of newspersons following him, the boss made me stay indoors. He was afraid of my surprises.

I had no style. My technique lacked the elegance and panache necessary for true peer respect. Like many self-taught skiers, I had an embarrassing tendency to allow a bit of space between skis, especially on turns. This resulted in something the ski instructors called an "abstem," a label better not discussed in polite ski society. And I hollered so loud when skiing under the chair-lift that the boss exiled me from that run because I was scaring the customers. ("My God, the Ski Patroller is screaming, what kind of a trail *is*

this?")

But what I lacked in style, I made up for in courage, endurance and excellent First Aid. The abstem was forgiven and I was accepted into the tribe. At last I fit in, was "doing it right." Adversity bonded us. We crouched in sub-zero twilight holding badly injured skiers while our feet got frostbite and our spines cracked. Our mitts froze to the toboggan handles. Sometimes we went along to the hospital and worried over x-rays and frightened families. We expected—and received—only the best from one another. On the hill, personalities disappeared under the stress and only expert Samaritans remained. By the third year, I received a national award. My kids were proud and we got patrol access to a bigger, more glamorous resort in Vermont.

Skiing was something my children and I could share. The youngest was in pre-school when we started and we didn't stop till I left home after everyone was safely in college. Ski trips were the one point at which we called temporary truce to our bitter in-fighting. I shelved my despotic approach to child-rearing and they held off on their vicious bickering. We laughed together. We huddled in sleeping bags on Vermont floors, rented trailers during school vacations, brought along Martha-the-St.-Bernard and dealt with frostbite, adolescent crushes and poor snow. We bought lift tickets at the most challenging ski areas so that we could enjoy "civilian" time together.

I'm standing trail-side, parka unzipped, my face turned to the hot spring sun. I've attached a little battery-operated toy to the First-Aid toboggan at my side. This gadget (called a "*Vroom*") is made for little kids to put on their bicycles because it makes a noise like an actual motor. Now, my toboggan emits realistic "putt-putt" sounds and when skiers stop to ask about it, I tell them that we are testing do-it-yourself First Aid transportation which will enable injured persons to drive themselves down the hill.

After awhile, messing with the heads of our paying customers loses steam, and I head downhill. I've rigged the inside of my parka as well: Harnessed over one shoulder in a First Aid sling is a newfangled transistor tape deck, currently emitting *Sergeant Pepper*. No one's ever done that before (Sony won't invent WALKMAN for maybe another ten years), and the music drifting out over the shiny moguls gives the run some extra pizzazz. I'm a spring bird. A swallow, perhaps, or a meadowlark.

At the bottom of the run I go to check the last trail-side toboggan tucked away by the woods and there, sitting on top, smiling at each other, I find my daughter Shelli and her beau, Tom. Like two benevolent tigers, they stretch, absorbing the warmth which the sun has amplified via its snow reflection.

They are waiting for 3:00 PM, when the sun will lose its intensity and the snow will turn into "corn." I open the parka a bit more to amplify the music and join them. We sing along a bit, idly, just being. Later on, the snow does indeed become "corn," which in ice-prone New England is almost as good as fresh powder.

Somehow, there was time for perfect days alone with each child. Jeff was much more daring than I, getting me onto wild terrain at Sugarbush and insisting that I could "do it." In his own whimsical way, he arranged for more than one triumph of the spirit, earning great respect for his quiet courage, his understated grace and proficiency. Megan and I took on Lake Tahoe together, where I discovered her wickedly dry sense of humor and excellent taste in music. "Good Day Sunshine," we sang together on the lift. And neither Shelli nor I would ever forget that perfect day, one spring.

It's a damp fall day, just before ski season, and Ernie has invited me to "break in" his new Longmeadow home. His wife is out of town with the two girls and we have a long, quiet Friday afternoon to ourselves. Satiated and content we inadvertently fall asleep, wake up with a start and Ernie says, "Good Gosh, it's time to light the candles." Of course it is. I am delighted. Lighting the Sabbath candles with Ernie—that loving family ritual which I've never experienced—will make me part of Ernie's family, even if just for a moment. Quick as a flash, I jump into my clothes and pop into the kitchen just as Ernie, wearing his *yarmulke*, strikes a match, begins the prayer. When he sees me, he suddenly blows out the match, stiffens and says, "Oh, I thought you were still in the shower."

"No. I didn't want to miss this. Go on, don't mind me, I'll just watch."

I'm beaming. He clears his throat. He says, "Well, never mind. Here, I'll just walk you to your car." Puts down the matches, takes off the *yarmulke*, his face is tense, his lips form a thin line of dismay, his eyes bottomless with some awful kind of repulsion. Before I know it, I'm in my car. I sit and watch him through the open blinds. The *yarmulke* is back on his head. He walks toward the kitchen and soon the Menorrah is flickering.

I get it. I am too evil, I am the slut, the harridan, the whore, so besmirched, so vile, my presence at *"Benching Licht"* would blaspheme not just his ritual Sabbath ceremony, but profane the entire family, defile the new house. Ernie, it appears, suffers from a severe case of "The Madonna and the Whore" syndrome, and the reason he and the Missus have had such a tepid sex life is because he sees her as too pure to fuck.

Oh my God, this is the man for whom I would have left home, the man

who gave my life whatever meaning it may have had, the man I loved beyond sanity. For whom I risk life and limb, marriage, and personal safety just for a few moments of pleasuring him in the front seat of his car. In the park. On his way to work. Like a very inexpensive whore. I sit for a moment, beyond pain. I feel an anger so vicious, a grief so wild, a humiliation so deep I have to take immediate steps or I will do something rash. Deep breath. Find the ice. Find the grey tundra. Feel the desolate wind, the silence, the complete isolation of the only place in which I have ever known peace. "Aah." And drive down the hill and out of Ernie's life forever.

Time flew. My Ski Patrol tribe, which had long ago adopted three little kids, now watched over three eccentric teenagers. Everyone got along. "You Gimme Those Good Vibrations," we sang, out of tune and in harmony. Even Gene, outnumbered, grudgingly joined in the fun and I stopped having to serve elaborate nightly repasts. Now, he sometimes joined the Vermont weekends. When he came, we stayed in fancy lodges and the kids stayed home.

Somehow, helter-skelter, the kids managed. Both Shelli and Jeff became All-State musicians in high school and much enjoyed playing in resultant concerts.

Shelli was in the All-State chorus as well, and had a coterie of well-behaved and pleasant girl-friends. Jeff was more isolated, with one or two close personal friends who understood his wild intellect. His artwork continued, powerful and witty. He loved languages and—for recreation—immersed himself in *The Upanishads*. Megan continued to perfect her role of "Great Disruptor," becoming more creative as she neared puberty.

(I was somehow too enmeshed with Megan. Loved her too intensely, got too angry with her, wanted to kill her, wanted to hold her, protect her, didn't know what to do with either her or myself. I was too close. She, unaware, saw herself as second-best, the one who had to fight for herself, for every shred of self-esteem against those two rivals who seemed to do everything better, who got the applause, who got the loving rewards.)

Megan was strong, though, and she rescued herself with greater wisdom than either of her parents. Megan discovered horses. First, at age ten, she nagged for a summer at horse camp. We were only too glad to comply and sent her off to a place nearby called *Bobbin Hollow*. She loved it. And when we went up there for "parent's day and horse show," there was Megan, in her equitation gear, profiled against the afternoon sky, sitting on her horse exactly like the little Texan girl in her father's office. (I still wonder if that photo motivated her, if she thought that, perhaps, against all odds, she could

find a spot in her father's heart—and maybe even in his picture frame—if she did it like that Texan.)

The next year, she went back and then back again, as a Junior Counselor. By that time, she knew she needed her own horse. A bit of heavy-duty persuasion ("You want her to become a hippie instead?") and Gene said he'd pay for one. So Megan and I went shopping and, after many long trips to obscure stables, after much concentrated observation, deliberation, negotiation, she made her decision: *Meredith Ashmore*, a lovely Morgan, became her family. They were just right for one another, even the perfect size. Meredith Ashmore provided Megan with love, self-esteem and—at last—a sense of accomplishment. Now she excelled at something no one else in the family could ever even dream of doing. She and Meredith became "we," as in: "We cantered so smoothly just now, didn't we display a perfect gait?" or "We need a little more practice here, huh."

Gene, of course, was begrudging. Even though he could well afford the ninety bucks a month required for Meredith's boarding stable, he refused to pay. "I got you the damn horse, didn't I?" But Megan was cool (oh, how very much like her mother) and got an after-school job at the check-out counter of the neighborhood grocery. She did her job well and supported herself and her horse straight through high school. Not only that, but she kept her grades up. So there, Eugene!

Somewhere along the line, my good ol' buddy Marijuana reentered the picture. Not just *my* picture. Mr. Weed re-painted the portrait of an entire culture and was welcomed with open arms. Things were changing rapidly for everyone. Viet Nam lurked like an ogre in the shadows under American beds. Sons went off to die. Or to march in protest against going off to die. The fight for Civil Rights inflamed this brave new generation with a passion for justice and contempt for the opressor. Kids were tripping, smoking and gently placing flowers down the rifles of policemen amassed to keep them orderly.

As for managing our resident teen-agers, my instructions to them were: "What you experiment with is not as important as your safety. Therefore, it is iron-clad law, with no exceptions, that if you feel in any way incapacitated by any substance anywhere, anytime, you call home and I will come get you, no questions asked." This worked. The kids remained level-headed moderates and—thank goodness—not one of them chose alcohol as an experimental substance. And this, coming from a family that gave new definition to the word "dysfunctional." "Whew!"

Getting Gene stoned was a blessing. Under the influence, he was affectionate, laughed a lot and did not drink. Inevitably, he got a severe case of the munchies, making it necessary to keep lots of goodies available, but

that was a minor inconvenience compared to steering the household safely through his daily drunks so the kids wouldn't catch on he was a lush. Absence of alcohol eliminated his wild tantrums, those endless tirades which I had to array so everyone thought he was just generally pissed off rather than generally pissed. This had always been difficult, requiring a great deal of energy, diplomacy and duplicity. I welcomed the respite.

Of course, getting Gene stoned took some maneuvering. After all, the house was filled with three high schoolers who were also indulging and it was up to me—via Gene's unequivocal orders—to keep them unaware. So, now I had to protect him from being found out as a "freak" instead of a drunkard. Same trip, but a lot easier. After all, when stoned, he kept to the bedroom and was generally quiet.

Gene and I are upstairs, happily giggling at a new episode of *The Twilight Zone*, when there's a phone call from Shelli who's at the Greyhound station with two foreign exchange students she has just picked up and is about to deliver to their new homes.

"Mom, we've smoked some weed and I better not drive. Can you come pick us up?"

Gene and I look at one another. Oh boy. Could I navigate? Well, I'd better. So, after a bit of difficulty getting the key into the ignition, I'm off to the rescue. I'm scared, both of driving stoned and of being discovered. But the dilemma is also pretty funny, and I have problems keeping a straight face. Finally, I decide I'm a test pilot driving an alien conveyance on a foreign planet and must think like a proper astronaut. This works.

It's hard to tell who's the stonedest, they or I. The exchange students speak no English, Shelli speaks not at all, I turn on the radio and drive real slow. After awhile, they sing. Rescue mission accomplished and Shelli praised for having made the call, I float back upstairs and pop back on the bed—a hero spent in action, ready for rest and recreation.

Gene gave me money for the best Colombian, which I procured in Boston. I would dress up in my most respectable "Upper Class Suburban Housewife" outfit, borrow Gene's Buick Electra, which, after all, reeked of respectability, and drive off to the supplier—my teen-age nephew. On the return trip, I stowed my purchase in the trunk and always stopped at the turnpike entrance to pick up long-hair hitch-hikers. Their backpacks went in the trunk alongside the weed. That way, if we were ever stopped by the police, I could innocently point to the hitch-hikers, to their stuff in the trunk and, maybe, turn to the police, saying, "Tsk tsk, tsk, these kids today..." Fortunately, no cop ever

stopped me and I did a good deed by providing transport for hitch-hikers. After all, my own children hitch-hiked and this was the least I could do to provide other parents with safe rides for their kids.

The bedside phone rings at 12:00 AM. It's Jeff, calling (collect) from his cross-country hitch-hike.

"I'm at the bus station in Flagstaff, Mom, and someone's just stolen my backpack, I have nothing left but ten dollars and two hits of acid, so I'm catching a bus to the Grand Canyon, drop the acid, sit on the rim till sunrise and then jump in. Thought I'd better let you know."

It takes two hours of smooth talking, two hours of calm negotiation, support and very active listening to talk Jeff down. At the end, he agrees to contact Traveler's Aid and toss the acid down the toilet. Lucky for him he flushed it, because on his hitch-hike return home, he's arrested in Colorado for being a "Long-Hair on the Highway" and the cops' search reveals a weed pipe with residue. They let him go after threatening to shave his head and throw him in the pokey. Whew.

Stoned sex almost saved the marriage. With a little help from the weedy, Gene was able to put away his silent bedtime sulks, not have a headache or be too tired and remain functional throughout.

As for me, once stoned, I was so in love with our bodies that our borders got lost and I couldn't tell where I ended and he began. Our arms twined like one slithery snake, our legs refused to acknowledge whose knee was bending; even our toes mingled, causing delighted laughter at not knowing which little piggy was going to market. The beast with two backs was not in this bedroom. No, here there was just one being, one breath and as many orgasms as I could manage before Gene finally erupted.

For months, we were lovers. For once, he did not wilt if he sensed in any way that I was about to be satisfied. For months I wasn't left writhing, with the rage of a million furies and seething with a contempt too vicious and cold for vocabulary or definition. For months, I was happy to see him come home, was delighted to play.

We sail, that summer, just the two of us, for weeks, our differences left ashore. From our Connecticut berth, we make our annual sail up to Newport for the jazz festival. Along the way, we go scuba diving or skinny dipping in the sunshine, anchor in snug twilight harbors where we're rocked to sleep by "Mama Ocean" in the blessed calm of night. This time, there isn't even any AM bickering over whose turn it is to make breakfast.

We wake relaxed and sleepy, salute the little rubber ducky over the galley sink, cook breakfast together and sail off for another day's adventure. I am mate, in charge of jib and mainsail, jumping quickly to excecute the captain's orders with disciplined perfection. When the afternoon sun hits the yardarm, we wander into whatever cove is handy, anchor down and I serve the hash brownies. Within the hour, we are pleasantly swacked and out comes the tape deck with Cat Stevens or Chicago urging us to dance on the afterdeck. I'm careful not to bring more radical stuff like Jim Morrison or Jefferson Airplane and, stoned, Gene is willing to postpone Sinatra. We groove to the tunes, we dance, he slaps his thigh and laughs at the lyrics. Later, at dinner, it is time for Tatum, Ella and Brubeck. After all, we hadn't named the sloop "TIME OUT" for anything written by Mick Jagger. We laugh a lot. Our hands touch.

Sailing had always been Gene's domain. Perhaps, when aboard, he allowed himself to be so loveable because, for once, he did not see me as competition. He was the Captain here, this TIME OUT was his kingdom, his seven seas—and he got to shout orders, receive immediate compliance and get heaps of praise for steering us expertly between the buoys of strange harbors. And the afternoon pot, instead of those damn afternoon cocktails, relaxed him even more.

I didn't ask questions, didn't care, just enjoyed. It felt so good not to be lonesome, not to peer out at my marriage from an iceberg. Gene was fun. His keen wit, that acerbic, irresistible sense of humor which had entranced me so long ago, was back. And, best of all, sailing was exciting. Speed and danger danced in the waves like escorting dolphins who jumped into the air, splashing gleefully when I straddled the foreward rail to reef the mainsail while we were heeled over almost to the point of no return.

Gene pushed the envelope when sailing: None of the temperate caution he exhibited scuba diving, or any of the sheer terror that froze his face on the ski slopes. Here, he was a skilled adventurer, which caused enough respect for him to allow me a bit of sincerity.

And the ocean—a more intimate, more ardent, more steadfast lover than even the wildest ski trail —caressed, healed, soothed. At any moment, I could ask Gene to set anchor and jump right in, dive down, float back up, lie naked on my back pillowed by the entire Atlantic, look up at the sun and sigh, "Aaah."

Every moment, we sailed on a different sea, a different hue. In the morning, it was a silly blue, matching the sky and its little airy clouds above with its own offerings of puffy white foam. At mid-day, we were surrounded

by a matronly dark mother, with no chop, with broad swells that beckoned us to her bosom. "Come," she murmured, "jump in, get out of the heat, I'll keep you safe, I'll cool you down, come on in, meander down the anchor line, I'll give you a starfish if you're good." Late afternoons found us sailing on the color of pain. I would dip my hand in and remember drowning in exactly that same steel grey when I delivered Jeff and he crowned before the anaesthesiologist showed up. At bedtime, of course, we matched the sky again. Reflected lights from shore and other boats replicated the stars above and we sighed, turned to each other and cuddled together in our floating crib, "Mama Ocean" singing us her swooshing lullaby. How could this not be bliss?

When we got back home that summer, Gene invited the kids along each weekend and was, indeed, a gracious host to his offspring. Even though we stayed straight when the kids were aboard, he declared truce on his onslaughts of sarcasm at their lack of perfection. They were permitted to play, they were allowed to enjoy themselves. This time, he did not scold them, turn away from them in disgust or cut the trip short by pretending he was needed at the office. When we got back to the moorage, he treated everyone to dinner at the Mystic Pizza. Once in awhile, they were even allowed to bring friends. We were all content and, perhaps, the children wished it could happen more often.

Then, suddenly, the dream was over. Back in Longmeadow, stoned sex stopped working. Gene complained he could no longer keep his mind from entering along with him. And besides, he said, stoned sex made him too tired the next day. The old patterns emerged. Only now, it was worse for me, because now I was stoned and wild, a raving sexual maniac drowning in the relentless surge of some giant tsunami smashing itself onto the stormy shore of my libido.

It was too much. I hissed past him like an Antarctic ice storm, my loathing a frozen howl in the vast, barren tundra of my soul. And in the following year or so, found new ways to assuage anger, to cure ennui.

Meanwhile, Malcolm X went to Mecca and there, on his Hadj, he looked around and saw his fellow pilgrims. Their skins were brown and black and yellow and white. Their eyes were blue and black and green and hazel, and all of these eyes shone with reverence, with devotion to Allah, with love for God and one another. And Malcolm grew, in that moment, from man to hero. It takes a hero— a person with such courage and integrity that truth becomes larger than ego—to face God and humanity and state he has been in error. Malcolm X, who had flown to prominence on the tattered wings of outrage

and pain, for whom the white man was a "Blue-eyed Devil," against whom Malcolm preached vengeance for all Blacks who had suffered—who had been lynched and raped, dishonored, disrespected and discounted. This Malcolm X stood up and faced himself and faced God and proclaimed that all men were brothers, that anger solved nothing, that vengeance just produced more outrage and more pain. And that, in order for this nation and this world to survive, we would all need to put our differences away and work together as one—because that is what we were: One. And I knew in my heart and soul that this was the man who would finally unite the races in America. This man who was so honest with himself would be honest with us all. He would preach it so clear and so clean that even the reddest-necked bigot in Mississippi would eventually bow before the power of that truth and reach out to his neighbor, black, white, pink or high yaller. And I committed myself completely to his cause. I told the kids, I told my friends, I told the neighbors, I told Gene. "Peace," I said, "will come. Yes, indeed, the word is out. Peace will come." And then they shot him.

I don't have to pick Jeff up at the high school until 3:00, which means I have all kinds of time available to stalk Randy. I dress carefully: Hip hugger bell bottoms, tight enough to show a slight crease of vulva. Shirt of clingy, almost transparent jersey, giving a glimpse in the autumn sun of nipples, of movement and short enough for navel exposure. Platform clogs on my feet, huge green plastic earrings, same shade as the shoes. Sunglasses that Jeff says make me look like an ant out of a science fiction movie, but that's OK, Jackie Kennedy has a similar pair. Lots of eye makeup, no lipstick. I'm ready.

Randy has been my summer playmate and I want him to be an all-season buddy but Randy turned skittish around Labor Day. Stopped calling, stopped making unannounced stops in his Longmeadow Police Department cruiser bearing gifts of ice cream and confiscated marijuana, stopped bouncing me around all over my bed and onto the dresser, all over the dressing-room carpet and into the bathroom while the current German Shepherd moaned and growled helplessly outside the door certain that, given the noises we made, murder was in progress and it was her fault for not protecting me in time.

No more stoned afternoons at the Amherst Motel where, with the Moody Blues and Pink Floyd on my portable tape deck, we swam in the indoor pool and then rushed off to Burger King after hours of sweating and laughing and grunting and smoking ourselves into a severe case of the munchies. I miss all that, and I miss Randy. It's not time yet for ski season and I'm lonely.

So now I show up casually, accidentally, at Friendly's where I know he

takes lunch hour, do some shopping at the little grocery store where he works part-time, wander down to the high school track where he runs—oh, just happening to be in the neighborhood and whatcha up to, stranger?

I am a patient stalker, content to park on side streets for hours, awaiting just the right moment, just the right move. But it is becoming increasingly difficult to catch Randy. He is just as canny as I and knows all the correct cadences and rhythms for casual greetings that show only friendship and promise nothing. Worst of all, he allows his eyes to tell me that he is aware of the deliberate nature of our accidental encounters and that these are causing him to lose respect. We are done. I know it, I just can't admit it. I'm stuck on Randy, too tight to let go. This will lead to embarrassment and shame. I know that, too. But, just one more time, just once more, once more will do the magic and Randy will be mine forever. Just once, if I can catch him just right.

It had been in March, almost the end of ski season, when I stopped at the local grocery for some quick and easy dinner. My ugly-orange patrol parka sported stains of yesterday's chairlift grease and today's blood, my face had goggle sunburn marks like a neighborhood raccoon, I was limping from an encounter with a runaway ski and my fingers still ached from holding someone's leg in traction too long in the snow. Tired and satisfied, I was headed for the Hamburger Helper when I was suddenly confronted with a feral male, escaped from some erotic fantasy. He was crouched in the aisle and looking up at me, tense, like a cobra coiled to strike. He held my eyes with such passion that the dirty parka turned into a translucent designer jacket, the sunburn changed into an even tan, the limp turned into an undulating African mating dance and my fingers generated enough heat to melt anything they touched. Not only that, but under the parka, I was suddenly naked. I inhaled too sharply, hoped he didn't notice, and reached for Cap'n Crunch. When he was finished looking, he laughed and returned to stocking cereal boxes. I glanced back at him over my shoulder and noted the stellar globes of his behind protruding from his workpants like ripe cantaloupes ready for someone to take a bite.

Next time I shopped there, he was waiting to see how I looked all dressed up because he knew that this is how I would show up. Dressed to kill. He, of course, helped me carry groceries to the car (said he was a local cop moonlighting at the grocery store), and by the time we crossed the parking lot, we were ready for bed.

In summer, I invited him to swim at the Yacht Club where he caused whispers and raised eyebrows by emerging from the men's dressing room in

his bathing suit. Muscles like a python embracing a piglet, walk like a panther prowling for a baby doe, one brown curl falling over eyes like bottomless prehistoric tar pits and, of course, that savage smile, acknowledging his admiring public with unselfconscious grace. He squinted in the heat and plunged headlong into the deep end where he caught me, dragged me under and slid his hand inside my bikini bottom before we both exploded back into the sunshine. We swam entangled like two eels and lay exhausted on adjoining deck chairs, our hands dangling, our fingers touching.

He was more beautiful than I. When we walked into Burger King, heads turned for him, not for me. This was a new experience, slightly humbling but flattering just the same. After all, it was my hand he held.

Randy was no secret. "He's my friend," I told the children. "He's a good guy. Here, he brought you some ice cream."

"Married, got a family, looks out for the house when you're gone. Deserves a swim now and then, only fair," I told my husband.

"Just providing R & R for the cop on the corner," I snickered to the women at the Yacht Club.

But now it is over and I drive to the high school in despair because I have just seen his cruiser pull up at Janey Zlotnick's house and she is even slinkier than I. Misery builds in my heart, and I allow a small gasp. I am suffocating in the overwhelming shame of being a failure. I wish could cry, but manage only to grit my teeth and grin into the rearview mirror like a corpse with rictus.

Jeff is waiting for me with a friend: Tall, black curls, dark eyes, dimpled smile. "Mom, this is Michael. Can we give him a ride? Michael, I'd like you to meet my mom."

"Sure, get on in Michael, pleased to meetcha."

Michael gets in and turns to Jeff. "Hey," he says, "Your mom's not a mom, she's a chick," and flashes at me, flirting like a grown-up.

"OK, Michael, cool it," I say, and feel much better.

Marijuana changed for me. Instead of just being for fun, silliness for its own sake, smoking weed opened my brain. Like Richard Feynmann, the Nobel Prize Laureate physicist, I discovered that psychedelics had more than superficial use. Like Dr. Feynman[1], I discovered that weed unlocked some

[1] Feynman, Richard. *Surely You're Joking, Mr. Feynman.*
N.Y., N.Y.: W.W. Norton, 1985.

previously unaccessed parts of my brain. Smoking didn't get me to win the Nobel Prize, but did cause me to actually understand what Einstein meant by $E=MC^2$. Learning Einstein's theories was part of the impetus that eventually brought me back to school at University of Massachusetts. It was the beginning of a change in how I saw life, in how I saw myself. Almost like skiing.

Gene, *après ski*, talked too much. At the Vermont ski area, it was Patrol custom to gather at someone's place and, after a long day, pass a joint, sit back, listen to the music and just be with one another. We all pretty much knew one another's moods and—as always—needed few words. If someone broke out laughing, the rest of us knew pretty quick what was funny. Sometimes we went out dancing and did The Jerk till our necks hurt. Most of the time we just hung out.

But when Gene came along he talked too much. He was anchored in cocktail party small talk. Not even getting him stoned did any good. He thought he was with his own set—those folks who dressed up, drank a lot, passed the hors d'oeuvres, made meaningless chit-chat and flirted with each other's spouses. So he talked, his hands flapping ineffectually up and down on his knees.

It was during those evenings that I began to understand that I was no longer a member of Gene's culture. Even music, that mutual love which had brought us together, now ripped us apart. Gene clung ever more desperately to Frank Sinatra while I flaunted Jim Morrison like a battle flag. Finally, it was the music that spirited me away. When Jimi and Janis beckoned, Gene complained of the noise they made. The Jefferson Airplane flew me high and Aretha, that Natural Woman, Queen of *my* soul, demanded more respect than his Dionne Warwick who couldn't even find her way to San Jose. And then came Santana: He was fearless, this Carlos, completely unafraid to put his heart and his soul right out there onto his guitar strings. He managed to blend Latino, rock and multi-rhythmic jazz into such completely irresistible music that it grabbed and whirled me around any room in which it was played. Not since I went to Puerto Rico and got seduced by *Salsa* had any music touched me, danced me, in such intimate places. "Listen," I would beg, "listen. It's good, Gene, really, it's good." Maybe the times, they were a'changin', but he wasn't.

I thought about how I had always had great difficulty fitting in, "doing it like the others." The mystery of correct suburban social skills was no longer important. I thought about the ladies who played golf and showed up at Mt. Tom in their stretch pants. Now I was glad I never got the hang of how they did that.

Wrapped in a psychedelic halo, I dived into another time, another pace, another place. Gene could either come along or not. Trailing tendrils of weed, some choice blotter acid stashed in my bell-bottoms, I drifted into another generation and I wasn't coming back.

Chapter 12

California Dreamin'

Someone's pushed the "fast" button. Life is whirling along so quickly, so many things are happening at once, there's no logical chronology. But it's all right now, in fact it's a gas, because "the Pill" is freely available and no one has to worry about unexpected parenthood anymore. The war in Viet Nam is still blundering around like some frightful psychedelic monster created by a nightmare of bad acid : It kills and screams and makes very little sense. Maybe Lydon Johnson's tripping. The rest of us surely are. Well, at least the music's good: Stevie Wonder, Eric Clapton, Chick Corea, Lennon and Yoko: "All We Are Saying is Give Peace a Chance." Timothy Leary. Yeah.

The house is quiet. Shelli's a sophomore at Wooster in Ohio, and Jeff, a freshman at Reed in Oregon. Megan and I manage somehow. I drive her to the stable, attend all events, have even learned to hot-walk the horse. "Meredith Ashnoodle," I call him. His velvet lips nibble my hair, his wise eyes old as destiny. On our way back from the ring, he prances a bit, using his teeth to flip towels and tack off every stall door he passes. Meredith Ashmore is cool: An affectionate horse with a sense of humor!

Then, right at the beginning of the school year, Gene announced he was going to Oakland, California, for an extended sale and I decided enough was enough. Besides, I'd never been to the West Coast. This time, it was my turn for a tantrum, and Gene finally caved. We made arrangements with the stable to excercise Meredith and Gene arranged for a suitable apartment in Oakland. Longmeadow High forwarded Megan's records, and, with skis securely on the car-rack, away we went.

Driving across the country with Megan sulking in the back seat and Gene nattering in the front required planning. So, a bunch of hash brownies went into my back pack and I downed one in the bathroom stall of our daily afternoon potty-breaks. We were driving west, my current prescription sunglass lenses were purple: Needless to say, the sunsets were spectacular.

When we get to Arizona, for once we unanimously agree that the Grand Canyon would be worth a detour. And, wow, it sure is! We register at El Tovar, right on the brink, and take an afternoon stroll, gasping at the scenery. When Gene and Megan return to the hotel, I stay on. Late afternoon sun turns escarpments bright orange. In the infinite distance, violet cliffs hang in pastel sky. The wonder of it takes over. I cannot fathom such majesty, so I just lean on the railing next to an old Native American woman and stare. She turns.

"You got a cigarette?"

"Yeah, sure. Here ya go."

We light up, exhale. I ask, "When's the very best time to *really* see this place? Is it now, or morning?"

She takes a moment to look me up and down, and, inspection completed, says, "For you, the very best time will be starting at 4:00 AM," and walks off.

Next morning, at exactly 3:55 AM, I head out slowly, slowly, along the railing. I want to savor every nuance, want to sip it like fine brandy. I feel a presence, moving, alive in that giant chasm, so immense it fills even the remotest labyrinthine passages. It feels palpable, almost touchable. From deep river to stony rim, it makes a soundless sound of such resonance and power it permeates my entire being. This presence emits the conscious respiration of life itself. It breathes so silently, so softly, yet with the force that keeps our planet spinning orderly. I know, then, that I am in the presence of God. That God has been breathing the deep night of the Grand Canyon and is now just beginning to awaken a new day, is almost ready to stir morning toward dawn. I stand transfixed, accepting the impossible possibility of God as an actual reality like a child accepting its first snowflake. God flows in my veins and arteries, God beats the cadences of my heart, breathes my breath. And not just mine—everybody's, everything's. My intellect bows humbly: It is stuck. Can't formulate a proper explanation. And that's OK with me. I bow humbly, too, in respect for this experience, in respect for the inexplicable wonders surrounding me.

I walk, and the dark texture subtly changes, the colors lift, daylight inches its way over the cliffs, turning them mauve, till morning unfolds like a quiet flower. A lone hawk silently circles the pale new sky. He swoops and rides in the almost sun, looking for his breakfast.

I see a figure walking toward me on the rim path. It's a long-hair Asian youth, late teens, perhaps just turning twenty. We approach one another and when we meet, without a word, we walk into each other's arms. We stand, hugging, till he pulls his head away from my shoulder and says, "I don't care what they say. I am going back to San Francisco and live with my father."

"Right on," I reply, kiss him gently on the forehead and walk on toward El Tovar. Now, I hear grassy rustlings and bird chirps. In the distance, faintly, a dog yips out a perfect morning cliché; the sounds of earth are taking over.

Next day in the car, I skip the brownies and pretend to sleep. Instead, I recall once standing atop a misty morning mountain, listening to a convention of winter blackbirds discussing their plans for the day. Foggy wisps whispering, "Stay, stay" hold me in place. When the blackbirds disperse, the mountain becomes still and as the sun glitters its path across the snow, peace steals into my heart. Across the valley, grey-green old timbers and aqua saplings wave their arms at one another and at me, so far away. Serenity becomes reverence. This is my church, my sanctuary. No man-made place could be this holy.

I stand for a bit, leaning on my ski-poles, watching sun disperse mist. When the blackbirds suddenly begin crackling again, there rises in me such an explosion of joy that my arms fly up and my face tilts skyward. I want to sing, to cry, but settle for snow-plowing down the hill, slowly as possible. I want to float quietly, want each movement to be a paean to—to what? I dare not say the words, even to myself.

Now, today, God has become a living consciousness, breathing eternity into the universe. Not just out there in the cosmos, but here in the Buick, and in the ocean where the surf sings out loud what I heard silently, yesterday morning at 4:00 AM. I finally give up trying to find language for the experience. God, apparently, is both too complex and too simple for human cognition. I stay pretty quiet till we hit California.

The Bay Area was love at first sight. From Oakland Bridge to Bay Bridge, from Ghiardelli Square to Walnut Creek, from Nob Hill to Berkeley, that was it, folks, I was a goner. Every morning I jogged around Lake Merritt, which was an easy walk from our apartment, and every morning was sunny. There, wildly colorful birds yodled in the treetops, and once I even saw a monkey. Women's jogging shoes hadn't been invented yet, so I made do with boy's racers and they worked just fine.

Later in the day, it was time for Berkeley ("Berzerkely," we called it) just forever wandering around there, grooving on the long-hairs, the preppies, the "freaks," the tie-dyed, the bra-less, the vendors, the smells. One day, walking up Telegraph Avenue, I passed a woman just like me, on her way down. She was in her fifties, wearing a fringed serape over her bell-bottoms, and on her head was a wide-brimmed felt hat trailing a purple plume of feathers. I recognized me in her. She had ten years on me; she was who I was going to

be. She walked like a winner, every step self-assured. Shoulders straight, head held high, proud, sexy, unafraid, her body in very obviously good shape. I had never met a woman like me before. Here, I was not an oddity; here, I was commonplace. I wanted to live here forever.

During Christmas break, Shelli flew in from Ohio, Jeff came down from Oregon. We didn't miss a thing. We toured Alcatraz, Marin County, browsed the outdoor market at Fisherman's Wharf, rode the cable-cars, drove up Lombard, explored Golden Gate Park and China Town, used BART to get around.

Oakland had its own special flavor. Angela Davis and Huey Newton had left their marks. Everyone Black was proud and beautiful, the police had stopped major harassment of the activists, the streets were filled with triumphant vibes. Of course, Oakland was still Oakland. Shelli, coming home late from an errand, excused her tardiness by saying she'd have been back on time, but the bank next to the grocery was being held up and she had to wait till after the robbery to check out her purchase. It didn't matter. Casual bank hold-ups were part of the flavor, gave the place some extra panâche, some added excitement. I wanted to live permanently on a houseboat in Sausalito, and did my best to persuade Gene to make that happen. "Well, maybe," he said, "We'll talk about it when we get back home." It was to his credit that he found such a tactful way to say, "No." It was OK. Someday, I would be back. I knew that.

After Christmas break, Megan skipped school so we could drive to Lake Tahoe for a long ski-weekend. We had never seen such a giant hill, or snow so dry and powdery. On the lift, we heard someone complaining about "ice on the run," and when we looked down, saw a sliver of blue perhaps the size of a yardstick. Folks out here definitely didn't understand "ice" like New Englanders, which both amused and made us feel superior. Megan, who usually kept all personal information hidden, shared her love of the blues (she'd thought they were a current innovation and was tickled to learn about Muddy Waters), displayed a delightfully playful competetive edge, and actually looked horrified (did she really care about me after all?) when I took one of my more spectacular headers, which meant falling *off* rather than falling *down,* covering half the run in two or three bounces. Sunburned and relaxed, we picked up Gene and headed for Reno/Las Vegas which was also fun, albeit of a slightly different nature. Megan snuck into the casino to work a few slot machines before getting evicted, and we found a plethora of inexpensive restaurants which apparently made their money by serving delicious foods and gambling machines all lumped together.

We're back in Oakland. Megan's doing homework, Gene's working late and I'm lying on the bed attempting to define God. I think about quasars and the new Big Bang theory. I try to picture the enormity of the Universe, but cannot. (I can't even visualize our own small galaxy, the Milky Way, which has over four hundred billion stars.) Did this entire indefinably immense collection of innumerable constellations all really spring from some central point? And are all of these actually flying through space away from that central point at similar rates of speed? (Was God at that central point, and, if so, what was God's purpose?) How come this immensity—much too large for my little brain to conceptualize—remains in such orderly progression? Novas don't collide, constellations don't fall down and how can I use words like "up" or "down" in space which has neither?

What's making the bed so suddenly hard? I squirm around trying to get comfortable. Why am I doing this anyway? I wish I had a joint. But I can't resist the subject and go on speculating.

I finally decide that God is not just my philosophic concept, or Voltaire's; that God really is—again too large for my mind to define—the tangible Consciousness that did create, continues creating, has always created, this infinity of which we are part. And that this Consciousness, which keeps the stars from falling, which keeps quasars speeding along in such an orderly manner, is, in fact, some kind of energy-with-awareness, a completely pure, cognitive Energy-Entity. Bumper-stickers on decorated vans say, "God is Love." How can such a thing be? I think about holding a newborn, touching its ten perfect little toes, feeling its tiny fingers curl around my thumb. Maybe that's it: Love. But not love as we know it, all corrupted by our weird expectations and personalities. It's got to be love without emotion, distilled to its purest essence: Some kind of focused, conscious, electro-magnetic energy, too intense to contemplate, something which no physicist will ever be able to prove. I know it. Even if I've never felt it, I know it.

Megan is in the kitchen, hollering, "How come there's never anything to eat in this place?" I stretch, relieved, get up to guide my daughter to the bagels and recommend either cream cheese or peanut butter. She settles for both. I pour her a glass of milk and, since she won't engage in conversation, wander back to the bedroom. Flop down on my bed-of-nails and get on with God.

So, Megan and I are humans. But what are we? What's the point of us? Maybe everyone is simply a small grain of sand in a very large collection of cosmic sand dunes we've labeled "universe." Then, I decide that—in order for these dunes to continue to exist—they really need each and every little grain of sand to be there. So, I wonder, if God is both the dune and also each

individual grain of sand in it, aren't we interdependent? But I don't know what that means, maybe I read it somewhere.

Finally, I decide that God actually exists and, if we're made in God's image, it's because we, too, are that strange electro-magnetic energy, except we're not aware of it. Either we haven't evolved sufficiently to understand what we really are, or maybe we've evolved too much and can't accept anything unprovable by ego and intellect. It's like trying to define our souls: Our souls, those individual grains of sand, what are they really? It seems that animals, unburdened by intellect, are much more comfortable with their divinity; they don't lie around on lumpy mattresses in strange towns trying to identify their spiritual make-up.

$E=MC^2$ must be as true for Mars as it is for the little blade of grass stuck on my sneaker. Is that why Einstein said, "God is subtle?" I wish there were someone who could help me figure this out, but there isn't. I wish Voltaire were here. He'd know.

I hear Gene's key and his footsteps. He, too, is heading for the kitchen. I get up to join him. I've hidden a little sliver of lox behind the butter container, just for him. I'll make some tea and chat a bit, ask him all about his business day, how many Mr and Mrs. Marks he's relieved of paychecks in return for those great, bargain-priced, going-out-of-business, all-sales-final diamonds.

Chapter 13

Sex, Drugs, Rock 'n' Roll, Part I:
"Chain of Fools"

Women of the world, unite! Bella Abzug stands at the New York Horizon, waving one of her outrageous hats. Gloria Steinem tells us what it's really like to be a Playboy Bunny, Betty Friedan steers us toward our innate self-worth and Germaine Greer wants it to be known that females are not eunuchs, even if they do have to menstruate. "No more Bras" is the battle cry of our emancipation, and I, for one, enthusiastically remove mine: Not because of major political statement, but because I just entered my forties and am delighted to show off that I still don't need one.

We returned to Longmeadow in time for most of ski season, and life resumed its lurchy familial rhythm. Shelli, who had spent an urban school quarter in Portland, Oregon, fell so in love with the place that she now planned on quitting Wooster to spend some time in the Pacific Northwest. Jeff, who said that Reed valued him only for his brain, transferred to Evergreen in Olympia, Washington. He had just completed an internship semester at the Field Museum of Natural History in Chicago, where he became fascinated by Northwest Indian Art. Evergreen not only encouraged this interest, but—due to that semester between high school and Reed which he spent at Jerusalem University in Israel—gave him his own little office space where he, even though only an "undergrad," coordinated independent Mid-East studies. Megan had one more year of high school coming up, Meredith Ashmore was trotting right along, and life was as it should be.

My temper still exploded irrationally, I still happily devoured Dexedrine instead of food, marched in anti-Viet Nam protests and explored the brain. I learned, for example, that the left hemisphere is used for linear and logical thinking, while the right hemisphere is the creative, conceptual side. "Aha!" said I, "betcha psychedelics open up the right side of the brain more. That's why I can abstract Einstein so poetically when I'm stoned; and explains Richard Feynmann's experience, too. Timothy Leary's right. Yes, let the weed lead!"

Everyone's home for the summer; I'm upstairs grooving to my favorite Led Zeppelin LP and folding laundry when there's a sudden weirdness in my forehead. Up near my hairline, between the eyes, there's a pressure and a buzzing that seems to grow stronger every minute. Then, I hear voices coming from the foyer. "Mom," Jeff calls up to me, "c'mon down. There's someone here to see you."

I walk halfway down the stairs, the buzzing pressure now more pronounced. And then I'm stuck. Struck. Stuck.

The smile hits me first. Mischievous and salacious, framed by a (new) black moustache. Then the eyes zoom into mine. Black, merry, deep, mysterious, sad, happy, sexy and wise. Under a mop of black curls. Good Grief, it's that kid, Michael, from high school, only now he's a grown-up.

"Well, Hi Michael, howya doin'?"

"Oh, OK, I guess. Good to see Jeff again, though."

I descend the rest of the stairs, serve the guys some Pepsi and we settle down to catch up with one another. That thing in my forehead is revving up major decibles which seem to increase their intensity when I face Michael, but it's bearable.

Michael, it seems, is writing the Great American Novel, but has no place to stay. (Was living down south at his girlfriends', but her parents kicked him out.) He's nineteen now, he says, and expects to be published by his twenties.

"I'm gonna be the youngest ever Nobel Laureate for Literature, if I can just find a place to write it."

It's clear he's not kidding and I, against all reason, believe him.

"I thought, maybe, Mom, he could stay in the dining room. I mean, no one ever uses it. You know, just to have a place to sleep while he writes. Whatcha think?"

Think? What's to think? "Oh my God," some frightened little voice inside me says, "you do this and that's the end of skiing." I pay attention. Somehow, I know this to be true, even if it doesn't sound rational. But I don't care.

"OK, Michael. But you've got to keep your space neat. Gene's a stickler on neat." And, like they say in old movies, the die is cast. When the boys leave, the buzzing forehead pressure ceases. Now, I just have to figure out how to pursuade Gene that a boarder in the dining room is just what he's always wanted. Eventually, Gene breaks down and gives reluctant permission. "Besides," I whisper, absentmindedly twirling a curl of his pubic hair, "I mean, we don't have a dog now and, y'know, I could take him for walks and such." Giggle. And then get down to business.

Chaos ensues as soon as Michael moves in. Shelli and Megan sense a

172

certain tension between the new boarder and their mother. They do not approve of our interactions one bit. Never great shakes as a mom, I've stepped over a line: Michael gets my time and attention; they get neglect. Jeff is ambivalent, then guilty. After all, this had been his idea. Gene dislikes Michael, sees him as an interloper and a threat. The pressure in our household—which could fuel a locomotive—escalates daily.

Michael and I circle one another like two alley cats. On one level, we're buddies. We give each other gifts: I present him with "Stoned Picasso" and he, in return, bestows "Stoned Escher." This means when no one's home we toke up, put some Ravi Shankar on the stereo and sit for hours, leafing through large coffee-table volumes of these artists. Amazing what depths I get to see in Escher. (This chap couldn't have been straight, not any more than Lewis Carroll.) Musically, I receive post-Beatles Lennon and he, Stravinsky. And our literary swap entails William Blake, Romain Rolland and Gertrude Stein from me, while Michael in return lets me read his own poetry.

I'm impressed. Michael's been able to do what poets have striven for through centuries. He is a true minimalist, who makes one word do the work of several. His structure is clean, acerbic, savage. He lacerates emotions so deeply, so dryly, the reader sheds not a drop of blood, even while bleeding to death. Wow! This guy is good.

On another level, I can't escape those eyes. "Rasputin," I call him, eager to give in to our sexual attraction. He's a wild flirt. But does he mean it? I want to find out in a hurry. So far, we're just still sniffing around, but the atmosphere is tense.

But, most of all, I begin to realize that this buzzing pressure in my forehead is definitely connected to Michael. It starts when he shows up, accelerates when he's near, and sometimes jolts me out of sleep in the middle of the night when he scrounges the ice-box for a late snack. Michael is a nocturnal animal, but then, he doesn't seem to need much sleep: He's just as alert in the daytime.

Finally, I ask Michael if his forehead buzzes too. "Well, yeah," he says, dismissing the matter a bit casually. "It's just mental communication, that's all it is. We're on the same brain frequency. Haven't you noticed?"

"What do you mean, 'brain frequency'? Does this happen to you with everybody?"

"No. It only happens with you. We've got some kinda electro-magnetic connection. I suppose if we hang out long enough, we'll figure it out. You know, learn how to direct it. Maybe. I dunno. It's kinda like Astral Projection. Either you have it or you don't."

And wanders off to see if there's enough pot roast left over to make a sandwich.

I'm so impressed, so awestruck by this phenomenon, that I tune into it consciously and—sure enough—it works:

"Michael won't be here for supper tonight, probably be at his sister's."

"Oh? Did he call?"

"Nah, well, yeah, kinda."

Or waking up suddenly at 3:00AM, I rush into the kitchen to warn Michael not to touch the soufflé he's about to attack, because it's for tomorrow's dinner. Or answer his silent request for a typist by sitting down with him one day and offering to type his manuscript.

We begin to play with it. We like to mess around in a room full of people with stuff like: "Go get me a drink of water, would you please?" Or, "I dare you to walk over there and pull Cliff's braid." This is weird beyond imagining. This is miraculous.

In the middle of this muddle, "The Thing" shows up. "The Thing" looks like a giant roundish dust bunny the size of a fist and creates even more havoc than we already have. It meanders through the air at about eye level, cruising the full length of the house, or flies up and down the stairs and into bed and bathrooms. When it's done flying around, it invariably takes a swift, calculated dive under furniture, under baseboards, into corners or any other floor-level escape route.

It scares the living daylights out of Megan one night, by floating into her room from the upstairs hallway and suddenly diving under her mattress. She comes screeching down the stairs, hollering, "This is your fault. You attracted it. You." She refuses to sleep in her bed for a week, preferring to plop her sleeping bag down wherever she senses peace and quiet.

I seem to be the only one who doesn't mind "The Thing." Sitting at the kitchen table, I watch it one day float through the foyer toward the den. On its return trip, it hangs a sharp left into the kitchen, meanders past my nose and then dives sharply under the floorboards of the kitchen sink. I wish there were some way to communicate.

After long, earnest conference, the unanimous decision is that it must be lost from another dimension, or maybe attracted to our house due to all the crackling tension and weird energy—and, somehow, I'm responsible. After about a month, "The Thing" disappears. (I never did find out what it could have been, although I did read in the paper recently that some man in Ohio claims to have a pet dust-bunny.)

Shelli and Jeff leave in September, rolling their eyeballs at one another, saying nothing to me about Michael's and my bizarre relationship. They may

be afraid to speak, they may be so used to my eccentricities that they silently accept the humiliations my behaviors routinely cause them. (Like the time Shelli, then a conservative high school junior, came in the back door with two new friends to find me perched on a kitchen counter trying to get high on the insides of a banana peel which I'd scraped, dried in the oven and rolled into a joint: "Mom, I'd like you to meet Holly and Jane. Holly, Jane, this is my mother, she's smoking a banana.")

As time goes by, Michael and I become more and more closely linked. We hardly need to speak at all. Our heads turn toward one another automatically when one of us has a thought for the other. I believe this is the ultimate love. To love someone so completely that even the thoughts go arm-in-arm, to love someone so entirely that even the brain waves are shared is beyond comprehension. Michael is my Siamese twin. We are linked at the brain, we are linked at the heart and we are soon linked at the body.

Michael, it turns out, is a merely acquiescent sexual partner, who allows himself, rather reluctantly, to be seduced on occasion. It seems that all his intense flirting, with its meaningful eye-contact, verbal sexual innuendo, deep, late-night conversation and brushing physical touch, is just Michael protesting too much.

Nevertheless, when we become lovers, the wordless communication intensifies. His poetry exalts my heart; my wild emotional and sexual obsession terrifies his. I want him on every level. Thirst for him, squirm around his consciousness like a stoned anaconda, gulp his thoughts like an insatiable drunkard, can't get enough, want to jump into his eyes and come to rest in his brain, in his essence in the total depths of his being.

We are both crazy. He is scared but maybe he, too, is hooked. Unfortunately, not on me, not on my body or my spirit, but on my intellectual sustenance, my willingness to type his manuscript, on my unconditional support. And on my view of him as a demigod, directly descended from Olympus to carry out the extremes of some ancient, pre-ordained Greek myth.

Instead of Shelli and Jeff's cohorts, the house now teemed with Michael's friends. Especially welcome were the Jones brothers, Jonas and Cliff. Jonas, a gymnast, all slender grace and elegance, was charming, witty and perceptive—engaging company, well-informed conversationalist. Brother Cliff was a taciturn martial arts black belt who hadn't the slightest idea of his true power or beauty. His role, mainly, was observer and his immense long-lashed green eyes missed very little. We became good buddies at once and the place was soon a club-house for young folk. We shared the same

philosophies, these people and I. Politically, we were allies, raging against Viet Nam, against the covered-up murder of the heroic Black Panthers. The Kent State killings lingered on, an unhealed memory. That one-and-a-half-year-old photograph of Mary Ann Vecchio, her arms raised to heaven, screaming like an inconsolable Antigone over a young body, still haunted, still bruised us, like some malevolent specter. I was starting to believe that this country eats its young. Were we crazed radicals, or were we simply taking a stand against home-grown fascism? Who's to say...

We like the same music and it isn't just rock n' roll. These people love the classics, too. One night, Jonas and I drop acid and listen to an LP called *Four Centuries of Music for the Harp.* I'm lying on the soft, white carpet becoming the instrument. My spine is the harp's frame, my ribs the strings. Notes drift into my being, some unseen internal hand plucks the strings sending waves of music through the space inside me where my bodily organs used to be. Afterwards, we don't talk. The divinity, the beauty of that experience remains a beloved memory. I will never know the meaning of "bad trip." (Cliff is straight, and Michael uses only weed because he's afraid of "losing it.")

We like to argue, look at art books, debate the curvature of space/time, and holler at each other about women's rights. We discuss Nixon in China, and look with fascination at those first, incredible Venus probe photos. We wonder about some unsettling rumors beginning to float around—some kind of exposé by two Washington journalists about something called "Watergate" during Nixon's last election campaign. We wonder if this is going to be important, or is just some more routine meaningless muckraking. Nothing's definite.

Anybody who says that these young "boomers" are nothing but drug users and radical, hippy nincompoops is much mistaken. I learn and learn and learn, soak up new ideas, new music, new language, like some kind of demented sponge. These are my peers, more than members of my own generation ever were. At last I'm understood, at last I have a voice. Age differences disappear in a haze of pot and cameraderie. We are friends. We all agree Jim Morrison is great, even if he is a lush, and forgive Cliff his propensity toward Gordon Lightfoot.

Megan looks on. Makes no comment. Sneers. Goes her own way. Spends more time at the stable than at home. I don't blame her and tell her, "It's a more stable environment. 'Stable,' get it?" She doesn't laugh. But I lend her the car so she can get there daily, after her grocery store shift.

Gene, when he's home, tolerates Michael—just barely. Michael is polite,

Gene is non-committal. He doesn't seem to suspect when I have sex on the living room floor at 3:00 AM, directly under our bedroom. When I return to his bed, he grunts and turns over in his sleep. Well, no matter. It's almost November, time for him to be out of town for the annual Christmas sale.

Michael's puts flashing red, blue, yellow and green Christmas lights into the crystal prism chandelier. They warm up the place and sometimes seem to flash in time with the music. One night, we're listening to Joan Baez's *Diamonds and Rust* while the lights are going. Michael sits up with a start and says, "Hey, you know, reading poetry to music and a light show at the same time. What a groove." Then he smiles and says, "I can compose the music, too."

After that, Michael spends more and more time at the piano. He can't read or notate music, but he's composing, memorizing, taping, composing, memorizing, taping. He stops only to ask, "Whatcha think?" and then goes back to the music. He's onto something, apparently.

I'd been right about the skiing. Typing Michael's manuscript often took precedence. Why would anyone want to stay home and type when there was fresh powder on the hill? I shrugged my shoulders, because I had no answer. "Oh well," I said, "after the next chapter..."

Then, Gene came home from his Christmas sale and didn't like what he saw. His sufferance of Michael was becoming increasingly fragile and soon cracked into fragments of disdain. The feeling was mutual. Something had to give.

Somehow, I was losing Michael. Here he was, living in the lap of luxury, fed, cossetted, supplied with excellent Colombian—even had a typist-cum-sex-partner at his beck and call but he wasn't happy. Perhaps I'd become too wild for him, too much in his brain, too much in his business, in his body.

Michael didn't share my belief that our non-verbal communication was extraordinary at all. He had always been an "astral projector" and thought that the sharing of electro-magnetic energy was simply a random materialization. "We all share the same radio waves and X ray waves, and so what," he said. He believed my insistance that ours was a unique, amazing and powerful liaison to be just another manifestation of my craziness: An excuse to put him in a chronic choke-hold. Not only that, but my sexual demands were undoubtedly getting a bit intense. Even I could feel my heat. He was clearly uncomfortable. Wouldn't talk, wouldn't even let me type. Took to sleeping anywhere but in the dining room. We'd find him in the hallways, in the kitchen, anywhere but where he belonged. The more distant he got, the more I panicked, the more I upped the ante. Nothing worked.

Finally, in early spring, he packed up and left.

First, he moved in with his sister and her husband, right in town. My forehead still picked up his comings and goings, causing me incredible anguish. I argued, stalked, phoned, demanded explanations, wrote letters, visited unexpectedly, practically raped him in the grocery store parking lot, made offers, promises, proposals and begged. I did all this so proficiently and with such regularity and intensity that Michael finally packed up again and left for Boston.

The grapevine had it that he found a communal household in Brookline with a bunch of male roommates and worked in the Xerox room at Harvard. Apparently, he thought he was rid of me.

I was beginning to feel a bit like Antigone myself, only instead of burying Polynices, I was grieving over the loss of my Self. Everything went, every part of me that made sense disappeared and only a monumental howl filled my being. Yes, I'd lost lovers before. But Michael's value was only partly physical. I starved for that intimacy beyond intimacy, that wondrous mingling of mind which signified complete unity. I hissed like a wounded snake, my whole being became a fist. Didn't he understand that this gift was unique, that we could both search the planet for a lifetime and never be able to duplicate it—ever? Being without Michael was unacceptable, and I was going to either do something about it or die trying. Yes, I was!

Jonas, Cliff, and Jonas's girlfriend, Joanie, kept me sane for the interim. When Jonas wasn't attending nursing school, he was at our house with Joanie. When Gene was away, they slept over. They took me swimming and on hikes, shared a joint, fixed lunch, joked, studied, loved one another. They asked no questions, they nurtured with their eyes. Jonas, Joanie and I dropped acid and wandered into a Longmeadow field which suddenly turned into an Andrew Wyeth painting. No one could have asked for truer friends.

Even Gene opened up: Even took them sailing. Even took the whole shebang to Tanglewood. One glorious evening all of us were together, entranced and intoxicated with the music, with Sieji Ozawa coaxing the Boston Philharmonic into sending Mozart's *A Major Clarinet Concerto* piercing through the night sky, to sparkle the stars, to spice the breeze, to lull us into being a family.

But none of it was enough. In order to survive, I needed Michael.

When Megan was accepted at University of Maine in Orono (along with Meredith Ashmore, of course), I decided to go back to school, too. Maybe U. Mass at Amherst would cure my histrionics. What the heck, it was worth a try. So off I went, taking a full course load, including my favorite subject, Quantum Mechanics.

That physics course did help me bear the unbearable. The professor was a little guy named Steve, from Oregon. He had sandy hair, a good sense of humor and explained right at the start that physics and metaphysics were intertwined. When I had trouble with the Heisenberg Uncertainly Principle (what do you *mean* you can only theorize the behavior of an electron? How can the mere act of observing it change it? Come *on!*), he assigned me some unusual supplementary reading: *SETH SPEAKS*[2], by Jane Roberts. And demanded a book report.

I loved Seth. He put into simple words not only all the concepts I'd wrestled with on that lumpy mattress in Oakland, but even more. "God is in all things, God is All That Is; we—individually and collectively—create our reality, our spiritual destiny; and we reincarnate till we get it right," said Seth. Kind of like Jungian Buddhism, with faint echoes of Voltaire. Made sense....

For my Quantum Mechanics final, I submitted a series of poems about Muons and Interaction of Particles with Matter. I got an "A." Same with the Community Psychology class practicum at Northampton State Mental Hospital. For my class project, I wrote long narrative poems about interactions with patients in the locked women's ward. Aced that one, too. But none of it was enough.

Maybe I accepted intellectually, what Seth was saying: That I was busily creating my own reality. Yeah, sure. It sounded good, it sounded correct, but so what. I had no more idea of how to actually work that, than how to fly to the moon. Or, even better, to Boston.

I'm wandering through the U. Mass halls, looking at people. Everyone seems to have someone. Couples walk hand-in-hand. Sometimes they stand under trees and hug. They whisper to one another in class and share sips of pop in the cafeteria. I have never been so completely alone, so entirely isolated. My Antarctic sanctuary has become a prison. I peek out through the icicles guarding my soul and have no tears to melt them.

At home, I creep into bed next to my husband's body, but cannot find solace in his physical warmth. The tiny inches separating us under the blankets are so deep, so cold, that my hand, my arm can't reach over the frozen chasm. Everything is ice. I am unloved, I am only my intellect. I have no one. I am nothing. There isn't even a family dog to keep me company. It

[2] Roberts, Jane. *Seth Speaks*. Englewood, NJ: Bantam Books, Inc., 1972.

is time to take action, or I will surely die.

Yet I can't help paying attention to some of my female cohorts at school. I see strength, independence, self-esteem, such as I've never experienced before, not in myself, nor in others of my generation. In particular, I watch a woman (we no longer say "girl") named Ruth Goldberg. Her attitude is not that of a militant feminist at all. She has translated rhetoric into action. She looks at the world as her rightful challenge, a place to conquer and in which to excel. She has no patience with simpering flirtations, excessive eye make-up, or shaved armpits. And on her, it works. She exemplifies what Betty Friedan and Gloria Steinem are talking about. I take careful heed. What I see in no way helps my insane fixation on Michael. But in those few moments when I'm able to see past obsession, I observe the possiblity of what I might be—might have been.

School's out. I'm sitting in the den, curled on Gene's leather chair, reading Germaine Greer's *The Female Eunuch.* I've just gotten to the part where she describes how women have had to use their looks, their bodies to make themselves into acceptable female stereotypes in order to gain approval and acceptance. I see me. Ho there! The proverbial light-bulb goes on over my head.

Just then, in walk the two men of my life, my husband and my son. They sit down next to one another on the couch and one of them says, "Hi. Whatcha reading?"

"I'm reading Germaine Greer, and I've just discovered that I'm a stereotype. For years and years, I've received external validation by being a female stereotype. Can you imagine? I'm a *stereotype.*"

They look at one another, look at me, mystified at my outrage. "Yeah," one of them says, "so?"

I can't stand being away from Michael any longer, and drive to Boston. I pull up at his address and knock at the door. No one answers. I notice an open window, so I climb through. I fall into a living room and see a couch. Good. I'm exhausted. I lie down on the couch and fall asleep. Don't know how long I've napped, but suddenly there are male voices.

"Hey, man, there's a woman on the couch."

"Hey, you? Get up. How'd you get in, who are you? Get up."

I sit up, stretch, yawn, and tell them I'm here to see Michael. "OK," they say, "he'll be here by 5:00. Would you like a cup of tea?"

"Love it," I reply, and start making friends with the boys. Helps to have a head start on credibility...

I tell them Michael and I are estranged, but that I believe so strongly in his genius, in his remakable talent, that I'm willing to resume our friendship even with great personal sacrifice in order to mentor, in order to nurture, in order to help get him published. My presentation is sober, backed by quotes from his work and hints at possible publishing connections. They buy it. By the time Michael gets home, Tommy, Clark and Brendan are on my side.

When Michael comes in and sees me, his mouth clamps shut like the slot of a mailbox. One can almost hear the sound of his teeth gritting. His eyes are so blank, they don't even shoot daggers. He turns his back to me and walks upstairs. Brendan follows, and they don't come back down for another hour. But when they do, I have permission to type, provided I keep my mouth shut. Wow! Foot-in-the-door. Groovy!

I drive to Boston once a week on the pretext of visiting Lee. (I manage to actually drop in on her each time, as they live in the same neighborhood.) For the first month, Michael does not speak to me. He simply hands me pages, which I type and hand back. We avoid eye contact. But I get to talk to the roommates, supply them with grass, compliment their girlfriends and give them rides all over town.

One day, the second month, it's Michael's turn to cook dinner and he's prepared his famous lasagna. As the group sits to table, Michael, his eyes lowered, says, "Here, you want some?" and sets a plate for me. All participants sigh with relief, and I join in the chatter.

Michael: "We shoulda had a watch dog, man, she coulda been a burglar."

Clark: "We couldn't afford to feed a watch dog. How about a watch cat?"

Brandon: "Watch dog, watch cat, watch duck. That's what we need. A watch duck. It could quack the alarm."

Somehow, everybody thinks this is ineffably funny and we all start to laugh so hard, we can't continue eating. Maybe it's a release of tension. But it's got us rolling in the aisles. "Watch duck" becomes the evening's watch word.

Before my next trip into Boston, I drive to Amherst, to the duck pond at U. Mass and steal a duck. I do this by wading into the water with a crust of bread and looking legitimate. The duck drives to Boston rather unhappily, sitting in the back of the station wagon and quacking its displeasure. When the duck and I get to Michael's house, the roommates and I put her in the bathtub and wait for Michael to get home.

It's just the exact right ice-breaker we needed. Michael takes one look, shakes his head, bursts out laughing and gives me a hug. The watchduck stays over the weekend and then I return it to its duck pond, none the worse for wear. Ah, victory is sweet. I am whole again, at last.

When Gene's away, I get to sleep over, but certainly not with Michael. My new role is that of family friend, mentor, general factotum. I am sweet and loveable to Michael's various girlfriends and gnash my teeth into the living room couch pillow when they trundle off upstairs. It's OK, it's all right. One step at a time, I say.

We're all sitting upstairs in Michael's bedroom, chatting in the sunshine and admiring his new flute when, suddenly, Michael and I perk up. There's a sound, there's the strangest sound coming from downstairs. It sounds like the tinkling of bells, like the chirping of baby canaries, like the gurgling of some tiny crystal spring, all wound up together into some breathless chorus. No one else hears it, they all go about their conversations. But the sound becomes louder, more distinct, intense. Michael and I stare at one another silently, question marks in our eyes, and then he laughs and thinks, "Oh, that's Brendan's kid sister. It's her vibes. This's her first visit. She's fourteen and she's never been in the big city before."

Sure enough, the sound comes twinkling wildly up the stairs and bursts into the room just before she does, just ahead of her own excited, adolescent, twittering self: "Hi everybody, I'm here!" She waves, she hops, finds Brendan to embrace.

Brain-wave communication between Michael and me has apparently survived our time apart and is alive and well in Boston. I could kiss that little fourteen-year-old! Michael and I are back on the same wavelength again and I can tell by his warm eyes and satisfied smile that he is happy, too.

As ski season ended, I drove to Vermont and gave it my all. At the end of the final day, that last run before the lifts closed for the year, I went to the top of Mt. Mansfield. One last sweet ballet, one more *pas de deux*, wild and holy, held to the world by just a narrow elongated strip of metal called "downhill ski," the edge of which was our choreographer. It was a perfect performance by us all: By the mountain, by the snow, by the air and by infinite joy. There would be no encore.

Michael's book was taking shape, but he was also talking more and more about doing a music and light show to his own poetry. All of us encouraged him. He was a good poet. He was good enough to dream.

Shelli came home for a visit from Oregon. She loved it out there, had found a guy, they were making all kinds of adventurous plans; she couldn't talk enough about him, about Portland, its peace, its climate of tolerance, the friendliness of the populace. I was getting most interested. Firstly, I wanted to check out the boyfriend, make sure he was an OK guy. And also wanted to see this mythical paradise where the weather and the people were equally

temperate. She described mountains right outside the city, the ocean only an hour or two away and great vistas of wilderness— a giant, deliberately untamed, towering expanse—right within the city limits. This I had to see.

So when Shelli made plans to return there in May, I decided to give her a ride. After Portland, we could drive up to Olympia to visit Jeff. The station wagon was fairly new, had good tires, and by "we" I meant Shelli, me and Michael. He was amenable at once. Why not? New sights, new people, and all at no expense. So I got money and permission from Gene, who definitely didn't know what I meant by "we," picked Michael up at his aunt's and away we went.

We got to the West Coast in three days by taking turns driving and sleeping. No brownies this time. Shelli was in too much of a hurry. The place was pretty much as she had described it. Portland had a small-town flavor, even in its appearance. The houses in Shelli's neighborhood could have easily been transplanted to Gloucester. The weather was balmy and sunny and we ignored all those folks who insisted that we had arrived during a barometric fluke, that actually it rained here most of the time.

Jim, Shelli's boyfriend, turned out to be a well-mannered, pleasant young man. The two of them had just landed a contract with a future homeowner who wanted them to build his house in a rural area, using the architect's plans. They had supreme confidence in their ability and would soon be leaving for Eastern Oregon to do the job. They would be buying the lumber, renting machinery for digging a foundation and living in a tent throughout. I was thoroughly impressed by their certainty, knew they would succeed and would also have a unique and splendid adventure in the process. Good for them!

Meanwhile, Michael and I were taken over by Mary Anderson, a woman my age who was the mom of Shelli's favorite local family. Mary took us everywhere. Sure enough, Forest Park was exactly as Shelli had described it: Wilderness with a few trails cut through it by serious hikers and their laughing Labrador Retrievers. An impenetrable tangle of alders, evergreens, ferns, little creeks. And so green that even the birds looked green fluttering suddenly in the emerald air. Green and clean.

We drove to the coast and found that all the beaches had public access. In Massachusetts, most of the shoreline was hidden behind private property and only certain areas were open to the public. One could never walk up the Atlantic shore by way of its beaches. Once off the line designating public beach access, one became a trespasser. In Oregon, the entire shoreline was open to everyone, and it was clean.

The Pacific turned out to be calm, silver, and not at all briny. Nothing like

the wild, blue-and-white rock basher I was used to, and, after a day at the Pacific, my skin wasn't even salty. But it was an ocean. Certainly more of one than the Mediterranean, and only an hour or two away from town. Matter of fact, all the natural wonders—Mt. Hood, Mt. Saint Helen, the high mid-state desert—were all only an hour or two away from town. And one could see the mountains clearly every day, just by driving around the city. The view was preserved for everyone. No crowded, crowding sky-scrapers to hide it. There was even a car-free bus mall downtown, where one could walk unjostled, shop, look at public artwork. People nodded as they passed one another.There was even a downtown park: "Park Blocks," they called it. More of that incredible green, right in the middle of everything. St. Patrick would have enjoyed Portland. It was green as Ireland, for sure.

Shelli had been right about the tolerance and innate friendliness of the population. I observed Mary closely and noted that she accepted Michael and me as a couple without any judgment whatsoever. Wow, this hadn't happened before. Usually, when we went anywhere together Back East, there were stares of all kinds. It wasn't just Mary who took us at face value. Shelli's peers and everyone else we met welcomed us unconditionally, embraced the idea of a young poet and his amanuensis traveling together as not only natural, but as quite routine.

Finally, it was Multnomah Falls that did us in. It wasn't just the pristine waterfalls with their delicate stone bridges, or even the Oregon greenness of it all. It was several empty cans of soda-pop. There, at the base of the falls, next to the trash barrel near the road, someone had very neatly placed a miniature pyramid of soda-pop cans. "Look, Mary, what's that?" I asked, completely nonplussed by such orderly disposure.

"Well, we recycle here, and those cans are there so the trashmen won't confuse them with the regular trash and not recycle them by mistake."

"Whaaa?"

Back East, there was trash around all trash bins. Stuff got thrown in the general direction of the barrels, and sometimes landed inside. Trash patrols in parks Back East did full-time work cleaning up trails behind hikers, fishing litter out of ponds. The idea of anyone being considerate enough of the environment and of the trash patrol kicked me right over the line. Not only that, but this was a major city with a Jewish mayor. Mayor Neil Goldschmidt. What the heck, how much better could it get?

This was a good place. Michael's work could flourish here, the poetry/music/lightshow could come to fruition. Anything was possible here. We were staying at Shelli's house at the corner of NW 22nd and Lovejoy, where I noticed that the house next door was vacant. The property belonged

to a hospital, kitty-corner across the street. Michael and I looked at one another. Maybe, just maybe...

On the drive back to Massachusetts, we do some serious talking.

"Look, I've got a bit of money saved up, we could rent that house and you would be completely free, completely free, Michael. You could write, you could compose, you can be whatever, whoever, you want to be. All I want is to make it happen."

"Hmmmmm," says Michael. "Hmmmmmmmm." And then, "Wow, you know what? Let's do it."

When we get back to Longmeadow, I tell Gene I'm leaving.

"Give me half of what the house is worth, and I'll be on my way."

Gene stares at me, is silent for a moment, apparently in shock. When he speaks, it's in the slightly nasal drawl he uses in unfamiliar social situations or when selling diamonds to Marks. His face shows no expression, but his eyes hold the same combination of hollow grief and rage that I see in those strange guys who've just completed their tours of duty in Viet Nam.

"You're sure you want to do this? Well, fuck it. I've been seeing someone else for the past three months anyhow. You didn't know that, did you?"

"Wow, Gene, far out. Now I don't feel so bad, knowing you're not alone."

Gene turns away. "I could kill you. You know that? Take whatever the fuck you want and get lost."

We sign the requisite paperwork within a few days, and I get a check for five thousand dollars. Well, if five thousand is all he thinks half the place is worth, that's good enough. I'm impatient. I call Good Samaritan Hospital in Portland and tell them I want to rent their house, will take possession within two weeks.

We say long good-byes to Jonas, Joanie and Cliff, who promise they'll come out to see us. I phone Megan in Maine and tell her what's happening. She says not to worry, she's planning to spend the summer with her boyfriend, Frank, the bass player in her cousin Andrew's band. She doesn't sound distressed, but with Megan it's hard to know.

Within a week, I've got a cheap mover who's willing to take my bed, skis, some books, my electric typewriter, the stereo system and a few LPs. That's really all I need. I pack the station wagon with a foam rubber pad so we can take turns sleeping. I also take whatever marijuana's left in the freezer, some spare bluejeans, a fresh Dexedrine prescription and a steamer trunk full of I. Miller shoes. The basic necessities, you might say. House on Lovejoy Street, here we come. How can we go wrong living on a street with a name like that?

Chapter 14

Sex, Drugs, Rock 'n' Roll, Part II:
"Mama Tol' Me Not To Come"

Nobel Laureate Alexandr Solzhenitsyn talked about a photographer who was trampling the rose bushes at the Solzhenitsyn's Vermont home. Alexandr stated he leaned out the window and hollered, "Why are you doing this?" To which the photographer replied, "I have to get a shot, or I'll get fired." Alexander then said the words still engraved in my heart, a lesson never forgotten: "You know," he said to the photographer, "recent history has taught us that each one of us must take personal responsibility for his individual ethics. If the littlest private in the German military had said, 'What you are asking me to do is immoral and I will not do it,' and if he got executed for this, and then another private, and another private, and another private had all, in turn, refused to implement the insane commands, we might not have had the Holocaust. So, if you get fired, and the next photographer also refuses to trample on my rose bushes, and so on, the editor will learn a valuable lesson. There are no heroes, my friend. There are only the littlest privates in the armies and the beleaguered photographers, and all the rest of us, and if we each do not take personal responsibility for our behavior, for our ethics, then we are all doomed." His words anchored in my mind, and my soul agreed, but in every day life I preferred numbness. But that was indifference—the greatest crime. Was taking personal responsibility the opposite of Indifference?

Well, nobody's indifferent at NW 22nd and Lovejoy! The neighborhood teems with leftover Flower Children in various degrees of disarray, upscale householders, medical staff from Good Samaritan Hospital who hang out at Quality Pie Restaurant in their scrubs, scruffy "Reedies," and a wild assortment of street people. In with, but not of the street folk, are increasing numbers of those silent, haunted Viet Nam survivors in their scraps of military attire and uniform dedication to whatever substance keeps them from screaming in the night. Everybody shares the streets, the shops and one another with such equanimity, it's a constant delight just walking.

The moving truck is weeks late, so Michael and I have been camping in

our sleeping bags. But not alone. The day after we arrive, a large, friendly, long-hair type walks up our steps and asks if he can move in, too. Says his name is Charles, he's a musician, has just broken up with an older woman, is willing to pay rent and thinks we'd all get along just fine. We think so too, and Charles becomes immediate family. He's right: We all get along just fine, and he's conscientious about the rent.

A week later, Michael comes marching home from the laundromat arm-in-arm with a long-braided Native American woman. Says he couldn't resist the beadwork in her hair, and, also, by the way, she and her baby are looking for a place to live. Her name is Zorrah, and she's a charmer, a Tlingit from Alaska with a ready smile and the rent-deposit in her shoulder bag. OK, why not. So, Zorrah moves in, along with her two-year-old, Nathaniel—with whom we all fall in love. There's never been a better behaved, funnier, more endearing little guy and he, in turn, thinks his new family is groovy.

As for Dawn, she just shows up one day. Says she's an acquaintance of Charles's and would like to live with us because she's currently staying in someone's garage and the weather's gonna get wet shortly.

Dawn, in her early twenties, appears to be the result of some mythic mating between a gypsy and a cougar. Her hair and skin are tawny, her eyes cat-green, her moves feline. Her clothing is a combination of hippie and gypsy; the shawl, head-band, beads, long fringed skirt somehow come together with with elegant panâche. An aura of sexuality surrounds her like steam from a sauna; her conversation is rife with sophistication and clever discernment.

Charles says he knows her from outside "Q P's," where she panhandles. Right now, Dawn says she's getting money from selling her personal jewelry, but she has a steady job lined up. No problem. In she comes, trailing beaded artifacts from the nineteen twenties and turqoise thunderbirds. We like her right away.

Zorrah is a different breed. She is shy, quiet, and seems dedicated to the care and feeding of her son. At first. After a week or two in residence, Zorrah sidles up to Michael and me, gets us in a tight group hug in which her hard little pelvis repeatedly thrusts itself into mine. "Ah," she whispers, "if I could have an old man and an old lady just like you, wouldn't that be cool. Can we kiss? Can we do it together?"

She is so attractive in her presentation that if Nathaniel, sleeping like an innocent apple in his little crib, hadn't chosen that moment to stir, to murmur, to make himself known, we might have acquiesced. Oops. I tread more cautiously. Zorrah, apparently, is more than—or not all that—she appears to be.

We get to know a few of the street people. They're intelligent, good-natured and in various stages of addiction or recovery. They come out of the rain, grab a bite to eat, share a joint and listen to Michael read his stuff. Particularly, Jesse. Jesse is a former speed freak, so much so that the speed rotted out most of his teeth, leaving only blackened stumps. While jailed for some speed-related crime, he gave up the meth and is now a righteous alcoholic. Jesse is tall, a graceful, flightless raptor; what's left of him is immaculately groomed.

These folks are so cool. They are clean (where they wash before they visit is unknown), quiet, don't drink or shoot up on the premises and do not steal. Somehow, in all those months on Lovejoy Street, no street dude ever takes or breaks a thing. Jesse and his friends continue, always, to be welcome guests. And that's our household.

So, weeks before the moving truck ever shows up, we're a family. Thank goodness it's a large house. I've got the master bedroom, Michael commandeers a giant attic suite, and there are three extra bedrooms for the roommates. The dining room—of course—is designated Michael's studio. I sleep on that foam rubber pad from the station wagon, Michael rigs up a hammock in the attic, and now all we have to do is create a musical light show for Michael's poetry and get rich and famous.

Soon enough, we found a guy willing and able to rig up a small set of stage lights. The plan was for an arch-shaped set of light bars, in the center of which Michael would sit on a high stool and recite his poetry while the lights changed along with mood and music. The lights were connected to a mother-board and easily choreographed. We located a Dolby-type synthesizer for Michael's music, and now it was time to refine, rehearse and book the act.

I landed a job across the street as clerk in the X-ray department at Good Sam, working the 3:00-11:00 shift, so it was easy to man the phones and present myself as Michael's agent during early afternoon and morning.

Mary Anderson, who had taken us under her wing so early on, became a good friend willing to share her connections to various Portland venues. Everything was going according to plan. I even managed to sneak up to the attic once in a while for a bit of sex in Michael's hammock. Pre-dawn in Portland was more green than gray. I loved swaying in that misty ocean light, snuggled up with my personal idol, welcoming daybreak with a kiss, watching his sleepy face with my acolyte eyes.

We sat on the porch, all of us in the warm, misty evenings, passing a joint, listening to Charles play the guitar. The security guards from Good Sam strolled by, tipped their hats and smiled, never seeming to notice the distinct

odor of abused substance drifting into their parking lot. Sometimes, Jesse would stop in and contribute a bit of Cajun melody salvaged from his Louisiana childhood.

Nathaniel often joined our circle, and when the joint came his way, took an occasional hit. Michael and I were both chagrined and amazed. Chagrined that Zorrah would see this as routine, acceptable parenting and amazed that—at his age—Nathaniel knew exactly how stoned he wanted to get. "No tanks," he would say, waving the joint away when he had had enough. And then sit quietly with us, his peers, listening to the music.

But Michael and I stayed concerned. Zorrah's idea of mothering was becoming worrysome. The day she got Nathaniel stoned and then took him to see *The Exorcist*, our concern turned into red alert. Now we watched carefully and compared notes: Zorrah screamed at her son more and more loudly, using increasingly damaging language. "You rotten little faggot, you fucking faggot, you piece of shitty fairy," she would blast into the morning air if Nathaniel was slow waking up, or not quick enough at toilet or dressing. The entire household could hear slaps on bare flesh, along with Nathaniel's whimpers as he tried desperately not to cry. If he cried, the abuse became worse.

Michael became protective, taking Nathaniel with him into the studio during the day. Michael's father had walked out early on, and he knew from personal experience how sadly a steady, loving male in a child's life could be missed.

Everything was going according to plan, and everything was disintegrating. Up went hand in hand with down; for every accomplishment, there was a matching disaster. A lot of it was personal. Michael wanted to have girlfriends, and I was righteously possessive. Didn't he get it? He was the man for whom I had walked out on twenty-five years of marriage, whose road to success I was singlehandedly paving. He didn't get it.

He was mine, mine, I said. Not loudly, clearly, so the whole world would listen, but grimly, silently, into my pillow. On the outside, I accommodated as best I could, but I was a terse watcher and soon enough, an angry provider. "Maybe you oughtta get a job," I hissed at him when he was out of hearing, "make a little contribution here and there."

Michael, of course, established just as clearly that no one owned him, that I had guaranteed his freedom. Hadn't I said, hadn't I sung, "You get to be who you want to be, do what you want to do," right in sync with those Mamas and Papas lyrics? He, too, refused to verbalize his discontent. We just glared at one another a lot, sent nasty thoughts, and made our roommates uncomfortable.

190

Zorrah's in the porch swing Michael rigged up, leaning back, feet in the air, dark loose hair billowing into dark, loose sky. It's almost time for bed. Someone yawns, stretches and then, suddenly, with no sound, Zorrah's flung into the air onto the sidewalk where she lands in an unconscious huddle. She's swung too far, apparently, and now, maybe she's broken her neck? Fractured her skull? Is dead?

Michael goes yelling for Good Sam's security, who immediately take Zorrah to the ER. Michael and I trail along. We hold hands, animosity drowned in a vortex of fear. Dawn stays with Nathaniel.

When the doctor finally comes out with whatever dreaded diagnosis is on the chart, he is angry and laughing at the same time. "Drunk," he says. "Intoxicated. Drunk as a skunk. We'll keep her overnight for observation, but that's it. Tomorrow take her home and sober her up."

We start to argue. "No," we insist, "we weren't drinking, she didn't smell of booze, she acted rational. She was just swinging and then she fell backwards. She couldn't be drunk. Could she?"

"Lucky lady," says the doctor. "Falling down drunk. She's been in here before," and turns away. Case closed. Michael and I stare at each other. Now what?

Next morning, Zorrah comes home contrite, subdued. No yelling at Nathaniel. Not for several weeks.

Dawn and I sit at the kitchen table sipping tea, smoking Virginia Slims, sharing the bit of sunshine sneaking in the tall window. Dawn's telling me of her travels. "Been all over the country," she says, "and the best place, ever, is Galveston. You should see those beaches, man, and the attitude is so cool. The cops don't chase you off, and the weather's great. You oughta go, man, you'd love it."

When I tell her about Tanglewood, her head bends to her teacup, her cigarette stubs viciously into the saucer and I see a large tear hanging from the tip of her nose.

"Yeah, I been to the Berkshires, man, that's where I lost my baby. Didn't know I had a son, didya, huh. Well I did. Me, my old man and the baby. We wuz happy, man. We had a little trailer, we did odd jobs, we got by. Good life, know what I mean? Good. So one night we sloshed a brewski or two, y'know, and went outside in the moonlight and made love. I'll never forget that night, man, that moonlight, his face in the moonlight. And the baby started crying and my old man said, 'Hey, better go see what's up with the kid.' And I said, 'Nah, forget it. Probably wet his diaper,' and kept on with the act, I was so close to coming. The baby, sure enough, stopped crying.

See? So we lay there for a minute afterwards, had a cigarette and then, when we went back in the trailer, there was the baby. He'd got his head somehow wedged in the crib-bars and he was, like, hanging there, and he was dead."

I put my hand on Dawn's shoulder, not knowing what to say that might comfort her. She looks up at me. "I never told this to another soul before, man, you know? I just split, man. That's when I started drinking for real. That's when I became an alcoholic and I've been one ever since, except for this summer. I've been clean and sober for three months right now. Maybe I can make it this time."

"Dawn," I tell her, "I am so sorry. Whatever I can do, just ask, OK? You have my support. Believe it. You can do it." She smiles into her teacup, lights a fresh Virginia Slim and walks out to the porch.

Great excitement, immense joy and tremendous butterflies: We've got a gig. It's our first gig, whoopee! Mary Anderson's steered us to the owner of a kind of literary pub, The Questing Beast in Southeast, and we've got a date. Michael becomes wildly irritable, I become numb (my usual defense when faced with crisis). We rehearse the lights, go over the tapes, the poems, the whole shebang a million times. We fight so hard that at one point, Michael pins me down on the floor and sits on me while he howls his dismay. This frightens the lighting tech guy so much he quits forthwith, and the job is suddenly mine. I better learn those cues in a hurry. But we're doing it, we really are! Meanwhile, I've learned to tune out Michael's thoughts. They've gotten too vicious.

I take Michael downtown and buy him a white three-piece suit, complete with white shoes and white shirt, so the lights can reflect on him as if he were a screen. And, suddenly, it's Saturday night—performance time. And it works. The poetry is good, the lights and music flow together, Michael's tenor neither cracks nor wavers. We get applause, the audience wants more and we haven't planned for an encore. It's OK. They owner says we can come back again.

We're on the way to Nobel Prize Land at last. Michael and I declare a truce, slip off to the attic toward early morning and do a bit of private celebration. Michael's my lover again, after all.

The next week, Dawn announces proudly she's got a regular job. She's going to be a topless dancer at a bar in Northeast Portland. Lots of tips, make some money, pay the rent on time for a change. She's proud; I'm mortified.

"Dawn, you're an alcoholic. For God's sake, get a job at MacDonald's, become a house-maid, do anything except work in a barroom. Dawn, don't do this, it's suicide."

"Oh for crying out loud, Doris, cool it, willya? I haven't had a drink in months. Why would I start up again? Gimme a break, get off my case, willya? What're you, my mother?"

"Oi."

Well, it didn't take very long. No need to spell it out. She did her best, Dawn did, and—at least—didn't drink at home. But her hours became irregular, her kitchen habits a disaster and her rent money unpredictable. But we all loved her so much, we just couldn't turn her out. Besides, the fall rainy season had launched into full drizzle and surely most garages were cold and damp.

Meanwhile, I'd made friends at the Xray department with a young woman named Marcie. When I invited her over, she and Charles made immediate and joyful eye contact. And, in a quick jumping jack flash, Marcie became Charles's roommate. Those two lent such a refreshing air of normalcy to the place. They dined at dinner time, retired at bedtime and didn't fight. Marcie was pretty, she was quiet, she was respectable. Just right for Charles, who was straighter than any of the rest of us, even if he was a musician.

I've been fired from Xray. No reason given. Oh well, now there's more time to book Michael's act. And, sure enough, Portland State University wants us at the Smith Center next semester.

I'm sitting in the bedroom, sorting out which colleges still need query letters, when there's a sudden commotion in the bathroom. Zorrah's bathing Nathaniel, but something's wrong. Her screams at him sound the same, but Nathaniel's response is a frightening series of choking, gurgling, coughing, breathless gasps. Suddenly, he is quiet. Oh my God, I rush to the bathroom and there is Zorrah, holding Nathaniel's head underwater. She is actively attempting to drown her son.

I grab her away, snatch Nathaniel, lie him on the floor and do CPR. He responds immediately with a long wet exhale, followed by terrible sobs. Over my shoulder, he looks at his mother with the stare of a wolf in caught a steel leg trap watching the hunter take aim.

"Zorrah, you need to go calm down. I'll take care of Nathaniel."

Zorrah leaves, I take Nathaniel's clothes to my room, calm him, dress him and bring him to Michael. Michael already knows what's up, and he takes Nathaniel to their favorite spot and their favorite ritual: They look out the window at the Fremont Bridge, Nathaniel says, "Looka the bridge, looka the bridge." Nathaniel loves that. He can do it for as long as Michael is willing to participate. "Big Michael," he says, looking up at his surrogate daddy with complete trust.

I call Children's Services Division and they send over a case worker who immediately removes Nathaniel and places him into foster care. It turns out that Zorrah is no stranger to "CSD." A previous child, a daughter, was removed from her three years ago under similar circumstances. Zorrah departs that same evening, abandoning most of her belongings. Except for one visit allowed Michael and me at the foster home, we never see either of them again.

Thanksgiving provides a hiatus from both pain and progress. Everyone's invited. The street folks show up, scrubbed and sober as possible. Dawn, Marcie and I have cooked our collective tails off and each guest brings a little something, as well. Jesse contributes a pot of Louisiana gumbo with no explanation as to where he got it. It's good. What a gala. What a dinner. What a loving, gracious set of folks. If Thanksgiving can be such a heartfelt delight, can you imagine how enchanting Christmas will be?

I can't breathe. I'm afraid to breathe. If I breathe I will scream and if I begin to scream I will not be able to stop. All the screams I've never screamed will begin, a whole lifetime of screams, of shrieks, of howls, wails in the night will begin and shatter me to pieces like all the glass that smashed in Berlin, sharp shards flying, penetrating my soul, my soul because I haven't got a heart anymore—that was slashed yesterday.

I can't sit. If I sit the pain will kill me. I will become powerless over the dark, slimy pain like the excrement of some vile insect, slime that will creep up my legs, into my belly and upward till it chokes me with its poison.

I have to keep moving. I pace. Back and forth, I walk in my room. To the window, to the door, to the window to the door. I want to slam my fist against the wall, but they'll hear me and when they hear me, they will laugh like they did yesterday. "What is it with you?" she'll ask. "Getting a bit histrionic in our old age, are we?" And they'll look at each other, their eyes a sly nudge, and they'll laugh.

Yesterday, when I told them, when I was hoping, when I said, "I am in so much pain, I can hardly bear it. You, the two people I trust most, I am in so much pain," when I told them that, they looked at each other and laughed. Oh God, they didn't even understand how much it took for me to admit to them how much they hurt me, to come to them expecting comfort, somehow—certainly not laughter.

I don't want to leave my room. I don't want any of them to see me, to look at me, snickering behind their eyes. I don't know how to hide the pain, it is too big and, besides, everyone in the house knows. I can feel tendrils of heat searing my cheeks, my eyes must look like the blackened windows of a

haunted house. I am terrified I might cry. This has not occurred since age ten, and the very idea of tears is such an assault to my pride, to my very identity that, should they start, I might lose who I am altogether.

And there is no refuge. For the last time in my life, Antarctica has flooded. A torrent of anguish has scalded it out altogether, has turned the pure frozen, comforting tundra into a morass, into a final gooey swamp where feelings writhe like giant starving worms, like squirming maggots, devouring. This time I know the destruction is complete. I know I will never be able to get back. I have been exiled forever to this evil, temperate clime where feelings roil, where pain stings, where I cannot survive.

Last week, we had a welcome party for her, in Oregon for the first time on Christmas break. All the roommates gathered, Charles brought his guitar, Marcie and Dawn made chocolate chip cookies, we sang, all of us together in front of the fireplace; and Megan, in the center of us, her head snuggled in my lap, warm like she hadn't been since grade school, Michael at my side.

She looked up at us, she smiled, she said, "I'm so glad I came. My two favorite people in the whole world," and nibbled at a cookie and talked to us about Meredith Ashmore. For once, in our turbulent eighteen years together, she wasn't angry. Her speech held no sarcasm, she did not attack with her particular brand of lethal accuracy, which guaranteed lacerated egos and flaring tempers. She was simply quiet. We were at peace.

Three days later, they disappeared into his attic suite where—right above my room, right above my head—they performed their mating dance. Next morning, when she walked into my room, I asked, "What could you have possibly said to one another that made this OK?"

"You know what I said to him? I said, 'Haven't I got the tightest little cunt you ever did fuck?'" Waited for my response and receiving none, rolled her eyes at the ceiling, gave an exaggerated sigh and left.

I don't understand shame; I am obsessed without knowing obsession. I know only that there is more pain than I can bear: Almost a half-century of it, descending upon me in the sound of my daughter's laughter and my lover's cruel eyes.

Megan, my baby, the one with whom I have the most intense relationship, the one who forgives nothing and asks everything, the one whose language I have never understood, whose needs I have never known how to meet, the one who is most like me. And she is here for another week. Somehow, I will have to be her mother. Somehow, she will have to understand how deeply she has hurt me. Somehow.

I am driving Mary Anderson's daughter, Barbara, and Megan to some planned activity, dreamed up by Barbara, who wants to play Pacific Northwest Hostess and entertain the visitor from "Back East." As I drive along, listening to their innocuous chatter—comparing schools, comparing climate, comparing pizza—I can barely contain myself. I see my knuckles, white on the steering wheel, and almost laugh. As we pull up to our destination, I turn to the back seat and apologize to Barbara for my silence in the face of her cheerful socializing.

"Megan and I are having some problems. You'll have to forgive me. I am in an awful lot of pain and don't know how to handle it."

I park and open the door. As Barbara turns to get out, she gives me a sympathetic pat on the shoulder and smiles. I meet Megan's eyes, and she laughs, her voice dripping venom, her eyes hard. "Yeah," she says, "handle it. I'm not leaving till next Tuesday."

Before I can stop myself—in front of Barbara, whose mother is my friend, whose family a bastion of normalcy—I spit full in Megan's face. Barbara gasps, reaches for Megan, pulls her sharply away as if saving her from a car suddenly caught fire and slams the door. As I drive off, in the rear view mirror stand the two girls, Barbara's arms protecting Megan from further damage. As for Megan, although she has forgotten why it happened, she has never forgiven it.

Next Tuesday arrived soon enough, and it was time to survey the ruins in the bomb crater. Vengeance came to comfort me, a Valkyrie chorus of women who chanted encouragement at every turn. "Kill the motherfucker, and I'll help," was Dawn's drunken promise, delivered regularly in full volume at 3:00 AM when she came home and again at 5:00 PM when she went back out.

Joyce-the-Voice, who didn't really live here and only showed up when she wanted something, whispered her instructions: "Throw him out, just throw him out. Throw him in the gutter, throw him down the stairs, throw him through the window, throw him into pieces, just throw him, throw him out."

Marcie peered anxiously over Charles's shoulder and said, "I'll help, I'll help, won't I, Charles, won't we help?"

Vengeance was a dungeon, a foul, damp pit of mildewed stone where rats tittered and skittered in the corners, where there was no light, where the atonal music of my moans was the only sound. Yet Vengeance kept me alive. It provided my next breath. It allowed me to sleep. In its own prison, Vengeance gave the only hope there was. Vengeance was my comfort, my

sanity. Somehow, this black abyss of retribution was a safe haven and in it lay salvation.

I needed to be alone. The very sight of Michael propelled rockets of adrenaline to shoot me in the ribs, hammer into my heart and burst open my eardrums. The thought that my own daughter and I had shared Michael's genitals sneaked incest-once-removed into consciousness and caused nausea. The only way I could imagine being with Michael again was with a lethal weapon in my hand. I needed to be alone.

But this was not possible. We had gigs to fill. Portland State Universitiy was due in January. We had to rehearse. The light show was smoothly choreographed, but Michael stumbled over his lines and lost his pace and rhythm whenever we made eye contact. This filled me with powerful vituperation, causing me to torment him verbally, which, of course, interrupted rehearsal and caused one of our fights, which were becoming increasingly physical. I had no compunction about throwing heavy Klieg Spots in his direction, and he, apparently, took great pleasure in his "pin-her-to-the-ground-and-sit-on-her-while-you-cuss" maneuver.

Charles was the first to bail. He hugged us both, looked into our eyes with sadness and relief, and moved himself and Marcie into a studio just around the corner on 21st Street.

Dawn was next. "I can't handle this, man," said she, "I'm gonna move in with Eddie." And off she went to join her best beau, Eddie-the-bass-player, whose gigs at local jazz clubs afforded him his own place and the beginnings of a slight cocaine addiction. She left, clutching her sequined evening purse, Navajo turquoise Thunderbird around her neck and a bottle of the same name under her arm.

Portland State was a fiasco. Charles—who belonged to a men's sensitivity group—had brought Jack, the group leader, and his friend Betsy, who calmly watched the show unravel. Michael appeared unable to concentrate, missed his lines, his cues, was left with nothing but an embarrassed smile and lame applause. Betsy came over to me before she and Jack left.

"Well, that was interesting. You and I, we'll get together, though."

"Yeah, well, thanks for coming."

The next day, I cancelled our gigs at Lin-Benton and Reed. There was no further reason for Michael to remain, but I didn't have the strength to kick him out into the damp Portland night. Charles took compassion and offered him a cot in the studio, and, finally, I was alone.

Now I could plan his death. Poison? I pictured a sudden doubling over, one hand to the gut, another to the heart. Perhaps convulsions and a bit of foam at the mouth. Very satisfactory, but there was a problem with delivery.

There was no way I could feed him arsenic without being in physical proximity, and besides, taking food from me would require more trust than Michael could possibly muster.

A gun? Good! A sudden lurch, a falling over backwards, blood appearing at the chest and—with the second shot—at the groin. A groan, a final murmur of apology and then, *finis*. But, no, I didn't want to spend time in jail, and besides, where would I find an Uzi?

An attack dog? Yes, that had possiblities, but I'd have to buy one and board it with an animal trainer who would take six months to get it vicious. Six months was too long. I wanted Michael dead as quickly as possible. What then?

Mulling around various methods for Michael's destruction gave peace. The adrenaline ebbed, I was able to sleep; I cleaned the house, did laundry, snoozed to Bernstein conducting Mahler, danced to Yoko conducting Lennon, put an ad in the paper and sold my skis. Hired movers to place the furniture into storage. Except for the steamer trunk full of I. Miller shoes, which I used for a kitchen table. And bed was, once again, the foam rubber mat. Solitude was healing. I had all the time in the world to determine how to rid the world of Michael. The project eased my soul, gave me back some coherence, some sense of control. And then one day, Cliff called.

"Oh my God," he said, when I told him the story, "I'll come right out." And sure enough, there he was, on my doorstep a week later. What a comfort he was, dear Cliff. He knew how to hug, he knew how to listen, he knew when to talk, and his big, guileless green eyes glistened with innocence and empathy.

I looked at Cliff and suddenly saw him at his physical best. His every movement was filled with superb martial arts grace. He stood, sat, danced as if airborne. Simply picking up his cup of tea and taking a sip was reminiscent of Baryshnikov sweeping his arm to the sky in *Swan Lake*. I remembered the black belt in karate Ciff had so magnificently defended in dozens of tournaments and how the boys used to take him along on their midnight excursions like an attack-trained bodyguard.

Ah, Cliff, who idolized me, who wanted only to protect my honor. I looked at him with such delight, it was almost impossible to remain abject and—with a barely concealed burst of glee— switched into Scheherezade mode. All my grief, all my pain, shone into his being. My head drooped in total defeat, resting sadly on his shoulder, the top button of my blouse somehow undone. I sniffled quietly, with a slight undertone of whimper.

"Cliff, you are my only friend, you are the only person in the world I can trust, the only one who understands. You're the only one who cares, Cliff.

Oh, Cliff, I am so thankful you are here.

"I'll kill him," he said. "Do you want me to kill him?"

"Do what's right, Cliff, I trust you. Do what's right."

So, Cliff walked over to the third floor studio on 21st Street, told everyone why he was there, and threw Michael down the stairs. Then, he came back to the house and said, "I shouldn't have done that; I did it for you. But I'm not going back east, either. I belong here. Maybe I'll become a logger. Anyway, I'll stay in touch. You'll probably need me."

Michael hadn't broken any bones, but it was good enough. At least he knew who tossed him and why. By week's end, he fled back to Massachusetts.

As for me, before I could move the I. Miller's and the foam rubber pad back into the wagon and set out for nowhere, one of the guys from that men's sensitivity group invited me out to dinner and then for a quick nightcap at his apartment. I stayed a couple of weeks, till we got so tired of one another that the station wagon was looking pretty good again.

Chapter 15

The Sorcerer's Apprentice

Nixon ran off howling, scalded by the hot water of Watergate; and so did our armed forces only a year later, fleeing ingloriously from the heat of Viet Nam. America had stopped, momentarily, eating its young: History was taking a breather, dancing in place, fussing around with the cold war a bit, just to keep in practice. Someone invented the "CAT scan," someone else invented crack cocaine, and all our soda pop cans got permanently attached flip tops. Nurse Cratchet tended the Cookoo's Nest, Mel Brooks's Saddles were Blazing and Bob Marley, that Rastaman who Shot the Sheriff in reggae time last year, was still Wailing. Diana Ross reigned supreme, Dylan found religion and— uh oh—Dexedrine's been designated a controlled substance. Now what?

I'm sitting in the Wheel of Fortune, sipping one last coffee, munching one of their famously excellent giant cookies and trying to decide where to park the station wagon tonight: Gotta be a quiet street, but not so exclusive that some alarmed resident will call the cops on me. I'm idly turning imaginary pages of a Portland map in my head when Mary Anderson pops in.

"Doris," she says, "my goodness, I'm just in the neighborhood to stock up on chocolate chippers. So good to see you. Where are you living? I haven't heard from you in much too long. What are you up to?"

I tell her I'm currently scouting for a good spot to park myself for the evening, and does she have any ideas? Forest Park entrance, maybe? Except I hear that a platoon of homeless Viet Nam vets camp up in there, and does Mary think they're dangerous?

Right about then, Mary becomes pretty firm both in voice and posture.

"Now, you listen here. You are coming home with me. That's final. Just wait while I buy these cookies and then you sure *are* getting in your car, only you're following me home. That's it and that's all. And don't give me any stories."

Mary is being for real. I can tell. That woman doesn't have a phony bone in her body, and she's not extending charity. She's simply being a friend.

"OK," I tell her, and so the station wagon and the trunk of I. Miller shoes

and the foam rubber pad make another turn in the road.

Life at Mary's was most orderly. I had a little room all to myself, amongst her cotillion of four daughters. There was a brother as well, but he was a bit older, already a married guy with his own household. These women were vibrant individualists, all of whom had exciting interests. The whole tribe was powerful and imaginative. Mary was their leader; her husband, who was outnumbered, remained genially benevolent. The sun shone at Mary's house every day, even when it was raining. What a blessing, what a respite. And Mary was as honest as she was kind.

"You know," she said while we were doing dishes, "you're crazy right now. Your eyes are too intense; there's a craziness in there."

"Probably. Or maybe it's just the Dexedrine. This's my last bottle, Mary. When that goes, I probably will be crazy. But I should have my own place by then, wouldn't you think?"

"I hope so. How many pills are left?"

"He gave me a double 'scrip, 'cause it's the last one; I'd say about sixty."

"Yeah, that should do it. But I still think you're crazy. I've never seen eyes like that in a sane person. Hand me that platter, willya? It needs to soak a bit more."

I settled in comfortably, craziness and all. One of the girls had just finished Carlos Castaneda's book, *Don Juan, A Yaqui Way of Knowledge*, and handed it to me. "Here," she said, "this is right up your alley." And it surely was. Don Juan, the Shaman, not only had inexplicable occult powers, but he also shared my passion regarding the sacred and mysterious properties of psychedelics—in his case, peyote and other natural wonders. Each word rang true.

Several peaceful weeks passed, and then there was a call from that woman, Betsy, who'd attended the Portland State gig with Jack-from-the-men's-group. Seems she got my phone number from Charles, with whom I was always in touch. She said it was time to get together and invited me over to her place in Northeast Portland.

As soon as I got there, Betsy sat me down in her kitchen and said, "Charles says you've read the *Seth* books. How do you feel about Seth?"

"Well, gee, I love Seth. I mean, I truly love what he has to say, and I truly believe if everyone adhered to his guidelines, I mean, all of us, even the government, then we'd be living differently. Why do you ask?"

"I want to live by those guidelines, and I want all participants involved here to also do that. My husband, Bob, is studying Seth. I wanted to find out where you're at with that before we go any further. So, when do you want to

move in?"

This time, it was my turn for the attic. There, in my little room, was a large dormer window which let in air, sunshine and birdsong. My foam rubber pad was still a perfect bed, and the steamer trunk full of I. Miller shoes became a vanity/dressing table.

Everything had happened so fast, I still wasn't quite sure how I got there. One afternoon I sat at Betsy's table talking about Seth and sharing a joint. The next minute, there were good-bye hugs at Mary's house, and then, all of a sudden, I was leaning out an attic window and smelling the foliage.

She stands in front of her fireplace, smoking a cigarette, one hand gliding gently down the zipper of her jeans toward her crotch. The hand stops short, just before raising the eyebrows of females and the hopes of males and then travels back up toward her face, toward her hat, with only a brief stop at the right breast. Her hand makes this journey intermittently throughout the evening, causing everyone in the room to pay attention.

She masquerades as a housewife, blending in with the shoppers at *Safeway*, attending parent-teacher conferences with her son, keeping dinner warm for her husband, and either going to bed with or terrifying most of her acquaintances.

Betsy is maybe in her late thirties. She is a monkey-puzzle tree; she has no leaves to drop in the fall. Her spine curves, she leans with the wind, one cannot determine her age or even her shape, not really. "You gotta blend," says she, and makes herself into the image of a current TV character named Mary Hartman, who epitomizes Mrs. Average American. She even has the same hairdo: Curls in front and two long braids at each side. When "Mary Hartman" goes off the air, Betsy becomes someone else. But no one at *Safeway* ever turns to look.

I don't know why she plucked me out of semi-homelessness and installed me in her attic, but we are immediate fast friends. Maybe she's never had a truly intimate friend before, one who simply accepts her at face value, for whom she does not have to pretend to be an everyday housewife, who doesn't freak out at her magic and listens to her when she is sad. Maybe there has never been anyone with whom she can share how she deals with the world or laugh with her at the weirdness of it.

She tests me early on by cornering me in the back hall. There is no light, there are only brooms and mops hanging from the wall and a stray galosh or two, all making shadows that reach out arms to strangle and claws to snatch. She's wearing her hat with the brim from *Gone With The Wind*. When I turn to face her, she has pulled the brim down around her face, but there is no

face. There is only a pitch-black, infinite void from which shines one light, piercing the darkness violently, aimed directly at me like a locomotive with no brakes, screaming out of some deep mountain tunnel carved into her house by astronauts from another planet.

I laugh so hard, I'm doubled over. "Betsy, how do you *do* that?" and collapse merrily onto the linoleum.

Betsy unbrims her hat, resumes her face and says, "You have to have the right hat," thus establishing my apprenticeship.

Her husband, Bob, habitually sits cross-legged on the floor, one hand eternally shielding his eyes as if from some glare that will cause him to shrivel up with pain. He never looks up when she speaks. "Man, she *hurts*, you know? It's better not to," is his answer when I ask him why he does that. When she becomes impatient with him, he goes to his room. "You don't want to get her mad," he says.

Their son, going-on-ten-years-old Billy, has no such problem. We're driving back from the coast one Sunday night when he says, "Mommy, how come there's no deer? Aren't there supposed to be deer through here? How come we never see deer?"

"You want deer?"

Suddenly, around the curve, there are deer. Not one or two, there must be at least twelve. A herd. They stand quietly at the edge of the road, staring at our car. There are stags and does and little fawns, all placed in clear view of the back seat. They stand immobile, they pose like a family from a Disney movie. Billy is thrilled. "Wow," he says, "deer!" What he does not notice is that, even though they are all looking directly into our headlamps, their eyes do not reflect light. Not even a smidgeon.

"Wow," I say, "deer?"

When she made sexual overtures, I declined politely, even when she resorted to bringing a male along to make it interesting for me. I was the only person in her world who refused to go to bed with her, which—unbeknownst to me—caused her to trust me.

I laughed when she scared the innocent, became amused at her choice of bedmates, which ranged freely over most sexual designations identified by Masters and Johnson. I believed her when she said that she had been a witch in a previous incarnation, burned at the stake for making a careless mistake. She said that standing in front of the fireplace was a good reminder for her to remain alert.

I watched every moment, every movement from my perch of delayed adolescence, which was swinging me so wildly, so delightfully, through this new existence. Being an adolescent at age forty-five was definitely more fun

than if I had done it at the usual time. No zits.

Before long, Charles and Marcie, who had become regular visitors, were invited in, too, and we became a commune. But they never caught onto who or what Betsy really was.

We maintained a pot farm under gro-lites in the cellar, had discussions on the metaphysical. I began to play the flute, Betsy gave us all art lessons and privately tutored me in her ways. She was Becky Thatcher, who pulled the world behind her on a string like a balloon, who had never had playmates before. We called ourselves *The Ethnic Alarm Clock Family*. Every commune, after all, had a name.

Even finally running out of Dexedrine wasn't as bad as I'd thought it would be. It took a week of cold turkey misery, all stupor and depression and wandering around like a sleep-walker, and then it was over. Or was it? Starving wasn't so simple anymore. Unease, not unlike the kind I'd felt as a kid in Berlin, crept up my spine. Something wasn't right. Three meals a day were too much and not enough. My clothes got tight and then tighter. But for now there was too much to enjoy, too much peace, too much to learn, so that nagging little bit of incipient alarm took a back seat—for now. Maybe I was just meant to be fat? What the heck, bring on the next excitement, the next discovery.

I asked a million questions, but never did figure out how to do the magic—although I understood the principles, both from reading the Castaneda books and from that course in Quantum Mechanics which had explained sub-atomic molecular energy focus back at U. Mass. But understanding wasn't the same as doing. All my experiments became so tangled in the mesh of my intellect that none worked. Like Castaneda, I took too many notes, sought too many explanations, and remained too clenched.

"OK," she says, "your turn. Put them all someplace else." It's Sunday afternoon, *The Ethnic Alarm Clock Family* at peace. Marcie is finishing a sweater, Charles practicing the guitar. Bob is reading the comics, Billy playing "Mail-Order Catalogue"—in this instance wearing his mother's kimono and her sandals, but not her hat, which is forbidden. He stands in front of us, stretching out one arm to nowhere, body slightly turned, his eyes on middle distance.

"How'm I doing?" he asks without moving his lips.

"Well, Shirley Temple you're not," I tell him.

"Don't listen to her, Billy, I'd order that kimono in a minute," she says, glowering in my direction, which causes me to feel a prickle just between the eyes.

"Come on, Doris, move them."

I can't. No matter which way I direct the energy coming out of my forehead, no matter how I concentrate on nothing to make everything, no matter how I visualize, fantasize, focus, flow with the cosmos or against it, nothing happens. Bob reads the comics, Billy strikes catalogue poses, Charles strums his guitar and Marcie knits. I squirm, I sit, I glare, I stand, I inhale, exhale, pretend I'm Don Juan, pretend I'm Castaneda, nothing happens. Jack turns a page, Billy turns the kimono sash.

"Can't, Betsy, can't do it. Can't."

"Oh, for heaven's sake."

The comics drift away, the kimono lies on the floor near Charles's guitar. Knitting needles sway on empty rocker. Betsy grins, touches her crotch, lights a cigarette. "Aah," she sighs, "Peace and quiet."

When the cigarette is done, she says, "Well, let's get 'em back," at which Billy comes down from his bedroom with a book on model trains, Charles flushes the toilet and comes out of the bathroom zipping up and Marcie emerges from the kitchen with a milk moustache.

But Bob is nowhere to be seen. We look everywhere. In the basement, in the yard, in the garage, under the car. "Oh my God, I've misplaced Bob," she howls. Now we are both in danger of wetting our pants. We bend over, we roll on the floor, tears come.

"Mo-om," says Billy, "Mo-om you keep *doing* that. It's not funny, Mom, Mom, you better get Dad back, don't keep *doing* that." His voice becomes a whine. He is not amused.

Immediately, Bob comes out of their bedroom. "I was in the closet," he says. "How did I get in the closet? Betsy, you've got to stop *doing* that. It's not funny." He sits back down with the paper and shakes it back into order. He is not amused, either.

I look at Betsy. "OK," she says, "I'll take you all out to Poor Richard's for dinner."

Betsy was an amazingly talented artist. Nothing weird or psychedelic about her artwork: Her watercolor pallette consisted of clear mixes, with which she created imaginative, quite classical masterpieces. She took incredible risks with wet-paper washes on washes, and always came out a brush-stroke ahead of disaster. Betsy understood the power of strategically placed unpainted areas and knew when and where to add just the right tiny finishing brush-strokes to provide charm and detail. Her oceans roared, her still-lifes sizzled. Her pen-and-inks, rendered with simple rapidograph pens, caused nasturtiums to leap off the paper, drenching viewers with their fragrance. She

just never drew or painted human beings—not even so much as a sketch of Billy. I nagged constantly, asking why she didn't exhibit or market, told her the local galleries were ripe and ready for her. She just shrugged, said it was for fun, not for hassle.

When I tell her I can't do watercolor, that I'm a visual klutz with no sense of perspective, she insists that all I have to do is let go.

"Let go of *what*?" I wail, sitting on her bed, knees under chin, desperately hugging my shin-bones.

"Just let go. Take a brush and play. Just let go. Don't make a 'picture,' just play."

What a revelation. But I'm still scared, so we turn on some Crosby, Stills, Nash and Young, light a joint, and I pick up a brush. Put down a wash (blue), just like Betsy's taught, let myself loose in the music and—before I know it—a giant G Clef begins taking shape on the paper. A G Clef, whose curve toward its "G" becomes an infinite spiral. For the first time in my life, I've created something beyond stick figures. Art for fun, without fear of being judged and not to accomplish a goal. Art as music.

Betsy knew how to encourage, how to teach. I began to play. Getting stoned and letting my brush dance to music was fun, especially when I ditched Joan Baez and started pen-and-inking to Tito Puente. Eventually I began to sell my own line of artsy note cards, which, I must say, were psychedlic and weird as all get-out.

Same with the flute. "Tin Ear Lizzie" up in the attic, got stoned and jammed with the LPs: George Shearing accompanied me on piano, and Hubert Laws taught me the "Love Loop." Bobbie Humphrey and I tootled up "Harlem River Drive" together. I was working my way up to Jean Pierre Rampal, who definitely had a place in my stoned repertoire. Gawd, I was having fun.

Betsy also taught some remedial skills which had sadly been omitted when I was a teenager the first time around. The most important lesson was honesty. My shameless manipulation of the Welfare system, particularly in the Food Stamp department, came to a grinding halt. "You have financial assets," said Betsy. "You don't lie about these things." Matter of fact, I learned, I didn't have to lie about anything at all. Nothing bad ever happened, even when the truth was scary. I listened carefully. At first, this meant taking risks, dancing on shaky ground. For the first time in my life, I was living with ethics and the longer it kept on, the stronger I felt, the better I liked it. Life was a lot simpler without having to keep track of Scheherezade and her

bizarre manipulative tricks!

Jeff stopped by on his way from Olympia to Israel. He had decided to emigrate, become an Israeli with dual citizenship. He seemed content and happy with his decision. He laughed and said, "I think you probably OD'd me on those six million. So, I'm just returning one body to the group." We all wished him well, entertained him royally, and he left a trail of joyful optimism sparkling behind him.

Shelli and Jim were still in Eastern Oregon. With the house-building contract successfully completed, they used the resultant money to buy a blacksmith business, and after that, a farm. Shelli kept in touch by mail, or with an occasional phone call.

Even Megan resumed contact. Said she was thinking of driving out to live here permanently. This news made my heart sing. We would be able to forgive and forget at last. Could life get any better?

We're lying in the backyard sun, half dozing, when Betsy sits up, lights a cigarette and starts talking.

"I'm a farm-girl, really. Central Washington. You know what? I can remember my own birth. That's how far back my mind goes. But this stuff, it started before I was two. I remember that day like it was yesterday. My mother put me down for a nap, and I got mad 'cause I wasn't sleepy. I got so mad I made all the toys come flying down off the shelves without moving a muscle.

"I was always in trouble 'cause I hadn't figured out how to control it yet. Like, when I was real little, if we had visitors, I'd hide behind the fridge and when they got all over my mom with that gooey visitor's talk, I'd pop out and say stuff, like, 'You're lying, Mrs. Doe. You just came over here to borrow something, and you hate yourself for it because you can't stand any one of us. Why are you lying?'

"I was nineteen, attending Whitman, when they sent me off to the booby-hatch. I really had to learn to be careful. One day, I just walked out of there, bought a bus ticket to Portland, and here I am."

"Wow, Betsy, I sure coulda used some of that when I was a kid," and lie back, light a cigarette, too, and ponder what I could have done to MacKinney.

"When Billy was little, I used to bring the moon down out of the sky for him and set it on his bedpost. He'd laugh and clap his hands. He loved that."

We talked a great deal about God, Betsy and I, and how God really is in all things, actually *is* All That Is, and how we create reality. We discussed the

Jungian collective unconscious in that regard. Maybe that's how we created the Holocaust: With all our collective indifference, with our deliberate refusal to take personal responsibility for what we, as a people, saw and heard. When we mixed indifference with all our secret prejudices and hatreds—Voilà—along came Adolph. Indifference kept popping into the mix. Indifference to lynchings in the South, to starvation in Africa, even way back in history to the Spanish Inquisition. We kept returning to Solzhenitsyn's photographer and how differently humanity could have created the world had everyone only known we were all creating it.

We decide to track how we create our lives, moment by moment, just for one day: That night, I'm lying on the living room couch, listening to Janis Joplin, and waiting for Betsy to come home from a worm-grower's convention. She's gone with her friend Jack, who is interested in using worms to cultivate soil in his cellar mushroom-growing business. I almost fall off the couch laughing: "Wow, I'm forty-seven years old, stoned, bivouacked in the home of some kind of shaman-type woman, who's gone off to a *worm-grower's convention?* While a drunk, dead rock star whines in my ear about some jerk named Bobby McGee? Who is Bobby McGee? How did I get here? How did I manage *this?*"

Next day, there's a phone call from Cliff. He's down at the coast, dreaming of becoming a fisherman, and living in a trailer full of roommates. Did I want to come down? Far out! So, I drop a hit of acid to keep me company on the drive and head for Newport. The drive is magnificent. I'm traveling through one of Betsy's watercolors, the dense, bright trees beckoning their green welcome, the coastal mountains keeping calm and stony watch. By the time the ocean appears, light is fading and the usual Pacific silver is becoming a dark velvet blanket whose white lace borders snuggle up to the shore with foamy whispers, hissing secret promises.

Cliff's trailer is easy enough to find, filled with his usual complement of agreeable hippy intellectual misfits. We're strolling the moonlit beach, he and I, when there appears a sudden, brilliant, purple blob, big as a soccer ball, hovering behind his head. "Wow," I think to myself, "I think I just saw an aura. Cool. Purple is excellent." So, when we get back to the trailer, we climb into his little nest and make some purple love. I've never made love before with a person who has first been a friend. How lovely. Cliff's long braids come undone and fall in waves of brown satin over both our faces. He is gentle, he is strong, and—most of all—so calm, so comfortable that when we are done, there's no room for anything at all except acceptance. There is goodness all over everything. We spend the weekend on the beach, taking

photos, holding hands, not talking much. I tell him that if his fisherman dream doesn't float, there's snug harbor for him in Portland.

Sure enough, Cliff gets seasick on the trawler one time too often, and shows up on Betsy's doorstep with his duffle bag and his Gordon Lightfoot records. Betsy takes one look and says that if I'm willing to share my attic, he's welcome to move in. Am I willing to share, or what?

Cliff, dreaming of becoming a Genuine Pacific Northwest Lumberjack, fits in beautifully. He gets along well with everyone, remains quietly independent and stays straight. (He's not immune from contact highs, though. When the living room becomes suffused with enough marijuana smoke, he turns into a graceful dancer, reveals a magnificent baritone, both of which, unfortunately, dissipate after a stint in fresh air.) Betsy watches.

But as willing as I am to share the attic, I begrudge sharing Cliff. For one thing, I've noticed that once Betsy has bedded, the persons involved seem to disappear from her reality. Charles and Marcie, for example, are beginning to argue, which they hadn't prior to their one-time experiment as a *ménage a trois*. Besides, I'm still recuperating from the last time I inadvertently wound up sharing someone. I grumble, albeit silently. After all, Cliff's a free agent. But still, but still....

Cliff stays a few months and then—(Hah! I told you so!)—becomes disenchanted with his hostess.

"She really hurts you in the head, y'know? I can't handle that anymore. Besides, if you really wanna know, all she did was lie there. I mean, she didn't move or anything. She just lay there. It wasn't worth it. Anyway, Karen's got a spare room. Attic, would ya believe? And I've got a job lined up near there. Hey, look, here's the phone number. We keep in touch, for sure. OK?"

"OK. I love you, Cliffy. You take care." And kiss him a fond good-bye. We keep in touch. Sometimes he even visits. Calm, quiet, strong, steady Cliff: The man of La Mancha, sure, but also, always, the man of integrity.

Soon after, there's a call from Mary: Seems her daughter, Mary Jo, landed a job as Bridge Tender on the Hawthorne Bridge, and they're looking for one more hire. They want it to be a woman, in order to fulfill their affirmative action, equal opportunity contract with the state. Am I interested? Wow, am I ever! Can't thank Mary enough and make an interview appointment for the next afternoon.

That night, after a light snack of peyote, I'm lying on the living room floor, listening to "All Along The Watchtower," wondering into what Jimi would have evolved, what form his art might have taken had he lived, when I suddenly feel great discomfort in one of my shoulder blades. I turn to

Charles, tell him my back hurts, and he offers massage.

"Yeah, Charles, that would be so good. It's my shoulder blade. Thanks, kiddo."

But when Charles touches my scapula, I experience a pain so sharp and dreadful it takes my breath away. It's hot, searing lightening, traveling down my left arm. I can't move, can't breathe, it hurts more than childbirth, it hurts more than pain. I turn to Charles. "Help," I whisper, "help."

It's obvious something is very wrong, so Charles and Marcie load me into the station wagon and drive me to the ER. The pain won't go away. My arm hangs paralyzed. The ER doctor listens to the symptoms and then Xrays my neck. (My neck?) When he comes back after viewing the film, he asks me when I had the motorcycle accident. What's he talking about? What motorcycle? What accident?

"Then it was a car. Did you have an auto accident?"

"NO. I was lying on the living room floor, listening to Hendrix. Honest."

"Well, I've never seen this type of damage without trauma. You have ruptured cervical disks numbers three and four so badly that your brachial nerve was caught on a bone spur and became inflamed. That's why your arm hurts. You need to be admitted, ASAP, you'll need surgery to fuse the disks."

I tell him I can't, that I have a job interview tomorrow. Can he fix it so I can go to the job interview, and then I'll come get admitted? "Yes," he says. "You'll surely want to return after the job interview, because the pain will be unbearable, but I'll give you some Percodan, meanwhile."

So, the next afternoon, I manage to drive to the Hawthorne Bridge. I'm wearing my best job interview outfit: A quilted ankle-length skirt, platform high-heel clogs and a frilly blouse. My left arm hangs helpless at my side, the pain dulled by Percodan just enough to keep me from screaming. When I get to the bridge, it's raining. I walk to the little hut by the traffic gate and ask for the supervisor. The man from the hut points up into the superstructure where the main control house sits in the bridge rafters. Then he points to a metal ship's ladder and tells me to climb it. "Wow," I tell him, "I've got these shoes. Whatcha think? They'll slip, for sure."

The man agrees and lends me some bright yellow galoshes. "Here," he says, "put these on, they've got non-slip soles."

So now I'm wearing a quilted ankle-length skirt, a frilly blouse and high-heel clogs inside a pair of bright yellow men's galoshes. And there I go, in the rain, up the ladder. My left arm hangs, useless. Underneath the bridge grating, the water swirls and wobbles and tilts. The Percodan is doing strange things to my vision and balance. I am halfway up when a life-altering experience lifts me the rest of the way: "If I can do this, I can do anything.

There is nothing in the world I cannot do, if I can do this."

This is more than a thought. This is an alteration of my whole molecular structure. This, for the first time in my life, is the experience of inner strength. So I decide not to look down at the water, which is only getting me dizzy, and just concentrate on my next step. And in no time, I'm at the top.

The interview goes well. I'm apparently what they are looking for: Someone a bit older, a bit more settled, mature enough to handle passersby. The man offers me the job right then and there. I accept, but with the provision that I get two weeks before the start date. He agrees.

I climb back down, hand the man in the hut his galoshes and drive myself to Emanuel Hospital where I'm admitted and placed in the care of a neurosurgeon.

I stay almost the full two weeks. I'm on morphine twenty-four hours a day, which helps a lot. I refuse surgery, deciding I can get well by following the dietary guidelines of author/wellness guru, Adele Davis[3], who seems to have discovered that almost anything can be cured if you eat right. Instead of surgery, I opt for daily physical therapy, which involves traction and time in a spa kind of tub. The neurosurgeon is outraged.

"You don't seem to get it," he lectures. "That brachial nerve needs to get unhooked from the bone spur, just for starters. You're setting yourself up for disaster. I've never seen disks ruptured this bad before without trauma. The ER doctor was right. Looks like a motorcycle accident, at least. What are you trying to prove, anyway?"

My hospital roommate, an elderly Haida Indian, looks on, amused. "You know," she says, "Saturday would be a good day to die." So, on Saturday, she sits down in her wheelchair and dies. I'm impressed.

Next Monday, the neurosurgeon comes back, still angry. He makes me sign a dozen releases and, when there's nothing helpful left to do, discharges me.

Driving home, I feel like the princess of some happily-ever-after fairy tale. I've never seen a bluer sky, never felt such a soothing breeze, never seen trees so green. Far out. I've survived.

But something's amiss. Once I get settled in the attic, I begin to feel terribly restless, my nose runs, feels like the flu, feels like I'm going to die—and it's not even a good day for it. I can't seem to stop talking, and it's all nonsense jabber. Finally, I call the doctor. Something's so wrong, it's

[3] Davis, Adelle. *Let's Get Well.* Bergenfield, NJ: New American Library, 1965.

scary.

"Oh," says he, "it's nothing. You're just having a touch of morphine withdrawal. Eat some sweets, calm down, you'll be OK in a day or two."

"Yeah, easy for *you* to say."

Betsy hovers like a real mom, worrying and bringing hot chocolate. Everyone's helpful. Best of all, Cliff's stopped by, and he takes me through it. Listens to my non-stop prattle, feeds me Butterfingers and holds my hand. He stays till it's over. Thank you, Cliff.

The following Monday, I start being a Bridge Tender. What a job! I work a variety of shifts, so I get to see the river at its best, all hours. There's the pink dawn, stirring up river birds, shining the water into rosy swirls; there's the mid-day bustle of scows and tugs and sail-boats; there's sunset on Mount Hood, turning the mountain into a huge strawberry sundae, all whipped cream and frosting. And there's late night when the whole river world is a silent midnight blue with only the occasional groaning of the superstructure or the whizzy rattle of a car crossing to remind the world it's still real.

Every day, I come to work toting my flute, my sketch pad and a little taste of marijuana. I am a combination of Tug Boat Annie and Siddhartha. The bridge only gets raised maybe once every shift or so. The rest of the time, I light up, blow the smoke out the river-facing window, play the flute and sketch. When my arm hurts, I lie on the wooden floor and do the hospital-recommended stretch excercises. Mary Jo and I even make the Sunday paper: We're the first two female Bridge Tenders in the state of Oregon, and in the mid-seventies, that's news. I love that job so much, I want to stay for the rest of my life. It pays $3.50 an hour—more than enough.

Between traction and spa (which I still get daily as an outpatient) and faithful adherence to Adele Davis, the arm hurts less and less. I know it's there, and will know it's there for the rest of my life, but it's a better choice than having vertebrae fused and not being able to turn my neck. Sometimes, that brachial nerve scolds me hard for neglecting to remove it from the bone spur, but anti-inflammatories manage to calm its temper. We get by. And no more peyote, that's for sure!

I've enrolled in a 5:30 PM adult education class at the nearby community center—*Introduction to Counseling*, and it's been fun. I usually take a little toke, and then walk over there to groove on learning the differences between my inner parent, inner child, inner adult and the instructor, who strikes my fancy. So today I've dressed in my best outfit: That same quilted ankle length skirt, the platform high heel clogs and the frilly blouse. I'm trying to cross Union Avenue at rush hour to attend class, when I get stuck in the middle of

the avenue due to a zillion rush-hour cars zooming by in both directions. I'm stuck.

And as I stand there, waiting patiently for someone to slow down, another life-changing experience shakes my bones, my guts, my spirit. Right there, standing in the middle of Union Avenue at rush hour, I realize with complete acuity that, should another human being approach me from the other side of the street and take a look at my eyes, I would be hauled off to the local insane asylum within moments. I realize, with absolute clarity, that I have gone crazy. That the last vestige of sanity hovering reluctantly around my consciousness has evaporated and not one bit remains. It's gone. Absolutely everything that society considers hallmarks of sane citizenry has fluttered into rush hour traffic right along with the exhaust fumes, and only craziness remains.

This is an absolute—what I call a molecule changer—just like the one when I was halfway up that ladder on the Hawthorne Bridge. (Maybe it's the outfit?) What a relief! No more hanging on, no more trying to be what society expects of me as a woman nearing fifty, as a responsible adult, as a middle-class American, as anything at all. I am now a bona fide nutcase, and it feels so good.

In that moment, I realize that what Mary saw in my eyes when I was living at her house wasn't me being crazy, it was me clinging desperately to a few remaining shreds of sanity. Crazy feels much better.

I sigh, adjust my skirt, the traffic slows enough to let me through; I arrive at class just in time, eager to learn. We're doing dyads tonight and that's always fun.

As soon as I get back home, I corner everyone and make the announcement:

"Hey, guys, I've gone over the edge, I'm crazy. Finally. Irrevocably. Insane. Honest."

"Yeah, so?" (From Charles.)

"You missed dinner and it's your turn to do the dishes." (From Billy)

No one, it seems, is particularly impressed. Well, no matter. I didn't really expect cheers. As for sanity, it never does return. I will spend the rest of my life without it. Isn't that a trip?

A few months later, the county decided to automate the bridge, and all of us little hut keepers were laid off. How sad. I packed up the flute, the sketch pad, the little packet of weed and went out to seek employment. Not much luck. Till one day a neighbor lady told me that Mr. Correy, over at Workers Together, the Minority Employment Program, had just lost his secretary.

So I phone for an appointment, put on the quilted ankle length skirt, the platform clogs, the frilly blouse and walk on over.

Mr. Correy sits at his desk, squinting up at me suspiciously while I stand there trying to look professional.

"You married?"

"No, sir."

"You ain't wearing a bra?"

"No, sir."

"You type?"

"Yes, sir."

"Ok, when can you start?'

"Tomorrow?"

"OK, 9:00 AM, and don't be late. I don't like late."

And so started my illustrious career as Mr. Correy's Girl Friday, Job Developer, Soother of Irate Applicants, Terrorizer of Employers-Who-Paid-No-Attention-To-Equal-Opportunity-Laws. I went through the classified section of the paper and called potential employers to let them know they needed more minorities on their staff. I found a job for a young Ph.D. from Harvard—creosoting telephone poles; jobs for guys on parole, whose freedom depended on immediate employment; jobs for women wanting to get off welfare and ADC.

My co-worker was Leonard, a truly affable young man who sometimes nodded off, possibly due to something stronger than marijuana. Together, we made folks into painters, warehousemen, forklifters, crane operators and sales clerks. Got them into electrical and plumbing unions (both of which, by the way, were amazingly reluctant in their compliance) and into CETA—the Federal Comprehensive Employment Training Act. We cheered everyone on, including each other. Good team!

Mr. Correy paid on time, never made a pass and gave me complete automony. Better still, the job was within walking distance, so I'd put my high heels into a back pack with lunch, and hike to work in tennis shoes. The clients were pleasant, I was a contributing member of society at last, and, just like fifth grade in Harlem, the only Caucasian in the crowd. It felt comfortable there; it felt like home.

All things considered, this was just as good as the Hawthorne Bridge. Even better, maybe. Got me back in touch with the world, gave me some validation as an actual wage earner, and the music was terrific. I'd been out of hearing for awhile, and the new sounds were enticing. I loved George Benson, who was most definitely and obviously a disciple of that great minimalist of years past, Wes Montgomery—only with an upbeat flair.

Grover Washington was coming into his own, as were the Crusaders (Jazz with a Ghetto twist) and the Commodores, whose lead singer, Lionel Ritchie, stole my heart immediately. Most interesting of all was Al Jarreau: Except for that very, very old-timer, King Pleasure, I'd never heard a male scat singer do such a thorough job of getting my knees to twitch and toes to tap. I even typed in time.

I'm on the phone with the personnel department of a local lumber company. We are discussing the three well-qualified persons I sent to interview for the posted job openings. I'm just asking the personnel person what specific variables either worked for or against the employment of my clients when Charmagne walks in. Tall, slender, bony face, wise eyes. Motion her to a chair and finish the conversation, satisfied that at least one of the applicants got hired.

"So, how can I help you?"

"That was some fine shuckin' an' jivin' you just got done doin'. My name's Charmagne. You gonna do the same for me?"

"Well, we try. There's a form to fill out, and then we can talk."

"OK, we'll do that."

Charmagne fills out the form, hands it over, crosses her legs, lights a cigarette and scopes me out. By the time she's through looking, she probably has a clear picture of me, including religious affiliation, sexual preferences and favorite junk foods.

"I don't want to be a dish washer, baby sitter, lumber-jack, house-painter, or taxi cab driver. What I really want is to go out on three job applications and get refused by all three so's I can stay on my unemployment stipend and satisfy my parole officer. How's that?"

She's grinning. I'm grinning. We're laughing at each other, Ms.Con-Person and Ms. Bureauocrat diggin' each other.

"You wanna be overqualified or underqualified?"

"Under is fine."

"Well, that's gonna be harder, because you have that high school diploma, but I'll try. Say, could I maybe hitch a ride home with you? It's pouring rain, I didn't bring my car, it's almost 5:00 and it says on your application that you live on Garfield Street, which is right past my house. "

And so, true friendship was born. Charmagne and I were soon inseperable, running buddies, partners-in-fun. We were all over the place. She was welcomed at my house, but Charmagne avoided Betsy assiduously. I noticed, also, that this was mutual. They were polite enough, did the usual small-talk,

216

but Betsy was usually not visible when Charmagne appeared.

On the weekends, we toured the local bars, from *Geneva's* where the yumbies gathered, to *The Baron* where guys were the most agreeable, to *Cleo and Lillian's* where white women got the cold shoulder. We hung out at *Jamie's Place* which had an excellent juke box, played pool at the *Dekum Tavern*, and went dancing at my very favorite spot, *Bourbon Street*. We could cover five places a night, me drinking Perrier, Charmagne nursing a beer. Sometimes, Saturday nights wound up at the "After Hours" where I had to order a glass of wine or get murderous looks from the bartender. We picked up guys, we danced our tails off, we grooved to the music, lit a joint, got exhausted went home, slept a lot and then did it some more.

Charmagne tried out for the women's softball team at *Geneva's* because she had a crush on Paul, the owner. I tagged along to the first team meeting and wound up designing the team uniform. I, the visual klutz who—until just a few months ago—could only draw stick figures, designed a Vee-necked uniform shirt emblazoned with an Amazon Black Woman, head up, fierce-eyed, wearing a belligerent Afro and about to pitch a softball into the record books. Was I proud? You bet! Twenty-six year later, I still have one of those shirts carefully stored in the bottom drawer of my bureau.

"The Ethnic Alarm Clock Family" had been together now, for over two years. I was having fun, working at a real job, dating neat guys, living with wonderful roommates. I was even exploring the possiblity of developing my own identity, complete with a set of values unique only to me. (What a thought!) Betsy and I found time for one another, always, and now I had a playmate, too. Mary and her family also kept in touch, as did my children from their far-off worlds. If this was how crazy people lived, then hooray for the straight-jacket set.

One fine day a pickup truck with a camper-top pulls up at our house, and out climbs Megan. She has driven across country with two Borzois and all her belongings. "Well," she says, "here I am," and walks nonchalantly back into my life. She, Betsy and Bob hit it off well. Bob gets her an immediate job as nannie for the daughter of a friend, whose wife has just left without notice. The place is within easy driving distance, and gives Megan the precious time she needs to get a foot-hold on her new town, on permanent employment, on scouting for a place of her own.

Megan said the second Borzoi, Ruschka, was a gift for me. Alyosha, the premier Borzoi, was actually a bona fide family member. He was my "Grand-doggie," most beloved and respected by one and all. Where Ruschka came

from was unclear. She was pure white, with a scattering of beige markings and her pedigree name was "Diamonds and Rust." There was no place for her at our house, due to Betsy's resident bulldog, Butch, who looked unkindly at canine intruders. Megan agreed to "board" Ruschka for the time being with the clear understanding that I would take ownership soon. Perhaps Ruschka was a peace offering? I dared not refuse, but worried greatly as to where or how I could keep her.

Meredith Ashmore had been well provided for: He was now the property of the woman who had boarded him while Megan was at college in Maine, Megan knew and trusted the new owner, and the transition had been smooth for everyone. Megan's permanent move out here was, therefore, the real deal. She would never have left Meredith for just a lark. She, however, gave no reason for the move. It didn't matter. If she was here, it was—on some level—to be near her mother. That's all that mattered.

There was some trouble brewing at home, though. Betsy and Bob's marriage had always been an open one, but on Betsy's end only. She claimed the right and privilege to sleep with whomever she felt was appropriate, but if Bob so much as looked at another woman, there was hell to pay. Bob, at the moment, was looking at Megan, and Megan was looking back. Betsy was not amused and Bob did, indeed, pay hell, as only Betsy could dish it out.

On top of that, there wandered into our world a man named Costas. Initially, he was a friend of Megan's but it soon became evident that Betsy had her eye on him, too. And when Betsy had her eye on anything, she got it. Things had never been so wobbly. The "Ethnic Alarm Clock" was about to go off.

It's 1976, and the "Ethnic Alarm Clock," having rung itself silly, appears now to be unwinding. Charles and Marcie have split up, Marcie moves in with an ex-biker friend of the family and Charles disconsolately wanders off for an extended visit with his folks. What's left of Bob and Betsy's marriage is foundering on Costas' shore.

There's a brief respite when Cliff's brother, Jonah, comes out to visit. He's celebrating his B.S. and his R.N., and wants a vacation before settling into his career. Everyone gathers to greet him; he's given *carte blanche* of the territory. Jonah, who's staying with Cliff, lands a summer job washing dishes at a local mall, but has plenty of time left over to socialize. He has fun with everyone, including Charmagne, who thinks he's cute.

But Betsy's gone too far with Costas. She has actually installed him in her bedroom, right across the hall from Bob, and Bob finally has had enough. After a while, he finds a little one-bedroom apartment nearby, and moves out.

218

He comes back regularly to visit Billy, but that's it.
Which leaves me.

Chapter 16

Leaving Your Heart In San Francisco

Bobby Bland sings to the world, looking for someone to give his love to. Everyone else is giving their love to Roots, *and word is out that the book will soon be a major event on TV. What a milestone! Never before—except for those "Shaft" films, featuring Richard Roundtree in high heel boots—has Black America taken over the entire nation's cultural awareness and entertainment spotlight so completely. This is a societal turning point, and we all know it. In Portland, Oregon, morale in the world's only integrated ghetto is way up. Everybody's reading Alex Haley and there's a lot of hand-slapping going on!*

We're driving to somewhere or other on the Fremont Bridge when Q.T. turns to me and asks, "Doris, is you the police?" His voice is soft, but carries metallic edges. I know he is serious, but I can't take the question seriously or keep my face straight when I reply.

"Nope, I'm not."

That's the best I can do without laughing out loud. It is only many years later that I realize how close I came, that day, to death.

Jonah brought him over on a Saturday night from his job washing dishes, where Q.T. was a fellow slave, albeit one with excellent marijuana. Q.T. stayed long after dinner, talking about life, love and how good it felt not being in San Quentin.

"Man, just a long, hot bath, man, that can be such a blessing. Square bid'ness, man, last month, when I got out, man, I bet I stayed in that tub for three days."

He didn't say why he had been in the pen and no one asked. I, for one, was more interested in his eyes than in the grubby details.

I hadn't seen eyes like that since Michael. Warm, like a hot fire on a cold night, penetrating into my heart like a flaming spear, they sang to me and sparked live embers, made love, made jokes, played games and challenged my sanity all at the same time. Everybody else listened to his words, I listened to his eyes. His eyes, they were prettier even than Michael's. Larger,

longer lashes, edges slightly up-tilted, their black-brown a shade darker than his skin. They beckoned, flirted, announced their power in direct communication with my gut as soon as we were introduced. I wanted to jump into those eyes without a parachute, right away, as soon as possible, the minute we were alone. For the first time, since Michael, I felt like playing.

He was a little guy, this Q.T., but he was put together like a ballet dancer, all controlled muscle and harnessed energy that came out of him like electricity even when he was sitting down. "Zoom," said his body, "I'm a wild one, I'm a dancer, and I can kill you, too." Wow.

We were, apparently, headed toward some intense personal business and as soon as the others went off to bed, we settled down on the couch to discuss terms, negotiate power and, just maybe, sign the contract. Everything was whispers. Betsy's room abutted the living room and she was such a light sleeper that even clearing one's throat could wake her up and cause her to come storming out, yelling obscenities. Smothering our giggles delighted us, made us feel like wacky conspirators, caused us to sit very close.

"I don't get you," says Q.T. "You are either a five-year-old child or an aging hooker. And I'll never know which you will be, not from one minute to the next, will I ?"

He puts his hand on my face and laughs. "OK, I always wondered what would be next, so it's you, is it? UMM, umm-umm."

I turn on the local Black radio station, soft with midnight music. We dance, we dance slow, we share a joint, we talk. I listen carefully to what his eyes are saying.

"So,Q.T., you a gangster, or what?"

"Yeah, I guess so, I was a gangster or what. Doin' some pimpin', dealin' some dope, gettin' over just fine, everybody happy. I was running some ho's and this one holdin' out, y' know? We had a difference of opinion, you hear what I'm sayin, and this bitch, she ran to the police and said my partner and I, we put an electric cattle prod up her cunt. Next thing I know, I'm in the pen. And now I'm here with you. Strange world, ainit?"

"You a local native? You look kinda big city for here. I mean, look at you, with that newfangled Jeri-Curl, everybody else still doing Afro. I like it, though, looks real cool." And snuggle closer.

"Doris, I'm from San Francisco and I can't wait to get back there. Square bid'ness. They released me to here, because I've got a wife here, we got married while I was in the pen, you need that, y'know, for parole, but I gotta get back home. Man, my whole family down there, my mom, my brothers, my sister, my oldest son, everyone of them waiting for me. I'm just hangin'

till I can get a ride. And that whole wife thing has got to go. So you like the curl, yeah? Cool."

He touches his hair with hands like claws, their knuckles deformed from too many fights, patting his "do" with a surgeon's delicacy, as if each curl were made of crystal, and he smiles.

At 3:00 AM, I make us tea and we sip and talk and eat stale bagels, looking at each other like two lost explorers finding the first sign, the first little blossom that signals "Oasis nigh, death in the desert defeated." Sunday, he is at the doorstep by noon, ready for more. Me, too.

The minute I get a minute, I call Charmagne. "Charmagne, you gotta see this one. Can I bring him by?"

Charmagne hears in my voice a call of the wild and yelps, "Whooey! Yeah, Child, come on by after work, you know I'll be here."

It's a date and the minute she lays eyes on him, she lights up. They chat like instant intimates, Charmagne looks at me, looks at him goes, "UMM umm-umm" and they both start laughing.

When we're alone and I ask, "Well, what do you think?"

Charmagne shakes her head, smiles and says, "Oh, I been knowin' him since before I was born. We're cousins, you might say. Same tribe, hear what I'm sayin'?"

Next, we visit Dawn and her boyfriend, Eddie-the-bass-player. Eddie's cocaine habit usually has him either playing riffs on the bass, jumping around to music on the stereo, or telling non-stop anecdotes about his latest gig. Not today. Today, as if impaled to the kitchen chair, he mumbles polite non-conversation having to do with the weather. When we get up to leave, he asks me into the bedroom where he closes the door, puts his hands on my shoulders and looks into my eyes as if they contain at least a gram of his favorite substance and if he stares hard enough he'll get high.

"Listen," he says, "this guy is dangerous. I mean, Doris, he is really dangerous. I'm not kidding. I wasn't born mixed-race for nothing, give me credit for some sophistication, willya? Jesus, Doris." He stares some more, waiting for a response, gets only a hug and lets me go, shaking his head at the ceiling.

We're driving around in SouthWest Portland, where I'm looking for a Scandinavian clog store, but I'm lost. Then I spy a cruiser and when I delightedly honk the horn to stop the cop for directions, Q.T. yells, "Bitch, is you crazy?" and turns around in his seat looking for a non-existant exit. When the cop comes to my window, Q.T. smiles up at him like a kid just caught masturbating in the classroom. I get directions for the clog store, Q.T.

looks out the window and doesn't talk for a few blocks. Finally, he stares daggers at me and hisses, "That was the police."

When I get home, Betsy calls from the kitchen, "You had a visitor today. Come on back and I'll tell you." Betsy has made coffee, pours me a cup and offers a cinamon bun. We settle down to chat and Betsy explains. "There was a woman at the door, I let her in 'cause I thought it was Charmagne, you know, how they all look alike, so I let her in. Turns out this woman was a lot taller and also she walked with a cane, and she was so mad I had my eye on that cane, believe me. Said she was Q.T.'s wife and to tell you to keep the hell away. You better straighten that out, Doris, I don't want stray weird women banging at the door and having tantrums. OK?"

Next time Q.T. appears, I tell him to go home, I'm not going out with a married guy. Q.T. is adamant. "We got married so I could get parole. I told you that before. And you know I ain't a lie. She been paid off, she got no complaint, besides the money she got from us, she also gets disability, she a cripple, y'know? Besides, girl, what would I be doing with a woman six foot tall? I stay there, sure. Where would I go? You want me here? I don't think so. She won't be back, tell Betsy. Square bid'ness."

The woman never returns.

We're lying in the grass, the sun on our bodies giving us playful instructions. I am tickling Q.T.'s nose with a dried stem which causes him to laugh and wave his arms for protection, and I am suddenly enchanted with his grace, with the mischief of his smile, with his sudden flash of dimple. "Q.T.", I say, "has anyone ever told you that you are beautiful? You are such a dumpling," and lean over to poke him in his washboard abs.

"Nigger, is you crazy? I am the ugliest sonofabitch in the county. Get away from me, woman, and shame on you for lyin'."

"Come on Q.T., get off it. I mean, if you deny having brains, at least cop to pretty."

Q.T. becomes silent for a minute. Then, "Seems I have some serious explaining to do, white woman. Don't you know I am too black? Man, I used to almost get killed when I was a kid. My brothers, they beat the shit outta me for it, my mom, too. Especially my mom, hollerin', 'Pig, you even blacker than your father, how did you dare get in this family' and she knew how to use that that belt, too. You know she was right, Doris. All my family is light complected except me, I don't even know how I got born that black. Ain' nothing I can do about it though, huh. But don' you be telling me I'm pretty. Mean, that's what I am. Mean. Come here, woman, let me show you how mean I can be."

224

And now it's my turn to be tickled. We roll in the warm grass till it's time to lie back and stare at the sky, which, for a late September day in Oregon, is an unrealistic shade of blue.

I take Q.T. and Charmagne sight-seeing. We start out at the Rose Garden in Washington Park, take a leisurely drive to the far suburbs and then head for the farm country where Megan works at her new horse-training job. I've never been out here before and view the golden hills framed by the distant hazy purple Coast Range with some pleasure. My passengers, too, enjoy the view. "This is nice, ainit?" murmers Charmagne. "Sure feels good gettin' away, donit?"

Q.T. grunts satisfaction and relaxes his shoulders agains the car seat. "Hey, y'all," I say, "this the mos' outta-townest I ever been." Q.T. and Charmagne shoot up in their seats and grab at one another. They're laughing like two idiots at a Three Stooges movie.

When we get back, Q.T. becomes solemn. "Looka here, Doris, if I wanted some black chick, I'd a got me one, hear? Don't you be talkin' trash. You a white woman, and how you speak is parta that. Ain' no market for dumb-ass white chicks talkin' black. You watch that, hear?"

Q.T. has decided to treat Charmagne and me to lunch at The Wheel of Fortune, a comfortable family spot in NorthWest. We're seated, waiting for the menu when three men at the next table begin to stare. Finally, one of them bows exaggeratedly, makes a courtier's gesture as if he were introducing us to a large audience and says, "Well, good day, ladies." He turns back to his mates and they laugh loudly into our faces, cold malice shooting from their eyes like steel bullets." Q.T.'s face and eyes are blank. "Oh wow," I realize, "that's the police and they think we're hookers and Q.T. is our pimp." My face begins to break up into laughter, but Charmagne kicks me hard under the table so I squelch it and I look resolutely down at two forks and a napkin.

Q.T. and I have become inseperable. He has taken to sitting on the front steps of Workers Together, waiting patiently for five o'clock. When the weather is good, Leonard wakes up from his nods and goes out to keep him company. Mr. Correy is angry.

"Who *is* that out there, Doris? Get him a job, or get rid of him, he makes us look like a halfway house."

So, Q.T. waits for me at the corner, but he's there every day. We walk home, arm in arm, nuzzle at each other, smile at little kids, pat stray dogs,

pick flowers. In the evening, he visits, listening dutifully to Betsy's Joan Baez records and making appropriate comments when *Mary Hartman, Mary Hartman* comes on the TV. We drift upstairs, make love on my foam-rubber sleeping pad and look out the little attic window watching fog drift in to make a blanket for the moon, watch one last shooting star dive and be swallowed by the mist.

Q.T.'s youngest son, six-year-old Gary, has just been returned to him after years of foster care which began when he was six months old. Q.T. is livid. "They gave him to a white family, Doris, he don't even know he Black, he don't know nothin', he talk white, he think white, he believe he white. Oh, thasso harsh, thasso cold, that's so cold." And so Q.T. sets out to reclaim his son.

Q.T. brings Gary to The Wheel of Fortune and when lunch arrives, picks up a bottle of Tabasco sauce from the table and empties most of it onto Gary's plate. "Eat that," he says, "and if you know what's good for you, you do not leave a crumb, you hear me?"

Gary looks up at him, petrified. He has his father's eyes, and they are shining bright with fright and unshed tears. He takes a forkful of his potato salad and chokes. He dares not cry, he dares not speak, he dares not move. He grabs his glass of water, takes a long drink, waits for the choking to subside and then spears some more salad. Even with the most infinitesimal bites, his eyes run, he chokes between mouthfuls, he drinks copious amounts of water. Q.T. keeps unbroken eye contact with his son throughout. I have never seen such naked hatred. "Yeah, son, you learnin' to eat like a nigger now, huh. Eat like a nigger, not like some white-ass trash, not like your white-ass buddies. Yeah, you black now, ain't you, nigger."

Who does Q.T. hate so much? Is it his son for speaking a different language? Does he feel betrayed by his own blood who doesn't know that hot sauce is a staple on many Black tables, who thinks his food is just fine without it? Does he hate the foster parents for not teaching Gary his blackness, for stealing his love? Is it the whole white world for taking his son away in the first place, for deciding arbitrarily that a father in jail and a mother on the streets are bad parents who cannot love their children?

In a flash, I know that Q.T.'s training will pay off. I understand how Gary will soon be inextricably trapped between memories of his loving foster family and his desperate need to survive as Q.T.'s son. He will become a reverse racist, he will be a sociopath by age thirteen. I am seeing a life of hatred, at its very inception. And when we read about him in the paper, we will say, "Uh, what a shame. That ghetto violence." But who's at fault? Do

I know what happened to Q.T. when he was Gary's age? Do I know the source of his bitter hate? I cannot presume to judge this scene, nor change it. I can only learn from it. I feel compassion for them both, especially for Gary.

Finally, Q.T. looks over to me. "Little motherfucker gonna be the blackest-ass nigger in town by the time we're through," turns back to his six-year-old who has used up all the napkins, who is now finished, who looks up at his father triumphant. "Ain that so, Gary?" In Gary's eyes, there is a quick flash of something frighteningly not at all like fear. He remains silent.

Two weeks later, Gary is gone. Q.T. has shipped him to San Francisco to be with the mother of his oldest son, Robert. "Robert can teach him the trade," says Q.T. "You know, your courier gotta be under twelve so they won't arrest him, and Robert's already eleven. Just young don't cut it. You gotta be slick, you gotta be fast and Robert's excellent. Got a real talent. Robert can teach him. Let him earn his keep."

Q.T. introduces me to his best friend, Granger, an older guy with graying hair. Granger says he's a former pimp, but now he's straight, man, making an honest living selling dope. I seem to have passed inspection, and Granger is all good manners. Even serves tea, albeit not without meeting Q.T.'s eyes and, for a moment, losing control of his laughter. "You two ought to take a drive up to Tacoma," he says. "Business good up there, especially at the bus station."

"What you think, Doris, can you give me a ride on the weekend? I got a friend up there, might-could connect me to a decent job; besides, he owes me some money."

I don't mind, never been to Tacoma before, gas up the wagon and away we go.

Q.T. directs me to a street address, but when we get there, it turns out no one knows his friend. We cruise down to the bus station where Q.T. disappears for an hour while I read a *Seth* book at the parking meter. He comes back, disappointed. "I dunno, Doris, times sure have changed. Don't know nobody nomore. Bus station folks, they used to be all alike, San Francisco, Portland, all the same, but it's gone. Well, what say, you up to drivin' back home?"

It's been a long day, it's a three hour drive, we won't get back till late, late but—on the other hand—there's not enough money for a motel. We grab some coffee and take the long ride, sing along to the radio, Q.T. snoozes, we get back to Portland at 3:00 AM, I drop him off and prepare for a quiet sneak in, but there's no need.

The lights are blazing, the front door is open, the living room is crowded

with everyone. Even Bob is back. Billy is in a corner, sniffling, Betsy is pacing. When she sees me, she charges at me like a lioness after a gazelle.

"You and your damn Black friends, now you've done it, I could kill you." She corners me at the dining room china cabinet and is about to lunge for my throat when Bob grabs her.

"Two wrongs, Betsy, take it easy, she didn't do it."

He embraces her, strong and gentle, she glares at me over his shoulder.

"Will somebody tell me what happened?"

Betsy's voice is hoarse as a chainsaw, intense as lightning. "What happened is one of your fucking Black friends came in here and raped Billy, that's what happened, and you need to get your nigger-loving ass outta here and never come back, that's what happened."

I sit. I can't assimilate this. What Black friends? Who? I look to Bob. He takes Betsy back to Billy, comes to sit with me at the dining room table and tells:

Around eleven o'clock, Billy heard someone in the back yard, yelling up at my attic window. Billy poked his head out and asked what the guy wanted. Guy said he had some weed for me, all paid for, just wanted to deliver it and get going. Could Billy take it? Billy, that old grow-lite-in-the-cellar expert gardener said, "Sure, wait up" and let the guy in. Older guy, he said, with graying hair, followed him into the living room and—without further ado—raped him. Billy, of course, yelled bloody murder, but no one heard. When the guy was done, Billy woke his mother. His only comment: "My ass hurts."

I am completely bewildered. That must have been Granger, but why? And Betsy, who wakes up for coughs, for tip-toes, for the front door closing, slept straight through?

"You need to leave tomorrow, Doris," Bob says. "You can move into that little one-bedroom place I rented, and I'll move back in here. I'll help you move. Lucky that place is available and I've already paid the cleaning deposit and two month's rent. I'm sorry."

No one sleeps that night. The next morning, Betsy comes to my room, sits down on the I. Miller trunk and lights a cigarette.

"Obviously you can't stay here. That's a given. Things are completely up in the air, anyway. Billy needs his dad right now, Costas will have to go, at least for the time being. I have the phone number for your apartment; all you'll need to do after you move in is put it in your name. When things get back to normal, I'll call."

Such an extraordinarily generous statement, given the nightmare of an assaulted child, must have taken a great deal of courage. If I were in her

shoes, I don't know if I could have done the same. I cannot find words to express my respect.

Betsy has done a good job with me. I never did learn to bend spoons or manipulate reality with my brain waves, but I am beginning to discover my soul. I have learned that God is, indeed, in all things, in all life forms of which I am no exception. Betsy must have learned, too, or surely she would have wreaked some terrible vengeance.

I move, of course, and sit for hours trying to make sense of what just happened. Billy is just eleven. Betsy was just eleven when she was raped by her grandfather. Is that why she did not wake up? And why did Granger—if that's who it was—come in just to rape Billy in the first place? There had never been dope to deliver. Why were the police not called? How did I get here?

Charmagne says, "Q.T. planned that, fool. He wanted to get you out of there. Did a good job. Knows his business, don't he. Wait, you'll see, next thing he'll ask for a ride to San Francisco."

I don't know. I don't get it. What just happened? Well, never mind. Here I am, in my very own first apartment, which is clean, pleasant and has two months' rent paid. Location is fine, and Bob did so very much want to move back in with his wife. Seems like everyone got what they needed, except Billy, of course. I am still puzzled by Betsy's incongruously sudden heavy sleep. It's almost as if she allowed that to happen to Billy. Not only that, but neither Granger, nor any other human being, could be a match for Betsy if she were protecting her young. But she slept. I finally let that go, as best I can, although it never entirely leaves me and, even over twenty years later, I ponder...

Megan stops by to drop Ruschka off: "She is yours, you need to take her."

I try to explain that the landlord doesn't allow pets here, but she's adamant. I tell the landlord it's only for a short time, and he says, "Well, all right, but have her out by the end of the month, OK?" What a shame. Ruschka is such a pretty thing...

A week or two later, Q.T. and I are lounging on the foam-rubber pad, nibbling chips and sharing a joint. Q.T. puts his arm around me and nuzzles my neck. "You know, Doris, you oughtta come on down to the Bay Area. You ever been? You'd love my mom, what say, come on, what's there here for you anyhow?"

Well, not much, I guess. Mr. Correy just fired me because Q.T. began to wait for me inside the office, smelling horribly of stale weed and making a lot of noise with Leonard. Finally, last Friday, he brought Ruschka with him,

and Mr. Correy, coming out of the bathroom, was suddenly confronted in the dark hall by a giant white Russian wolfhound which put both paws on his chest and howled in his face. "You get out of here," he hollered, "and take that evil excuse for a human being right with you. This is not a whorehouse, nor is it a drug den, nor is it a dog kennel. Now, you scat." I scatted. So, having nothing better to do, we loaded Ruschka into the station wagon and set off for Q.T. land.

We drive to California in a daze of love and sunshine. Even Ruschka has temporarily dropped her Dostoyevskian gloom for an occasional wag and driver's ear-lick. Q.T. is in an expansive mood. "Looka here," he instructs, "you don't have to have track-marks all up and down your arm. You can shoot up between your toes, you know, and in the corner of your eye that's nearest your nose, only you gotta be real careful there and not hit your eyeball." I pay close attention. It's not every day a lay person gets the real deal scoop from a dedicated professional.

"They're expecting us, you know, got an apartment all ready and waiting. Can't hardly wait, Doris, it's been too long away. Square bid'ness."

He hums to a Johnny "Guitar" Watson tape, demands details about how I know Natalie Cole, twitches, fiddles with his Jeri-Curl, twists in his seat to bark at Ruschka, wants to know when we're stopping for food, says he has to pee, calls me cold-blooded for not stopping, even though we took a break less than an hour ago. Asks why he can't drive, asks why I'm going so slow, says it's time to stop for Ruschka to take a run, points out the road to San Quentin and finally dozes off.

It's late when we get to Golden Gate, but his brother, Jordan, is waiting for us. There's a lot of hugging going on when I notice a large bedsheet in the middle of the living room floor with what appear to be the accoutrements of an entire household in the middle. Clothing, toiletries, groceries, pots and pans, everything needed for civilized living is there. I'm impressed.

Jordan sees me looking and explains that he and his lady had to move that very day and they will be our new roommates. "We'll get our shit unpacked in a minute," he says, "soon's Layla gets back." No problem. I stagger off to what will be our bedroom and collapse on the double bed, Ruschka on my feet. I fall asleep thinking that tossing everything into a sheet beats packing boxes, at least if you're moving locally. It's been a long drive.

The apartment is on the ground floor, has an extra room for Jordan and Layla and even a tiny little yard accessible via French doors from the living room for Ruschka.

Next day, Layla is friendly; we do our best to make a kitchen out of

whatever we can salvage from the packing sheet, while Q.T. and Jordan disappear on family business. I especially like the little yard. Some previous tenant has give thought to trellises, the bushes are trimmed and there is a perfect miniature paved path through the greenery. Ruschka relaxes in the sun, pats her tail on the ground in welcome when I join her. "Aah."

I notice the house next door being painted and that one of the painters wields no brush. He sits on the scaffold looking down at us. I look back. He nods in greeting. He leaves. I notice him there most every day, in his white coveralls, not painting.

I get sent to the corner convenience store on balloon errands. This means buying packages of little toy ballons availabe there in copious amounts. Beats me why the store keeper would stock so many packages of so many balloon varieties, till Q.T., ever the dedicated teacher, explains.

"First you measure very carefully so nobody comes after you for shortin'. Then the heroin goes in the balloon, see, and gets tied off with its neck. You gotta make little balloon balls, just right, round, equal in size, lotsa pretty colors, some folks color code for weight, see? Then, when you go selling, you store them in your mouth. That way, the smack won't hurt your gut if you have to swallow and also it's easy to measure quantities that way. Later on, we'll go take these over to my cousin Harold's house and maybe he'll let you help pack. And Doris, in this neighborhood, there's aways balloons in the 7-Eleven, store keeper knows his customers, you hear what I'm sayin'?"

At cousin Harold's house, there is a small cottage industry in progress at his long kitchen table. All the little Harolds are busy weighing, measuring, tying and running to their daddy for approval of their product. Harold is generous with his praise and patient with his instructions. His workers range in age from puberty to young adult and all are male. There's a lot of cigarette smoke and excellent music. Marvin Gaye appears to lend impetus to the process better than Aretha, because when Aretha comes on, everybody stops working to dance. Harold inspects me carefully and then tells Q.T. to take me over to Uncle's. "She no use here, Q.T., just confuse everybody."

"OK, then, but I'll be back for the shit, you hear?" And to me: "Come on, woman, we'll go see Uncle, you're gonna like Uncle. You ready? Come on then, let's go."

We drive down to Embarcadero and enter the blackest, dirtiest, most cavernous barroom this side of Hades. There is so much smoke-haze that I can just barely make out the customers. They all appear to be older Black males in various states of disrepair. Gray hair sticks out from under hats, shabby three-piece suits bulge at the stomach, white stubble sprouts on wobbly chins. There's a pool table with a lamp over it, the only apparent

source of light. When Q.T. enters, there is a big commotion. Back slaps, hugs, laughter, he is passed around like a baby on a tour of doting grandparents, drinks are proferred, I am inspected slyly, out of eye-corners, head shake in disbelief. "Q.T., you are a caution," is the verdict.

We mill our way through, behind the bar, past the kitchen and to the very rear of the building where there is a large stairway with incongruously carved and polished bannisters that rises toward a well-lit upstairs. Q.T. runs up, excited, like a little boy. "Hurry up, Doris, come on, get your ass up here," so I run, too.

At the top of the stairs is a giant foyer of rich mahogany woodwork and a small chandelier whose lights are reflected in large squares of black and while marble flooring. Next to the brass doorbell is an ornately carved double door. Q.T. rings, dancing excitedly on his toes. "Uncle," he whispers, "Uncle."

The door is opened by a parlor maid, dressed immaculately in black uniform complete with starched white frilly apron and little white head-dress. When she sees Q.T., she lets out a yelp and rushes him for a hug. "Ooooh, Q.T.," she squeals, "you're back. Oh come on in, come on in, let me get Uncle, bring your friend, get on in here and let us take a look at you." She pulls Q.T. by the arm and in one lurch, we're home at Uncle's house.

All the walls seem to be windows. Warm streams of light bathe the Persian carpets, linger on crystal, sparkle the silver and intensify colors of houseplants and tapestry. We wind up in a solarium that overlooks the landscaped garden, complete with yellow-gravel path and blooming trellis. The Rachmaninov Piano Concerto (Rock 5) is on stereo, but who's playing? My ears perk up. It's not Horowitz with his incredible sharpness of tone, and it's not Cliburn with his deliberate warmth. But never mind, here comes Uncle.

An apparition so immense, he uses up both space and oxygen: A giant, wrapped in magnificent Armani, silk shirt exactly the right tone for the suit, necktie providing subtle contrast of tone, oxfords gleaming with Italian gusto. Hair is shaped into a close-cut natural, showing just the tiniest, quite distinguished (almost deliberately perfect?) sliver of silver at the temples. His eyes, with their subtle touch of liner and mascara, are warm as a lover's, the slight pomade of his lips sets his teeth agleam in such a fond smile that Q.T. and I are both welcomed and nourished at first sight. "Uncle," sighs Q.T., and they embrace.

Uncle is a gracious host. Q.T. is soon sipping a scotch, Uncle and I, tea. A tray table has appeared, loaded with snacks, the brie and pears both ripe to perfection. We sink into chairs that invite permanent relaxation and look

at one another. And chat.

Uncle looks into my eyes and wants to know what I think of his new recording.

"Great," I answer, "but who is it? It's not Horowitz, it's not Cliburn, so who?"

"Hah, gotcha." Uncle waves his cigarette holder like a fop from an Oscar Wilde confection and says, "We got one of our own now, Missis! That, my dear, is Andre Watts, one of our very own. Yes indeed, Missis. Young, talented, Black and not one wrong note, not one misinterpreted phrase. So what do you think? Gotcha!" He stretches in his chair, twinkly shoes pointing at the ceiling and laughs."

"Got me good." I laugh, too. "Wow," I think to myself. "Andre Watts. How about that."

The conversation shifts now to include Q.T., and they begin to argue about drug distribution methods. Kid couriers versus adults, male versus female. It's an abstract discussion, not meant to actually implement change. Uncle turns to me and says, "The system is in place, you know, and it will never change."

I take the bait.

"The system is corrupt, it needs to change. Selling drugs won't change a thing. It just keeps the system in place. Inflitrate the system, make changes from the inside, that's the way, or else, yeah, it won't change, it will continue 'Them' versus 'Us.'. Is that what you want?"

"Oh, what have we got here, Q.T. my man? We have a Back East Liberal, do we, an innocent, a flower child?" Uncle is vastly amused and then turns to me like a lecturing professor.

"My dear child, there is no 'Them,' there is no 'Us.' We are symbiotic, we need one another. There can be no cops without the presence of robbers. Together, we survive. You shall see for yourself if you hang out with Q.T. You shall see. Q.T., he ain't too bright, he don't know how to work the system anymore than you do."

Uncle suddenly looks angry. Gets up, marches toward the stereo and says, "Oh, the hell with it. How about some Sly and the Family Stone." The music changes, he beckons, the shoes shimmer, we dance.

Q.T. slouches in his chair, glowering over the rim of his scotch. "Do too, Uncle, do too work the system," but it's a faint mutter.

Q.T. walks me down Haight Street at night, showing me how to eat yogurt from a container while keeping a mouth full of heroin balloons.

"See, if you keep eatin' the yogurt, the narcs think you ain't holdin'."

We take Ruschka along. "Makes good cover, Doris. Ain't never seen a

dealer with a wolfhound before, have you?"

Haight Street is crowded, even at 10:00 PM, and Q.T. has customers in a convenience store. I wait outside with Ruschka, and there, walking down the street, is the painter. The housepainter, now wearing a turtleneck and jeans. Who doesn't paint, who looks into our yard. He, too, is eating something and his eyes are everywhere, just like Q.T.'s. Q.T. comes back.

"Man, see that drunk over there, the old guy, the wino? That's my dad. Come on, I'll introduce you."

We walk over to where an old man is wobbling toward the gutter. He is small and muscular, like his son, and his vacant face sports Q.T.'s dimples. He shambles on, eyes unfocused. "Hey Pop, Hey, Old Man, Hey, Mr. Douglas," Q.T. shouts and runs. But the old man does not hear. He crosses Haight and is gone. "Oh what the hell," says Q.T., "come on along, we got a stop to make."

"Q.T., I saw that guy again, that painter I told you about. Q.T., I think he's a narc. I think he's watching us. Q.T.?"

"What're you, Doris, *Starsky and Hutch*? Come on, let's move. I'm late." He is not amused. Oh well. On the way home, Q.T. points to a third-floor apartment balcony and tells me, "I once pushed a woman off that there." His eyes slide to note my reaction.

"Wow, Q.T. what happened to her?"

"Jeeze, woman, do you think I stopped to find out?" Shakes his head at my naiveté, takes my hand.

We drive to Oakland to meet Q.T.'s mom. She lives in a smart, split-level ranch on a patch of green on a flat, bland street. Mrs. Douglas wears a severe suit of navy wool, a conservative pearl and diamond lapel pin, her hair pulled back into a tight knot at the back of her neck and a scowl upon her face. Q.T. gets a perfunctory hug, I get a quick once-over. "Well, Jerome, my son, welcome back from prison. And what have we here?" she asks, nodding in my direction.

"Mamma, this is my friend Doris. I imagine you and she will have a lot in common."

"Well, I imagine so, Jerome, seeing as we are both about the same age. Probably more in common than the two of you, don't you think, Doris?

An ancient, long-buried impulse to curtsey wakens in the back of my head and snickers. I smile. Well, it's clear we're not going to be bosom buddies, but Mrs. Douglas likes Ruschka, who has come along for the ride.

"I do adore Borzois," she tells Ruschka, scratching behind her ears. Must have found the right spot, because Ruschka wags delicately, which she only does for one or two humans in her life. I sigh relief. My landlord in Portland

won't let Ruschka back in, and so far there has been no one of whom Ruschka has approved. "I betcha," I say to myself, "I betcha this will work," and do my best to charm Mrs. Douglas. Pretty soon, she and I are past the hostility and I am learning fast. For one thing, now I know Q.T.'s real name is Jerome.

Now there are only two family members left to meet. Dorothy is the kid sister. She lives with Mom and shows up later that afternoon wearing a tight black dress so low-cut that her ample bosom appears on the verge of flight. Dorothy has branched from the family business and is the entrepreneur of her very own enterprise. "I'm a hooker," she twinkles, "but not your ordinary, you understand. Corporate call girl, you know what I'm sayin', only for them visitin' top out-of-town executives. Whooeee, girl, those folks know how to spend. My own business, no pimp, Q.T., no pimp like your black ass pimp self. Woman's lib, Q.T., woman's lib, we don' need no pimps, huh, Mamma."

Mrs. Douglas rolls her eyes at the ceiling and turns to me. "Kids," she says. "Kids nowadays. UMMMMHH ummmh ummmh."

Oldest brother, Harvey, lives back in town in a cavernous duplex on one of those winding San Francisco hills. We're invited for dinner, which is a bit make-shift because Yvonne, Harvey's wife, has just gone back to school at Berkeley and is more engrossed in curriculum than cuisine. She's wearing a heavy, intricately knit Irish fisherman's sweater, a tan plaid skirt, knee socks and loafers. Hairdo is a simple, close-cut Afro, jewelry minimal. "Ugh," she tells me, "I am exhausted. Try to keep a decent GPA, keep that nine-year-old son of mine doing the same, and Harvey's out of town too much on business. I don't know how those working moms do it. Only they don't have all those papers to write, maybe." She chatters on while we set the table, she heats up some spaghetti sauce and I cut salad. "Darryl, that's my son, he needs orthodontia, you know? That's so expensive. I don't blame Harvey for hustling so much, but it's hard, y'know?"

Harvey chimes in, laughing, "Y'see, I'm a business man, just like the rest of those commuters I sit next to on the plane to L.A.. I don't ask what they got in their attaché case. For all I know, it's the same as what I got in mine. Darryl's teeth got a right to be as straight as the next guy's, huh, Yvonne."

Harvey's got it right. His hair is short. No Jeri-Curl, no Afro, his loafers are polished and his suit is of excellent cut. If he sat next to me on a plane, I do believe I'd ask him about market trends.

After dinner, some friends stop by, and we women are relegated to the kitchen while Harvey, Q.T. and their buddies in the living room share loud stories about women, johns, and how to keep your ho' from holding out

money. The stories aren't pleasant, and we, in the kitchen, tune them out while loudly discussing kids, schools and the fact that in order to get a B.S. one has to take a class in statistics. Ugh.

The rest of the week is business at Ruth's. Ruth is the mother of Q.T.'s son Robert, that experienced courier and trainer of courier-to-be, Gary. They're a close family. Ruth tells me she's a junkie, through and through.

"Done time, done tricks, done whatever need doin' to get over."

Her face and body are a series of hard planes, grim muscle and no soft spots. Her eyes are expressionless agates, warming only at Robert and new little Gary. Robert, too, seems to dote on his new brother. His attitude is avuncular, patiently patronizing, but he's generous with praise. I'm so relieved. Gary has found a new home and he looks happy. The apartment is cramped, shabby and in the wrong part of town, but no one pours Tabasco sauce on his plate and Ruth finds time for hugs.

Now, there's a business meeting. Three or four men talk earnestly with Q.T. and Ruth. The boys and I sit together, being very quiet, keeping out of the way. We understand this meeting is way over our heads.

Afterwards, a joint passes. Q.T. glares at Gary when it reaches him. Robert nods slightly, Gary takes a hit and passes it to me. This is not weed. God only knows what I'm inhaling. It tastes terrible and makes my head spin, but I know better than to refuse. Robert, too, looks askance. Our eyes meet, we shrug helplessly. If it passes this way again, we know we'll have to take more. And it does. Q.T. watches us carefully. We toke. We toke again. We sit close, the three of us, wondering what will happen next.

What happens next is I fall into a long, dark hole, a tunnel so black and deep it reaches the center of the earth where there is nothing. I know I am alive, because I believe I am breathing, even if I can't feel it. I cannot move. Not a finger, not a muscle, can't tell if my eyes are open or closed. Am stuck down this bottomless well and know I have to stay there till the high wears off. At least I can think, I decide, so I'm probably still alive. I sit and wait. There is nothing else to do. I have no concept of time. I just sit. Eventually, there is movement in my neck, so I look up to see if there's daylight at the top of the mine shaft. I see a circle of daylight. Into the circle, move two giant eyes. Two giant eyes that must be part of someone's face. I concentrate hard. Eyes. I recognize these eyes. They are Q.T.'s. No one else has such giant, black, mellow, intelligent, loving, beautiful eyes. Q.T.'s eyes are looking down the long hole and give promise of hope. I love those eyes. They are alive, they are all that connects me to humanity. I hear my voice. It is saying, "Q.T., I love you. I belong to you. Entirely. I am yours." Thank God, I can speak. All I have to do is concentrate on the eyes, I'll be OK. And so

I do.

When I come to, I find myself sitting on the floor at Q.T.'s knee, smiling up at his face. Whew! I get up and walk quietly back to where Robert and Gary are sitting. Q.T. and his friends are laughing, slapping thighs. Falsettos ring out: "Q.T., I belong to you. I am yours." Q.T. smiles. He is satisfied.

Robert, Gary and I huddle. We whisper.

"Man, that was awful."

"You guys OK?"

"What *was* that shit?"

"Angel Dust, Doris, man you never had some before?"

"Nope. Don't like it."

"Me neither, but he makes ya, you know?"

"Yeah."

So, now I'm not so relieved about Gary anymore. A reverse racist-junkie-in-the-making, with brain cell loss from Angel Dust. Oh, now what....

"Now What" happens soon enough.

Two days later, there is a terrible thumping at our apartment front door. I've never heard such a noise. Before I can open it, the door crashes in and there's the painter. He is not wearing coveralls, he is wearing a business suit, he is not alone, he is very determined. Before anyone can take a breath, Q.T. is face down on the floor, in handcuffs, lying mutely next to Jordan. Thank goodness Layla isn't home. The painter says, "Where's the bedroom?" I take him there at once.

"Sit down on the floor, in that corner and do not move," says the painter. I sit. I do not move.

Painter goes at once to the double bed. His eyes remain burning into mine. With an ease born of long practice, he lifts the mattress, swoops his hand between the mattress and the box spring and comes up with a cornucopia of heroin-balloon-balls all ready for distribution. At no point does painter lose eye contact with me, not for a blink, not for a moment. His eyes are locked with mine and his hand, full of heroin-balloon-balls, swoops swiftly, smoothly, graceful as a diving falcon, into his pants pocket. The heroin balls are his now. We are both aware.

"OK, what are you doing here anyhow? I've been watching you for days. What are you, some kinda social worker?"

"I'm visiting from Portland."

"Well, go back to Portland, and do it quick. You don't belong here. Social worker."

And he turns, exits with his cohorts, with his trussed prey, with his new personal stash of heroin balls, leaves me sitting on the floor in the corner,

pondering the truths of symbiosis.

I hop into the station wagon, drop Ruschka off at Mrs. Douglas's. She says she would love to have the dog, but does not ask for Q.T. I kiss Ruschka goodbye, give Mrs. Douglas her bag of dog food and head up the interstate.

I am speeding past Crater Lake, late at night, when a cruiser pulls me over. I am happy. A speeding ticket in great, green Oregon. I had forgotten for a moment how green this place is. San Francisco is not green. Not even a little. "Thank you, Officer," I tell him. "It's good to be home."

Back in my cute little apartment, it was time to take inventory. I missed Ruschka. Had nightmares about her being locked up in some dismal courtyard. Hated myself for giving her up. Running low on funds. Time to get a job.

I wandered down to the Urban League and applied for a CETA position, just like one of our Workers Together clients. At least I knew how it worked: Businesses got money for having CETA employees, and CETA employees got a foothold on job experience. I loved it. Just right for someone like me who had no idea how to get, hold, or qualify for anything beyond Mr. Correy. After all, Mr. Correy had hired me after that amazing, never-to-be-forgotten-three-question-interview, and I was pretty sure this wasn't how it went with most employers.

Sure enough, I'm immediately hired for a City of Portland job based at City Hall. We are a CETA team whose goal it is to investigate every single City of Portland department to determine how much paperwork these departments generate and then reconfigure departmental routine to eliminate the excess.

We're a strange composite of desperate women, new immigrants and recovering drunks. We all get along well. Larrayne, the team boss, takes her position seriously. Every time she and I drive somewhere in one of our City of Portland automobiles, Larrayne sits in back, smoking cigarettes and looking out the window, while I play chauffeur. She does the same with all of us. The rest of the time, she pays no attention to anything we do. We indulge her. After all, who knows how any of the rest of us might respond to being named as superior. Besides, she doesn't track time sheets, cares not a jot as to how long we take for lunch or even if we leave early. All she wants is a little respect.

And so we march through the Fire Department, the Police Department, the Sanitation Department and every other Department we can find. We go through files, eliminate outdated material, create piles of paper for recycling and write lengthy reports on all our findings. In the process, we generate

approximately the same amount of paperwork as we eliminate. But it's OK. This job is fun.

Some of us become friends. In particular Jo-Anna, José, Aridythe and I meet regularly for meals, chit-chat and gossip. José is a new immigrant, in personal life a poet. Sometimes, his eyes afire with passion, he reads to us. The Spanish words flow like music. Passion transcends translation; we sigh and applaud.

Jo-Anna's a newly divorced woman whose husband had been the wage-earner. Now, she is the sole support of a teenage daughter with college aspirations. Jo-Anna needs to better herself quickly. Her Liberal Arts degree from Texas' SMU isn't helping her much and she hopes to somehow transfer from CETA to City Hall itself.

Aridythe is our team secretary. She is a Diana Ross presence, all poise and grace. Tall, slim, impertinently high bosoms, strong neck holds up her graceful head with its long, Queen Nefertiti eyes. She looks like a chocolate liqeur any male would want to sip. Only her hairline is receding, which sometimes makes her cry when she looks in the mirror. Aridythe's other job is being an exotic dancer at Darcelle XV, the local transvestite night club. She is an excellent cook (a bonanza for us all) and flashes a non-stop, ironic sense of humor.

At work, we're all smooth sophisticates, sharing extensive knowledge on how to avoid working too hard, making time-sheets fit one's needs, and dodging supervision. We're avid learners who put our shared information to good use.

Betsy calls. Billy is OK, thank God. Bob moved out, and Costas moved in. They're going to marry as soon as her divorce is final. Betsy wants me over. It seems Costas has turned her onto something she wants to share. "Something" turns out to be a New Age minister, John Roger. Betsy says he takes over where Seth leaves off, and not only that, unlike Seth, he's still alive.

Soon, we are studying together. What attracts us to this guy in the first place is his initial statement to us. He says, "Listen to what I have to say. Take those things you can actually use and believe them. And dump the rest." These are enticing words, indeed, from a spiritual leader. All others I have ever encountered have uniformly informed me that theirs was the only way. Period. "My job as 'guide,'" he adds, "is to point out any doo-doo lying in your path. You decide whether or not to step in it." Wow. We are both intrigued enough to take John Roger and his little New Age church, "MSIA," seriously.

The weeks go by, our CETA team is flourishing, we're happy with one another. Share a joint in the back alley. Wave excitedly from the City Hall balcony when our basketball team, the Trail Blazers, wins the league championship and parades past in the rare late-spring sunshine. All's well with our world. Then, Larrayne herself gets a supervisor. And this guy is raring to go. He can't wait to supervise everybody. He pounces fast.

Steven is his name. He watches, he lurks, he waits for inevitable mistakes. José preaches extreme caution in the time sheet department. Our little trysts in the alley now require look-outs, and leaving early becomes a masterpiece of choreography in which at least three of us must cover for the fourth.

Steven wanders through our offices at City Hall, where he stares with such intensity over Aridythe's shoulder as she works that she makes typos which he then announces to the world, his voice brimming with rich sarcasm. Aridythe's hand flies up to her hairline, her shoulders slump.

One day, he watches me type a report. I'm using a typewriter from the back of which the paper hangs down rather dispiritedly because I haven't put up the little metal gizmo which is meant to keep the paper upright. Paper hanging down makes it harder for Steven to read.

"Put that back bar up, Colmes." It's a shout.

"Why?"

"You don't have to know why. Put it up and put it up now."

"Steven, you're out of line. Whether or not that little support bar is up has no bearing on the quality of my work. OK?"

"Put that bar up, Colmes, or you're fired. Got that?"

"Don't think so, Steven. Now, if you'll excuse me, I need to call the CETA office and report harassment."

I get up and walk over to the pay phone, but Steven is ahead of me.

"Oh no, you don't," and grabs my arm.

"Steven, are you attempting to physically prevent me from calling for assistance?"

"Just get back to work and put that metal support bar up."

A slight shove on my shoulder, his voice just short of a screech. People turn from their desks to look. I leave and head directly for the CETA office to file a complaint. There is an immediate hearing.

The very next day, we sit at a large City Hall conference table, and I declare there are witnesses to Steven's irrational harassment. Steven's supervisor—also a CETA employee—strokes his beard and looks puzzled. The CETA folks hear me out. They confer. They reconvene with their verdict:

"Doris, this may not be the right CETA job for you, so we are setting up

an interview for you with a brand new project. The City of Portland is funding a pilot project for a Neighborhood Mediation Service and you might certainly qualify for that. The interviews are next week. You would probably enjoy that much better."

And so I become a Mediation Specialist with the project, which survives its pilot status to become a regular city agency. The CETA folks were right: I enjoy it much better. And my life has just taken a new turn which will eventually lead to an actual career.

Chapter 17

Disco Madness

History is about to enter the information age: Bill Gates and Paul Allen played "Microsoft" in their New Mexico garage, and Steve Jobs just opened cyberspace by founding Apple Computer. The rest of us have Saturday Night Fever. Here come the BeeGees, here comes Donna Summer, and The Jackson Five and Shake Your Booty Down To The Ground, and KC And The Sunshine Band and Girls Just Wanna Have Fun, at least this girl does. Oooh, can it get any better than this? Not likely!

We were such a happy tribe of dedicated kooks: Left-overs from the CETA job, along with fellow mediators, ready to party, ready to celebrate. Charmagne began wearing dark glasses, even at night, and seemed a bit distracted, but she came, too. Most weekends found us at *Earthquake Ethels*, the most fun disco in the Western Hemisphere, frequented by just enough Brothers to keep the mix interesting. And did we ever par-tay!

I had the party clothes, too, oh yes, I did. I was almost fifty, looked thirty-five and knew the right look for me, which was "strange yet attractive woman dressed up as John Travolta." I managed a collection of three-piece suits, ranging from white with sequined lapels to blue pin-stripe. I had white, patent-leather high-heel clogs and navy ones with silver studs. I had boots and I had a hat. The hat was soft, off-white felt, large brimmed with one side of the brim turned up like an Australian army sargeant, and it had feathers that danced in the air behind me when I walked, no, when I strutted. Because I strutted in, made entrances, looked around and received the appraisals. Where I went, no one was certain of who I was, what role I was to play. The mystery woman got attention. (Sometimes, I still wear the hat.)

We'd walk in, grab a seat at the bar where I'd order a large Diet Coke because we'd already smoked a joint in the car. And so I'd sit, face expressionless, foot barely tapping, letting the music wind me up.

Soon enough, there'd be a touch on my shoulder from some Brother with deep eyes, lithe body, smooth rap and flashing smile. Sometimes, his suit matched mine, sometimes his desired effect was disdainful cool, evidenced by faded jeans and a V-neck cashmere sweater. And how the music carried

us. No one could outdance us. I was an anomaly: A white woman who danced black. I loved the initial look of surprise on the faces of my partners when they "got it," and then we would truly take off. We spun right out of our bodies, straight into our souls where we communicated most sincerely. Charmagne would watch and smile, like a proud mommie. Sometimes, others would stop their own dancing and give us attention, sometimes the hat went sailing off onto the bar stool because I sweated so hard, my hair got so soaked, that women in the ladies room asked if I'd just come from swimming.

And I loved it so, loved that music, loved the partners, the dancing, the life, the job, the magic of being free. I could feel the music beating through my heart, into my veins, becoming my blood and I was happy.

Ethel's, however, was in a suburb whose cops did not yet look kindly upon interracial couples and if I gave some dance partner a ride back to the inner city, we'd get tailed, once even got stopped: They pulled us into a gas station, spread-eagled the Brother against the car, and frisked, none too gently. I stood by, next to a pile of tires, into which I gently dropped our stash. The cops said, "There's a warrant out for someone who fits your description," before letting us go. We shrugged, got back in the car and sang along with Marvin Gaye who wanted to know "What's Going On?" We knew what. There was no need to discuss it.

Back in town, the dee-jay played Parliament and Brick and the Funkadelics. The music took control of all our moving parts, yes, we surely did shake our booties down to the ground, laughed, hugged, blamed it on the boogie. Yes, that's the way—uh huh, uh huh—we liked it. We whipped it, good.

The job was whippin' good, too. Neighborhood Mediation had several offices throughout the city, with staff reflecting the various ethnicities of each particular neighborhood. Our office was inner city, beautifully located a quick drive from home. My nickname here was "The White Tornado." (Not really because I was the only pale-face mediator, but because I cleaned the bathroom faster than anyone else when it was my turn.) We were an excellent team, backed one another up and calmly accepted each other's various personal peccadilloes.

We had a wonderful supervisor, a woman of twenty-four named Karen. For the first time, I experienced supervision from someone willing to teach, willing to discipline fairly, willing to listen, willing to be consistent. Going to work was a pleasure, the pay was adequate, and we were, in fact, an asset to the city, saving lots of court-cost and police dollars by helping folks settle their differences at our place instead of in the courts—or with violence.

And I got a couch! I got a couch and a chair, can you believe it? Not only did I get a couch, but how I got it was magic, made me yodel in the streets. I met a guy who was just starting an arts and crafts shop on Union Avenue, and he was interested in adding a line of goods featuring astrological signs. When I showed him the rapidograph pen-and-inks I'd drawn of the Zodiac signs, he got all excited. He loved their stoned flavor, wanted to make them into greeting cards. He was newly divorced, definitely short of cash, so we swapped the drawings for his couch and matching easy chair. The couch and chair were great, but—of course—what was even greater was the validation: My stoned artwork really *was* salable. I danced all over my living room, screamed my joy at Betsy over the phone, and invited all the neighbors in for a sit.

The following weekend, Charles and I took our respective instruments down to Saturday Market and played for the public. Somewhere, I'd accumulated a pair of Tumbas, so we took those along as well. Folks listened, folks applauded. Stoned art, stoned music. Sunshine, rainbows and roses all a-bloom in my heart.

I got all that stuff from Lovejoy Street out of storage and found I had a kitchen table complete with two chairs. (Bed was still the foam rubber pad, but it was comfortable enough and no overnight guest ever seemed to mind.) The I. Miller shoes left their trunk at last and found permanent residence in a real closet. The trunk became a coffee table, I bought some curtains, and—Voilà folks—a home at last. The finishing touch was a stereo set, complete with excellent speakers, offered for a small bit of cash by a local junkie. I played The Isley Brothers and The Pointer Sisters, dancing with the vacuum cleaner on Saturday mornings. Life sang.

On the other hand, I was dipping my toe delicately into the crème brulée of an eating disorder which made anorexia look tame. It crept up on me quietly, insidiously, when I stopped using Dexedrine. At first, at Betsy's, it was just a matter of satisfying a little craving here, a little "nosh" there, a few pounds sneaking onto the waist, nothing spectacular.

Now, however, I was living alone and there was no one to observe. Now, I was drowning in an addiction as scary and dangerous as any other. Just as Charmagne knew where to find a smack dealer in the wee hours, I knew which convenience stores were open all night. It was nothing out of the ordinary to wake at 3:00 AM, get in the car, buy a pound of M&Ms and a quart of ice cream. I felt helpless, scared and out of control, but the food kept coming and it was getting worse and worse. When I unpacked my clothes from their three years in storage and found them to be four sizes smaller than what I was now wearing, I was so shaken, I almost cried. Every last shred of

them went to a neighbor, immediately. And I ate, that night, gorged beyond physical capacity, wildly, voraciously, as if I would never see food again, as if I would die in the morning—which I wished I could.

It would have been easier, I decided, to be addicted to heroin. A junkie or an alcoholic could finally decide he or she had had enough, toss out that last fix, go back to normal living and never have to see or smell the addictive substance again—ever. Not so a food addict. Food addicts had to face the substance of their demise every single day, three times a day, and—furthermore—be deluged with printed, televised and radioed urgings to get some more, get some more, get some more. Food: The enemy from which there is no escape. Food: Not only a legal substance, but without it you die, with too much of it you die.

Even at work, there was one of those little snack-shelf thingies which stocked packets of junk food for which one payed on the honor system. I must have put our vendor's kids through college single-handedly. Not only that, but I had to sneak those peanut butter crackers and Milky Ways, because I didn't want my co-workers to know how much of the supply was going my way.

There was nothing to do but binge and starve, binge and starve, binge and starve. If I wanted to still fit into my disco clothes, that is. But I was terrified. I didn't know where this would end.

Then, quite suddenly, Charmagne disappeared, swirled into some bottomless vortex of her junkie river, swallowed by *her* addiction while I was swallowing mine. We had attended an Earth Wind and Fire concert, where we clapped and danced and cheered ourselves hoarse. We had a splendid time and walked out afterwards arm-in-arm, happy and exhausted. Afterwards, on the way home, Charmagne said, "You know I been wearin' these dark glasses so you won't know how fucked up I am. But I am. Fucked up. Very. Been fucked up forever, and you never even noticed, huh. Anyway, I'm outta here." I never saw her again, nor did anyone else, no matter where or how we looked.

Betsy and I continued exploring MSIA, which was an acronym for "Movement of Spiritual Inner Awareness." John Roger said his mission was to teach us to love ourselves so we could love others, take care of ourselves so we can take care of others and not hurt ourselves or others. He said this was simple, but couldn't promise it was easy. He wanted nothing in return. We stuck with this guy. He seemed to have taken the best teachings of Eastern and Western religions and translated them into baby-boomer-speak. Little books arrived monthly, short, easy to read, and never "preachy." They

explained how karma works, what the levels of enlightenment were about, what Jesus meant when he said, "The kingdom of heaven lies within." We also got tapes. It seemed there was a little MSIA community right here in Portland which met once a week to play a tape and talk about it.

We started following instructions, Betsy and I, which meant learning daily meditation, and—as best we could—actually implementing what we were taught into everyday life. More easily said than done. This business of "loving myself," just for starters: I didn't even know who or what "myself" was, and as for loving this ridiculous mess I had become? Hah! Gimme a break! "Well, then," John Roger said, "if you really believe you are only your body, I suggest you get naked, stand in front of a mirror and have a good laugh." I didn't get it.

We learned the fallacy of "I'll try." Instead, it was making conscious goals tiny enough to actually accomplish, and then just doing it. Every single minuscule, positive change in behavior, in attitude, in perception, in behavior, counted.

For me, this was learning to meditate. I'd make little, tiny goals—like keeping my mind quiet for five minutes. OK, five minutes too much? So how about three? Three minutes out of an hour, was that bad? No, that was excellent, that was good, that was a major victory. Because for those three minutes, there was complete clarity, the perfect experience of what meditation really is and can be. Because, yesterday, there were zero minutes, and tomorrow there might be four. Each and every single minute of meditation was a tangible spiritual and physical goal accomplished.

Corny? You bet! But I was (still am) one of those folks with what meditators refer to as a "monkey mind." Monkey minds make grocery shopping lists, review yesterday's phone conversations, plan the menu for next Tuesday's dinner, you name it. Monkey minds engage in everything except the internal chanting of one's mantra or simple Zen silence.

The catch to all of this was that once any new positive behavioral goal was met, no matter how small, I couldn't go back to my old way of doing it—whatever "it" was. Having experienced three minutes of true meditative state, I could no longer pretend I didn't know what that felt like. Hah! Spiritual growth along with its inseparable component, self-acceptance, were thus built in, one step at a time. One little teensy-weensy step at a time was still a step.

Was I afraid of failure? You bet. Initially, it was: Do it perfectly the first time and achieve immediate sainthood or commit hari-kari (preferably in front of a mirror). It took a very, very long time to internalize that everyone on the planet does the best he/she can, with what he/she's got. (Like my

parents, for instance.) Sometimes, that just isn't enough. (Like me toward my kids, for instance?) Folks forget they are their souls, that they are part of God, and then do terrible things (serial killers, rapists). It's not God who's gone away, it is the person who's gone away from God. Anyway, not one soul will be lost, we read. You just get to relive it, til you get it right. Karma. OK, I'll buy that...

I'm en route to see a Neighborhood Mediation Center client. Some householder whose dog barks, whose bushes intrude, whose child steals, is waiting for me to arrive, assuage his bruised ego and make him amenable to compromise. But I'm lost. The city map reads like hieroglyph and now I'm not only lost, but late. The corners I pass look increasingly unfamiliar; my wristwatch is racing.

Suddenly, there is an internal stir: A tightness of solar plexus, a change in breathing, a sudden trembling of heartbeat, a difference in thinking I've never experienced before. I don't know what to do. I wish I could escape. I begin to sweat when—Hallelujah! Joy of Joys!—I realize I am experiencing an emotion, feeling a feeling I can identify.

Anxiety! I am feeling anxious. I laugh, I cry, I honk the horn, wave my arm out the window. It is 1977. I am close to fifty years old and have just gotten in touch with a feeling. Anxiety. Wow! It's a beginning.

I can't wait to tell somebody, can't wait for Betsy to get back from the coast, gotta get this out before I burst. Now, I'm feeling excitement, butterflies (is that part of anxiety?), general craziness and euphoria. I phone the client, tell him there's been an emergency and reschedule.

Only one place to go, and that's Jo-Anna's. Jo-Anna, my old buddy from CETA, has her day off today, so I tool on over there, prepared to jump up and down, waving the authentic credentials of my dread and unease, because now—on top of everything else—I've screwed with a client and feel guilty. Guilt, remorse, anxiety, what a trip.

I come bursting into Jo-Anna's foyer where her easel stands and stop a minute to inspect the newest art form. Jo-Anna has placed a pure white canvas there, and on occasion, she or her teenage daughter Ayesha fling paint at it. Jo-Anna says it works wonders for releasing aggression. Last time I visited, there were just a few strategically placed blobs of interesting size and shape, which gave the piece a nice, spare elegance. But by now, I'm looking at a more Jackson Pollack kind of offering, which isn't quite as aesthetically pleasing, but tells me the household's had a rough week.

"Hey, anybody home?"

"We're in the kitchen, come on in."

Jo-Anna is sitting at one end of the kitchen table, absorbed in a book. She is studying for next month's Civil Service exam, struggling mightily with details of protocol. She hardly raises her head.

At the other end of the table is a man, diligently rolling joints and pretty much absorbed in the task. As I enter, he looks up, smiles at me with the innocence of a five-year-old and waves me over to the empty chair. I figure Jo-Anna's got a new beau and maybe that accounts for the excessive paint splatters.

Jo-Anna looks up from her book and rolls her eyes at the ceiling.

"Girl, this is some ugly shit. They do believe I need to know every empirical governmental procedure in the entire State Department. Shit, I'm only gonna be at entry level. Anyway, Doris, this is Aaron, Aaron this is Doris. So what's up, girlfriend, what brings you to my humble hovel in the middle of the week?"

Aaron gets up and extends his hand. He's tall, carries no excess weight, has arms and hands like a basketball player or a sculptor. He's wearing a grey and white kind of polo shirt sweater, which, although hopelessly out of style, highlights his face into rich planes and accents his eyes. Again, he smiles, shy as a friendly forest creature, eager as a pre-schooler about to be given a candy, polite as a Boy Scout presenting his project to the den mother. "Very pleased to meet you, Doris," he says, and offers me the tray of joints, arranged to make a diamond-shaped fence around a tiny pile of left-over weed.

Jo-Anna puts down her book, finds a pitcher of iced tea and we settle down to visit. Aaron, it turns out, is a school-mate of hers from college back in Texas. He's a merchant seaman temporarily beached in Portland while his EXXON carrier gets repaired. Jo-Anna says, "You know, he's not equipped to stay sane without an ocean, so watch out, he might get crazy." Aaron nods, modestly acknowledging this possibility.

From my new vantage point of emotional expertise, of authority on human expression, I label their feelings: Familial fondness, camaraderie, pure affection and also—on Jo-Anna's part—some exasperation.

"Wow," I say, "how neat. You must be so happy to see each other. How long has it been?"

And they both start talking, start telling, start laughing, interrupt one another, and all the while, I notice Aaron's voice, soft as a tropical sea with hidden undertones of mischievous wavelets.

"So, how did you guys meet?"

"I was flyin' in the air like a condor on the updraft, reaching for my left toe, fast as a Lear Jet from Houston and there she was, jumpin' up and down

in her Howdy Doody suit. So when I landed, we said, 'Hi.'"

"What he means is he was running hurdles on the school track team and I was trying out for cheerleader." She shakes her head and takes a sip of tea.

As we chat, it becomes apparent that Aaron's speech is a combination of stream-of-consciousness and free-form poesy. If I open into the rhythm, follow the flow of his thought patterns, he is easily understood. He isn't doing this on purpose, I can tell. It's just his natural way of being.

"Jo-Anna, what happens with him and, say, bank tellers?"

"Don't ask," she laughs, "but it's worth watching."

"Well, folks, I'm feeling anxious, guilty and remorseful, but I'm very happy to be visiting with you both because now I am also feeling pleased, amused and affectionate. How about that. So, Aaron, how long will you be in town?"

"That full moon has trembled my electricity, my brain waves, and Portland waving back. I may never leave. I will grow a beard to test the waters. A Black man with a beard. That could never happen in Texas, could it, Jo-Anna?"

"So, where you staying?"

Jo-Anna's eyes beseech. "He's been staying here, must be over a week now. Ayesha's going nuts."

Aha! That explains the Jackson Pollock in the foyer.

We are at the beach in order to replenish Aaron's psyche, which is melancholy due to a serious saline deficiency, and to give Jo-Anna some time for Ayesha. Aaron inhales like a gourmet testing Napoleon brandy. His eyes scan the horizon for ships, whales, mermaids, peace rolling in waves.

"I've been a sea man all my life. Soon's I learned to read, I'd grab that *National Geographic*, get way up the climbin' tree in our front yard and just go travelin'. They used to have to shake me down for dinner. Land legs, they make me shaky."

I get it. I, too, have never been able to live comfortably inland. Doesn't matter which land, I've got to be within reach of the nearest ocean. Stayed in Michigan for six months once, and the Great Lakes didn't cut it. Call it land claustrophobia. I laugh when I think what it might be like to live in central Africa. Hemmed in by a whole continent. Yikes.

I have a secret place just north of Newport, where Aaron and I are camping out. At the end of an innocuous residential street where I can park the station wagon, there is a dense copse of coast fir at the edge of an escarpment which falls to the beach below. Inside the copse is a hidden glen, black even in daylight, completely concealed by overgrowth and exactly big

enough for one sleeping bag on the soft pine needles. The only way in here is to crawl. We stay up late, telling each other scary stories, exchanging secrets like two little kids playing pirate and wind up sleeping spooned, curled tight against the chill damp, one bag not big enough.

At daybreak, we stash the sleeping bag in the wagon and then comes a careful climb down the escarpment to a piece of Oregon coast that contains only itself and a horde of seagulls. In all the years I've camped here, there has never been another human being and I've never shared it.

Here, I unlock the door to my soul, let myself flow out into peace, absorb the ministrations of my ocean lover: My true beginning, my playmate, my essence, who asks nothing more than to embrace me on occasion and sing to me. That song, that quiet roar, which, as an enthralled five-year-old greeting the North Sea, I recognized to be voice of the universe. I had no words for it then, but it has remained my one constant. Never betrayed, never lied, never changed, never pretended, never asked, never placed conditions.

Why am I introducing Aaron to that most blessed love, allowing him safe harbor? No one else has ever been allowed into this secret chamber of my heart. Not even fellow sailors or scuba divers, most especially not since my husband—who was both—trashed it so. I don't know why I trust this strange man to comprehend such an inexplicable sanctuary and keep it sacred. We seem to have joined like old companions who know each other's eccentricities and are willing to honor them. We are close, as if forever intimates, from childhood, from long ago when we were shipmates on a Square Rigger, from when we were tiny sparks of light dancing in the night sky waiting to be born.

We hold hands like little kids, giving each other bravery. There is no fear of what the other might perceive. We need few words, we hear truth in our silence, and music, which makes us smile. I am perplexed with my own trust, which seems to have a will of its own. I am at peace. And I cannot for the life of me figure out where all this warmth is coming from. How did the world suddenly get so cozy?

We walk, we sit, I take out my sketch pad, he busies himself in the sand. When he is finished, he reclines on his elbows and smiles at his creation.

I look. There, in the sand, sits a masterpiece. A few bird feathers, a rock or two and a broken shell have been arranged into a collage framed by driftwoods of different colors and consistencies which flow into one another like tides into pools. The sand has been scooped and piled, but with such subtlety that only the wind could have shifted it so. This is minimalism at its peak. No thing omitted, no thing superfluous, all things in harmony. It is insouciant, makes impertinent jokes, ruffles and soothes, gives and receives

joy, all without losing a shred of power.

He built a thing that tells how I feel. How can I preserve it, take it home? I dig in the backpack for my camera and take photos from all angles. Aaron is lying there and he is laughing at me. "Fonky like a monkey," he tells the inquisitive line of foam nibbling at his feet. "She tryin' to catch the drift."

Of course, he moves in. Of course it's a match made in heaven, a match made in hell.

He is an unintelligible poet. He's an artist and a vandal, a creator and a destroyer. He's a wild clown and a brown frown. We dance, we stagger, we laugh, we howl, we vacillate. He gives up booze altogether—even beer—and I stop binge-eating, at least for now. But we sure do enjoy our weed. Can this last? Aren't we both too crazy?

The stoned artwork becomes more powerful. I'm fascinated with Northwest Indian Art. Nootka and Haida look over my shoulder, teaching me strength of line and composition. Aaron and I are both writing poetry. Poetry? Silly poems, love poems, captions for drawings, observations on life, love and the pursuit of everything. On the weekends we go dancing, we make sweet love. And, oh, how he makes me laugh. No man's done that in a very, very long time. I love him just for that: For our laughter.

It's late. We've danced ourselves silly at the disco, and now we're tumbling through our back door, giddy and exhausted. I toss my hat onto the TV set and turn to face my man. Aaron takes me by the shoulders and pulls me close. I raise my head to him, his hand reaches out and cradles my cheek, tenderly as if I were a little child. His eyes, brimming over with so much love they nurture the whole universe, make contact with my soul. And then he asks into my ear, into my heart, his voice stronger than a whisper, gentler than a murmur:

"Is you my Nigger? Is you?"

I can't speak. Can't even cry. We stand there, united, unwilling to let go. Somehow, we manage to undress and crawl under the covers. We lie there, holding one another, my head on his shoulder, our arms keeping one another safe. We cuddle like two sleepy angels who have just ascended to paradise and are tired from their long flight. And fall asleep.

Sometimes, I sneak home between clients to find Aaron stretched out on the bed, his arms opening wide to me, ready for a little early afternoon hanky-panky. (Oh, did I say bed? Yes, indeed! There is now a box spring and mattress on the bedroom floor, queen size, and the foam rubber pad relegated to a storage bin. I've even bought sheets with nautical motif to keep Aarons' dreams wavy.) Other days, I come home to find him cooking up some God-awful Texas mess, involving pork, smoke, a thick coat of grease all over the

kitchen and dirty pots everywhere.

When he wants attention while I'm drawing, he walks casually past the table, just knocking his hip into my elbow so slightly, so subtly, that a hand with a pen or brush in its fingers would be jarred—and the drawing ruined. As it happens, this maneuver never works, because when he approaches, pen automatically leaves paper. But I am acutely aware that he is doing this on purpose, wants to start something, is feeling left out. When Aaron is feeling needy, he is eight years old.

One night, after some particularly satisfying love-making, Aaron sits up, lights a cigarette, stares out into middle distance and says, "You fuck just like a Projects Woman, you know that?" I take this to be a compliment, assuming that "Projects Woman" symbolizes uninhibited wildness. But when I jump to hug him, he just shakes me off. I'm puzzled. I thought what we'd just done was great, and also aren't men reputed to like uninhibited sex? Don't know what to believe, and there's no one to ask.

After that night, Aaron really did become eight years old. His bids for attention became a bit destructive: Stuff started breaking, the TV knobs came off, my box of watercolors fell in the toilet, the kitchen became dangerous. When it was time to make love, he would simply lie there, stare into space and silently dare me to arouse him. Sometimes, he just stopped in the middle, with no explanation.

I began to suspect that what Aaron was really looking for was a mom: Someone who would give him the attention he needed, play with him a lot and certainly not molest him sexually. Now what? Finally, I told him: "Aaron, we are a couple. You know, male and female relationship. If that doesn't work for you, maybe it's time to move on." He said nothing. He lay down on the couch and pretended to fall asleep. Well, at least we had a couch.

Next day, I come home from work late and Aaron is gone, but his sea-bag lies in the middle of the living room floor. Something about the place is strange, something is different, something is scary. I don't know what, but I'm alert to danger. What's wrong begins to unravel when I open the fridge and find my old rectal fever thermometer stuck into a green pepper. Oh oh.

I walk to the outdoor garbage can with the green pepper and find the contents of my linen closet. I go to the linen closet, and there is the garbage. Every single thing in the house is someplace else, someplace awful. In the bathroom, I notice my favorite perfume bottle a bit askew, unscrew the top and discover it full of urine. (I assume the perfume's been flushed.) On a

terrifying hunch, I go to my jewelry etui and find a leaf of philodendron where my diamond ring used to be. Dig in the flower pot and, whew, there's the diamond under four inches of potting soil. In the closet, each pair of shoes has lost its mate. I finally discover all the shoes when I notice some strange bulges in Aaron's sea bag. My underwear's in the freezer, hamburger and ice-cubes dripping inside the dresser. LP's are in the oven, the broiler tray is in the record cabinet. As I unearth each new catastrophe, the place becomes piled with debris—some stuff waiting for its rightful spot, other stuff waiting to be tossed out. It must have taken Aaron untold hours to wreak this calculated havoc, and it takes almost two days to get the place straightened out again. If I weren't so mad, I'd have been amused. As it is, I take photos of the wreckage, because I'm pretty sure no one will believe me should I try to describe it. And the diamond ring goes in the bank safety deposit box.

When Aaron finally calls for a time to get his sea-bag, there are two Hell's Angels, borrowed from two doors down, waiting for him. They stand brawny, ominous guard, aiming their beards and flexing their leathers, while he—silently and quickly—picks up his stuff and backs out the door. I thank the bikers profusely and they depart, looking a bit regretful that Aaron didn't provide them with an excuse for homicide.

(The happy ending to the story is that, somehow, Aaron and I never did lose touch. Through his girlfriends, his sea trips, his eventual return to Texas, even through his marriage-or-two, we've mailed, phoned, exchanged photos. We really are connected, he and I, and always will be. My seamate, my fellow traveler, my baby brother.)

As soon as Aaron leaves, the eating disorder returns full force. Aaron hadn't been big on sweets, and I never did binge on pot roast or tuna casserole. So now I figure out that sugar is the poison. Sugar must trigger some kind of insanity, I muse, as I dunk some Oreos into Reddi-Whip.

Betsy and I are at a crossroads. We need to decide whether or not we stay on the fringes or whether we take the plunge and become John Roger's initiates. Becoming an initiate simply means access to greater areas of information, deeper levels of teaching, entry into fields of arcane knowledge. But are there strings attached?

For me, the immediate necessity is finding out how any official affiliation with MSIA will affect my Judaism. Will I be expected to pledge fealty to Christ, to Buddha, to Krishna, at the expense of my Jewishness? If that's the case, no way. I'm pretty militant about being Jewish and the very idea of anyone tampering with that raises my *Yiddische* hackles. But, no need to worry. John Roger hasn't the slightest interest in how I celebrate Channukah,

or observe Passover, or anything else, nor does he—even in the remotest way possible—wish to change anyone's religious affiliation. He makes that very clear. All he's after, he says, is to teach us how to love ourselves so we can love others, take care of ourselves so we can take care of others and get us to not hurt ourselves or hurt others. Simple, not easy, same as before.

But it turns out there is a prerequisite—not just a string, but a major rope attached—to becoming an initiate, after all. All addictive substances must go, and that includes cigarettes. That part's easy. A week or two of cold turkey, chewing gum and eating myself even sillier, and that's the end of it. I was beginning to hear little wheezes in my breathing anyway, and am glad to be rid of the habit.

As for recreational drugs, however, John Roger says he has nothing against these at all, not a thing. However, if I want to become his initiate, I have to give them up. That one's the bugger, and it takes me a good long while to decide.

I'm stoned, at Saturday Market, looking at a display of miniature marimbas when the artisan picks up his mallets, and starts to play. There's a spare pair of mallets lying by, and another marimba, so I pick these and we start a duet. Once started, neither of us wants to stop and now we're flying. Into the sunshine, into the music, this guy and I are taking off like a matched pair of jets at an air show. Rhythms, polyrhythms, intertwine. Our beats play off one another to perfection, neither of us hits a single wrong note, we don't even know or care what the tune's supposed to be, we are in perfect harmony, we are one and we can't stop. We keep it up for a timeless time, till we're both sweaty and satisfied, as if we've just completed a sexual act of cosmic intensity.

We come up for air, completely bewildered, look around, and realize we're jammed against his counter, a mass of people five deep surrounding us, pushing at us. Folks are clapping and jumping like we're rock stars. "More," they holler, "more!"

The guy and I look at each other, amazed. He says, "I teach percussion at Portland State University, and I have never, in my entire career, ever, had an experience quite like this before."

"Me either."

So, I buy the little marimba and go home in a daze. Now, there's this new lovely instrument to play, along with the flute and the Tumbas.

And I'm supposed to give this up in exchange for spiritual affiliation with some guy who runs a kooky little cult in L.A.? Give it up, along with the stoned artwork which is has currently attained a new level?

Years ago, I read a gem of a story, *Flowers for Algernon* by H.H. Munro

(Saki). It stayed in my heart all these years as if just read, fresh and powerful like a Gabriel Garcia Marquez novel. And, now I know why: It must have been an omen, a self-fulfilling prophecy on the deepest personal level, which has now come full circle.

The story's about a guy named Charlie, a severely retarded person, who, somehow, is placed on an experimental drug. The drug lifts Charlie out of his retarded state and brings him to near genius. He falls in love with the female researcher in whose charge he has been placed. He becomes a theoretician, an avid consumer of literature, a person of such keen intellect that he and his paramour spend hours arguing cosmic and mathematical theorems. He loves his new life, he wakes up each morning with new ideas, new ways of formulating them, eager to expound, express, expand.

But eventually, the drug's efficacy declines, then stops working altogether. Ooops. Charlie descends back into idiocy, back into the dark. He tries writing one last little note to the researcher. But he can no longer spell. He can no longer formulate a sentence, can barely write his name. His signature ends the story. It is a scrawl. It says, "charly."

That is how I now see myself: If I become an MSIA initiate, I will become "charly." I know this as clearly as I know my name, as clearly as I know water is wet. The choice I have to make is: Spiritual growth versus my right-brain paradise—where I lived and loved and flourished for these few years, these few short years of such joyous artistic expression that my whole life's become a song.

And what will I receive in return? John Roger promises nothing. He says all choices are mine, that I will get back to the extent that I put in. Is what I'm being offered greater than what I'll be giving up? Perhaps, a true, complete life commitment is true and complete in direct ratio to whatever attachment is given up for it.

I need time.

Betsy doesn't. "You know what this means for me?" she says. "For me it means giving up that stuff I do, what you call my 'Don Juan' stuff. It's worth it. I kiss it all good-bye, every aspect of it. Yeah, I'm putting those toys back on the toy shelf, permanently. That kind of power is illusion. Honest. Toys, toying around, that's all. You gotta do what's right for you, but I'm going with what's right for my soul. This is a path, Doris, it's a real clean path."

But I need time.

Chapter 18

Beginnings

History's spinning toward peace for just a little time, aided by Anwar Sadat's journey to Israel. On another level, we discover rings around Uranus and George Lucas gives us "Star Wars" in celebration. Musically, I do believe we've hit a generation gap at last! The punkers, like Johnny Rotten and the Sex Pistols, leave me cold, as do David Bowie and Kiss. Anyway, for musical solace, it's still Tito Puente, Cal Tjader, The Fania All-Stars and Eddie Palmierie who soothe my "Latina" soul. And, for quiet times, there's always that old Pentangle "Basket of Light" album. Or maybe some Getz/Gilberto...

I'm flying home from an L.A. wedding celebration, just approaching Portland airport. Portland, for once, is out from under its perpetual cloud, and I can see the town snuggled so comfortably between its two rivers. I gaze out the window and think about choices.

Like some early wanderer I, too, am standing at the juncture of two great rivers and know I must choose one for the rest of my life's journey. Each one leads to a different sea.

One is a white-capped torrent, full of adventure, unexpected twists, wild rapids foaming on rocks, speed and danger, my guides. The trip will be breathtaking, my little kayak will capsize a million times, I'll fly, I'll scream, I'll laugh, I'll freeze. There won't be much time to think, there will be only time to soar into the next danger, the next excitement and hope like crazy I don't drown.

The other river is a quietly powerful giant, rolling, undulating on its inexorable way. So strong, it's a canyon-carver, a landscape changer. Its silent, silver surface hides strange currents, eddies which might spin me in eternal circles of no escape. The rocks in this river are hidden obstacles, waiting to smash with lethal quiet. There are estuaries and tempting branches spinning off, leading to lush scenery, some to exotic beaches made of quicksand, others winding up in stagnant swamps of noxious gasses and lurking swamp-adders. To stay afloat, to ride this river toward my destiny will require patience, endurance and a lot of steady rowing.

Making such a fateful decision is—as I've been told before—simple, but not easy. If I choose this new passage, this river of no return, I will face myself for the first time. A lifetime of ice, a lifetime of self-loathing disguised as narcissism, a lifetime of hatred, of quite literally stuffing old grief with new food, all will look back at me from the smooth waves. I won't be able to hide pain behind danger. I will have to trust, truly trust, a Power greater than myself to assist, to steer, to show me the safe channel.

There is no question in my heart. As much as I like the status quo, my soul is suddenly more powerful than my ego. Spirit wins over substance. I can't *not* make God's move, I am too weak—or too strong—to resist the call. There is no choice but to choose.

This new river, with its wide, calm flow, is scarier than the wild torrent ever was. (At least I'm used to capsizing, to adrenaline rushing me through the next rapids.) What weirdness will float toward me now? What's around the next bend?

If I am going to commit to a spiritual path, it's going to be real, and it's going to be for the rest of my life. Except for my kids' safety and welfare, this commitment to spiritual evolvement will be the only true one I will have ever made (marriage never even came close), and it is, indeed, going to be permanent. So I do it.

Perhaps Betsy is stronger than I, and her thoughts never stray to deer in the road, or misplacing her husband in the bedroom closet. Sometimes, I look back at those times of my life with fond nostalgia. Except now I know what I am receiving in return, and there are not words for it. As it turns out, commitment is, indeed, true and complete in direct ratio to whatever attachment is given up for it.

When I flew down to L.A. for initiation, I asked John Roger for advice on the eating disorder. I got a one-word answer: "Exercise."

Exercise? Talk about simple common sense. Why hadn't I, that age-old jock, thought of this before? For years, I'd been sitting on my tush, accumulating fat and ignoring my entire cardio-vascular system. Exercise was not only healthy, it was joy. The skier, the judoka, the scuba diver inside all sat up and cheered. I started slow, biking to work instead of driving, added the Royal Canadian Air Force floor exercise program and then began jogging, neither of which I've ever stopped.

And I never touched sugar again—ever. Being exercise-full and sugar-empty startled the monkey on my back into loosening its grip a bit and shifting position: Binge-and-starve became binge-and-barf. Hello, Bulimia! I found plenty of sugar-free stuff to stuff, thought bulimia the greatest

invention since roller-skates. I binged and barfed at home, at work, anywhere there was a combination of food and bathroom. I binged and barfed enthusiastically, shamelessly. I was now the world's only sugar-free food addict.

There was a problem at work. I'd been dating Marc, mediation supervisor at another office, when the city decided to combine us all into a single unit. Karen left for a better job in the private sector, and Marc became my new supervisor. Only he didn't know how to deal with the fact that he was now both boss and bedmate. He got grouchy, tracked my whereabouts (I had to phone in every two hours to tell him where I was and what I was doing there), assigned unreasonable hours and the riskiest clients. And to top it all off, I discovered Marc was a married man when his wife walked in for lunch one day. (Lesson: Don't ever get personally involved with anyone at the job. Yikes, I learned that one the hard way, didn't I....) Time to move on.

Resumés went flying, and in short order I landed a job as after-care specialist at a residence for troubled adolescent males.

What a nut-house. Every staff member seemed to be in bed with everyone else. (Talk about ignoring that work-place-personal-involvement lesson!) Chrissie, the married head female counselor, was having an affair with Mitch, the married treatment coordinator. My supervisor, Dick, was having a *menâge a trois* with his wife and a female counselor who had recently changed her name from Sandra to Keith (?), and Keith was also messing with a male counselor named Hank. All participants involved freely discussed their comings and goings, except Dick's wife, who didn't work there. The clients appeared to be the only sane folks around.

I kept out of it, enjoyed the job. Besides, the office music was great: Hank was a Beatles freak, Dick played lots of Chicago, and Keith introduced me to Paul Winter's *Common Ground,* which wove the calls of wolves and whales into his own music. (Animals, by the way, all seem to sing in D minor, isn't that amazing?) Everyone was pleasant company. Dick, especially, challenged me constantly, while simultaneously giving unconditional support. When he assigned me to write an after-care booklet to teach clients everything about independent living, I panicked at once. "I can't do this," I whined, "I can't write."

"Sure you can," was the answer, "now get out of here and go do it."

So I did, and pretty soon the clients had access to information about everything from shopping for food and reading classified ads, to dressing for job interviews and writing resumés. Once the scare wore off, the job was fun.

This was a wonderful place for learning: Clients—both the youth and their families—I found, needed respect. For many, this had been a

commodity apparently denied them most of their lives. And they all thrived on attentive listening. For the most part, everyone responded sincerely.

In aftercare, those good old mediation skills sure came in handy. We routinely formulated mediation agreements which addressed individual as well as family-unit concerns, and I'd visit to make sure these were honored. And, often enough, I'd contact some company or other from the "Workers Together" job network, and be able to assist an out-of-work parent get employed.

Learning took place at home, too. I began hanging out with the local MSIA community, listening to John Roger tapes and discussing them with Betsy. Meditation was still hard. Mind still kept wandering. But there were subtle behavioral changes. I began looking at the world (and myself?) with a bit more compassion than judgment. No longer jumped into anyone's bed with such predictable alacrity. Instead, began to see myself as a human being who was worthy of at least the same amount of respect I gave to clients. Well, it was slow, and it was subtle, it was almost imperceptible but it *was*.

After three years on the job, however, all the staff chicaneries came home to roost. Dick divorced his wife when Keith became pregnant and they left together. So did the treatment coordinator, who decided to become monogamous. Hank, too, found true love and a better job elsewhere. That left Chrissie, me, and a new executive director, who was so crazy she gave legitimate nuts like me a bad name. Her first move was to eliminate all wheat products from the facility. Wheat, she said, made clients hyperactive, and things went downhill from there. Time to move on.

The resumés went flying again, and pretty soon I was interviewing with a guy named Burt, at Metropolitan Youth Programs, which ran various residential treatment facilities for disturbed and adjudicated adolescents. The job was case manager at one of their residences for adjudicated males.

What an interview! We talked about the usual stuff: Experience, background, special abilities, and then he asked what I thought my role was. I had only one answer.

"I'm here to learn. Not just here at Metropolitan Youth Programs, but in my whole life. I'm here to learn."

"Who's your teacher?"

"Oh, a guy in L.A., John Roger."

"I know of John Roger. You'll do fine here."

And, just like that, not only was I hired, I stayed with the agency for over seventeen years.

Burt was a great instructor. He patiently taught the requisite paper work (I'd never organized client files before, or written treatment plans), and gave

lessons in counseling and personal growth as well. He and his wife were disciples of the Maharishi, had even made a trip to India. He had a frame of reference similar to mine, which made communicating easy.

The first thing he insisted on was that I make mistakes. I was so uptight and scared of "doing it wrong" that little got accomplished. So Burt sat me down and told me that I had to make at least one mistake a week, which we would then discuss during supervision. "No pain no gain," quoth he. Well, yeah, I decided, kind of like skiing. If you didn't fall down, there was no way to get fluid and, just like in skiing, fear hemmed in creativity. Burt was right, and, all caution aside, I began trusting him.

Ten months later, Burt took me by the hand, put me in his car and said he had a surprise. We drove over to another residence, also for adolescent males, where he gave a house tour. Then he sat me down in their office, handed me the house keys and said, "Well, have fun. You're the new supervisor."

Was I scared? Was I excited? Wow, talk about new challenges. Thank goodness Burt stopped by a lot. "Remember," he'd preach, "catch 'em doing something right! When you're consistent with your praise, it's easier to set limits. But Doris, if you praise, make it for something real and you gotta be sincere. Staff can smell 'phony' a block away." He also kept on reminding me of that magic supervisory word, *"Nevertheless."* As in,*"Nevertheless,* you'll have to take Jim to school," or, *"Nevertheless,* your report is due by Friday." Supervision wasn't so hard. All I had to do was use Burt as a role-model and remember to put all decisions in the Light before making them. If I neglected that, all hell broke loose at once. Well, actually, all hell broke loose anyway, but if I asked for Divine assistance, I'd usually keep my cool and things got back to normal faster.

Soon Burt had another surprise. We were formulating a treatment program for the house, when Burt introduced William Glasser's *Reality Therapy/Control Theory*[4] . Goodness, here we go again: Now we've got a treatment program that also mirrors many aspects of MSIA philosophy.

Reality Therapy was so simple, easy for adolescents to understand, and powerful, as well. Dr. Glasser said that everyone had four basic needs: Power, Freedom, Love/Belonging and Fun. He said that all human behavior was an attempt to satisfy one or another of these needs, and that some of us did this more effectively than others. The words "good" and "bad" were out

[4] Glasser, William. *Control Theory.* N.Y., N.Y.: Harper & Row, 1984.

the window. Instead, clients were taught to evaluate the efficacy of their chosen behavior insofar as it satisfied immediate or long-term needs and goals.

Staff and clients were both taught the Glasser principles. Then, staff would observe inappropriate or harmful client behavior and ask open-ended questions, like: "What are you trying to accomplish, what need are you trying to fulfill, (each client had a "needs chart"), and how is what you're doing now helping you to effectively fulfill the need? What can you do right now that's more effective?" It worked so well, I got hooked, clients got hooked, everyone had little goals to meet.

I'm watching Ellis, one of our clients, get an EEG. He's had a sudden seizure and now we're at hospital to find out what happened. Ellis is lying quietly, apparently dozing, the EEG needle making orderly little spikes on the paper, when suddenly the needle goes bonkers, filling the paper with lots of ink, via a pattern of dense, large, needle movements. Alarmed, I ask the tech what's happening. "Nothing," says the tech, "he's just thinking something."

In an instant, I'm squirming around again, on that lumpy mattress back in Oakland. Electro-magnetic energy. Brain waves are electric, and they're strong enough to change the way a needle moves. John Roger is right! William Glasser is right! René Descartes is *almost* right: "I think, therefore I am," should have been, "I think, therefore I create, therefore I am." (And when Walt Whitman wrote, "I Sing the Body Electric," he must have been celebrating our connection to God!) Thoughts do have actual power. We don't just create our reality in the abstract, we do it quite literally. We send electro-magnetic waves throughout our bodies, and also out into space just like radios. Brian Wilson sang it best: "You gimme those good *(or bad?)* vibrations, you gimme those excitations..."

"OK," I say to myself, "create a feeling without thinking first. I command you to feel sad." Nothing happens. Then, I deliberately think of Bunzo being killed by that neighbor's car, and, sure enough, a sudden wave of sadness floods over me. The sadness cramps a little lump into my solar plexus. Soooo, not only did I just create a feeling with a thought, but the electro-magnetic energy of that thought affected my physical body as well, right in the gut.

Then, I decide, that process must go all the way to "fight or flee," which spurts excess adrenaline, which causes stress, which not only affects how we view our individual universes but also clobbers our immune system. We do it both individually and collectively, don't we. Individually, one person wakens to a dawn glorious with birdsong, while his neighbor is assaulted by

hideous feathered cacophony. And, collectively, we all created not only Martin Luther King, but also his assassin. Personal responsibility takes on a whole new dimension.

At work, Burt presents me with yet another challenge: "You know," he says, "any counselor can only be as effective as the degree to which he or she has resolved his or her personal issues. When we engage in counseling, we can only go as far as our personal issues, and there we stop. We can deny, we can equivocate, we can side-step and we can shuffle. But we can't serve the client beyond our own issues, not even for a moment."

Since I do a lot of counseling, with families as well as with clients, I decide I'd better start resolving pretty darn quick. So, now it's not just, "Oh I admire Bill Glasser so much," or "Oh, I am on a spiritual path with my spiritual teacher." Now it's, "OK, you've messed around long enough, let's begin working on the issues in earnest." (*Oi!* I'm having to take risks.)

First thing: Since I deal with a lot of addicted clients as well as a lot of addicted parents, it becomes very clear that I am not practicing what I preach. I'm still the world's only sugar-free food addict. I need to clean up the act, and be quick about it. So I join "Twelve Step."

The Twelve Step programs and I fell in love at once. It didn't matter to me if it was AA, NA, OA or ACOA, they all gave the same support, the same trust. The Twelve Step message was so much like MSIA's, it was uncanny. John Roger called it "The Light," Twelve Step called it "Higher Power." Either way, it was God, as we understood God to be, and both organizations asked us to turn our lives over to that Power. MSIA said, "Place it in the Light toward the Highest Good," (LIGHT was an acronym for Living In God's Holy Thoughts, and "Highest Good" meant trusting that God might resolve whatever it was differently than our own personality or ego desired); Twelve Step said, "Turn it Over to your Higher Power." Both asked us to take personal responsibility for our behavior and not judge ourselves or others. With such strong spiritual backing, slowly but surely, blessed recovery took a firm stand between me and the use of food as an addictive substance.

That adage, "What doesn't kill you will make you strong," turned out to be true. For the first time since becoming a teen-age anorexic, I was able to say—honestly and gratefully—"I am an addict, and I am in recovery." The monkey fell off my back, slunk off into its lethal darkness, and jogging pranced into its place. I was hooked on jogging. Addicted, you might say.

(Dr. Glasser called it "Positive Addiction," when a positive, effective,

need-fulfilling behavior takes the place of a harmful one. For me, this was, has been, will always be, daily jogging. What a glorious way to start the day.) So, now I could offer Twelve Step participation to clients, and feel good and clean about it, too.

Second thing: Twelve Step alone wasn't enough. Those fears, that despair, the lingering pain disguised as rage, all needed exorcism if I was going to address them in clients. I began studying toward certification with a Certified Reality Therapy counselor and started practicing in my personal life, what I had been preaching to others. I also flew down to L.A. quite regularly for week-long pastoral counseling sessions, called *Insight Seminars*. Between ACOA, Dr.Glasser and MSIA, something was bound to change.

OK, so I'm a slow learner. First I have to understand it, then I have to agree it's true, but before I *really* learn it, absorb it, accept it, I must experience it. It's always been that way: When I was little, two and two didn't make anything till I experimented with four radishes. As a teenager, liquor didn't make folks drunk till I barfed all over Reba's bedroom that New Year's Eve. So, I understand the principles espoused by Reality Therapy, by Twelve Step and by MSIA, agree they are true, but need the experience.

I stayed stuck at principle #1 (which is: In order to change anything, anything at all, first you have to accept it. Not only accept it, but not judge it) for a long time. Great concept, but it meant allowing myself to experience my more ineffective behavioral choices and not judge myself in the process. This was tough. Yet ignoring it was akin to breaking an ankle and refusing to get medical help for it, because I didn't want to accept its brokenness—and, besides, only wimps complained of pain.

Moral of the story? Before I could change anything (heal the ankle), I had to accept it (it's badly hurt, may be broken) without judging it (ankle injury is not a sign of wimpiness). It took dozens of hypothetical broken ankles to teach me that lesson, but their emotional discomfort was well worth it. Brought my whole life new meaning.

Now I was able to start taking fearless inventory. And, having accepted whatever it was that needed changing, I could love myself for having the courage to face it. It became clear that I was dealing with a forlorn, traumatized little kid—that frightened, unloved refugee from Antartica still cowering inside of me. So, we invented a game called "Catch It." Every time I caught that part of myself hiding pain under anger, or hiding fear behind obsession, not only could I accept the behavior, I would feel the pain or fear, maybe even cry, and tell that part of me, "It's all right, it's all right. You're

just scared," or "Had your feelings hurt, huh." Then I would soothe and comfort. I'd say, "Hey, It's OK sweetie, let's just place this whole mess right up into the Light. We'll just let go and let God." There would invariably follow a moment of purest magic. A physically tangible, actually palpable energy-presence would make itself felt. A giant, tender, loving hand would caress my head in one touch, and then surround my body with such calm, such serenity that the end result was a quiet, quite indescribably peaceful bliss. I'd stop (still stop) whatever I was doing, close my eyes and simply experience it. Surely that's what David meant in the 23rd Psalm when he said "He restoreth my soul." Anyway, that's what it felt like, still feels like. The object of the game was to recognize and honor every facet of my being as equally valuable—to become more and more whole.

"I love you," I'd say, "I love you." If I managed to "Catch It," that is..... which was, at the start, much more occasional than consistent. Perhaps, now I could begin to make amends to those I'd hurt. Making amends would bring the blessing of forgiveness.

And forgiveness was the next thing I needed to experience. John Roger said that in order to forgive others, we have to forgive ourselves first. For me, the two went hand in hand. It took years and years, not months and months or weeks and weeks. Forgiveness was hard.

Can you imagine? Forgiving myself for being an abusive mom while I watched my grown children still recovering from that impact? Talk about one small step at a time!

Much of this true experiential learning, occurred—still occurs—while jogging in the park. There's something inspirational about being out in pre-dawn nature, sometimes watching dark drizzle turn silver in the dawn, sometimes watching sunrise make a strident orange entry. Soon, the dogs swagger in, leading their owners by the leash, causing raccoons to scurry, squirrels to freeze, day to commence. I thank God, each morning, for heeding my prayers, and then, in the blessed silence, God, in turn, gives me information. "Oh, yes, I get it," I reply, "yes."

It's a beginning.

Chapter 19

The Trip Is Still A Trip

Whazzup? History turned its page into a new century and Y2K didn't get us after all. With the patience of saints and the endurance of elephants, America had slogged through a year of President Clinton and Monica Lewinsky. Some of us whimpered, some of us railed, but, all-in-all America remained courageous. This just substantiates what I've always suspected: We're a nation of heroes! Israel and Palestine are still doing their strange dance, a wondrous minuet in which all participants mince three steps forward, pirouette, bow to their partners and then take four steps back. The name of the song is: "Everybody's Right and Everybody's Wrong." Both sides sing it fervently. It ought to be their multi-national anthem. Fortunately, the music's better over here. I don't care what anybody says, I think the Spice Girls were cute. Oh, and the Latinos are at it again: Seis Del Solar has incorporated such an intoxicating rap into their "Decision" album, it makes me jump up and shake things I didn't even know I had. Same with Ricky Martin, who really ought to come live at my house. And, for a real, true "Supernatural" soul-shaker, Carlos Santana's done it once more: Hip-Hop, Salsa, all blended together in such a hot mix that even the most dedicated Gringo can't help but stand up and bust a move. Hey now, Carlos, I love you!

I'm driving home from a shift with my hospice patient, thinking how beautifully she is addressing her imminent transition. In our culture, I muse, we make a wonderful fuss about entry, but are usually very scared of exit, and try to ignore it. Not this patient. She is helping her family to cope, encouraging conversations that should, perhaps, have occurred years ago, inviting closure to perceived slights, forgiving herself and others. I told her today, "Gert, if there was an Olympics for this, you'd be a gold medalist."

She laughed, we held hands, and when her daughter came home, Gert said, "Hey, I'm a world champion dier."

So, now I'm driving home, searching in vain for Mount Hood under Portland's overcast and listening to Public Broadcasting. Then, suddenly, they play God's voice on the radio, in the form of an Amazonian bird called

the Uirapurú. I have never in my life experienced anything like this before, and pull over to savor it fully. I've always heard God's voice in the ocean, but I didn't know He also sang aria. This bird makes actual Divine melody. With its voice of liquid, coloratura velvet, it surely brings the sun up every morning and starts the Amazon to flowing. Uirapurú is so rare, the announcer says, the locals believe that hearing it blesses the life of the listener forever. Soon as I get home I'll call the station, so I can locate a tape or CD for Gert. It will bring such peaceful greeting. Whoopee, I'm excited, gun the engine and roar off.

I come careening down the back alley, make an exuberant turn into the driveway and stop short just in the nick of time. There, propped up against the fence, his legs stretched out directly onto the tire-tracks, is a homeless person of the large furry variety. You know: Full curly beard, hat with hair peeking out from under the earflaps, parka a bit too tight, pants a bit too short, shopping cart nearby. There he sits, a bottle of Thunderbird carefully perched on his lap, staring at nothing in the chill March drizzle. And his legs prevent the car from reaching its destination. I lean out the window.

"Hey, move your legs."

No response.

"Hey man, move your legs."

Aroused from his inner visions, he looks up.

"I'm from Minnesota."

"Well, cool, but you gotta move your legs."

"I'm cold."

"Hey, you're from Minnesota. Minnesota is cold."

"Yeah, but it's a different kind. This here is damp, chill, wet cold. This is colder."

"Well, OK, but you gotta move your legs."

"I was in treatment in Minnesota for eight months, but it didn't take, so I came here."

"You still have to move your legs, though."

"Move my legs?"

"Yeah, I can't get to the garage till you move your legs."

"I don't think I can get up."

I jump out and get him turned to the side, so he can get an assist from the fence and then squat, get my shoulder under his armpit and heave. Somehow, in concerted effort, we get him erect. Kind of. I take a good look and say, "OK, now wait till I get the car in the garage, OK?" No reply. He is back gazing at whatever he sees in the gray distance.

In the garage, I open my wallet. I know for a fact that there is a ten-dollar

bill in there, nestling amongst the singles. And then I—notorious skinflint, champion of the world's penurious, consistent winner of the monthly battle between my teensy little social security income versus the cost of living—I go for that ten.

There he still teeters, propped into a standing position by the fence, still looking into space.

"Hey, listen. Here's ten bucks. Now, what you gotta do is get yourself down the street to that MacDonald's and get in there, you hear? Get in there and sit and order something hot to eat. You got that? Go to the MacDonald's down the street, get in there, order something hot to eat and then just sit. OK?"

He looks at the money, looks at me, his eyes big and shining. He does not take the money. I reach for his hand, remove its fingerless glove, put the money in his palm and then wrestle the glove back on.

"Now: Get to the MacDonald's, go inside, order something hot and sit. OK?"

His eyes widen in surprise. He comes out of his trance. From his vantage point of giant furriness, he looks down at me—the little old retired lady—smiles and asks, "Can I have a hug?"

"You betcha.

I disappear into his huge enfoldment and smile up at his face.

"You remind me of my mother. You have eyes like my mother. My mother died when she was fifty-three. She was an alcoholic."

"Wow, that's tough. Sometimes alcoholism comes down through the genes. Makes recovery hard, doesn't it."

Arm in arm, we walk through the fence gate toward my back door. We look into each other's eyes like two old friends about to part forever.

"You an alcoholic?"

"Addict. In recovery. Now, remember, go to the MacDonald's, order something hot and just sit. OK?"

"OK."

We touch one another's shoulders and then he bumbles back out the gate to retrieve his Thunderbird and shopping cart. After awhile, I hear the cart rattling off in the distance, toward the MacDonald's.

Now, six months later, everything's the same and everything's different. Life lurches on as usual: The dog is still senile and confused about everything except food and my own short-term memory just about matches his. The social security check is still teensy, the weeds continue winning their relentless war against what's left of the lawn and my knee still hurts after jogging.

But, inside of me, at the very core, there is a steady light. It stays on, no matter what else is happening, warm and comforting. And I think of him every day: My guardian angel, that divine messenger who bestowed upon me a gift directly from God.

In our few moments, God, using "Mr. Minnesota" as His delivery person, returned to me a part of myself I hadn't even known was missing: A last little misplaced piece of my soul, tiny but vital. And the gift continues to grow. Each day it brings new serenity. And I, without even understanding its full meaning, somehow share it.

I thank God daily for the gift and for His divine messenger. I know that somewhere, somehow, "Mr. Minnesota" is asking for a hug from someone and giving back exactly whatever blessing the recipient needs. Isn't it wonderful how those messengers come? Disguised in clown suits, or grubby jeans, in fancy ballgowns or as furry homeless alcoholics, there they are, just waiting for us to open our hearts so the gifts can enter.

<div align="center">

"Baruch Bashan":
The Blessings Already Are.

</div>

Epilogue

911 hit hard, and for the first time in U.S. history, our own homeland bore the unbearable atrocities of war. Their tremors rattled the foundations of our blithe complacency, forcing us to face the reality of a quaking civilization. Yet, if we all work together, really together, we will not only prevent the unthinkable but will actually produce a different world. Together we will learn from our past mistakes. Together, we will learn from one another. Together we will create a world not brave and new, but strong and compassionate, built with and for the mutual support of all who live upon it.

So, what were those seventy-three years of learning all about? The only way I can measure that is to look back and note whatever isn't there anymore and what has manifested itself instead. Change came gradual as a change of season, old thought patterns fading like autumn grass, new behaviors emerging like acorns, planting themselves for eventual oak-hood. Slowly, there grew love to love, internal music that danced night into morning, sang serenity into my heart.

It was worth it, every bit of it, every tragedy, every triumph, every idiocy, every bizarre turn of events. The most amazing part of this on-going learning process called "Life on the Planet Earth" has been recognizing obstacles to be stepping stones. "Learning Stones," I call them, and yes, they sure can stub a toe.

I've found that everything that's ever happened in my life happened to instruct and am only now beginning to recognize what these lessons are all about. (I have a sneaking suspicion that this planet is for remedial students, like Cosmic Special Ed or something.) All of it, individually and collectively, brought me into this very moment: To this tiny increment of peace, frustration, tears and laughter, called "now."

Are there regrets? Of course there are. I hurt precious beings on the way here, and some days must take time, once more, to make amends to whomever making amends is possible. And if persons are out of reach, I write it to them without sending. Then, other days, the karma feels completed, peace reigns and I sigh contentedly, pat the dog, mow the lawn, swat a mosquito. Life goes on, either way, and it's really all OK.

All of the above is contingent upon the degree to which I'm at one with

myself and my Self at any given moment—which produces quite an absurdly broad range of behavioral choices. This, of course, makes any situation or circumstance much less important than from what level of consciousness I choose to respond to it. If the same kind of problem pops up more than thrice, it's time to figure out what I'm hanging onto that's not working. That can get deep! Often, there's nothing to be done but to let go and Let God, because I sure don't have the answer, and, you know, that works better than a lot of other things I've tried....

So, what's this all about anyway? All this is about all of us, together, taking personal responsibility for ourselves and for our planet. Collectively and individually, we create not only who we are, but how we affect one another. We are the governments we elect, we are the exterminators of endangered species, we are the global warmers. When I recycle trash, I'm helping. When I speak out against perceived malfeasance, I'm helping. When I stand in the grocery store parking lot collecting signatures against some poorly-thought-out municipal decision, I'm helping. When I refrain from the above, I'm hurting. It's that simple. Keeps going back to that photographer in Alexander Solzhenitsyn's rose bushes.

And, yes, our greatest crime *IS* indifference! Is this a diatribe? You bet. Indifference may have cost us the future of our planet when we ignored the Holocaust. No, don't slam this book shut and walk off. Just listen: To get the "final solution" off to a good start, the Nazis made the following offer: They began recruiting young, brilliant Jewish males for what they called the "Relocation Train," which was to take qualified participants to Scandinavian resettlement. In order to qualify, persons had to be between the ages of nineteen and thirty-five, had to submit 5,000 *Deutschmark* (which in those days was a hefty amount of money), and prove their brilliance via university or other official documentation. Only the very best and brightest were chosen.

So their mothers and wives came with them to the station, and waved their handkerchiefs and kissed good-bye and cried with joy, or relief, or sorrow, and sent their men off to Oslo. Only, of course, the train went directly to an extermination camp, while those same indifferent farmers watching in track-side fields, waved, laughed and drew their fingers across their throats. The good burghers of Dachau and Auschwitz watched the heavy, greasy clouds of smoke rise over their towns daily, like smog from hell. They sniffed the distinctive odor of burning flesh that permeated their air and turned away, indifferent. And thus was history amended.

Who was on that train? Or on any of those countless other trains which hauled six million diverse souls to their deaths? The question still haunts me as strongly today as it did fifty-five years ago. Maybe the next Mozart, or Rembrandt. Maybe the guy with the cure for cancer in his back pocket, or the girl slated to discover non-polluting fossil fuel, or the fellow who was about to figure out how to farm the Amazon rain forests without cutting down the trees. Maybe the one person who would teach us all unconditional love. We'll never know, will we?

Or maybe one of those innumerable children in the camps—whose deaths I still mourn, the ones who starved, or were shot, or succumbed to disease—would have discovered anti-gravity and we might all be floating.

Whoa! How did such an impassioned sermon get into this placid story of spiritual progress? Because the lesson still is: Love yourself so you can love others. Take care of yourself so you can take care of others. Don't hurt yourself and don't hurt others.

If we all do those three things the best we can, with whatever we've got going for us individually and collectively, we can save the planet after all. As we take complete responsibility for our behavioral choices—both personal and global—there will be no indifference, no turning away. Not from the homeless family trying to keep its kids warm in a November park picnic shelter, or from the child starving in a Sâo Paulo gutter. And maybe one of those children, saved from death-by-indifference, will discover anti-gravity, and we'll all float, after all.

* * *

Printed in the United States
717900004B

9 781591 294726